THE ABRAMS ENCYCLOPEDIA OF
PHOTOGRAPHY

THE ABRAMS ENCYCLOPEDIA OF
PHOTOGRAPHY

Edited by Brigitte Govignon

Translated from the French by Graham Edwards,
Nicholas Elliott, Elizabeth Nash, and Molly Stevens

Harry N. Abrams, Inc., Publishers

pp. 14–15:
Adolphe Humbert de Molard, *Louis Dodier as Prisoner* (1847).
Daguerreotype, 4.5 x 6 inches (11.5 x 15.5 cm)

pp. 144–145:
Bernard Faucon, *The Telescope* (1980)

pp. 184–185:
Juan Manuel Castro Prieto, *Navaluenga* (1994–1996)

FOREWORD

No one these days can get away from photographs. They are everywhere: in our passports, in the newspapers we read, in shop windows, bookshops, and even on the walls of our museums. We cannot escape them or avoid them. They have changed the way we look at the world. From their earliest days, photographs have captured key events in human history—the opening up of continents, science, natural disasters, space travel, wars—as well as personal and individual moments, like the birth of a child, a vacation, or some other happy event.

Tracing photography from the invention of the daguerreotype in 1829 to the rise of digital photography in the early twenty-first century, *The Abrams Encyclopedia of Photography* presents the amazing history of an invention that nowadays is available to everyone. This encyclopedia includes a selection of biographies of the greatest photographers. The various stages in photography's history are presented with clarity and precision, and the intention is to appeal to a wide public. Short commentaries from trusted specialists, strong images, a lively layout, and plentiful cross-referencing make finding out about photography interesting fun.

Quentin Bajac, Gabriel Bauret, Joëlle Bolloch, Christian Bouqueret, Christian Caujolle, Françoise Docquiert, Dominique Gaessler, Brigitte Govignon, Flora Mérillon, Hélène Pinet

CONTENTS

Foreword 5

Introduction *Quentin Bajac and Christian Caujolle* **8–10**

Some Key Dates in the History of Photography **12–13**

INTRODUCTION

This "small" encyclopedia of some 288 pages traces the history of photography from its earliest beginnings to the present day. Photography's more than 150 years of existence are tracked through fifty-two stages and are illustrated by 220 biographies and as many photographs. The first so-called encyclopedia was that of the Frenchman Denis Diderot; published in the eighteenth century, it ran to seventeen volumes with eleven plates. Our more modest aim is to sum up, in a single volume, the history of an invention that has profoundly altered the history of representation and that of the observing eye. The story is brought right up to date, and includes questions about the place of photography in the modern world.

To help achieve this aim, and to make the book as clear and informative as possible, we have adopted a style of theme-based double-page presentations that provide a range of information and raise numerous questions. *The Abrams Encyclopedia of Photography* is intended to be both an educational tool and an incentive to the reader to read on and consult more specialized material, monographs, thematic or theoretical works. Above all, it is intended to inspire the reader—any reader—to discover more about those grains of silver and the images they create, to reflect on modern challenges to the medium and the practitioner, and, beyond the images themselves, to encounter a era of human history imprinted with a great discovery—a chaotic time, but one still never equaled in terms of sheer creative force. We may be criticized for gaps in the list of biographies. Space constraints did force some difficult decisions, but we fully admit, to some extent at least, that the choice of biographies was subjective. We do not claim that our cast is a "fair" representation of all those who played decisive or essential roles in the evolution of photography, but we certainly hope that we have remembered all the most important.

Despite any limitations, this volume becomes all the more valuable when we consider that there really is no other book that serves as an initiation to photography. At a time when recognition of photography's importance in the modern world is as clear in the news and information media as in the contemporary art world, this is an important function to serve.

As you leaf through this small encyclopedia, and your eye stops on this or that image, you will experience the indefinable character of the "photographic." Within these pages are many well-known pictures, the work of photographers with every right to regard themselves as artists. Here, too, are anonymous and amateur snapshots, taken for documentary, or even amusement purposes. From Stieglitz to the spoiled shot, from Nadar to NASA, from Cartier-Bresson to Photomaton—you have an exploded view of the history of a contradictory medium. Even the many "icons" that are scattered throughout the book, the work of reporters, artists, scientists, and others who have left no name, are the result of a great diversity of intentions; they reveal a similar diversity and freedom of technique and perspective. Such diversity is responsible for the richness of photography today, and says much about its popularity.

But to leaf through these pages is also to experience the power, even violence, of the photographic image: the empty streets by Atget, the blurred soldiers of Robert Capa's D-Day photos—these are part of the indelible imagery of our collective memory. In 1859, in a now-famous text, Charles Baudelaire railed against the artistic pretensions of the new photography, reducing it to keeping the "archives of our memory." Today, photography can pride itself on having fully met the poet's expectations. But Baudelaire might now also be treated to a response from the great Austrian novelist Thomas Bernhard. In one of his last novels, *Extinction*, the narrator bitterly complains how hard it is to escape the photographic image: "If today's man were deprived of photography, if its products were stripped from his walls and destroyed once and for all, he would be losing almost everything." This small encyclopedia tries modestly to be a history of this "almost everything."

—*Quentin Bajac and Christian Caujolle*

SOME KEY DATES IN THE HISTORY OF PHOTOGRAPHY

INVENTIONS AND INNOVATIONS

HELIOGRAPHY, p. 17
Joseph-Nicéphore Niépce used this term to describe the earliest photographic procedures that he developed between 1816 and 1829.

DAGUERREOTYPE, pp. 18–19
Named after its inventor, Louis Jacques Mandé Daguerre, the daguerreotype was a unique image captured on a silvered copper plate. The French government purchased the procedure in 1839.

CALOTYPE (also known as **TALBOTYPE**), p. 19
Invented by William Fox Talbot in 1840 (patented 1841), the calotype or talbotype was the first negative/positive procedure on paper.

COLLODION, p. 24
Frederick Scott Archer created the wet-collodion-on-glass-negative photographic process in 1851. It was capable of producing sharp images, like the daguerreotype, but also had the capacity to produce multiple prints. Although dry collodion was more convenient, it was also much less sensitive and required longer posing time.

GELATIN-SILVER BROMIDE EMULSION DRY PLATES, p. 44
The invention of this process by Richard Leach Maddox in 1871 revolutionized photography throughout the 1880s and made it possible to take instant photographs. Negatives were made commercially available, and complete amateurs were able to practice photography.

CHRONOPHOTOGRAPHY, p. 43
In 1882, after studying Eadweard Muybridge's consecutive shots of a galloping horse, Étienne Jules Marey developed a fixed-plate chronographic photographic process.

THE FIRST KODAK CAMERA (the Kodak No. 1), p. 45
Invented by George Eastman in 1888, this was the first camera accessible to everyone.

GUM BICHROMATE, pp. 54–55
The gum bichromate process became popular in 1890 with the pictorialists. The subject of experimentation from the 1850s, this technique used a blend of pigmented gum and potassium bichromate.

AUTOCHROME, pp. 52–53
Autochrome was the first color photography process. The Lumière brothers patented the process in 1903, and it was marketed in 1907.

FLASH, p. 50
The magnesium flash, which produced a very intense white light, was invented in Germany in 1887. It has since been replaced by the electronic flash.

BELINOGRAPH, pp. 92, 122
Invented in 1907 by Édouard Belin, the Belinograph made it possible to transmit photographs over long distances by means of the telegraph.

THE LEICA CAMERA, p. 92
The Leica was invented by Oscar Barnak and hit the market in 1925. It was the first lightweight camera to use 36mm film.

THE ERMANOX CAMERA, p. 98
Because of its wide aperture, the Ermanox camera was able to take photographs indoors or at night without special lighting. It went into common use in 1924 and 1925.

THE ROLLEIFLEX CAMERA, p. 98
Paul Franke and Reinhold Heidecke launched the twin-lens Rolleiflex in 1929, and it quickly became a tool of the trade for professional photographers.

THE POLAROID CAMERA, p. 142
An invention of Edwin H. Land that was first used in 1947, the Polaroid was the first camera equipped with instant processing.

DIGITAL PHOTOGRAPHY, p. 188
From the 1980s on, digital photographic processing made it possible to record, visualize, and select images that, converted into pixels, could be transferred to a computer or printed on paper.

IMPORTANT EXHIBITIONS

In **1851**, photography first took its place as part of international exhibitions at the Great Exhibition in London (p. 23).

In **1855**, **1857**, and **1859**, the Société Française de Photographie organized three exhibitions of photographs.

In **1858**, the London Photographic Society and the Société Française de Photographie exhibited jointly in London (p. 23).

In **1902**, Alfred Stieglitz organized a show called "The American Pictorial Photography Arranged by the Photo-Secession," which was exhibited in New York (p. 57).

In **1913**, members of the Ashcan School organized the "International Exhibition of Modern Art," commonly known as the Armory Show.

In **1929**, the Dutch artist Jan Tschichold organized the "Film und Foto" exhibition. Known as Fifo, the show opened in Stuttgart and, in an abbreviated form, also traveled the world (pp. 74–83).

In **1932**, New York's Julien Levy Gallery exhibited "Modern European Photography: Twenty Photographers" (p. 88).

In **1938**, the Museum of Modern Art exhibited the works of Walker Evans (p. 86).

In **1955**, Edward Steichen organized the exhibition "The Family of Man," at the Museum of Modern Art (p. 130).

In **1958**, the Museum of Modern Art exhibited "Abstraction in Photography" (p. 128).

In **1960**, the Museum of Modern Art exhibited the works of forty subjective photographers under the title "The Sense of Abstraction" (p. 128).

In **1967**, the Museum of Modern Art organized the "New Documents" exhibition, which featured some of the great documentary photographers of the time (p. 129).

Tableau Photography, New York, p. 170

In **1973**, the exhibition "Looking at Photographs: 100 Pictures from the Museum of Modern Art" opened in New York City.

In **1975**, the "New Topographics: Photographs of a Man-Altered Landscape" exhibition was shown at the International Museum of Photography at the George Eastman House, Rochester, New York (p. 174).

In **1980**, the exhibition "Ils se disent peintres, ils se disent photographes" [They Call Themselves Painters; They Call Themselves Photographers] opened in Paris (pp. 170, 190).

In **1989**, the exhibition "Une autre objectivité" [Another Objectivity] opened in Paris (p. 190).

In **1989**, the "Photokunst" exhibition opened in Stuttgart, Germany (p. 190).

In **2000**, the exhibition "How You Look at It: Twentieth Century Photography" opened in Frankfurt, Germany.

PHOTOGRAPHIC SOCIETIES AND CLUBS

1843: Edinburgh Calotype Club, the first photographic society (p. 23)

1847: Calotype Club founded in London (p. 23)

1851: Société Héliographique established in Paris; from 1854, known as the Société Française de Photographie, or SFP (p. 23)

1853: Photographic Society of London; from 1894, known as the Royal Photographic Society, or RPS (p. 23)

1884: Society of Amateur Photographers (p. 56)

1888: Photo-Club of Paris, "Société d'amateurs photographes pour l'étude de la photographie et de ses applications aux arts, aux sciences, et à l'industrie" [Society of Amateur Photographers for the Study of Photography and Its Applications to the Arts, Sciences, and Industry"] (p. 54)

1891: Linked Ring founded in London; originally known as "The Brotherhood of the Linked Ring" (p. 54)
Das Kleeblatt founded in Vienna (p. 54)

1892: Wiener Camera Club founded in Austria

1897: Camera Club of New York, formed under Alfred Stieglitz (p. 56)

1902: Photo-Secession created in New York (p. 56)

1936: Photo League founded in New York (p.129)

1946: Groupe des XV [Group of the XV] founded Paris (p. 126)

1955: Gens d'Image Association [Association of Image-Making People]. Founded by Albert Plécy, the Gens d'Image is composed of people from a wide range of disciplines with an interest in the creation, publication, or distribution of images. The association awards two important prizes: the Prix Niépce, which is awarded to a photographer; and the Prix Nadar, which honors excellence in a photographic book.

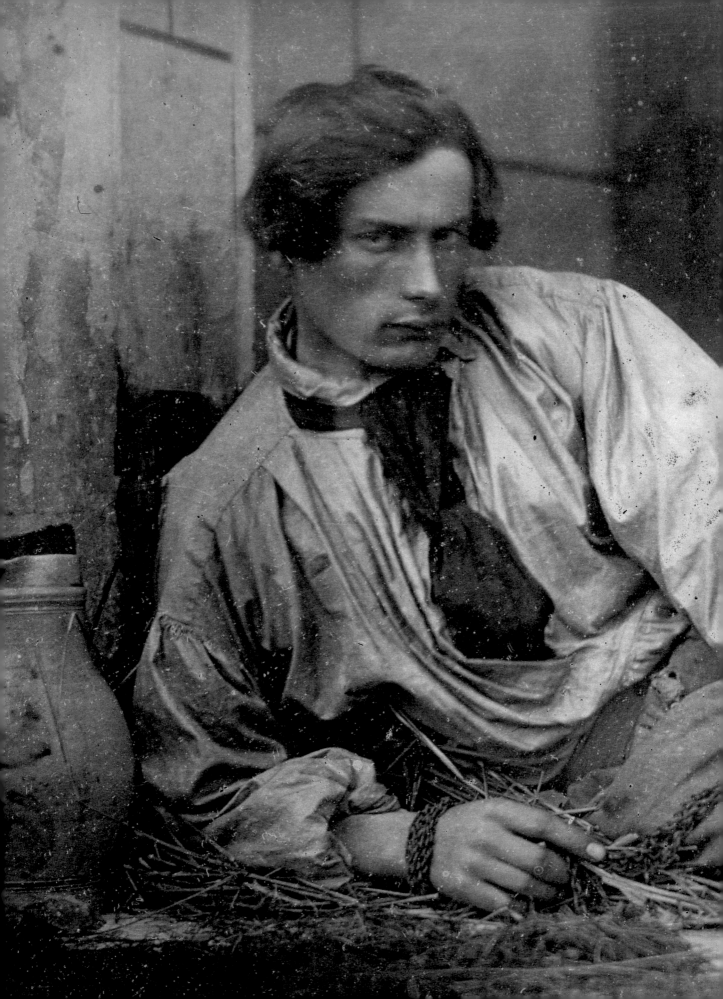

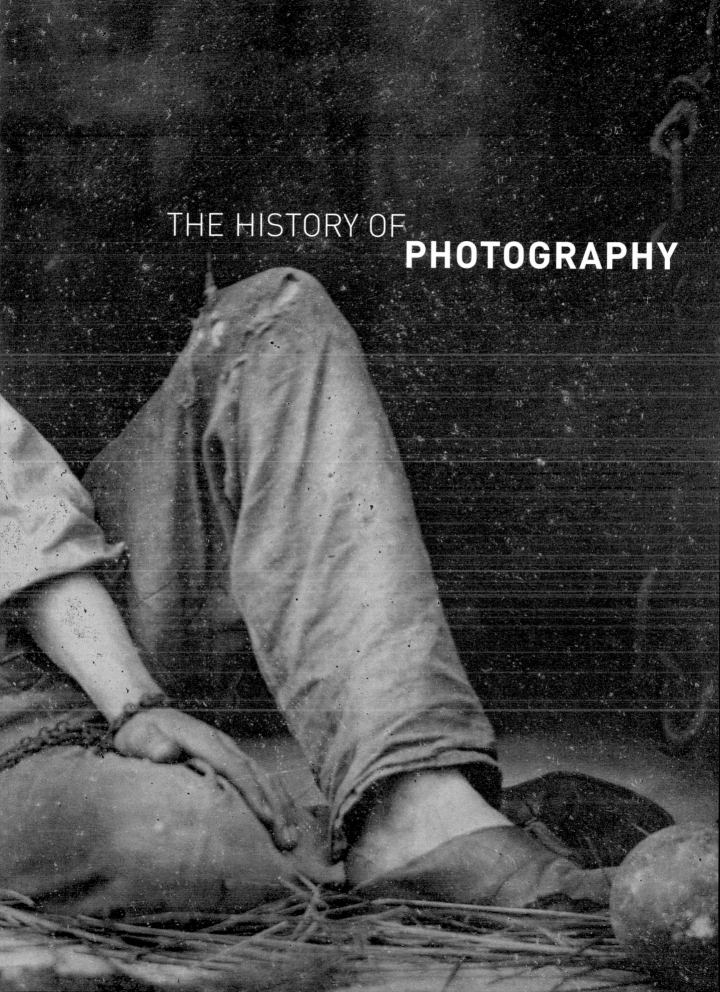

THE HISTORY OF
PHOTOGRAPHY

Joseph-Nicéphore Niépce's
"Chamber"; known as "the world's first photographic camera" (before 1830)

This is considered one of the first machines made for photographic experiments. Niépce probably used it, though exactly when is unknown. This early version of the camera is made from two parts that slide into each other.

1: THE ARCHAEOLOGY OF PHOTOGRAPHY (1820–1839)

The word photography comes from the Greek, meaning "writing with light." The term started appearing in a number of different languages during the 1830s, as photographic processes began to be developed. But the idea of using light to capture images, and especially of doing so in a "dark room," has been an age-old dream.

THE CAMERA OBSCURA

The camera obscura (literally, "dark chamber") dates back to antiquity, when it was used primarily as a way to observe the solar eclipse. The camera was originally designed as a closed-in space (as big as a room, or as small as a box) with a small opening in one wall where the sun's rays were allowed to enter. When they shone on the opposite wall, the rays formed the image of objects outside the box. Leonardo da Vinci described and used the camera obscura; Giambattista della Porta equipped one with lenses; and as early as the sixteenth century—and for centuries thereafter—the camera obscura became a true "drawing machine," used by painters from Dürer to Canaletto. With this history in mind, it becomes clear that photography emerged along with the first industrial societies and the growth of mechanization. Along with other drawing machines of the late eighteenth and early nineteenth centuries, such as the physionotrace or the diagraph, photography was a means of producing images more precise and exact than could be made by hand.

To a great extent, it was this dark room—along with the discovery of photosensitive chemicals, capable of retaining an image once it was captured—that created photography, and not the hand of man. By the Middle Ages, alchemists had already figured out that silver salts turn black when exposed to light. Experiments were conducted throughout the eighteenth century concerning the photosensitive properties of silver nitrate, in particular those led by the German J. H.

Schultze. In 1802, the British inventors Thomas Wedgwood and Humphry Davy were able to capture images on a sensitive surface, but they were unable to retain them. Other inventors, like Samuel Morse, the future inventor of the telegraph, also tried to fix the photographic image, but they too were unsuccessful.

Louis Jacques Mandé Daguerre, *Interior of a Chapel of the Church of the Feuillants* (1814)

Daguerre was a painter of interiors when he presented this piece at the 1814 Salon. This interior of a chapel at the Church of the Feuillants, built in 1608, shows the artist's penchant for the monumental, here underlined by the tomb remains and the darkness. The worker carries a lily, an allusion to the fleur de lis, the emblem of royalty. Louis XVIII purchased this painting for exhibition at the Musée du Luxembourg.

Joseph-Nicéphore Niépce,
View from the Window at Le Gras
(1826–1827). Heliograph

The low photosensitivity of
bitumen of Judaea required
very long pose times. This
image, the only one of Niépce's
made with a camera obscura to
survive, may have taken
seventy-two hours to expose.
This partly explains the lack
of detail.

THE INVENTOR OF PHOTOGRAPHY

Joseph-Nicéphore Niépce, an inventor from the
Chalon-sur-Saône region of France, gets the credit
for finding a way to retain the images captured in
the camera obscura, and it is Niépce who devel-
oped the first photographic process. He called it
heliography, or "sun writing." The earliest surviv-
ing photographic images are both attributed to
him—a reproduction of an engraving, made in
1825, and a view of his courtyard, made around
1826 or 1827. These prints are the results of ex-
periments Niépce performed in 1816. He wrote
about them in 1829 in his *Notes sur l'Héliographie*
(Notes on Heliography), a work he kept secret.
Although he conducted a variety of tests, Niépce
preferred bitumen of Judaea as a photosensitizing
agent and a tin plate for his photographic surface.
Using these elements, he captured images with
and without a camera obscura.

In 1829, Niépce began working with the Pari-
sian painter and decorator Louis Jacques Mandé
Daguerre. With Niépce as his collaborator,
Daguerre researched and developed a process
called the daguerreotype. He completed it in 1837,
four years after Niépce's death. In 1839, Daguerre
finally profited from his invention. Thanks to the
support of French politician François Arago, the
government of Louis-Philippe basically purchased

Daguerre's invention and awarded him a pension
as recompense. It was a condition of Daguerre's
pension that he publicize all details and processes
associated with his photographic method, and he
published a booklet containing this information in
the fall of 1839. The acquisition and publication of
the daguerreotype process mark the official date
of the birth of photography.

Both Niépce and Daguerre developed processes
that used a camera obscura to create unique
images; in other words, these images were cap-
tured directly on the photosensitive surface
without any recourse to a negative. It was the
British inventor and scholar William Henry Fox
Talbot who invented the first true negative/positive
process. In 1834, Talbot started researching how
to chemically fix images obtained from a camera
obscura. Around 1840 to 1841, Talbot's work
culminated in the invention of the calotype (some-
times called the talbotype). A calotype is created
when photosensitive paper is exposed to light,
thus creating a paper negative. The negative is
then laid over another photosensitive sheet (or
sheets—the negative can be reproduced infinitely)
and then exposed again to create a positive image.
Talbot's invention was the forerunner of all the
silver processes that came after it, responsible for
bringing photography into the era of reproduction.

2: THE REIGN OF THE DAGUERREOTYPE (1839–1850)

As a unique image, the daguerreotype is created directly on the photosensitive surface, without a negative. The image is captured on a copper plate coated with a thin, carefully polished layer of silver. The plate is made sensitive with iodine vapors and then immediately exposed for the amount of time necessary for the particular shot. In order for the latent image to emerge, the plate had to be developed with mercury vapors and then washed. Starting in 1840, silver chloride began to be used as a fixative and to give the plate a glossy surface. The plate was then stored in a case or mounted under glass to protect it from scratching and oxidation.

A MAGIC IMAGE

The daguerreotype produces a black-and-white image, but various processes were developed in the 1840s that allowed the plates to be colored by hand. Plates were still relatively small, but they were available in a range of sizes. The standard dimensions of what was known as a full plate measured 6 x 8 inches (16 x 21 cm), while the one-ninth-plate format measured just 2 x 3 inches (5 x 7 cm). The most practical format for portraiture was the quarter plate, at 3 x 4 inches (8 x 10 cm). Although the small size of the plate sometimes made it difficult to work with certain subjects (landscapes especially), the daguerreo-type was popular for its sharp image. It was the combination of detail and small format that gave this new mechanical image its magic.

THE PORTRAIT: A SUCCESSFUL PRACTICE

During the period from 1839 to the early 1850s, daguerreotype photographers used their craft for all genres and almost all subjects, from land-scapes to nudes, from scientific imagery to still life, from advertising to journalism. Nevertheless, the new technique mainly was used for portraiture. The earliest portraits known today and that can be dated with certainty were taken in late 1839 and early 1840 by the Americans Robert Cornelius and Henry Fitz. Pose times were greatly reduced around 1840 to 1841, due to the development of better optics and also a variety of "acceleration substances," made from bromide, iodine, and chloride. These advances made commercial work possible, and the first daguerreotype portrait studios opened at about this time. Although these studios appeared first in the cities, daguerreotype portraiture also found its way to the outlying areas via traveling cameramen and the occasional artist who had once been a painter of miniatures. Daguerreotypes were at first the province of the wealthy, but during the 1840s the practice was

Albert Southworth and Josiah Hawes, *Madame J. Hawes and Alice* (ca. 1840). Daguerreotype

Southworth and Hawes specialized in portraits of children and produced the greatest images of the genre.

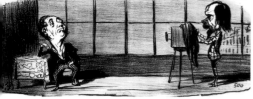

Honoré Daumier, *The Pose of a Man of Nature,*
The Pose of a Civilized Man (1853)

Caricature published in *Le Charivari* on March 31, 1853.

Pose de l'homme civilisé.

available to the lower middle class and even to the working class, especially in the United States. Although portrait style was often stereotyped and lacking in imagination, there were some talented photographers among the daguerreotype portraitists, and these employed undeniably aesthetic techniques. Examples of these early artists include the Southworth and Hawes studios in Boston; the Brady studio in New York; the Claudet studio in London; the Stelzner and Biow studio in Hamburg; and the Sabatier-Blot studio in Paris. These few exceptions aside, it was the amateur enthusiast who was responsible for the most remarkable achievements—in France that included Adolphe Humbert de Molard, Girault de Prangey, or Choiselat and Ratel, for example, or Eynard-Lullin in Switzerland.

RIVALRY OF SIZE: THE CALOTYPE

The daguerreotype method dominated the 1840s. Its closest rival, the calotype (or talbotype) was not used much during this period except by a small fringe group of amateurs, mostly in Great Britain. There are several explanations for the daguerreotype's supremacy. First, there were no permissions involved with creating a daguerreotype, while the patent Talbot held on his invention definitely limited its diffusion. Furthermore, because the calotype process was slow and exacting, it couldn't be used for commercial portraiture. Instead, it was relegated to the less lucrative genres, such as landscape and architecture, where it enjoyed remarkable success. Talbot proved to be not only an important inventor but an exceptional photographer, following the example of Hippolyte Bayard in France. But it was certainly the Scotsmen David Octavius Hill and Robert Adamson, trained as a painter and as a chemist, respectively, who perfected the practice, producing a considerable body of work within a variety of subjects (landscape, still life, and especially portraiture). Much of their work has survived.

As early as the second half of the 1840s, improvements were already being made to the calotype process, especially in France by Louis-Désiré Blanquart-Evrard. In 1851, a new photographic technique known as the collodion process

began to emerge. These developments highlighted the shortcomings of the daguerreotype: its cost, the heavy equipment it required, its unpredictable operation, and its ability to produce just a single image. Though it held on a little longer in the United States, the technique gradually fell out of use in Europe during the 1850s. The daguerreotype process produced no offspring in the sense of photography's technical evolution, but the precision of its images fascinated many photographers during the 1920s and 1930s, from Ansel Adams to August Sander.

Baron Jean-Baptiste Louis Gros, *Interior of Baron Gros's Living Room* (ca. 1850–1857). Daguerreotype, 9 x 7 inches (22 x 17 cm)

A diplomat by profession, Baron Gros was also a pioneer in the daguerreotype. This is most likely his living room on rue Barbet-de-Jouy in Paris. We can see several daguerreotypes presented as a painting on the easel in the middle of the room. Some of these images may have been produced by the baron himself.

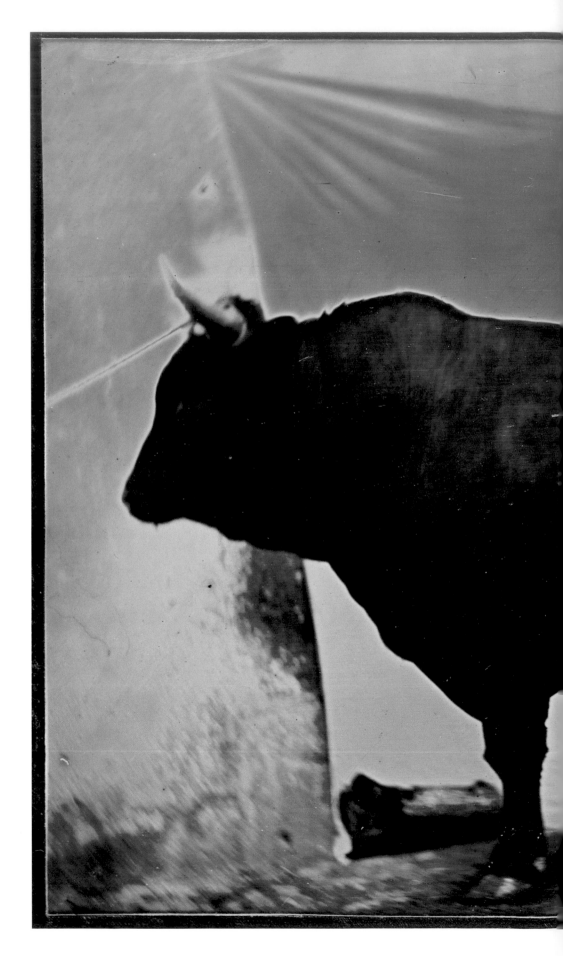

Louis-Auguste Bisson, *Bull, Aurillac* (1850). Daguerreotype, 9 x 7 inches (22 x 17 cm)

This prizewinning bull at the agricultural show of Versailles stands in front of a taut sheet. The tight framing accentuates the animal's power and majesty. The blue tone results from the solarization of the plate. On the back, it is noted that this Salernes bull is two years and ten months old.

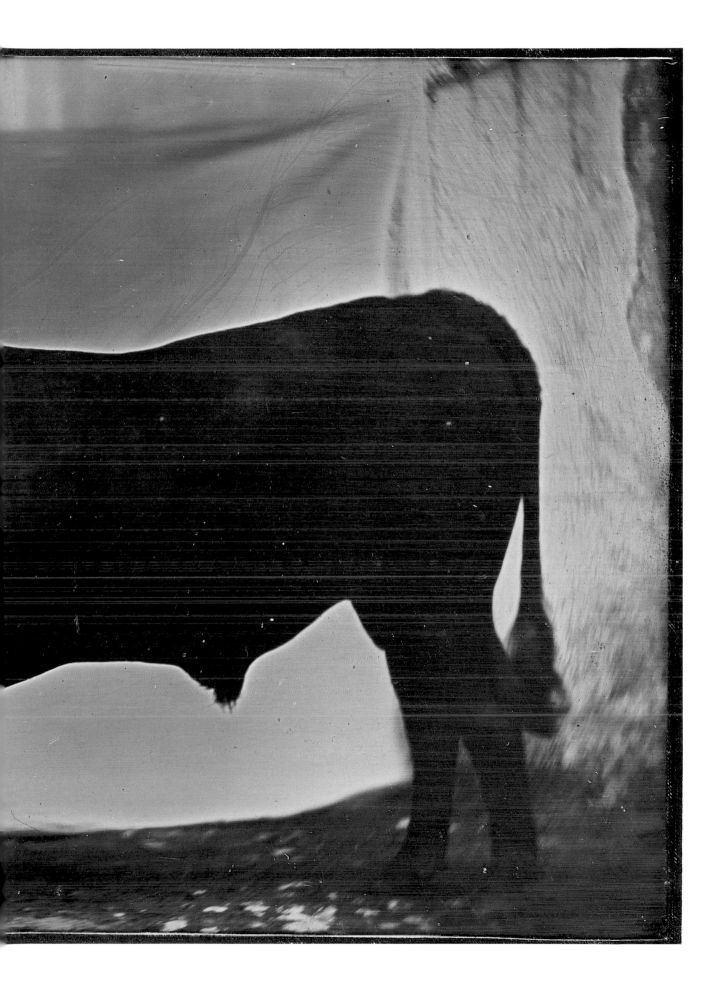

THE HELIOGRAPHIC MISSION

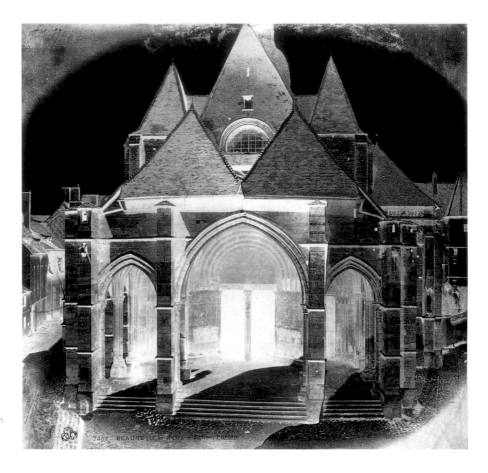

Édouard Denis Baldus, *Notre-Dame Church* (Beaune, France, 1851)

Baldus was one of five photographers commissioned to produce images of French landmarks for the Heliographic Mission. To obtain more precise and sharp detail, Baldus coated his paper negatives—of which there were more than a hundred—with an iodine gelatin.

On June 29, 1851, *La Lumière* informed its readers that "five members of the Heliographic Society, Mr. Bayard, Mr. Le Secq, Mr. Mestral, Mr. Le Gray, and Mr. Baldus, have just received from the Comité des Monuments Historiques (Committee on Historic Monuments) various large commissions within France. This involves photographically reproducing our most handsome monuments, especially those in peril of ruin and that require urgent repair.... Official notices entitled Photographic Missions are new, and act as proof that the direction of the Fine Arts is not ignoring anything related to art and its progress."

This first public photography commission was sponsored by the Committee on Historic Monuments, founded in 1837 with the aim of protecting endangered buildings. The director of the subcommittee on photography, Léon de Laborde, was one of the founding members of the young Heliographic Society.

Five areas were chosen to be photographed during the summer of 1851. Édouard Denis Baldus was assigned monuments in Fontainebleau, Bourgogne, and the Dauphiné region; Bayard was assigned to Normandy; Henri Le Secq went to Champagne, Alsace, and Lorraine; and Gustave Le Gray and Olivier Mestral, who decided to collaborate, were to work in the Touraine and Aquitaine regions. The whole project consisted of approximately 120 sites, spread throughout forty-seven departments. Bayard shot all his work on glass negatives, and none of those have survived. The negatives produced by the other photographers have been collected, but they were "placed in a drawer and locked," as the critic Francis Wey has lamented. They have not been published.

In 1870, the Committee on Historic Monuments hired Séraphin Médéric Mieusement for its next project, which received even better support.

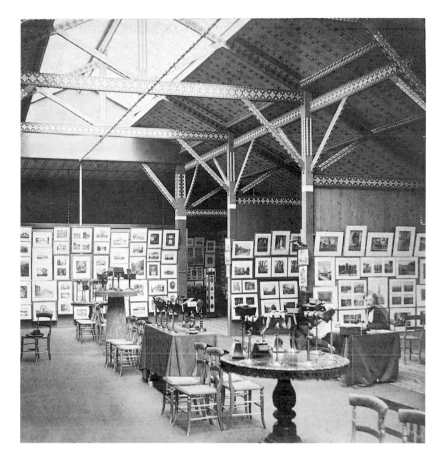

Charles Thurston Thompson, *A View of the Exhibition of 1858 of the London Photographic Society and the French Photographic Society at the South Kensington Museum of London* (1858).

This was the first time English and French photographic societies came together to mount an exhibition. More than 700 photographs were presented to visitors and made available for purchase. This large show was very well received.

Established in Paris in 1851 by Baron de Montfort, the Société Héliographique (Heliographic Society) was the first scholarly photographic society in the world. It consisted of scientists, photographers, painters, and critics "devoted to the study and practice of art and science." The first issue of *La Lumière* was published on February 9, 1851. This publication, which survived until March 1867, contained valuable information on all aspects of photography and would play an essential role in the creation of a critical language specific to the medium.

On November 15, 1854, the Société Française de Photographie (French Photographic Society, or SFP) was born, taking up where the defunct Société Héliographique had left off. More rigorous in nature, it published a bulletin and began organizing exhibitions as early as 1855. The SFP served many functions. It published technical discoveries and processes, collected the best images, brought together those responsible for presenting photography at fine art exhibitions, and offered training. In 1856, the society launched the Competitions of the duke of Luynes, which rewarded a discovery for stabilizing prints as well as the best process of photomechanical reproduction. Louis-Alphonse Poitevin won both prizes. Recognized for its public service in 1892, the SFP stands today on rue de Richelieu, in Paris, and publishes a quarterly publication called *Études photographiques*.

Societies with similar missions were formed in other countries. The Edinburgh Calotype Club was the first among them, founded in 1843. In London, the Calotype Club was founded in 1847 with Frederick Scott Archer as a member. The Photographic Society of London, established in 1853 by Roger Fenton, later became the Royal Photographic Society. The bequests left to these societies—by Bayard and Robert Demachy for the SFP, and by Fenton and Alvin Langdon Coburn for the Royal Photographic Society—are the core of rich collections.

3: GOOD TIMES FOR PORTRAITURE

In the 1850s, the number of photography studios in the capitals and big cities of Europe and the United States began to grow at an incredible rate. At the end of the 1840s, Paris could have counted about fifty; just twenty years later, there would be four hundred. This spectacular increase in photographic activity was the result, at least in part, of the transformation that came about with the use of a new product, collodion. Collodion took photography from its craft period into a quasiindustrial era.

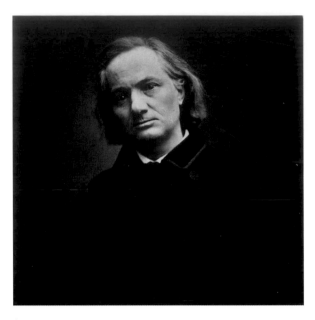

Étienne Carjat, *Portrait of Charles Baudelaire* (1861–1862)
Carjat opened his first photography studio in Paris in 1860. He took several portraits of Baudelaire, revealing both the elegance and complexity of the poet.

STUDIOS GROW IN NUMBER AND LUXURY

At the 1851 World's Fair, held in London at the Crystal Palace, photography fans would see quality daguerreotypes produced by Americans along with calotypes created by the French. They would also see a new technique in use by the British: the wet collodion process, developed by Frederick Scott Archer, which produced a glass negative. The collodion print had the sharpness of a daguerreotype, and the technique offered users the ability to make multiple images, a benefit that only the calotype had offered to that point. Moreover, the collodion offered the advantage of a much shorter pose time. In France, it would take a few years for the new technique to gain popularity over the calotype.

But by 1855, when the collodion process began using albumin paper for printing, it had finally prevailed, and the process maintained its dominance until the early 1880s. Like the major American daguerreotype photographers who spent huge sums on luxurious studios in order to attract their clients, European photographers opened their own fancy establishments. In the neighborhood of the Opéra in Paris, and on Regent Street in London, studios devoted to portraiture blossomed.

Wealthy clients were welcomed into waiting rooms decorated with period furniture and a gallery of pictures. Marble, crystal, soft carpeting, libraries, smoking rooms—these studios might even feature a conservatory, garden, and aviary, like Nadar's on the boulevard des Capucines in Paris. Nothing was too good, and nothing was too expensive when it came to building a clientele (and to keeping them in ignorance when it came to the process). When André Adolphe-Eugène Disdéri opened his studio on the boulevard des Italiens, the paper *Le Monde illustré* described the waiting area: "Here, there is nothing but festoons and fancy moldings. Gold, silk, and bronze glow, lit by hundreds of candles in candelabras hung with crystal pendants."

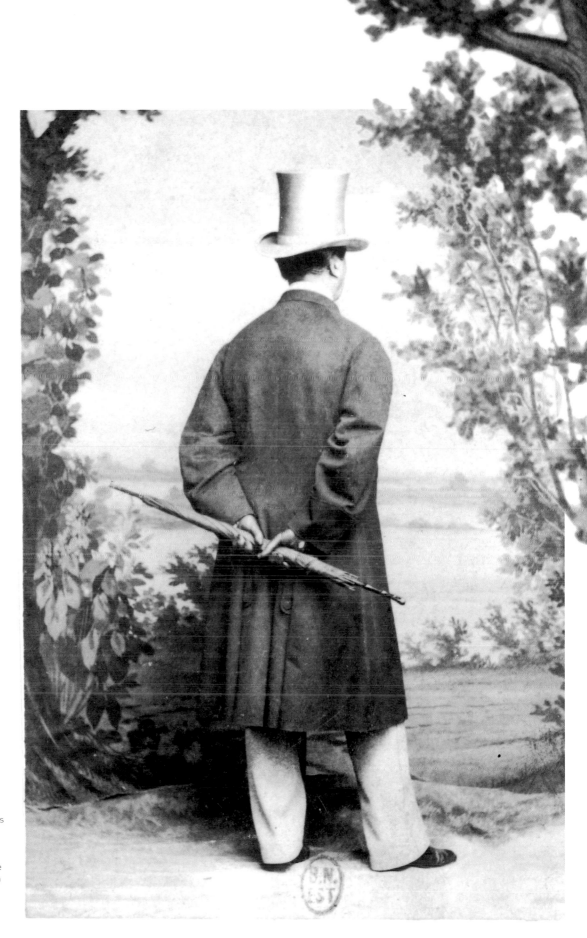

Léon Crémière, *Man from Behind* (n.d.)

As crucial to a photography studio as it was to a painting studio, light was usually provided by a skylight. Not until the end of the nineteenth century did photographers begin using artificial light.

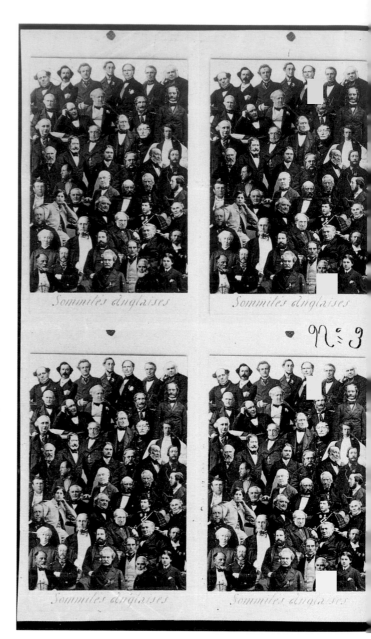

The client could choose to pose with a variety of props, such as pedestal tables, columns, furniture, fireplaces, desks, pianos, prayer benches, books, or toys. At the studios not so well off, the originals were replaced with fakes: "Today, they use wood to copy all kinds of objects, like pianos, bookshelves, columns, etc. These objects can be bought at a very low price and, with their carved surfaces, they look like real furniture. It's obviously an excellent idea, but the elegance and good taste of these objects leave something to be desired," reported *Le Moniteur de la photographie*. Different illusions were also created with painted backdrops for clients to pose against. These included luxurious interiors, forests, beaches, boulders, and mountainous landscapes. The most prosperous businesses also opened other branches in fashionable areas. In France, one of the more notable areas was the Bois de Boulogne, perfect for the equestrian photography that was all the vogue, along with other vacation spots and seaside resorts.

CALLING-CARD PORTRAITS: LOW COST, HIGH DEMAND

To broaden the portrait market and increase their profits, photographers started looking for ways to cut their manufacturing costs. In 1854, Disdéri obtained a patent for something that might not strictly speaking have been an invention but that he defined as "the new application of known means for obtaining a result and an industrial product."

Specifically, Disdéri's method used a camera with multiple lenses to create four, six, or eight pictures on a single plate. Thus was the calling-card portrait born, a format that would be in fashion for the next few decades. "Those who haven't been in Paris for a few months will return to find a mania growing. What's all the rage are small-size photographs in the form of calling cards," wrote the *Monde illustré* on October 29, 1859.

In addition to meeting the growing demand for this new product, which made photography available to a greater number of buyers, photographers also began selling portraits of celebrities as

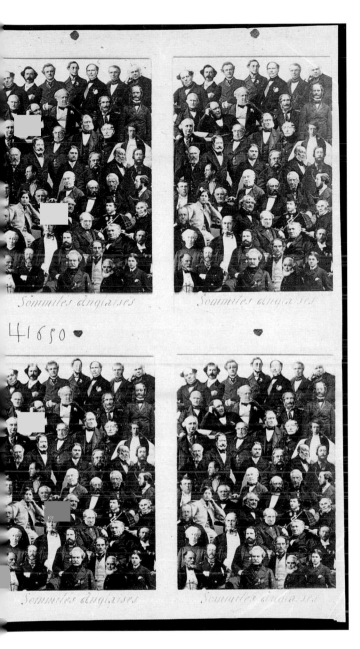

Sommités anglaises Sommités anglaises

4 1 6 5 0

Sommités anglaises Sommités anglaises

André Adolphe-Eugène Disdéri, *Group of Influential Individuals, Prominent Englishmen, in Eight Poses* (1857–1865).

Photographers often used this practice of photomontage, bringing several people together in mosaic like fashion.

circles, while Napoléon Sarony preferred performers. Disdéri focused mostly on high society. When Napoléon III was leading his troops to Italy in 1859, he stopped at Disdéri's studio to have his photograph taken; subsequently, Disdéri called himself "photographer of His Majesty the Emperor and the imperial family."

NEW DIRECTIONS

In their desire to attract more customers and admirers, it wasn't long before photographers started thinking about ways of adding passersby on the street to their clientele. Studios weren't usually on the ground floor, and they didn't always face the street. Photographers therefore made deals with other shopkeepers to exhibit work on their walls and windows. They also set up street displays in front of their studio entrances for publicity, usually wood-framed portraits in a case. New methods of creating photographs were adapted to a new, almost industrial mode of production. The single cameraman gave way to a whole team. In addition to the photographer, who was responsible for taking the picture, there were chemists to prepare the negatives, printers in charge of development, retouchers, and employees who hand-colored the images. At the height of the calling-card-portrait craze, Disdéri had as many as eighty employees. Clearly, the incredible success of the big studios also entailed a significant investment. Outside capital was sought to fund studios in which the photographer became a shareholder at best or, at worst, a simple employee, which was Nadar's fate after 1860.

collectible items. As a consequence, "Galleries of Contemporaries" flourished. These portraits were ordered by subscription and came with biographical information about the subject.

The fad was huge. While a private patron might buy a few dozen copies of his portrait, a celebrity portrait could sell in the thousands. At this point, photographers began to specialize. Pierre Petit took 25,000 portraits of clergypersons between 1862 and 1865. Nadar was drawn to bohemian

4: "THE ARTIST COLLABORATES WITH THE SUN"

The question of whether photography is an art or a trade, whether it is an industrial sort of practice or a branch of the fine arts, has been debated since the birth of photography itself. Some see it as nothing more than a purely mechanical activity, while others insist on the essential role of the artist in the quality of the image.

INDUSTRY OR FINE ARTS?

In 1859, photography celebrated its twentieth birthday. The Salon des Beaux-Arts could have been offering a birthday gift when it presented a photography exhibition next to one featuring painting and engraving. In the main exhibitions that took place between 1839 and 1859, the place the photography occupied is an important indicator of its evolving status.

Photography was featured at the industrial-products exhibition in Paris in 1844 and 1849 and again among the industrial products at the 1851 World's Fair in London and the 1853 World's Fair in New York. The World's Fair was held in Paris in 1855, in two separate places. The Palais de l'Industrie, on the avenue des Champs-Élysées, displayed industrial products, including photographic prints and cameras, while painting, sculpture, and engraving were displayed on the avenue Montaigne.

The Société Française de Photographie organized its first exhibition in the fall of 1855 at its headquarters on rue Drouot, and the second was held in 1857 at Gustave Le Gray's studio on the boulevard des Capucines. Two years later, in 1859, the society held its third exhibition at the Palais de l'Industrie but as part of the Salon des Beaux-Arts, an arrangement that would be used for the society's subsequent exhibitions as well. This was just a partial victory, since there were two separate entrances to the two exhibits. But it was a solution that ended a twenty-year debate dividing the heads of ministries, critics, and even artists. The day when photography could enter the "sanctuary" of the fine arts was in sight.

ARTIST OR CAMERAMAN?

A few well-known voices tried to introduce reason into this debate. For example, the artist Léon de Laborde stated, "Beyond a certain level of superiority, art, science, and literature is all industry." Louis Figuier, the author, joined in with his claim that "the lens is an instrument like a pencil or brush; photography is a process like drawing or engraving, for what makes the artist is the feeling not the process."

On the whole, however, the debates were heated, and clear camps formed. Baudelaire's essay entitled "Salon de 1859: Le Public Moderne et La Photographie" (The 1859 Salon: The Modern Public and Photography), is the best-known argument against giving photography any claim to artistic status: "It must [therefore] pursue its true purpose, which is to be the servant of the sciences and the arts, and a very humble servant at that, like printing or stenography, neither of which created nor replaced literature."

Another equally categorical poet, Alphonse de Lamartine, demanded some answers: "Is the reflection of glass on paper an art? No, it is sun taken in by a maneuver. But where is man's conception? Where is the choice? Where is the soul? Where is the creative enthusiasm of beauty? Where is beauty? In the crystal perhaps, but certainly not in man."

Among those who argued from the opposite side was Nadar, the portrait photographer, who made the intriguing claim that in a single lesson, he could transform a coachman and concierge into a couple of cameramen; that in one hour, he could teach them theory; and that in one day, he could make them grasp the basic concepts of the practice. But, he added, "I'll tell you what cannot be taught. A sense of light, the artistic application of the effects produced by various weather conditions, the application of one effect or another according to the nature of the physiognomy you have to reproduce as an artist."

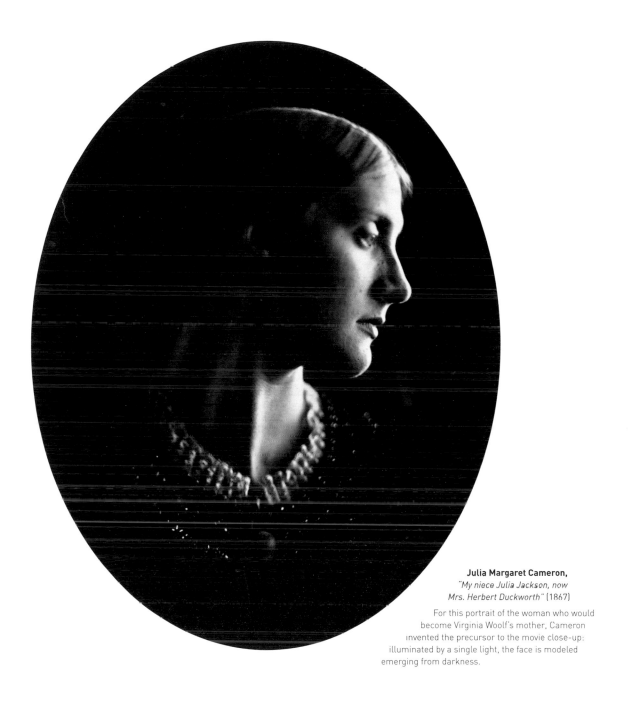

Julia Margaret Cameron,
*"My niece Julia Jackson, now
Mrs. Herbert Duckworth"* (1867)

For this portrait of the woman who would
become Virginia Woolf's mother, Cameron
invented the precursor to the movie close-up:
illuminated by a single light, the face is modeled
emerging from darkness.

Eugène Durieu argued in the same vein. "Un-
doubtedly, the lens can only render what it sees;
but it is up to the photographer to show it what he
wants; he can choose his points of view, limit
them, make them into an interesting composition,
distribute the light in such a way as to produce the
desired effects.... This is what constitutes the art
in photography."

The arguments were influential, and even

Alphonse de Lamartine, the great poet, radically
changed his position: "The photograph is the
photographer. Since the time that we admired the
admirable portraits seized in one instant of sun
by Adam-Salomon, the sculptor of feeling who
delights in painting, we no longer say it is a trade;
it is an art; it is better than an art, it is a solar
phenomenon in which the artist collaborates
with the sun."

5: PHOTOGRAPHY AND WAR: THE FIRST ENCOUNTERS

In the second half of the nineteenth century, photographers were presented with two opportunities to enter the battlefield: the Crimean War (1853–1855) and the American Civil War (1861–1865). At first, these photographers worked beside the painters and illustrators who had traditionally created the images of war. Eventually, the photographers would replace the artists entirely.

THE CRIMEAN WAR:
A WAR WITHOUT VIOLENCE?

This war, which started in October 1853, pitted Russia against Turkey in the beginning, but a few months later France and England joined the conflict to fight on the side of the Turks. In the spring of 1855, Queen Victoria asked Roger Fenton, the official photographer of the royal family, to put together a report that would counter the negative image of the war that newspaper reporters were creating. A wine merchant's car was transformed into a lab and served to transport Fenton's equipment and food. The weather conditions were perfect for the wet collodion process, both for creating the photosensitive glass plates and for handling the glass negatives they produced: "Until the beginning of spring, the light and temperature conditions were everything a photographer could want."

Fenton's photographs show what would today be called a "clean" war. There were no bodies. Battlefields were shown before or after action; for technical reasons and propaganda purposes, all scenes were posed. Once it got to be too hot, Fenton worked in the early mornings, photographing military leaders like Lord Raglan of England, Omar Pasha of Turkey, and General Pélissier of France.

The approximately 300 images brought back to England were shown in a London exhibition and praised in the press. The British royal couple

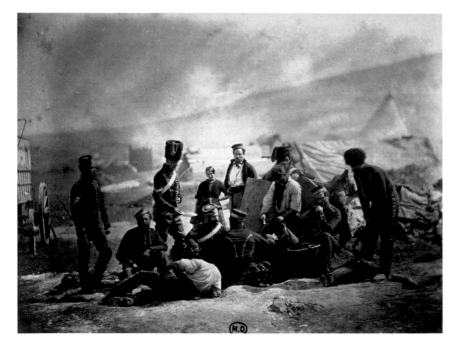

Roger Fenton, *Scene from the Daily Life of a Regiment of Hussars during the Crimean War* (1855)

Fenton's pictures were meant to be sold. He was commissioned by Thomas Agnew, the London print dealer and publisher.

brought twenty or more to Paris for the World's Fair. Napoléon III took great interest in them and decided to send his own photographers to the Crimea. James Robertson, another British photographer, completed Fenton's work. Arriving in the Crimea at sometime around June 1855, he stayed until 1856. When Sebastopol was seized on September 8, 1855, the allied troops departed, and Robertson, with help from his brother-in-law, Felice Beato, was able to enter the city to photograph the deserted Russian batteries, the buildings (before the Allied destruction, yet to come), and the panoramic landscapes.

Following the victory over the Russians, the French war ministry sent Jean-Charles Langlois, a military painter specializing in glorified French battle landscapes, to the Crimea. Accompanied by the young photographer Léon Eugène Méhédin, Langlois set out on November 13, just before the harsh winter season, and just in time to photograph the military bases and harbor in Sebastopol before they were destroyed.

Besides the picturesque views, the fourteen images Langlois took from Malakff Tower would be the starting point for his *Panorama de la Prise de Sébastopol* (Panorama of the Siege of Sebastopol), which opened to the public on the Champs-Élysées in August 1860.

THE CIVIL WAR:
THE FIRST VIOLENT PHOTOGRAPHS

Between 1861 and 1865, the United States was turned into a battleground for the violent conflict between the North and the South over the question of slavery. Mathew Brady, an established portrait photographer with several studios, set out on an adventure. He hired more than twenty assistants and intended to pay his expenses by selling his pictures. The photographs, taken for the most part for Union sympathizers, created for the first time a concrete public idea of the horrors of war: burnt land and homes, huge numbers of bodies. They showed the daily lives of soldiers and the consequence of war. The photographer's attempt to be objective gives this work its exceptional value as a historical document.

The experience turned sour for Brady, who didn't like it that his collaborators were signing their names to their work. Alexander Gardner, to whom Brady entrusted the management of his studio in Washington, decided to work independently. Then Timothy O'Sullivan and George N. Barnard followed suit. This war marked the first collaboration between the army and photographers, a partnership that would flourish during World War II. Gardner was hired at the time as an official photographer for the Army of the Potomac. In 1866, he published *Sketchbook of War,* which included 100 photographs. Forty-four of them were attributed to O'Sullivan, who became Gardner's assistant.

As the costs associated with photography went down, more and more people became able to see and enjoy photographs. The creation of the many military portraits and stereoscopic views—appreciated for their "realistic" effect—meant that soldiers and their families would have a souvenir of the event. Brady ended up losing his entire fortune on this venture and had to surrender his negatives to A. & H. T. Anthony, the firm that had financed him and that would publish his images under its name for many years.

George N. Barnard, *Destruction of Hood's Ordinance Train* (September 1864)
Barnard also worked with Matthew Brady. In 1864, he followed General Sherman's troops on their march on Atlanta and then Savannah; he was the only photographer to cover this critical moment in the war. After the war, Barnard published sixty-one of his plates in *Photographic Views of Sherman's Campaign.*

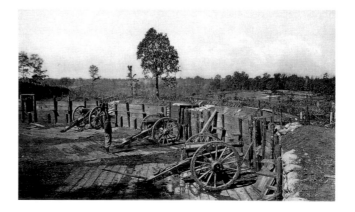

6: TRAVEL PHOTOGRAPHERS

In 1839, François Arago made a presentation to the Academy of Sciences extolling the extraordinary benefits that travel photography would bestow: "For the traveler, for the archaeologist and for the naturalist, Monsieur Daguerre's device will be of constant use and will be indispensable. It will allow them to seize their memories without having to resort to the hand of a stranger." Soon after, travel photographers did begin to journey around the world. It was not easy at first, and technical problems were the recurring subject of their written accounts: the equipment was heavy, cumbersome, and complicated. Weather conditions such as wind, cold, heat, or humidity made it tricky to handle. On top of these problems were issues concerning water and darkness, both of which were necessary to produce the photographic image.

FROM THE BANKS OF THE NILE

Egypt has enchanted European scholars and artists since the late eighteenth century, and as soon as they were available, these travelers brought photographers with them on their journeys. Rather than photographing the picturesque detail and inhabitants, they focused on the monuments and on the areas bordering the Nile as they traveled up the river in a *dahabieh* to Wadi Halfa, in the manner of French Egyptologist Jean-François Champollion.

Frédéric Goupil-Fesquet was the first, in 1839, to come back from such a trip with a few rare daguerreotypes. But the commission for the first state-sponsored photographic venture to the East went to Maxime Du Camp in 1849. Du Camp was accompanied on this trip by Gustave Flaubert, and the resulting publication, *Égypte, Nubie, Palestine et Syrie* (Egypt, Nubia, Palestine, and Syria), considered to be the first book of photographs, enjoyed great success.

Between 1850 and 1860, a series of independent travelers, mostly amateurs who took pictures only to document their trips, would follow suit. Some were engineers, such as Félix Teynard (1851), while others were artists and archaeologists, such as John Green and Auguste Salzmann (1854), sculptors such as Frédéric Auguste Bartholdi (1855), or simply persons of private means, such as Henry Cammas (1859). Like Maxime Du Camp, they used the calotype, a manual technique that was difficult and often unpredictable but that created a beautiful, velvety image on paper. And, unlike the daguerreotype, it could be reproduced.

The albums these amateurs put together upon their return are beautiful and excellent in quality. After 1858, the professional photographers Francis Frith and Francis Bedford followed in their footsteps and took several collodion pictures of various sizes (using a glass-plate negative). Modern Egypt, now Muslim and clearly no longer ruled by pharaohs, has been photographed by Émile Béchard and Carlo Naya, who have turned to local people and daily scenes as their subjects for consumption by tourists. Nowadays, private travel has mostly been taken over by guided tours.

Maxime Du Camp, *Egyptian on Top of Colossal Statue of the King, in the Large Temple of Ramses II at Abu Simbel* (March 29, 1850)

From 1849 to 1851, Maxime Du Camp traveled with Gustave Flaubert as the photographer for an archaeological mission in the Middle East. He returned from Egypt, Nubia, Palestine, and Syria with 220 images. They were to be printed in 1852 at the Blanquart-Evrard press and would become the first book illustrated by photographs.

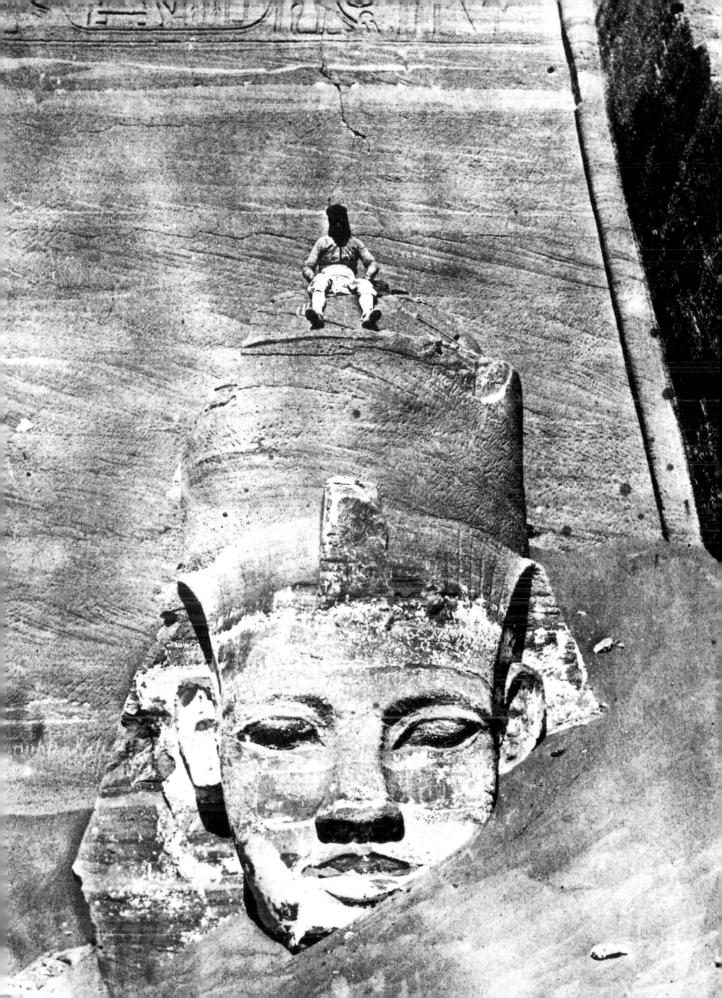

Louis-Auguste and Auguste-Rosalie Bisson, *The Crevasse: Departure* (1860).

The Bisson brothers tried many times to reach the summit of Mont Blanc, finally attaining their goal on July 26, 1861. The 1860 excursion, during which this photograph was taken, required twenty-five porters and guides from Chamonix. They carried a tent and all the other bulky photographic equipment necessary to capture the panoramic views of the Alps.

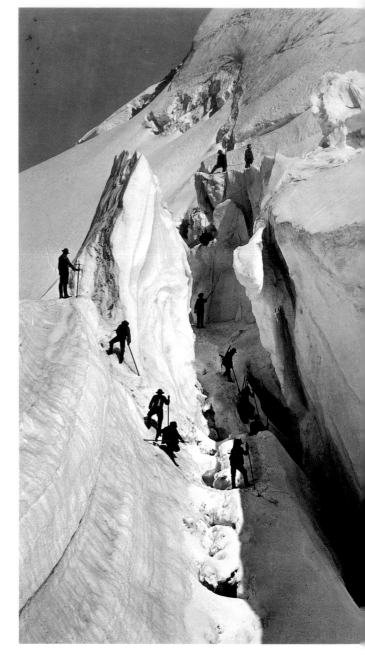

TO THE PEAKS OF MONT BLANC

Daniel Dollfus-Ausset, director of the fabric company Dollfus Mieg & Cie., was an important figure from the very beginning of mountain photography. Fascinated by geology and glaciology, he set out in 1849 to study the Alps with a daguerreotype photographer named Gustave Dardel. Dollfus-Ausset's Paris address was 8, rue Garancière, in the same building where Louis-Auguste and Auguste-Rosalie Bisson established their photography studio. This proximity probably explains why Auguste-Rosalie (the younger of the two Bissons) accompanied Dollfus-Ausset on several of his trips to the Alps, starting in 1855. The photographer traveled with a true field laboratory that weighed roughly 500 pounds and included three cameras of different sizes: one for stereographs, a 12 x 16 inches (30 x 40 cm), and an 8 x 12 inches (20 x 30 cm). All this equipment allowed him to develop collodion glass plates on site.

In 1858, Auguste-Rosalie took several panoramic views of the Mont Blanc range, from Flégère, Buet, and the Talèfre garden, where he set up his cameras at an altitude of almost 9,500 feet (about 3,000 m). But the most memorable was his 1862 excursion, when he photographed Napoléon III and Empress Eugénie on the Mer de Glace.

This portfolio wouldn't be complete without a view of Mont Blanc. After several attempts marred by bad weather, the photographer's tenacity finally paid off. On July 22 and 23, 1861, Auguste-Rosalie achieved his seventy-seventh climb up Mont Blanc, accompanied by two guides, Auguste and Alexandre Balmat, and Gabriel Loppé. The photographer refused to start his descent until he had taken at least three good plates. Struggling the whole time to keep his equipment from freezing, he was satisfied only a full two hours later.

Unfortunately, these first plates have disappeared, and the expeditions came to an end in 1863 because of their prohibitive cost. The first known images of Mont Blanc were taken in 1869 by Charles Soulier.

TO THE AMERICAN WEST

Once the Civil War ended and peace had been restored, the photographers who had spent the years between 1861 and 1865 covering the conflict seized the opportunity to discover the vast lands

William H. Bell, *Looking South Into the Grand Canyon, Colorado River* (1872)

William Bell traveled across Colorado with what he called his "photographic mule," loaded with a black tent, boxes of chemicals, and a camera. Despite problems resulting from the temperature, he produced impressive views that presented the immensity and grandeur of the West.

of the American West. The government offered funding to topographical expeditions, which usually traveled with photographers. Accustomed to working under difficult conditions, some of these men could be found at the side of engineers building the first railroad across the country; others were hired to document land clearing, mining, and agriculture. They often used large-format cameras, with plates sometimes measuring as big as 20 x 24 inches (50 x 60 cm). Not only was this size suited to the limitless territories they were traveling, it reflected their desire to magnify nature.

Alexander Gardner, for example, followed the construction of the railroad across Kansas. The photographs he published in *Across the Continent on the Kansas Pacific Railroad* (1868) showed not only the technical aspect of how the track was laid but also the beauty of the landscape. During the same period, Timothy O'Sullivan joined a geological expedition led by Clarence King, who was traveling across the Sierra Nevada from San Francisco to Salt Lake City. Carleton Watkins arrived in California during the gold rush and, in 1861, was the first to photograph Yosemite Valley. William H. Jackson and Eadweard Muybridge followed in his footsteps.

7: AN ARTISTIC JOURNEY, FROM GIOTTO TO PIERRE-PAUL PRUD'HON

With demand growing from artists, art lovers, academic institutions, and the general public, publishers of art reproductions flourished all across Europe throughout the 1860s. For "the price of a seat at the opera," they delivered great works of architecture, painting, sculpture, and objets d'art to one and all and within a short span of space and time. The writer Joséphin Péladan guaranteed that "not one studio, not one school would go without a library of pictures of master-pieces, and all at a small cost."

Auguste Giraudon,
Photograph of a Mirror at the Château de Versailles (n.d.)

Giraudon's company specialized in reproducing works of art. It offered various formats, from the calling card to large prints, as well as the stereographs so popular at the time.

THE VERY HUMBLE SERVANT OF THE SCIENCES AND THE ARTS

In Paris, Auguste Giraudon, whose business had stood next to the École des Beaux-Arts since 1877, judiciously called his collection of fine art reproductions the Photography Library. His predecessors in this field were Goupil, known since 1827 as a print dealer, and Adolphe Braun, who started out in Dornach in 1847 before opening his Paris branch in 1872. In Italy, the Alinari brothers founded their company in Florence in 1852. Charles Thurston Thompson had been prospering in London since 1855, Franz Hanfstängl in Munich since 1832, and Jean Laurent in Madrid since 1857.

Each of these enterprises tried to distinguish their work with some special characteristic, either through the technique they employed (permanent carbon process, pigment varieties), through presentation (large format, calling cards), or even through the themes and historical periods they presented. In order to offer the greatest range of choice, they published images from foreign houses.

Giraudon maintained a special relationship with the Alinari brothers, but he also sold photo prints by Hanfstängl. In 1866, Braun signed a contract that awarded him "a thirty-year privilege" to reproduce masterpieces, giving him "the official title of Photographer to the Administration of Fine Arts and the Musée du Louvre." This privilege, which created contempt and jealousy within the profession, was not exclusive but allowed instead "the capacity of moving painting and reproductions into their studio." Furthermore, the contract specified that 7,000 works of art be reproduced.

Philippe de Chennevières, the fine arts director, said that bringing a photographer to the Louvre was like inviting the money changers into the Temple of Jerusalem, but journalist Thiébault Sisson defended the publishing houses. He stated, "Paris should be overjoyed to finally see a museum of photography among its best art collections, and all at no cost to the state." The idea of a photography museum was not new, but it wouldn't catch on for a long time. In the 1930s, collections of art prints would be called "pocket museums." In reaction to these, André Malraux would publish his famous *Musée imaginaire de la sculpture mondiale* (The Imaginary Museum of World Sculpture, 1953). As early as 1868, the painter Odilon Redon was wondering "how provincial cities, especially those without museums, are not considering having a superb collection of photographic reproductions of drawings taken by Braun?"

"TO SORT AND NOT TO CHOOSE": THE PROBLEM OF SELECTION

Publishers of photographic art prints had to choose among a multitude of museums, monuments, and objects. In 1856, the editor in chief of *La Lumière*, Ernest Lacan, offered the following opinion: "If these very experienced artists were to take the masterpieces of sculpture from our museums and reproduce them not individually, according to their own whims, but by period and by following the classification naturally taught in various schools, it would be a great and useful endeavor." Selection, structure, and systemization of knowledge were all terms emerging from the positivist trends of the nineteenth century, and they were to become the vocabulary of order for all disciplines.

To understand how the photographers' selections were organized, and to evaluate the methodical character of their work, one only has to leaf through the catalogs of different publishing houses: decade after decade, museum after museum, capital after capital, they attempted to sort rather than choose. Their collections mirror the preestablished preferences of the majority, and they are sure to include reproductions of works that had already become popular by means of engravings.

Photographic art printing was a lucrative market, for "aside from portraiture, which is the main line of work, it is the reproduction of works of art, architecture, and landscapes that offers the most to a few." But there were certain risks involved. Although some reproductions hardly sold at all, a few big classics could by themselves make the whole collection profitable. The same holds true today.

Alinari brothers, *View of the Cathedral from the Palazzo Vecchio* (Florence, 1900)

The company founded by the Alinari brothers in Florence, Alinari Editori Fotographi, quickly became a true publishing house.
It provided work for many photographers and sold reproductions throughout the world.

8: PHOTOGRAPHY: "A HUGE SERVICE TO THE ARTS"

As soon as it came into being, photography began raising questions in the world of art. Was it a danger to the fine arts? What role would it play among drawing, engraving, and painting? Before, engraving had been responsible for reproductions, and it should therefore have come as no surprise that engravers felt most threatened by photography. In 1839, the painter Paul Delaroche hailed photography as a "huge service to the arts" and praised its virtues so effectively that some of his own students became professional photographers while continuing to work as painters. Le Gray and Le Secq, who, because of their training, were familiar with the standards of printing quality, were among the most notable from this group.

DOCUMENTATION FOR ARTISTS

Opinions were more divided when this new medium attempted to break out of its role of "humble servant," as Baudelaire had phrased it. In 1862, twenty-six artists, including Jean-Auguste-Dominique Ingres, signed a petition "against all assimilation of photography into art." Eugène Delacroix, a founding member of the Heliographic Society, refused to sign. In 1854, the painter had asked Eugène Durieu for a series of twenty-six photographs of nude models, posed alone or in couples, and used them as direct inspiration for certain paintings. A study of the archives of painters and sculptors shows that this simple and helpful practice—which Delacroix was among the first to adopt—became more popular in the 1870s and especially in the 1880s.

Photography is a vast memory bank from which painters, sculptors, and architects would draw elements to regenerate their vision and feed their composition and imagination. They obtained images from publishing houses, such as Giraudon and Alinari, and from specialized photographers, such as Marconi and his *Studies from Nature*—that is, nudes, animals, trees, and plants. This documentation complemented sketches and engravings that artists gathered for their compositions.

Of course, what was available commercially was not always enough, and artists would create more personal documentation. With the technical improvements that made photography available to all, some bypassed the intermediary figure and photographed their subjects and models themselves. Edvard Munch, Fernand Khnopff, Édouard Vuillard, and Pierre Bonnard are some examples.

In the twentieth century, it became common practice for artists to take their own photographs. Images were no longer cropped for reproduction but projected directly onto the canvas to be painted. In recent times, Andy Warhol and Gerhard Richter have used photographs, turning them into models in their own right as a foundation for the paintings they make.

EFFICIENT DISTRIBUTION

Once their work was complete, artists quickly learned what greater role photography could play in its distribution among the general public. Again, they called upon specialized photographers. Sculptors proved to be more demanding since sculpture in the round was by nature more complicated to reproduce. Auguste Rodin was fond of Eugène Druet's methods, but Antoine Bourdelle and Constantin Brancusi chose to use their own shots. Later, Henry Moore and Tony Smith photographed their sculptures themselves as well.

EDUCATING THE EYE

The use of photography changed the way that people saw, looked at, and studied nature. Artists, even those who chose not to use a camera, no longer saw their surroundings and environment

the same. Close-ups and the isolation of details, which are intrinsic to photography, began to appear in paintings. Muybridge's series on the deconstruction of the movement of man and animal, and Étienne Jules Marey's chronophotographs, which deconstructed movement, fascinated various figures in art, from Edgar Degas and Marcel Duchamp, to the Italian Futurists, such as Boccioni and Balla. Rodin, who was one of the first to subscribe to Muybridge's *Animal Locomotion* (1887), still refused to recognize photography's capacity to render true movement. For him, "it is the artist who is true and the photograph that lies."

Eugène Durieu, *Academic Nude from the Delacroix Album* (1853–1854)

Eugène Delacroix was a close friend of Eugène Durieu, who provided the painter with photographs of female and male nudes. The artist used them for drawings and sketches.

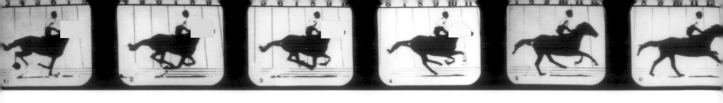

9: PHOTOGRAPHING MOVEMENT

The notion of speed in photography is of course relative. In 1826, it took Joseph-Nicéphore Niépce seventy-two hours to photograph a window; thirteen years later, in 1839, it "only" took Daguerre ten to twenty minutes. Two years later, almost-instant pictures could be shot in a quarter or—according to certain cameramen—even a tenth of a second. Rapid movement could be captured at this speed, although imperfectly, and still with some blur.

SAVING A FEW SECONDS

These speeds, however, weren't common yet. The length of a shot still varied greatly. It depended on the quality of the chemicals used, on the cameraman's technique, on the time of day, the weather, and light conditions, as well as the subject, lens, and size of the plate.

Between 1850 and 1880, shooting at speeds of less than a second still required some skill, technique, and ability, though the development of the first mechanical shutter in the 1850s helped matters. Most photographers continued to work at the relatively slow pace required by wet collodion prints, the prevailing process, and by the fact that an exposure of several seconds was sometimes required for a large-format picture.

These technical limitations naturally determined subject choice (mostly still), format (the smaller the negative, the shorter the pose), or the approach to the image. In this respect, when

Charles Nègre, in the early 1850s, photographed his *Petits Ramoneurs en marche* (Chimney Sweeps Walking), he had to carefully compose the scene, with the subjects, who remained still, miming their motions. Just a few years later, in the mid-1850s, the small stereoscopic format became the primary (and very successful) means of capturing subjects in movement, especially active street scenes.

THE HORSE'S GALLOP: A REVELATION

From the 1850s to the 1870s, most professional and scientific photographers were experimenting with ways of reducing pose time. In France, that number included Auguste Bertsch and Jules Janssen; in England, Oscar G. Rejlander; and in the United States, Eadweard Muybridge. By the end of the 1870s, Muybridge had gotten the most remarkable results.

As early as 1872, Muybridge was drawing on

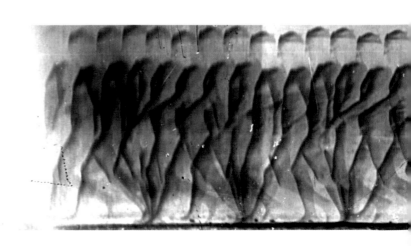

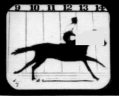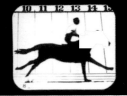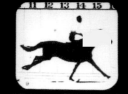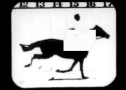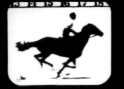

Eadweard Muybridge, *Sally Gardner at a Gallop* (ca. 1878).

This photograph is from the album Muybridge made for Étienne Jules Marey (plate 43). The gift shows the photographer's admiration for the scientist's studies, which guided his early research.

the work of French physiologist Étienne Jules Marey, done in the 1860s, on deconstructing the movements of man and animal. Muybridge was commissioned by Leland Stanford, an ex-governor of California who also bred racehorses, and he began by using photography to freeze-frame a horse at full gallop. To get the shortest possible pose times, Muybridge built a white runway lined with cameras that fired when the horse passed. The images show the dark silhouette of the animal against a white background, which was made especially bright by the California sun. The results were first published in 1877 by illustration engravers and then as a book of snapshots in *The Horse in Motion* (1882).

For the first time, these images showed a new reality that the eye was unable to perceive on its own and that disproved traditional theories about the way horses moved. At a certain point in its gallop, none of a horse's hooves are touching the ground. This was a revelation for both artists and scientists, many of whom drew from photography in the 1880s. Simultaneously, various individuals (such as the photographers Ottomar Anschütz in Germany and Albert Londe in France, and the painter Thomas Eakins in the United States) used Muybridge's deconstruction of movement as a departure for their work. At the end of the 1870s,

the first gelatin-bromide plates, which were faster, made such research easier.

It comes as no surprise that Étienne Jules Marey himself was fascinated by Muybridge's work. In 1882, Marey set up a physiology station in the Bois du Boulogne and developed a procedure called chronophotography that on a fixed plate deconstructed and recorded movement. Reversing the system of contrast that Muybridge used, Marey made his subjects (human and animal) white in front of a black background, capturing the movement with a special crank-driven machine. Ten years later, he developed a procedure that projected chronophotographic strips, meaning that deconstructed movement could then be reconstructed, a technique that became the precursor to the moving image. Both Muybridge and Marey inspired images developed in the twentieth century, such as those by Duchamp and the Italian Futurists.

Étienne Jules Marey, *Lateral Step of Man* (1890).
Chronophotograph

In accordance with the principles of chronophotography on a fixed plate, the pictures obtained show the successive phases of action overlapping each other within a single image.

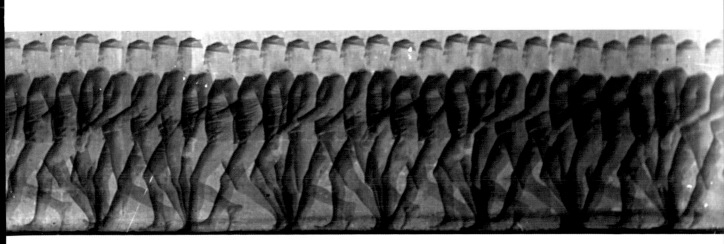

10: THE SNAPSHOT REVOLUTION

At the beginning of the 1880s, the emergence of the new gelatin-bromide process brought about a real revolution in photography. This technical innovation laid the foundation for a new direction in photography.

THE GREAT POPULARITY OF THE INVENTION

The Englishman Richard Leach Maddox first developed the gelatin-bromide process in about 1871. It was perfected over the next decade and replaced the collodion technique in 1880. Until that point, photographers could choose between the wet or dry collodion process. The former was relatively fast but tricky, since it required photographers to both prepare and expose the negative during the picture-taking process. Outside the studio, this was complicated. Dry collodion was more manageable since the negatives could be prepared in advance, but it was much less sensitive, which meant pose times had to be longer. Gelatin-bromide was both a dry process that could be prepared in advance and very fast, allowing for snapshots to be taken at almost one one-hundredth of a second. The dilemma was solved.

The industry began using this discovery as early as the beginning of the 1880s, making negatives available for business. At the same time, progress was being made in enlarging techniques, meaning that negatives and cameras could both be made smaller. From this point on, they were more manageable and less expensive. A new group of enthusiasts who had no technical knowledge were now drawn to photography. The real snapshot revolution came not so much from the reduction of posing times but from technical simplifications that opened the way for new methods and new

buyers. The notion of instant photography meant both a faster and easier photography.

"PRESS THE BUTTON"

The revolution found its symbol in the first Kodak camera (Kodak No. 1), which George Eastman, the

American inventor and entrepreneur, introduced to the market in 1888. This camera was just a little bigger than a box of cigars and was loaded with paper film (celluloid after 1889) that could take up to 100 pictures. The famous ad campaign not only reflected the new "instant" philosophy but also illustrated a new division of labor: "You press the button, we'll do the rest." Owners now only had to bring cameras to the store to have their film developed. From this moment on, the act of taking photographs was reduced to a single shot. The industry was responsible for what came before— preparing the negatives—and after—developing and printing. Now anyone could be a photographer.

Although it was somewhat expensive, the Kodak camera was a hit, and other cameras succeeded it, including the 1900 Brownie Camera, which sold for the unbeatable price of one dollar. More than 100,000 were sold in the first year. In Europe, companies such as Lumière, Agfa, Voigtlander, and Gevaert contributed to this new market, and a number of small, more manageable cameras appeared. These new developments proved not to be a passing fad for either the amateur or the common photographer, and they lasted throughout the twentieth century.

As part of the revolution, images began to be taken of subjects in action (jumping, running, falling, and so on), creating a new language that completely contrasted the poses of the professional studios. Artists joined in. Bonnard, Vuillard, Maurice Denis, Munch, and even Hendrik Breitner tried their hand at it, and sometimes got amazing results. Because they had no viewfinder, and because of the photographer's love of speed, the great flexibility of these small cameras rang in a new aesthetic that favored the accidental and

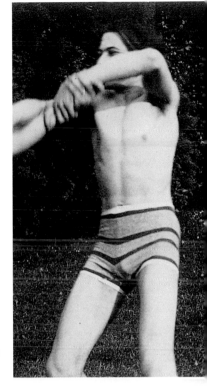

Pierre Bonnard, *Claude Terrasse and Jacotot Fighting* (n.d.)

An amateur photographer, Bonnard used the new invention to capture scenes from his daily life and family. What interested him most was shifting light. He pursued photography between 1894 and 1920.

rejected the formal. Most Kodak pictures were taken from waist-high, at about four feet (1.3 m) from the ground.

Its popularity was so widespread that the snapshot revolution could almost be called the renaissance of photography. The craft stood on a new foundation and grew up strong. Not until the 1980s, with the democratization of photographs and the proliferation of video, camcorders, and eventually digital cameras, would there be a comparable revolution. The movement toward smaller, faster methods also gave birth to a new iconography and was a death knell for the gelatin-bromide picture.

11: THE PHOTO-GRAPHIC NUDE IN THE NINETEENTH CENTURY

The nude held a privileged place in nineteenth-century photography, despite the fact that it unleashed the protestations of bourgeois morality: "The nude, which is the necessary basis of the arts of drawing, sculpture, and painting, would be shameful in photography." Beyond the erotic snapshots and the stereoscopic views that led to its popular success, or the anatomical shots that made it useful to the traditional arts, the photographic nude produced several masterpieces.

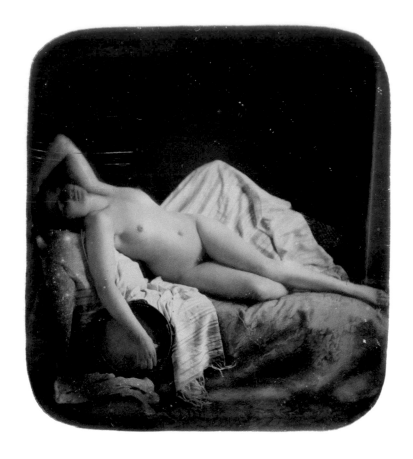

HISTORY OF THE NUDE

"Photography is the raw effigy of reality rather than reality itself."

—Henri Delaborde

Until the French revolution, only the academic nude, which was transcended by art in every form, was socially acceptable. It was strictly forbidden to display nudity, and the Directoire went so far as to make the dancers of the Opéra wear flesh-colored suits. Nudity was first publicly displayed in 1846, at the theater of the Porte Saint-Martin, which was quickly emulated by a multitude of small, clandestine theaters known as "artists' studios" in which young women stripped under the pretense of acting out the fables of antiquity. The recording of the naked body became one of the major issues of photography in the second half of the nineteenth century. The first daguerreotypes of academic, erotic, and pornographic nudes date back to the moment of photography's invention.

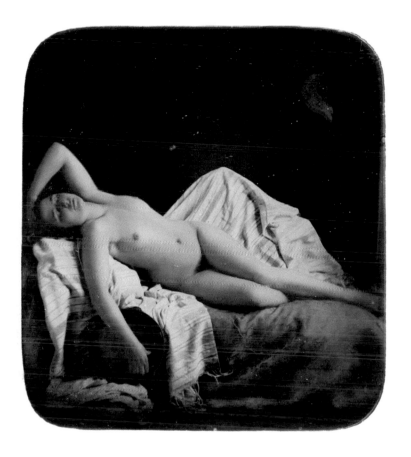

Auguste Belloc (attrib.), *Woman on a Bed*
(ca. 1851–1855). Daguerreotype, hand-colored
stereograph, 3 x 6 inches (8 x 16 cm)

At the Salon of 1859, Baudelaire was particularly
struck by the stereographs. "Thousands of eyes
peered through the holes of the stereoscope as
if they were windows looking into infinity. Love
of the obscene, which is as enduring in man's
heart as self-love, would not let such an
opportunity go to waste."

But it wasn't until the invention of stereoscopic
images, in 1851, that the nude became an
industry, whether it was intended for artists or
not. From this point on, it became possible to
purchase large quantities of nudes everywhere.
Censors of the time only served to slow a portion
of the market, which soon found alternate outlets.

With its authenticated realism, photography
opened an unknown realm to representation. It
did not know any real taboos: though it showed
a body that really had been there, in front of the
lens, it simultaneously created a distance between
the subject and the viewer, a distance that allowed
for every audacity. In 1853, nude studies ac-
counted for about 40 percent of photographic
production. Simply put, nudes sold. Even now,
many photo magazines only manage to survive by
publishing nude photos. The difference between
these and the nudes of the nineteenth century,
more than aesthetics or inspiration, is primarily
a matter of the way the models are posed.

THE NUDE REALM
**"The difficulty when it comes to nudes is to
renovate."**

—Émile Bayard

When we talk about "the nude," rather than nudity
or the naked body, we are talking about the
artistic domain. This distinction automatically
eliminates the realms of scientific and
ethnographic photography, which specialize in
detailing, studying, and classifying bodies. Yet is
the nude a photographic genre in the same way
that it is a genre in painting and sculpture? Do
photographs of a torso, of a back, or of genitals
enter into this category? Is a half-undressed
body already considered a nude? Despite all the
questions the term raises, the nude remains the
way we refer to images as eclectic as an aca-
demic nude by Marconi, a prostitute by Atget,
a pictorialist nude by Demachy, Kertész's
Distortions, or a solarized nude by Man Ray.

12: SCIENTIFIC PHOTOGRAPHY: THE REVELATION OF ANOTHER REALITY

As early as 1839, the physicist and statesman François Arago had presented to the Chambre des Députés (the French Parliament) the potential areas for the application of the daguerreotype. Clearly he had the sciences in mind, including the study of light and astronomy. Scientists of the time grew eager to use the new photographic processes, especially given the speed and exactitude of the images they created. Following in the footsteps of human observation and drawing, the camera promised to come in where the eye tired and the hand failed. It would present true reproductions and create a faithful record. Furthermore, because of its mechanical character, authenticity and objectivity were guaranteed.

Édouard Duseigneur Kléber, *Physiology of the Cocoon and the Silk Thread* (1855). Figures 36 and 37

MEN OF SCIENCE TAKE THEIR FIRST STEP

Several men of science became pioneers in the technique, including British physicist John Herschel, U.S. astronomer John Draper (who took daguerreotypes of the Moon as early as 1840), Austrian optic professor Andreas Von Etting-hausen, and French doctor Alfred Donné. In 1840, Donné commented on his first findings in microscopic photography that, because of these findings, his branch of medicine would henceforth be founded "on a solid and incontestable base."

The daguerreotype and, to a lesser extent, the

paper photograph, penetrated most fields of science: astronomy (first lunar eclipse captured by Malacarne in 1842), botany (Anna Atkins's work on flora in the British Isles, *British Algae* and *British Ferns,* 1843–1853), physiology (*Mécanisme de la Physionomie humaine* [Mechanism of the Human Physiognomy] by doctor/photographer Duchenne de Boulogne, 1862), psychiatry (Professor Hugh Diamond and the photographs of his patients at the Surrey County Asylum in the early 1850s). But these photographs were still far from meeting the expectations of a jubilant scientific community. The low sensitivity of these processes and their uneven results made them hard to use for many purposes. For some time, the eye and hand remained more truthful than the machine.

One of the rare feats achieved by photography in the sciences between 1840 and 1880 involved capturing the lunar eclipse of 1860. On this occasion, for the first time, the pictures taken by various British and Italian expeditions (Warren De La Rue and Angelo Secchi, respectively) proved the existence of solar prominences, a phenomenon considered until then to be an optical illusion.

THE SCIENTIST'S RETINA

It was only in the 1880s that the photograph became a faithful friend of the sciences. By then, gelatin-bromide plates had been developed that were more sensitive and more practical than previous methods. In the words of astronomer Jules Janssen, the camera was "the scientist's true retina." In France, Louis-Alphonse Davanne, the president of the French Society of Photography, along with photographers Étienne Jules Marey and Albert Londe, were among the most fervent when it came to using photography for science.

Londe, head of the photography studio at the Salpêtrière hospital, emerged as one of the first to systematically use the new medium in a hospital, and he published several books on the subject. His *Nouvelle Iconographie photographique de la Salpêtrière* (New Photographic Iconography at the Salpêtrière hospital) was a survey of the principal clinical cases encountered from 1870 on and remains one of the most fascinating examples of its kind.

Both in Europe and the United States, photography finally replaced drawing and engraving as a means of recording fine visual information. As a consequence, there were widespread campaigns to capture this information, for archival purposes or for individual cases, in medicine, physics, and astronomy. For example, the Paris Observatory founded the Carte photographique du Ciel (Photographic Map of the Sky) project in 1889. At one point, eighteen observatories from all around the world joined together to meet the goal of "drawing up the most exact and complete inventory of the perceptible Universe at the end of the nineteenth century." For undertakings as grand as these, photography proved to be the positivist's tool of choice, a recording instrument trustworthy enough to penetrate the depths of all the surrounding world.

In the hands of scientists, photography even ventured into the beyond, pushing back the frontiers of the visible. As early as 1883, the new sensitive gelatin-bromide plates brought stars into view that had been invisible even to the best telescopes. In 1895, Wilhelm Conrad Röntgen discovered X-ray photography. This process drew instant fascination. Photographers were clearly no longer satisfied with simply recording the visible. They wanted to transform it into a tool for research, even into a means of discovering another reality.

Paul and Prosper Henry, *Portion of the Constellation of Cygnus* (Observatory of Paris, August 13, 1885).

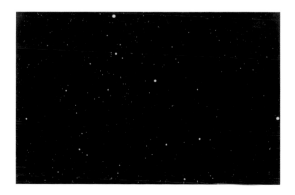

13: "AUTHENTIC CASES" OF POVERTY

In very little time, photography came to be considered the best way of showing reality. It became a tool for people who wanted to reveal and denounce the injustice of the world around them.

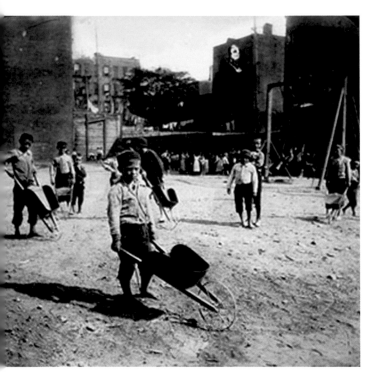

Jacob August Riis, *Sports Field* (ca. 1890). Hand-colored photograph

The photographer would often show children in their impoverished surroundings to raise public awareness of their living conditions. It was also a way to trigger an emotional response.

p. 51:
Lewis W. Hine, *Hazardville: Girls of about Twelve at Work in the Tobacco Factory* (1905–1910)

No laws protected young children, many of whom worked long hours for almost no pay.

PICTURES TO STIR EMOTION

In 1877, John Thomson published *Street Life in London* with Adolphe Smith. The report, which was illustrated with photographs aimed to raise consciousness about the life of Britain's poor, argued that the "indisputable precision of this report will show real cases of London poverty, without adding or subtracting from the true lives of the poor."

However, this social force was strongest in the United States. In 1870, a twenty-one-year-old Jacob A. Riis set out from Denmark for New York, where he lived for the most part among immigrants in the poor sections of downtown Manhattan. Seven years later, he became a general news reporter, first for the *New York Herald Tribune* and then the *New York Evening Sun.*

The central precinct was then located on Mulberry Street, in the heart of the Lower East Side, a neighborhood Riis knew well. At this point, he worked to show how the poor weren't just simple working people but rather the tragic victims of their awful living conditions. He gave lectures and used a magic lantern to project images that he hoped would touch spectators and stir up compassion and understanding, inciting them to act against poverty.

At first, Riis worked with a few photographer friends, then just an assistant, and in the end alone. He was among the first to use the magnesium flash, invented in Germany in 1887, to illuminate the minute details of the slums, shelters, and tenements. These photographs showed wretched homes whose inhabitants lived one on top of the other. They denounced the deplorable conditions of the homeless in the police shelters and the equally deplorable conditions of the adults and children who worked in the filthy sweatshops.

Riis also took many pictures of streets, parks, and gardens, enlivened by passersby, vagabonds, and the down-and-out, to whom he often gave coins in exchange for a picture. These photographs were sometimes posed; for example, the same group of three children can be found in several photographs, and their stance is rigid. The negatives also indicate that Riis meant to use them for a series on a theme.

PICTURES FOR POLICY CHANGE

Riis's lectures and articles moved the general public, but it was through his book *How the Other Half Lives*, published in 1890, that he earned his greatest success. This book of thirty photographs continues to be printed today. It brought Riis into contact with Theodore Roosevelt, then the chief of police in New York but soon to be president of the United States. He left the following note at Riis's home: "I saw your book and I've come to the rescue." Through his photographs, Riis played an important role in renovating tenements, closing police shelters, opening public gardens, creating sports fields, and repairing schools.

In Vienna, a similar project was undertaken by the photographer Hermann Drawe, who in 1908 published *À travers les quartiers viennois de la misère et du crime. Journal de voyage de l'autre côté* (Through Vienna's Neighborhoods of Poverty and Crime: Travel Journal to the Other Side), with text by Emil Kläger. Jessie Tarbox Beals, one of the first female photojournalists, worked for Riis for a while, as did the sociologist Lewis W. Hine. After completing a series on European immigrants arriving at Ellis Island, Hine worked for the National Child Labor Committee from 1908 to 1918. During this time, he photographed children working in glass and textile factories, fields, and mines for twelve hours at a time. In this case as well, the pictures raised the American consciousness and brought about change in the legislation concerning child labor.

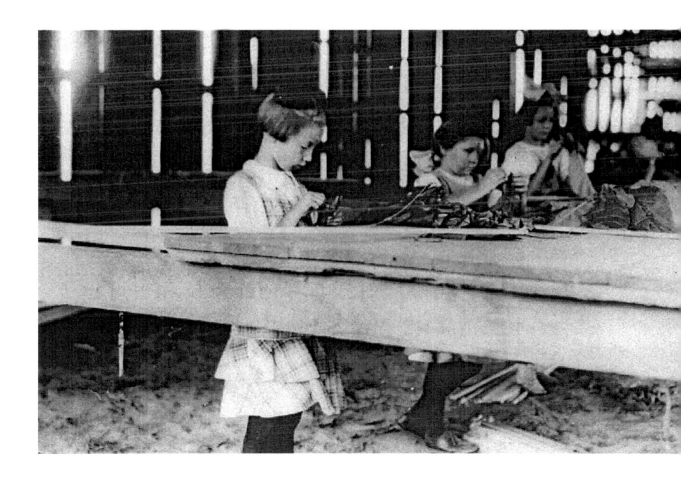

14: THE SEARCH FOR COLOR

At the end of the seventeenth century, Sir Isaac Newton used a prism to prove that white light contains all wavelengths—and therefore all colors—of the visible spectrum. By directing white light through a prism, Newton was able to demonstrate the "dispersion" of light into a series of colored rays, ranging from purple to red. Drawing on Newton's conclusions, the British physicist Thomas Young proposed in 1802 that the human eye is composed of three different types of color receptors—in other words, that it basically only "sees" three colors: red, green, and blue. In 1861, the Scottish scientist James Clerk Maxwell perfected this theory with his development of the color triangle, which used three imaginary or "ideal" colors (cyan, yellow, and magenta) in addition to Young's three "primaries." With this addition, Maxwell was able to prove that all colors could be represented through a mixture of colors from his triangle, thus providing the foundation for the three-color printing process.

THE UNEXPECTED ENCOUNTER BETWEEN A POET AND A PHYSICIAN

In 1869, two scholars, the poet Charles Cros and the physicist Louis Ducos du Hauron, strangers who knew nothing of each other's experiments, came to similar conclusions, which they revealed on the same day at a meeting—surely a memorable one—of the French Society of Photography. The two started from the principle that by combining three chosen colors in proportion, one could reproduce an infinite variety of colors from nature. Their photographic procedure had two stages. First, color filters broke down the light used to expose the negatives. The original colors were then reproduced by layering the three negatives according to the primary colors of the three-color process.

The work of Cros and Ducos du Hauron corresponded to the observations of Michel Eugène Chevreul. In 1839, this chemist noted the phenomenon of colors blending at a distance (using tapestry and mosaic as an example). The dyed wool and the elements of a mosaic that the naked eye can see can be "so similar and mixed together, that at a distance where the whole can be viewed, they will come together into a colored surface, all its parts one." Chevreul's writings were very influential in the art world because of Charles Blanc's 1867 publication of *La grammaire des arts*

du dessin (The Grammar of Painting and Engraving).

But because the process was so complex, and especially because the images were unstable, Ducos du Hauron and Cros could not market their findings. For a few more years photographs would remain either black-and-white, hand-colored, or toned.

"CAPTURING THE MEMORY OF FLEETING COLOR"

It wasn't until the end of the nineteenth century and the emergence of a three-color process for printing illustrations that an important innovation was made.

Antoine Lumière had left photography to settle in Lyons, France, and devote himself to the making of glass plates. In the early 1880s, he passed the family business down to his two sons, Louis and Auguste.

The brothers began to explore the various paths that past research had cleared, especially that of three-color-process photography developed by Cros and Ducos du Hauron. At the same time, they delved into new discoveries about printing. In 1898, the Prieur and Dubois studios began using a new method of forming their printing matrix. Instead of creating a dense field of crossing lines, they covered their plates with a thin film of very fine-grained resin. From this advance, Louis Lumière took another leap and invented the "autochrome"

Fernand Cuville, *Little Girl Seated at the Foot of a Font within the Church of Saint Zenon (Eleventh Century) in Verona* (May 16, 1918).
Autochrome, from the Albert Kahn collection

From 1894 to 1931, the banker and humanist Albert Kahn hoped that better knowledge of the world would bring about peace. He
financed one of the most ambitious projects of the century, bringing together the exhibition "Archives of the Planet" under one roof.
The 1929 world financial crisis ended his dream. Still, 72,000 autochromes and 550,000 feet of film were produced by Kahn's associates
in France and the world over.

plate. His biggest innovation came in sprinkling the plate with color grains to create a fine mosaic. The autochrome process was registered in 1903.

It took a number of attempts to find the best materials for color photosensitivity. After early trials with grains of starch, fermenting agent, yeast, enamel pigment, and other transparent materials, potato flour was finally adopted in 1904. The flour grains wove through the surface of the plate in a mosaic of microscopic colored elements to create a color filer. When light shone through these elements, the photosensitive emulsion recorded the image one point at a time.

The autochrome plate was marketed in 1907, four years after its invention. It created a unique image whose subtle, precise colors could not easily be transferred to paper. The image was created as a glass positive and was most luminous when projected on a screen. The photo would then be as big as a painting, and its grainy surface drew comparisons with the pointillist technique in Neo-Impressionist art. The process was simple and enjoyed rapid success, even though it was fragile and required long posing times. In 1913, annual production grew to a million plates.

Not everyone was enthusiastic about it. Paul Strand, for example, considered black and white to be elemental to photography. In 1917, he wrote, "color and photography do not belong together." The argument stood strong. It would take another fifty years for color to gain artistic legitimacy.

15: PICTORIALISM: THE PHOTOGRAPHER AS ART LOVER

Pictorialism has always played a critical role in the history of photography, from the time of its pioneers, who discovered and experimented with the processes, to the avant-garde in the twentieth century.

Robert Demachy, *Struggle* (*Camera Work,* January 1904)

Robert Demachy perfected the gum bichromate printing process so beloved of the pictorialists. The paper is coated with a mix of pigmented gum arabic and potassium bichromate. Exposed to light through a negative, the surface of the paper hardens to different degrees. The photographer then reworks the surface of the print. To obtain different colors, additional coats of gum bichromate may be used on the same print.

ARTISTIC AMBITIONS

The idea that photography, a technique of mechanical and chemical illustration, could be used as a means of artistic expression, as well as for functional purposes, became the subject of debate very early on. In a short period of time, photography evolved from a highly regarded craft to a simple professional activity no longer requiring cultural or scientific expertise.

From 1850 to 1880, photography tended to be used as a documentary tool, but by the turn of the century this had changed radically. More and more fans began to insist that it was an art. Influenced by the writings of Henry Peach

Robinson, who believed that nature was to be interpreted according to the canons of art and aesthetics, and by Peter Henry Emerson, who was more innovative, photographers sought to break with the commercial prescriptions of professional photography that the studios had made standard.

These early photo artists banded together to form the first movement in photography, pictorialism, which had its glory days between 1890 and 1910. Societies were founded across Europe: the Photo-Club de Paris (1888), the Linked Ring in London (1891), Das Kleeblatt in Vienna, and others in Hamburg, Munich, and Brussels. Each had publications in which art theory and technical

processes sparked debate and encouraged experimentation.

PHOTOGRAPHY SALONS

The pictorialist movement became important in part because of its international character, with British members taking the lead in the last decade of the nineteenth century. At this time, American photographers began undertaking artistic explorations, and unknowingly, they found similar solutions that would make photography one of the drawing arts. In the mid-1890s, photography salons opened in the European capitals that were based on the old salons for painting and sculpture, where hundreds of pieces were displayed in very close proximity. The trend started in Vienna in 1891, then moved to London in 1892, and to Hamburg the following year. These photography salons established pictorialism as a strong force in Europe, and they attracted the attention of Americans who eventually formed the Camera Club of New York. By 1900 American photographers had also begun to be heavily represented in the exhibitions at the Royal Photographic Society and at the Linked Ring's photographic salon, headed by Alfred H. Hinton. Frederic Holland Day embodied this "new American school," which came to lead the international scene.

"IN ART, THE SUBJECT IS NOTHING, INTERPRETATION IS EVERYTHING"

Moving away from the old, familiar, documentary content, the pictorialists found subjects in the traditional genres that fit their artistic ambition: nudes and draped figures, landscape, genre scenes, and the still life.

The negative became an intermediary step before, and in service of, the print. The pictorialists stayed away from images that were too sharp and from shiny and polished surfaces, preferring to use carbon printing and pigment processes. Gum bichromate and greasy inks were their favored tools. These techniques meant that they worked the surface of the image as though they were drawing. The image was no longer obtained automatically but was developed through the artist's skill and concern for precise values.

The best-known figures of the pictorialist movement were George Davison and Frederick

H. Evans from England; Robert Demachy and Constant Puyo from France; the German Heinrich Kühn; and Alfred Stieglitz, Gertrude Käsebier, Alvin Langdon Coburn, and Edward Steichen from the United States.

From 1904 to 1906, the British pictorialists, including Frederick H. Evans, joined the American school and turned toward pure photography—that is, photography that placed more importance on subject than on how the image was rendered. Demachy stood against the new alliance. His position isolated the French movement from the international scene, which was governed by allegiances with or reactions to the American avant-garde. The movement endured for several years, but eventually waned.

Heinrich Kühn, *Lottie Picking a Flower* (1905–1910)

A member of Das Kleeblatt (Vienna's photographic society), Kühn was influenced by Stieglitz, whom he met in 1904. Kühn's delicate and personal work remained pictorialist until the 1930s, even though the movement was waning.

16: PHOTO-SECESSION, *CAMERA WORK*, 291: PHOTOGRAPHY ON PAR WITH THE FINE ARTS

Adolf De Meyer, *Portrait of Alfred Stieglitz* (n.d.)

"WHEN I MAKE A PICTURE, I MAKE LOVE"

To write the history of the American pictorialist movement and the Photo-Secession movement is to tell the life story of Alfred Stieglitz. It is impossible to ignore the man and what he did for the art of photography.

Stieglitz's father, a man of German origin, came to the United States in 1850 but decided to return to Europe in the early 1880s in order to complete his children's education. Having learned all the technical nuances of photography in courses with Hermann Wilhelm Vogel, Alfred dropped his studies in mechanical engineering, which he had taken up in Berlin, in order to become a photographer. From there on, he devoted all his energy to ensuring that photography was recognized as its own art, like painting and sculpture. Upon his return to New York in 1890, his determination grew when he discovered that the Society of Amateur Photographers lacked the vigor of its European counterparts.

Very soon after, his articles and photographs started drawing attention in Vienna, Hamburg, and London and, in 1893, he became the editor in chief of the club's magazine, *The American Amateur Photographer.* For three years he fought to create a salon that compared to those organized on the European continent. In 1896 he resigned, realizing that his readers were much more interested in technique than in artistic expression.

In 1897, Stieglitz became the vice president of a new association, the Camera Club, which combined the Society of Amateur Photographers and the New York Camera Club, and took on the duties of editor in chief for the new quarterly *Camera Notes.* Under his direction, it became the country's most influential publication on photography.

Alfred Stieglitz, *The City of Ambition (New York)* (*Camera Work,* October 1911)

The streets of New York, the skyscrapers, and the city were a new source of inspiration for Stieglitz. To him, they represented subjects anchored in modernity.

Particularly concerned with the selection of images and their print quality, he included thought-provoking articles on controversial subjects by art critics such as Charles Caffin and Sadakichi Hartmann. The quality of the publication drew in several photographers, including Clarence H. White, Edward Steichen, and Gertrude Käsebier. Despite all his efforts, however, Stieglitz could not yet establish his point of view.

In March 1902, and not in association with the Camera Club, Stieglitz organized an exhibition of pictorialist work at the National Art Club of New York, which he called "American Pictorial Photography Arranged by the Photo-Secession." In choosing this title, Stieglitz asserted a bond with European groups like the Secession of Munich, which brought painters together against official art. The show was also an opportunity to display all the photographers his magazine had published.

In less than a year, the once-informal group gained structure. The Photo-Secession appointed members and a board, and Stieglitz became its director. In June 1902, weary of the limitations and hesitations he faced, Stieglitz resigned from *Camera Notes*. He wasted no time, and in January 1903, the first issue of *Camera Work* was published. He found the funding, directed it, and selected the writers, photographers, and artists that were included. His hands were totally free.

Clarence H. White, *Raindrops* (*Camera Work*, July 1908)

A founding member of the Photo-Secession in 1902, along with Alfred Stieglitz, White presents a poetic and personal dimension in his pictorialist work.

"THE PUBLICATION INTO WHICH I TRULY PUT MY HEART AND SOUL"

Dedicated to photography, *Camera Work* was radically different from everything that had come before it, both in its aesthetic choices and print quality. Its readers discovered the work of American as well as European pictorialists, such as Clarence H. White, Frank Eugene, Paul Haviland, and Heinrich Kühn. Also featured were the writings of top critics of the photography-as-art movement by the likes of Bernard Shaw, Maurice Maeterlinck, Demachy, and Francis Picabia. The magazine was constantly evolving and, after focusing on photography, opened to all the arts. Well before the famous Armory Show of 1913, the magazine introduced modern art to the United States by publishing the drawings of Rodin, Matisse, Picasso, and Cézanne, along with Gertrude Stein's first writings. Although it was written by and for a small group, with no more than a thousand copies printed per issue, *Camera Work* had a considerable influence on the history of American art. Between the first and last issue—there were fifty in all, and only six between 1913 and 1917—the magazine's direction, like that of its director, changed and turned toward new aesthetic values. These were best represented by Paul Strand, and the final issue—the double issue of June 1917—was devoted entirely to him.

"WHAT DOES '291' MEAN?"

In order to offer an exhibition and meeting space to the members of Photo-Secession, Edward Steichen encouraged Stieglitz in 1905 to rent three rooms at 291 Fifth Avenue in New York. This space became the Little Galleries of the Photo-Secession. Steichen was its decorator and designer. The first exhibitions, like the first issues of *Camera Work*, presented European and American photographers. But no matter what they did or how active they were, Stieglitz and Steichen had a hard time establishing the artistic role of photography as part of the New York scene. In January 1907, they opened the Little Galleries to painting and sculpture, just as *Camera Work* had done; in 1908, the space—now known as 291—presented the watercolors of Rodin and Matisse for the first time in the United States. This was all thanks to Steichen, who was the Paris and New York go-

between. Stieglitz's personal taste and aesthetic values began drawing him further and further from photography, and between 1910 and 1917, only four exhibitions at 291 included his work. Stieglitz made a final turn toward European

modern art and introduced the artists Toulouse-Lautrec, Cézanne, Picasso, and Brancusi. World War I took a massive toll on his work, however, and 291 closed in June 1917.

Alfred Stieglitz, *The Little Galleries of the Photo-Secession* (April 1906)

The gallery, which opened in 1904 at 291 Fifth Avenue in New York (and came to be known simply as "291"), exhibited photographs at first but then welcomed the plastic arts after 1907. It was here that Stieglitz showed engravings by Matisse and Picasso, sculptures by Rodin and Brancusi, and paintings by Cézanne for the first time in New York.

EUGÈNE ATGET
(1857–1927)

"They are but documents, documents that I make."

Born into a humble family and orphaned at age five, Eugène Atget was raised in Bordeaux, France, by his grandparents. Before becoming a photographer, Atget lived a succession of failures. He was an unsuccessful traveling performer and painter; according to those who knew him, he was a loner, a "character." He became involved in photography around 1890, when he began taking shots for artists. Around 1897 he began photographing a variety of subjects—streets, working people, Paris interiors, lonely parks, and shop windows—for architects and artists but also for libraries and museums. His life's goal was to complete a photographic catalog of Paris.

From 1898 to 1900, Atget worked on two complementary series: the life and customs of Paris that formed *Paris pittoresque* (Picturesque Paris), and *Vieux Paris* (Old Paris), which presents historical monuments, street corners, the banks of the Seine, and some picturesque neighborhoods. Then he worked on recording the decorative arts, facades, balconies, gates, door-knockers, and woodwork of the city, calling the series *L'Art dans le Vieux Paris* (Art of Old Paris). *Environs* is an inventory of the small churches, old villages, chateaux, and gardens outside of Paris, especially in Versailles. In 1906, he began working on the *Topographie du Vieux Paris* (Topography of Old Paris), which would cover every street in certain neighborhoods of the old section of the city.

Atget met Man Ray in the early 1920s. Man Ray's studio on rue Campagne-Première was near Atget's home, and Man Ray introduced him first to the American artist Berenice Abbott and then to all the Surrealists. This group was the first to discover the double language of Atget's photographs, made with the sole intent of documenting reality, and to appreciate the poetic and oddly disquieting atmosphere captured in each image.

Eugène Atget, *Saint-Cloud: 1908. View of the Park*

Atget took pictures to fill the needs of his clientele. He was well aware that his work was for the use of others. His tree would help a painter finish a landscape, his building facade would aid an architect, while reproductions of wrought-iron banisters or balconies might be used in construction catalogues. Walter Benjamin was struck above all by the emptiness and solitary character of Atget's images, for example the flight of stairs covered with dead leaves that was part of the series on the Paris environs. The Saint-Cloud garden was one of the places Atget preferred to photograph. He went there first in 1903, then in 1925 and 1927, and then during the last summer of his life.

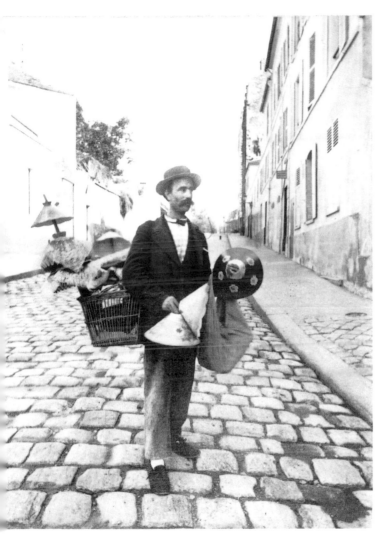

Eugène Atget, *Lampshade Merchant, Rue Lepic* (n.d.)

Around 1926, Man Ray chose more than fifty photographs from Atget's portfolio. He was particularly attracted to certain subjects: nudes and brothels, mannequins, storefronts, fairs and architecture, window displays and trades, including this lampshade merchant. In 1952, Man Ray sold this collection to Beaumont Newhall for the George Eastman House in Rochester, New York. Pierre Mac Orlan, who considered photography to be "an infinitely more psychological than plastic record," was also fascinated by this image. He published it in 1930 in his book *Atget: Photographer of Paris.*

Eugène Atget, *At the Homme Armé: 25, rue des Blancs-Manteaux* (1900)

Old Paris enthusiasts, who gravitated to topographical archives of the city, as well as longtime Parisians, collected the facades, the old streets, squares, and storefronts photographed by Atget under the condition that they would find not a single trace of modern times. Starting in 1779, a ruling required all wine merchants to have "barred signs designate their business." In other words, they had to enclose their stores with bars. A decorative art developed as a result. This cabaret sign, in which a man sits on a cannon with a glass in hand, gives information about the shop address—a part of the rue des Archives called rue de l'Homme Armé (Street of the Armed Man)—as well as the function of the business. This was one of Atget's favorite angles, the owner appears like a ghost behind the window.

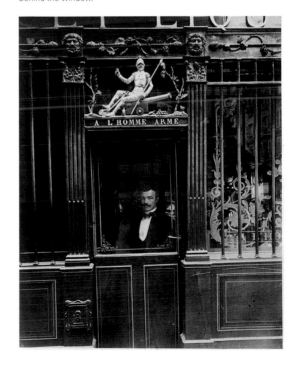

17: WORLD WAR I

"The real painter of the war today, the most ferocious one, is the Kodak." This statement, made by journalist Jules Clareties, was backed up by the abundance of photographs taken during World War I. At the same time, moviemakers had also started aiming their cameras toward the battlefield.

PUBLIC IMAGES

In a letter dated April 22, 1915, the photographer-reporter Meurisse asked permission from the French war ministry to take pictures. A half-century earlier, in his report entitled "De l'emploi de la photographie dans l'armée, des avantages qui peuvent en résulter et des moyens pratiques de l'organiser" (Army Photography: Possible Advantages and Practical Application), André Adolphe-Eugène Disdéri had proposed the creation of a special photography unit. His suggestions were well received but were not implemented. The Section photographique de l'armée (the Army Photographic Division) was then founded under the aegis of the Ministry of War, along with the Ministry of Foreign Affairs and the Ministry of Public Instruction and Fine Arts. Pierre-Marcel Lévi, a Parisian art critic and professor of history at the École Nationale Supérieure des Beaux-Arts (National School of Fine Arts) was chosen to head the unit. Lévi was assisted by Gaston Jougla, a pharmacist, who was in charge of putting the laboratories together. In May 1916, fifty-nine "special photographers" and a film division were mobilized. Their goals were well defined: to serve the ideals of patriotism and to create a clear record for future generations. Anonymous images, signed only with a letter and number, illustrate the dimension of the conflict: crowds, marching troops, ceremonies, equipment, women and children at work, military hospitals, and more. The fighting itself was usually not photographed. Instead, the French soldier was

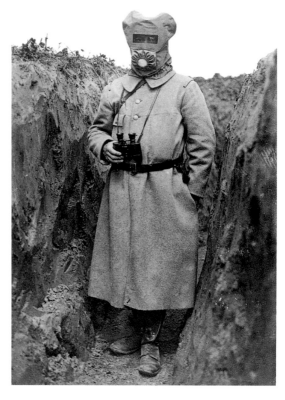

Capitaine de Preissac, *Self-Portrait with Gas Mask* (Beaumetz-les-Loges, 1915–1916)

shown before or after battle, going into attack, in the trenches, exhausted and filthy upon return, or performing some off-duty activity. The violence of war was not hidden; many images show the wounded and mutilated. There were also pictures of bodies, mostly from the enemy camps, face to the ground and unrecognizable. The first photographs of bodies appeared in *L'Illustration* in September 1914. Aerial photography was also used. From 7,500 feet above ground, it was possible to observe enemy positions, lines of defense, and troop movement. Maps for the artillery could also be drawn.

The Ministry of Foreign Affairs was responsible for distributing and managing the photographs. In

August 1916, a retrospective of photographs taken by this special division was held in London and taken to several British cities. In Paris, in October of the same year, the Louvre mounted its first exhibition, entitled "Interalliée." The following year, there was another exhibition at the Jeu de Paume museum, also in Paris.

PERSONAL PHOTOGRAPHS

In addition to the official photographers, many new soldiers were also amateurs with a camera. Its small size, manageability, and relatively low cost had made photography a household passion. Still, "carrying and using a camera are forbidden by all persons, military and civil, who do not have permission from an army major." In spite of this ban, the government still asked citizens to hand in any photos they had taken in order to create some formal record of the beginning of the war. Newspapers such as *Le Miroir, J'ai Vu, Sur le Vif, Sur le Front,* and *L'Excelsior* also valued these pictures: "*Le Miroir* will pay any price for photographic documents relating to the war and presenting a particular interest." Thousands of photographs were collected and put into books labeled by author. For the soldiers, this meant recording their memories, their days at the camp, the field kitchens, cannons not in use, the faces of their companions, card games, and unplanned events. During attacks and bombings, there were some photographers who risked their lives, as Henri Lafeuille recounts. "With the camera just above the parapets, with an eye to the viewfinder, the fast and fatal bullet shot by the enemy lay to rest more than one imprudent soldier in the trenches." Sometimes film was taken from the dead bodies. "I stole a great picture depicting one of the most moving parts of the battlefield of September 1914," the nurse Andrée Kahn noted.

Léon Gimpel, *The Celebration of Flags (114th Infantry)* (Paris, July 14, 1917). Autochrome plate, 3.5 x 5 inches (9 x 12 cm)

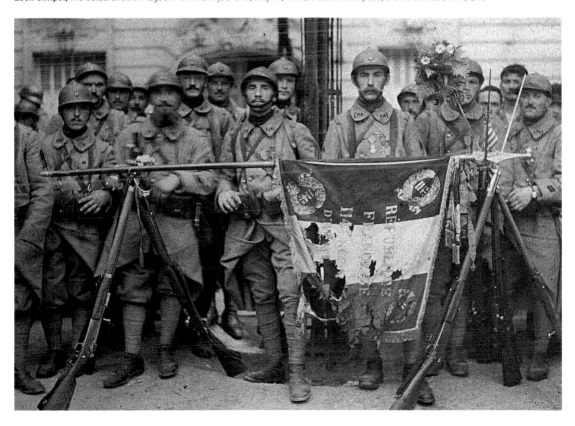

18: NEW VISIONS

⊠ FUTURISM AND VORTICISM: NEW DIRECTIONS

The avant-gardes of the early twentieth century shared a common desire to upset both the traditional order and the established aesthetic canons. It was therefore natural that photography, a young and still illegitimate art on the fringes of the fine arts world, would be a very attractive technique to these artists. In the midst of the utopia of the "blank slate" beloved of futurism (founded in 1909) and the glorification of dynamic forces common to futurism and vorticism (which appeared around 1914), photography was recognized as a new language in direct contact with life and modern issues.

FUTURISM AND PHOTOGRAPHY: A RELIGION OF SPEED

For the poet Filippo Tommaso Marinetti, futurism was "a continual effort to go beyond the laws of art and art itself through something unexpected, which we could term life-art-ephemeral." Under Marinetti's guidance, photography was recruited to serve this new religion of speed. Starting with its *Manifesto of Futurist Painting* (1910), the Italian futurist movement embraced Muybridge's late nineteenth-century photographic work on the decomposition of movement.

The futurist painters also found a model in Étienne Jules Marey's chronophotography, which came from outside the old art world and the traditional canon of the representation of movement. This new model was in keeping with the futurist search for a new dynamism and a new,

expression, Marinetti enrolled photographers in his movement. In 1911, the Bragaglia brothers (Anton Giulio and Arturo) started experimenting with photodynamism. In contrast to Marey, whose approach they considered overly rigid and scientific, they used a more fluid and spontaneous method, inspired by spiritualist photography, which resulted in a dematerialization of shapes in motion. They exhibited the results in *The Photography of Motion* (1913) and in *Fotodinamismo Futurista* before being excluded from the movement in mid-1913.

VORTICISM AND PHOTOGRAPHY: THE CONCENTRATION OF ENERGY

As this first wave of futurism was dying out, the British journal *Blast* was just being created. *Blast* was the mouthpiece of vorticism, a movement started by various artists (the writer Ezra Pound, the sculptor Henri Gaudier-Brzeska, the painter Wyndham Lewis). The basis of the vorticist movement was a set of ideas spiritually akin to Italian futurism: the two shared a similar idea of dynamism (the vortex is the point of highest concentration of energy), the same fascination with the machine, an equal rejection of tradition (for the vorticists, represented by Victorian England), and the same glorification of a modern urban world and of war. Vorticism attracted those British pictorialists, chiefly Malcolm Arbuthnot and Alvin Langdon Coburn, interested in the direct photographic vocabulary developed in America (notably in Stieglitz's work). In the spirit of experimentation, in 1916 Coburn built a successful system for photography without a lens. Captured with a basic black box outfitted with mirrors, the images were similar to kaleidoscopic drawings and cubist experiments, and they posed serious questions about the nature of representation. Some of these pictures were published in *Blast*. Certain images, such as *Portrait of Ezra Pound,* were still recognizable as portraits, while others were purely abstract geometric visions. In an article entitled "The Future of Pictorial Photography," Coburn described his work in the native terms of vorticism: lauding the abandonment of any technical know-how, he extolled a free and spontaneous approach. This short (1916–1917) and radical experience should not obscure the fact that there

Alvin Langdon Coburn, *Vortograph* (1917)

For this series of photographs, Coburn put crystals inside a triangular cone lined with mirrors. This device, which he called the vortoscope, allowed him to make abstract images. He often played with light effects.

absolutely contemporary urban reality. Futurist painters Umberto Boccioni and Giacomo Balla took free inspiration from chronophotography in order to suggest a dynamic sense of vital intensity in their work. Rather than suggesting a new way of depicting movement, the futurists were more interested in creating a complete freedom of expression in opposition to any rules or restrictions. Still, it is hard to deny the influence that visual discoveries in the sciences (and the occult) had on a lot of their artwork. Along with Röntgen radiation, the futurists carefully studied the double-exposure method (a favorite of the spiritualist photographers) and Ernst Mach and Professor A. M. Worthington's work on the capture of objects in motion.

Following his desire to multiply the means of

were other avant-garde photographers (including Pierre Dubreuil, George Seeley) conducting experiments at the time. Though they explored different ideas, these artists contributed just as much to developing an abstract vocabulary for photography, one that spoke of the effects of pure light without any identifiable visual referents.

⊡ PHOTOMONTAGE AND COLLAGE: RECONSTRUCTING THE WORLD

Strictly defined, a photomontage is composed of various photographic images, or fragments of photographic images, assembled outside their initial frames of reference (that is, a montage of prints, fragmented prints, and/or direct prints from negatives). Another type of composition, more accurately called "collage," assembles diverse elements including, but not limited to, pieces of photographs. Both approaches are deeply connected to avant-garde practices and have a common lineage: on the artistic side, they are derived from the cubist practice of collage; on the more common and purely photographic side, they come from the popular and playful photo collages and montages that were widely distributed in the form of postcards and advertising through the nineteenth century up until the outbreak of World War I.

DÉTOURNEMENT: ASSEMBLY AND DISASSEMBLY

In the time between the great wars, an unprecedented vogue for both these techniques swept through artistic avant-gardes of every order (dadaism, constructivism, surrealism). According to László Moholy-Nagy, who called these practices "photoplastic," the combination of photographic elements "favors the appearance of unexpected tensions…which largely surpass the significance of the isolated elements." The press

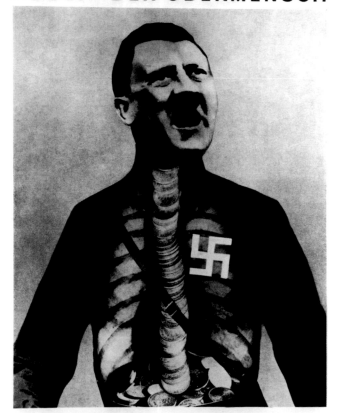

ADOLF – DER ÜBERMENSCH

SCHLUCKT GOLD UND REDET BLECH

John Heartfield, *Adolf, the Superman: "Swallows Gold but Spouts Junk"* (*Arbeiter-Illustrierte Zeitung,* no. 29, April 1932)

At the beginning of 1930, the editors of the *Arbeiter-Illustrierte Zeitung* announced to its readership the paper would include a page by Heartfield every month. Heartfield published his photomontages, but he also collaborated on the paper's design and influenced its layout.

had begun using photographic images more and more, allowing for the diversion (*détournement*) of meaning and for the assembly and disassembly of images. At the same time, the freedom that photomontage conferred made it the ideal instrument for these artistic revolutions and for the construction of a new world and a new language. The mainstream press quickly adopted these photographic experiments, which also featured in the most modernist examples of the era's advertising.

Dada was the first of the great avant-garde movements of the early twentieth century to use the photomontage—to the point that, along with the collage, it became the movement's favorite mode of expression. In Germany, it frequently had a political connotation and an undeniable tone of antibourgeois or antiliberal violence. Photomontage was practiced in Hannover by Kurt Schwitters, whose entire protean body of work is mainly associated with accomblage, collage, and, occasionally, photography. But it belonged in particular to Berlin, the home of Hannah Hoch, Raoul Hausmann, Johannes Baader, and John Heartfield. The Berlin artists used the technique most intensely, frequently producing very complex photomontages. Using sources such as illustrated newspapers, they played with accumulation, saturation, and the multiplication of points of view to achieve a formal rupture in line with their desire to denounce the political and social order.

PHOTOMONTAGE: A MEANS FOR POLITICAL PROTEST

Of all the dadaists, John Heartfield is most closely associated with the photomontage, his exclusive means of artistic expression. After dada, his work became even more overtly political. In the thirties, Heartfield, who had been a member of the Communist party since 1919, devoted his talent to the antifascist cause. He worked for the *Arbeiter-Illustrierte Zeitung* from 1930 to 1935; the more he became involved in creating posters and covers for papers and journals, the more stripped down and immediately decipherable his style became.

Heartfield was not alone; the photomontage technique extended far beyond the dada sphere. Constructivists (El Lissitzky, Alexander Rodchenko) took it in various, even opposite, directions, but all approaches carried a utopian dimension. Photo-

montage and photocollage artists were participating in the creation of a new world, whether it was through the socialist propaganda posters of Rodchenko or the dreamlike surrealist games of Georges Hugnet (*La Septième Face du Dé* [The Seventh Side of the Die], 1935).

In the thirties, the mainstream press and the publishing world, then advertising, were quick to follow suit. By the end of the thirties, a mere twenty years after their appearance as marginal, antiestablishment forms, photomontage and photocollage had become central elements of the photographic language of the twentieth century.

⊠ LÁSZLÓ MOHOLY-NAGY: WRITING WITH LIGHT

Judging from the range and the influence of his work, László Moholy-Nagy was undoubtedly the most important figure in the New Vision movement, which took place in Europe between the world wars. The beginning of Moholy-Nagy's life is reminiscent of the early days of his compatriot and near contemporary André Kertész. Born in Hungary in 1895 (in Bacsborsod), he left school at the outbreak of World War I, served as an artillery officer in the Austro-Hungarian army, and was wounded on the Russian front.

After the end of the war and the failure of the Hungarian revolution, he chose to give up his studies and pursue painting. He left Budapest in 1919 for Vienna and, the following year, Berlin. It was in Berlin that he

began associating with avant-garde movements close to dada circles (and artists such as Schwitters, Hoch, and Hausmann) while representing the Hungarian avant-garde group *Ma* (Today) and maintaining close ties with the *De Stijl* movement led by Theo van Doesburg.

Moholy-Nagy remained in this central position, at the crossroads of various movements, for his entire life. Between 1922 and 1925, he regularly exhibited paintings at the Der Sturm gallery. He also showed reliefs and sculptures, a sign of the wide range of his interests, which would grow to include film, typography, and photography.

LIGHT, THE EXPRESSION OF MODERNITY

Moholy-Nagy did not develop his interest in photography until 1922, and when he did it was via the photogram, a technique that took photographs without a camera by recording an imprint of objects placed on a sensitive emulsion then exposing it to light. Though he discovered this technique shortly after Christian Schad and at about the same time as Man Ray, Moholy-Nagy took a very different, more ethereal approach to it. His photograms were based on the play of light rather than the imprint of actual objects. For over twenty years, this technique would constitute the basis of his photographic practice. For Moholy-Nagy, the photogram represented the essence of photography: an authentic "writing with light," the most modern means of expression of its era, in which light played a primordial part. Throughout his life, and no matter the techniques used, light remained at the heart of Moholy-Nagy's experiments. His greatest dream was to open an

"Academy of Light," an entire school dedicated to the study of light.

This writing with light seen in the photograms represents only one aspect, though one of the most poetic, of his experiments. It should be put in context with the other part of his work, the most rational, which consisted of the glorification of the engineer and the mechanical age. There are echoes of this side of Moholy-Nagy's interests in the photographs he took with a camera, notably in his architectural shots, including the Loading Bridge series taken in Marseille in 1929.

THEORIST AND PROFESSOR

Moholy-Nagy was more than a multitalented, ever-changing artist whose work had a profound impact on his contemporaries. He was also a great theorist with numerous interests: photography in all its aspects, of course, but also film, painting, advertising, typography, social issues, media, and design. *Malerei Fotografie Film* (Painting Photography Film), published in 1925, remains his most famous book. It is here that he exposed his conception of photography as the "shaping of light" through three main branches: photography without a camera (the photogram), shots taken with a camera, and "photoplastic," a term he invented to describe techniques such as photomontage and photocollage.

Teaching played a significant part in the considerable influence Moholy-Nagy had over several generations that followed him. Invited to the Bauhaus by Walter Gropius in 1923 as a replacement for Johannes Itten, Moholy-Nagy left after just five years due to what he considered an overwhelming pro-Communist political influence coming from the group surrounding Hannes Meyer. He moved to Berlin, to Amsterdam in 1934, then London, and, finally, in 1937, to the United

László Moholy-Nagy, *Portrait of Lucia Moholy* (n.d.)

From 1923 to 1928, Moholy-Nagy was at the Weimar Bauhaus. He was the head of the metal workshop and replaced Johannes Itten as teacher of the introductory course. It was here that he and his wife, Lucia, began to experiment with photography. For most of his portraits, he used the kind of extreme close-up that had recently been discovered in cinema. The direction of the light gives the impression that the head is masked.

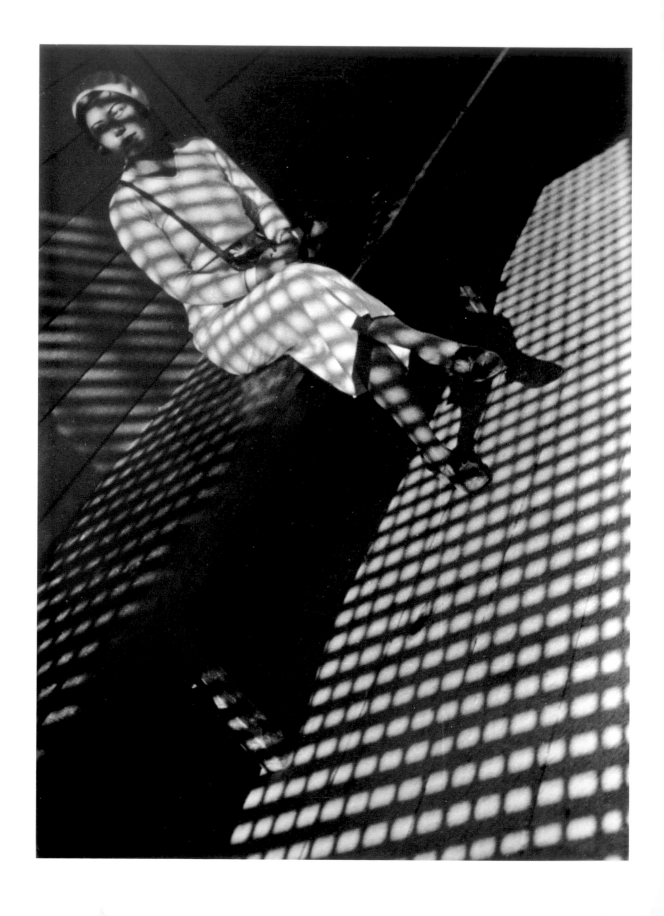

States, where he returned to teaching at the head of the New Bauhaus in Chicago. In 1939, he started his own school, the Chicago School of Design, which he directed until his death in 1946. Along with Gropius and Ludwig Mies van der Rohe, his Bauhaus colleagues, he led the generation of exiled Germans that had a profound influence on postwar American art and allowed for the dissemination of European avant-garde ideas in the United States. In 1947, less than a year after his death, a large posthumous retrospective was dedicated to his work and was circulated around the United States.

⊡ EL LISSITZKY AND ALEXANDER RODCHENKO: THE FREEDOM OF THE EYE

Most prominent among the many Russian avant-garde artists who made use of photography are El Lissitzky and Alexander Rodchenko, who are also linked by parallel career paths and similar conceptions of the role to be played by photography.

PARALLEL PATHS

In the 1920s, after having practiced various techniques—painting, sculpture—El Lissitzky and Alexander Rodchenko switched to photography by associating it with two of the early twentieth century's most important means of distribution: books and posters. Like Moholy-Nagy, the two artists shared a progressive conception of the history of art, influenced by the ideas then being discussed in Russian constructivist circles. Deposing

easel painting, the new technological arts—with film and photography at the forefront—played an essential part in the advent of a new vocabulary and of new artistic practices that were appropriate to a technical, even machine-driven, society.

Lissitzky and Rodchenko both taught in the new Bolshevik academic structures created after the revolution. On Marc Chagall's invitation, Lissitzky joined the People's Art School in Vitebsk in 1919; in 1920, he was at Inkhuk (the Moscow Institute of Artistic Culture), as was Rodchenko from 1920 to 1924. Both artists taught at the Vkhuthemas (Higher State Artistic and Technical Workshops); Lissitzky in 1921 and off and on until 1930, and Rodchenko from 1920 to 1930.

TWO INVENTORS OF MODERNITY

El Lissitzky, whose real name was Lazar Markovich Lisilskii, was born in the Russian province of Smolensk. He earned a degree in engineering and architecture from the University of Riga after having completed a portion of his studies in Germany, at the Technische Hochschule in Darmstadt. In fact, it was in Russia and Germany that his influence was most strongly felt in the years following World War I.

Close to dada circles in Germany—in 1922 he participated in the dada congress in Weimar—El Lissitzky came to photography via dadaist photomontage. Influenced by the abstract or nonobjective experiments of constructivist circles, he attempted to transpose this vocabulary (of transparency and superimpositions) to photomontage, which he helped rationalize by making it both more legible and more geometric. He took a few photographs himself, but his use of photography was most groundbreaking in the fields of book publishing and curating exhibitions—he was responsible for the Soviet room of the "Film und Foto" exhibition. His attempts to transform "the architecture of the book," a dynamic and mobile medium for the future, were primarily associated with an intensive use of photography in conjunction with typography.

Though he was as multidisciplinary an artist as El Lissitzky, Rodchenko gave photography a more central place in his work. Born in St. Petersburg, he studied at the secondary school of the arts in Kazan, then in Moscow at the Stroganov art

p. 70:
Alexander Rodchenko, *Young Girl with Leica* (1934)

The light that passes through the gate structures the whole photograph, bringing out the spectacular diagonal even more. As a result, the entire image seems to topple over.

school, where he met Vladimir Tatlin and Kazimir Malevitch. From 1919 to 1922, he participated in an informal group of young avant-garde artists called Obmokhu.

In 1922 and 1923, Rodchenko tried to transpose to photomontage the formal experiments that for the past seven or eight years had led him to promote an abstract, nonobjective art. A close friend of Vladimir Mayakovsky, he contributed to the poet's *LEF,* an avant-garde journal, and illustrated one of Mayakovsky's poetry collections with his photomontages (*Pro Eto,* 1923). In his work for Mayakovsky, Rodchenko attempted to give a visual equivalent of free verse.

In 1924, he began to take his own photographs. Contrary to El Lissitzky, whose actual photographic work remained relatively limited, Rodchenko started in 1926 to make photography his primary medium. He attempted to implement a new vocabulary, influenced by the cinematic experiments of his contemporary Dziga Vertov (with high-angle and low-angle shots, and superimpositions). In 1927, in Moscow, Rodchenko exhibited his photographs for the first time. Three years later, he became the head of the photography department of the avant-garde October group. During those years, Rodchenko's means of expression moved closer to photoreportage, which he practiced for numerous newspapers and which was the subject of many of his articles and conferences.

In 1933, a law subjecting the practice of photography in Moscow to authorizations limited Rodchenko's activities and the subjects he addressed; parades, athletic events, circuses, and personal portraits became his principal themes. Nonetheless, he continued to hold an important place in the major Soviet photo exhibitions organized by the authorities, and he worked in collaboration with his wife, the artist Varvara Stepanova, until his death.

◉ NEW VISION: THE BEAUTY OF THE OBJECT

The New Objectivity movement, which sprang up in Germany during the 1920s as a reaction to postwar expressionism, is characterized by a desire for objectivity and a cold and precise representation of reality. Initiated with painting and drawing, the movement quickly spread to architecture, music, and literature. By the end of the twenties, photographers such as Albert Renger-Patzsch, Karl Blossfeldt, and Willy Zielke had found a new means of expression in the New Objectivity and appropriated it. They joined together in the New Vision, which quickly became an international movement.

TO LOOK AT THE WORLD AND ITS OBJECTS

For the photographers of this New Vision, a photograph had to represent the exact reality of the world and its objects; they claimed as their motto Renger-Patzsch's statement that "only photography can render the rigorous structures of modern technique through images.... The absolutely true rendering of forms makes it superior to the other means of expression, and the sharpness of the gradation of tones, from the most brilliant light to the depths of the darkest shadow, gives the technically mastered photograph the magical charm of the real life event."

The New Vision photographers preferred everyday subjects that were often small, banal, even trivial. They magnified these objects by enlarging them with the angle of the shot, unusual viewpoints, extreme close-ups, unexpected diagonals, or subtle lighting. The rendering of matter became the true object of research and experimentation, and the insignificant took on a new aestheticism in simple pictures of feathers and satin (Emmanuel Sougez), in a close-up of a comb with a few hairs on it (François Kollar) or of an ordinary ball bearing (Renger-Patzsch). The accumulation or multiplication of objects, and

sometimes even of people, gave them a new presence, another dimension, as can be seen in Sougez's pictures of a pile of dishtowels, René Zuber's reels, or Kollar's propellers. Published in the press, these photos also put industrial production into the spotlight, the assembly line and the proliferation imposed by the new mass society.

This type of photography, which oscillated between an objective rendering and a kind of aestheticism, took on its full meaning when used for advertising or propaganda. Beneath the stated purpose of showing or seeing different things and thus underlining their potentially unexpected aesthetic aspects, there was a desire to modify the spectator's way of looking, a sort of didacticism that attempted to change the world by changing the way it was looked at.

MIRROR EFFECTS, ABSTRACTION, ACCUMULATION

In France, Florence Henri was the best representative of this new way of looking at space and the object. She had discovered photography at the Bauhaus art school under the tutelage of Moholy-Nagy and had studied shapes, rhythms, and tones by using objects and mirrors. The objects she photographed only interested her for their graphic and formal qualities. Her photos were plays on black and gray, on repetitions and reflections of simple shapes in still lifes that were powerfully elaborate and geometric, probably owing to Henri's informed observation of cubism. When she could, she used her discoveries within her personal advertising work in compositions that were both rigorous and effective, such as her photograph for Lanvin perfumes.

For his part, Emmanuel Sougez was fascinated by the photographic rendering of matter. Glass, fabric, flowers, and minerals were examined and photographed with an attention that bordered on the obsessive. His photographs were the fruit of research based on classic pictorial culture, not surprising given that Sougez had given up painting for photography. He was particularly attentive to lighting, to the alternation of light and shadow that created rhythms and revealed or softened the qualities of the material. Uncompromising when it came to the quality of his work, Sougez worked with a technical camera and printed highly detailed 12 x 16–inch negatives.

Mirror effects, infinite repetitions, plays on rhythm, even screening effects were used as elements that were both essential and representative of modernity or as the basis of a social or political position. Beginning in the middle of the thirties, a more illustrative reaction to this admittedly sterile conception of photography began to grow throughout Europe. After World War II, this illustrative movement established itself and permanently swept away the remains of the New Vision.

Emmanuel Sougez, *Glasses* (n.d.)

Director of the photography department at *L'Illustration* from 1926 until World War II, Sougez was very influential in the photography world. In the 1930s, he founded *Rectangle* to organize exhibitions, and he helped found the Groupe des XV.

◉ "FILM UND FOTO," A LANDMARK IN THE HISTORY OF PHOTOGRAPHY

Though journals and books were the era's primary medium for the circulation of the new photography, the period between the two world wars also witnessed an increasing number of photo exhibitions. Of these, the "Film und Foto" exhibition—organized in Stuttgart in 1929 and frequently called by its nickname, Fifo—was incontestably the most significant in terms of scope, diversity, and geographic range. (A reduced version of the exhibition was in circulation until 1931 and traveled to Munich, Danzig, Berlin, Vienna, Zurich, Tokyo, and Osaka.)

The exhibition fell directly in line with the work of Moholy-Nagy (who also organized some of its sections), and included contributions from the major figures of the new photography. The presentation was prepared by Dutch graphic artist Jan Tschichold, and the national selections were made by foreign photographers such as El Lissitzky for the USSR, Man Ray for France, and Edward Weston and Edward Steichen for the United States. The exhibition was both a display of power—the power of a movement that had gained an international dimension—and a final assessment of the era of boundless experimentation that had started at the beginning of the twenties and was now coming to a close.

PORTRAYING THE NEW REALITY: CONSTANTLY CHANGING, RESOLUTELY MODERN

Dedicated to photography and film, the Fifo exhibition opened with the acknowledgement of a double debt, first toward a certain documentary tradition, as clearly embodied by Atget in the Historical section, and, second, toward objective contemporary photographic practices outside the realm of fine art (astronomic photography, X-ray photography). The exhibition also attempted to account for every aspect of the new photographers' research, no matter the field it was applied to: experimental research, photoreportage, advertising, sports, or fashion. The German photographers were the greatest in numbers, but American, French, Soviet, and Dutch groups were also included. Every trend in the new photography was represented, from the most experimental (El Lissitzky) to the most classic (Kertész), from the most ideologically committed (Heartfield) to the most apolitical (Man Ray), from the purest (Weston, Charles Sheeler) to the most fabricated (Schwitters, Herbert Bayer). As for Moholy-Nagy, his central position was made evident by the fact that he was given an entire room in which to display about a hundred of his photos.

Heavily inspired by Moholy-Nagy's *Malerei Fotografie Film* (Painting Photography Film, 1925), the catalogue's introductory text made an attempt to define the shared aspects of this highly heterogeneous selection of works, but it remained very general. Perhaps what was needed in the quest for a common denominator among all these photographers gathered under one banner was not so much a question of style or practical approach but of state of mind: every one of these photographers shared the desire to use new creative tools to produce a different portrayal of a modern reality that was constantly changing, no matter the scope of the work, or the field to which it was applied.

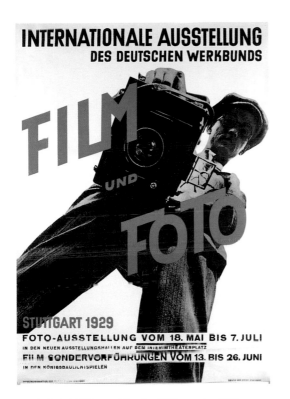

Jan Tschichold, "Film und Foto" exhibition poster, 1929.
Lithograph, 33 x 23 inches (83.8 x 58.6 cm). Photograph by
Willi Ruge

Foto-Auge, front cover (1929)
Foto-Auge, (Photo Eye) is a book by Franz Roh and Jan Tschichold
The cover of this publication, which was realeased following the
"Film und Foto" exhibition, was based on El Lissitzky's most
famous photomontage, *The Constructor*, created five years earlier.

AN IMPORTANT STEP FOR PHOTOGRAPHY

History has remembered Fifo as an essential step
in the process of legitimizing the objective photog-
raphy of the 1920s avant-garde. In fact, Fifo was
the subject of burning debate, on both the aes-
thetic and the political level: the most conserva-
tive critics protested this evolution toward a
collective, even collectivist, art that intended to
completely eclipse the individuality of the oper-
ator. On the opposite side, the most progressive
critics rejoiced over the appearance of photog-
raphy, a great anonymous art form that was both
popular and mechanical and represented the
death of the old system of fine arts.

Of course, Fifo was not the first of the great
photo exhibitions organized in Germany. "Neue
Wege der Photographie" (Iena, 1928), and
"Photographie der Gegenwart" (Essen, 1929),
which were organized around the same time,
clearly indicated that Fifo was part of a group
dynamic. However, no other exhibition was as
influential as Fifo, particularly due to the books it
directly inspired. Franz Roh and Jan Tschichold's
famous *Foto-Auge* (Photo Eye) appeared soon after
the exhibition, as did *Este kommt der Neue
Fotograf!* (Here Comes the New Photography!), by
Werner Gräff, whose iconographic choices were
obviously close to Fifo's. Fifo's influence was
visible in later exhibitions organized in Germany
("Das Lichtbild," presented in Munich, then Essen,
in 1930–1931), as well as in American shows such
as "Modern Photography at Home and Abroad"
(Albright, 1932) and "International Photog-
raphers" (Brooklyn, 1932).

19: THE NEW AMERICAN PHOTOGRAPHY

The break with pictorialism began with Edward Steichen's return to the United States in 1902 and with the publication of Frederick H. Evans's photographs in *Camera Work*, including *Wells Cathedral: Sea of Steps* (1903), which revealed the simple beauty of the architecture. In 1907, Alfred Stieglitz's photograph *The Steerage* asserted itself as a document directly connected to reality.

PAUL STRAND AND STRAIGHT PHOTOGRAPHY

Starting in 1915, Alfred Stieglitz attempted to replace any sentimentalism in photography with a pure, objective, simple reality. The last issue of *Camera Work* (June 1917) was entirely dedicated to the photographs of Paul Strand, who had made a definitive break with pictorialism. Strand was trying to convey the specificity of photography, to describe the everyday without any effects. He rejected any tampering with the negative or the print and turned his back on the type of academicism represented by pictorialism and its imitations of drawings. This approach came to be known as Straight Photography. Along with Charles Sheeler and Morton Schamberg, Strand was the best proponent of Straight Photography, and he remains the most rigorous of the group's photographers. He devoted himself to photographing the pure forms of everyday objects by placing them out of context and using tight framing to concentrate the viewer's attention. For his part, painter-photographer Sheeler took inspiration from cubism to photograph his country house. In a twentieth century dominated by the skyscraper, the automobile, and massive factories, Paul Outerbridge, Paul Strand, and Charles Sheeler wanted to account for this modernity by emphasizing in their photographs cars and other graphically bold objects. For financial reasons, they also accepted photo assignments from the industrial and advertising worlds. Sheeler produced Ford advertising campaigns that glorified factories, the new cathedrals of modern times.

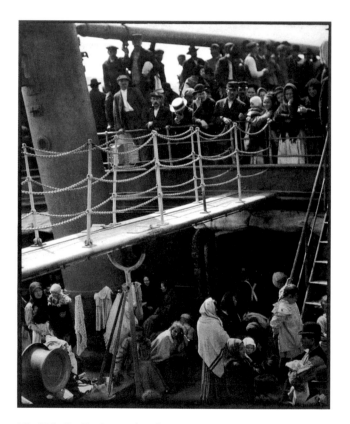

Alfred Stieglitz, *The Steerage* (1907). Published in *291* magazine, no. 7–8 (September/October 1915, New York)

In the spring of 1907, Stieglitz crossed the Atlantic on the *Kaiser Wilhelm II* on a trip to Europe. During the voyage, he went to the decks that separated the second- and third-class passengers. It was here that he caught sight of the white boater hat of a young man leaning against the gangway and the chimney leaning left. The two-plane composition, as well as the realism of the subject, marked a turning point in the history of photography.

A MORE RESTRAINED MODERNISM

Clarence H. White's students at the school he opened in 1914 practiced a heavily restrained form of modernism, and their cityscapes still carried traces of the pictorialist atmosphere. Nonetheless, students such as Outerbridge, Anton Bruehl, and Margaret Bourke-White would eventually distinguish themselves to the point of becoming the great photographers of skyscrapers and the invasive advertising of American modernity. Inspired by cubism, they even managed to capture something of the zeitgeist in commercial assignments such as Paul Outerbridge's *Saltine Box*

(1922). Margaret Bourke-White specialized in majestic representations of industrial constructions, emblems of American power such as the Ford Peck Dam in Montana, her photograph of which was featured on the cover of the first issue of *Life* in 1936. Another of Clarence H. White's students, Ralph Steiner, searched for an exaggerated graphic sense through his photography. As for Berenice Abbott and Walker Evans, they spent time in Europe and returned enriched by the old continent's modern vision.

EDWARD WESTON AND GROUP F/64

The West Coast photographer Edward Weston made a rapid transition from the artistic blurriness of pictorialism to clearer and more precise forms. Like Paul Strand, he was interested in recording objects that so far had not drawn photographers' attention. Weston was a master of the photographic print, who was able to show the perfection of the shapes he shot, whether seashells or nudes, through his control of the silver print's gray scale. In 1923, he settled in Mexico with his Italian companion, Tina Modotti, and inspired her to take up photography, notably of geometric shapes and figures. Back in California in 1927, Weston took close-up shots of the iridescent twists and turns of seashells.

Imogen Cunningham was interested in the still life, in plants and in flowers, which she photographed with extreme precision in order to reveal their secret forms in all their sensuality and complexity.

In 1932, Ansel Adams and several other photographers, including Weston, founded Group f/64, named after the minimal aperture opening of a camera, which allowed for perfectly sharp images with great depth of field. Adams devoted nearly all his work to photographing the spectacular and wild landscapes of American national parks. At the end of the thirties, American photography was to renounce the beauty of forms in order to devote itself to reportage.

Paul Strand, *Abstraction: Porch Shadows* (*Camera Work,* June 1917)

In the fall of 1915, Paul Strand visited Stieglitz's gallery at 291 Fifth Avenue. The young photographer remembers how Stieglitz welcomed him: "You've done something new in photography and I want to show it." The first Paul Strand exhibition did indeed take place in March of the following year.

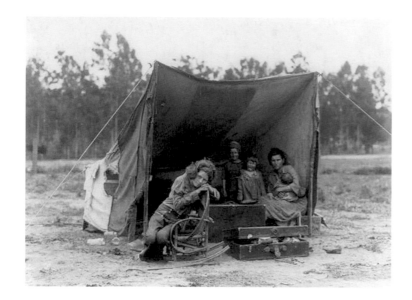

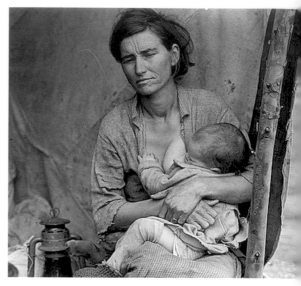

19: THE NEW AMERICAN PHOTOGRAPHY

FARM SECURITY ADMINISTRATION (FSA)

After the stock market crash of 1929, the United States experienced an unprecedented economic crisis, which led to the bankruptcy of a significant part of American industry and agriculture. In 1933, U.S. President Franklin D. Roosevelt implemented an economic recovery plan called the New Deal. The Farm Security Administration was created to work toward the recovery of the agricultural sector. In 1935, R. G. Tugwell, the undersecretary of agriculture, asked sociologist Roy Stryker to hire a team of photographers to make a photographic assessment of the situation of American farmers.

The photographers chosen had diverse backgrounds. They included the illustrator Ben Shahn, the scientific photographer Arthur Rothstein, and the photojournalists Carl Mydans and Walker Evans. They were joined by two women, Dorothea Lange and Marion Post Wolcott, and, at the end of the thirties, by Jack Delano, Russell Lee, and Gordon Parks. From 1935 to 1942, about a dozen of these photographers traveled throughout the United States and created a photo archive consisting of 270,000 photographs, two thirds of which are now kept at the Library of Congress in Washington, D.C.

In order to stir public opinion and convince the public to support the government's actions, these photographers were asked to document the extreme poverty that Americans were experiencing throughout the country. Many of them took portraits of men and women at work, of farmers and cotton pickers in the fields, while underlining the dignity of these people who had been crushed by fate. Other photographers showed the countryside, traditional or modern architecture, and the interiors of homes that were poor but always well maintained. Though the situation of these ruined farmers and homeless sharecroppers was terrible and often desperate, and though most of them lived in sordid and degrading conditions, the FSA photographers all produced a dignified image of poverty, as if they had been bound to do so by a moral contract with the government that had ordered this vast photographic campaign. Yet these excellent pictures, which were distributed throughout the press, then widely published and exhibited, achieved their goal. They remain an exceptional account of a moment in the history of the United States but also in the history of photography.

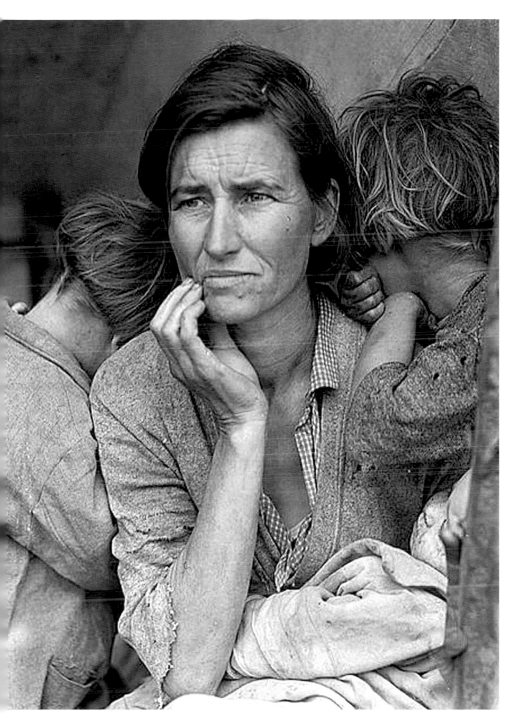

Dorothea Lange, *Migrant Mother*
(Nipomo, California, 1936)

In a conversation with Roy Stryker, Dorothea Lange told how she photographed this young mother and her children. "I made five exposures, working closer and closer from the same direction. I did not ask her name or her history. She told me her age, that she was thirty-two. She said that they had been living on frozen vegetables from the surrounding fields and birds that the children killed. There she sat in that lean-to tent with her children huddled around her, and seemed to know that my pictures might help her, and so she helped me."

The long and bitter winter had just come to an end. Dorothea Lange had been working for the FSA since 1935. When she arrived in the pea pickers' encampment in March 1936, she found 2,500 workers and their families, all trying to find food to sustain themselves. The young woman Lange noticed with her children was called Florence Thompson and, like all the other migrant workers, she was hoping to find work. She had seven kids to feed. Without looking for a spectacular composition, Dorothea Lange approached the family and stepped closer with each exposure, as if she was entering the ramshackle lean-to the family used for shelter, while the children got progressively closer to their mother, to the point that they were eventually huddled around her. The mother's wrinkled brow, thin tight lips, and worried gaze expressed the anguish and suffering of an entire people.

Two of these photographs were published on March 6, 1936, in the San Francisco News. The reaction was immediate: the federal government sent supplies to the area. Published several times over and shown throughout the world, Migrant Mother has become one of the most famous "icons" of the twentieth century.

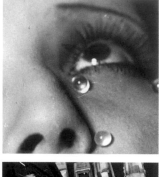

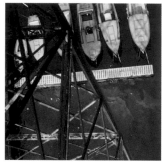

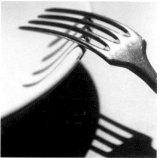

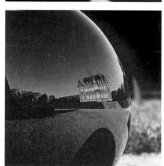

SCHOOL OF PARIS

MAN RAY

ELI LOTAR

GERMAINE KRULL

ANDRÉ KERTÉSZ

ANDRÉ STEINER

FRANÇOIS KOLLAR

ILSE BING

BRASSAÏ

JEAN MORAL

YVONNE CHEVALIER

DANIEL MASCLET

RAOUL UBAC

EMMANUEL SOUGEZ

ETC.

20: PARIS, CAPITAL OF THE NEW PHOTOGRAPHY

At the beginning of the twenties, Paris was the capital of the artistic avant-garde; ten years later, the City of Light would prove to be the capital of the new photography. The appeal of modernity and the constant stream of refugees coming to France for political or economic reasons gave Paris its cosmopolitan character. Man Ray, the American, Germaine Krull from Germany, Rumanian Eli Lotar and the Hungarians André Kertész, André Steiner, François Kollar, and Brassaï all started fresh in Paris and joined the French photographers Jean Moral, Yvonne Chevalier, Daniel Masclet, and Emmanuel Sougez as the main players in the School of Paris.

Florence Henri, *Self-Portrait Composition* (n.d.)

In both her daily life and work, Florence Henri represented the modern trend in photography that thrived in Paris in the 1930s. As a known portraitist, she experimented with her self-portrait, subtly playing with the mirrors in the middle of the composition.

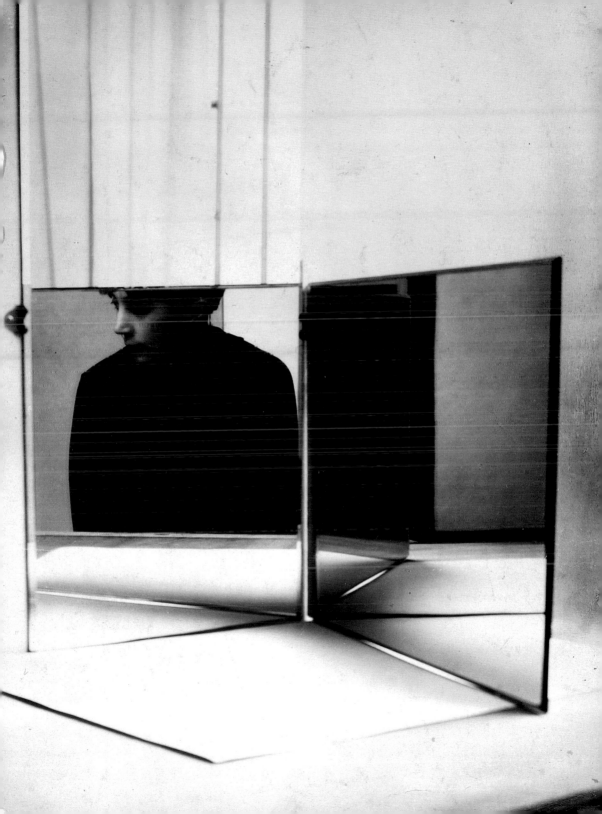

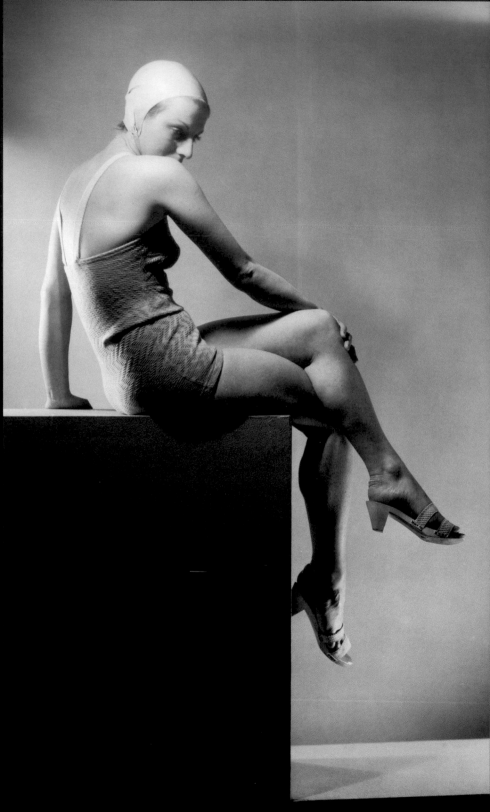

DISCOVERING THE WORLD

These photographers grappled with the world by photographing it in a brand-new way: in extreme close-ups; shaken up by unusual compositions (Germaine Krull); in aerial photography (Pierre Ichac); rendered unidentifiable by deformations (André Kertész); or with low-angle and high-angle shots (André Steiner). They tightened the frame, accumulated objects, and, in the darkroom, practiced the photogram technique (Man Ray, Jacques-André Boiffard), negative and positive copies (Maurice Tabard), photomontage (Roger Parry, Pierre Boucher), solarization (Man Ray, Maurice Tabard, Raoul Ubac), and even the combination of photography and drawing (Boucher). For them, the camera was a tool for discovering, rather than recording, but above all it was a tool for producing an objective photography.

A VERSATILE MOVEMENT

The photographers of the Paris School practiced every form of photography. Portraits were expected to be faithful, objective, and tightly framed, all without allowing even the slightest detail to escape the lens' gaze (Florence Henri, Jean Moral, Laure Albin-Guillot).

The male or female nude became a subject with many possibilities. The body was subjected to formal and lighting variations via fragmentation or framing. Relieved of its appendages (legs, arms, hands, and frequently the face), the trunk of the body was explored from every angle (Emmanuel Sougez, Ergy Landau). Through the powerful play of contrasts and obscurity, light and shadow reinforced this fragmentation, this way of recreating and remodeling the body (Dora Maar). Sports photography offered spectacular shots: a diver caught in full flight, a low-angle shot of a jumper, and superbly fit bodies bursting with energy (André Steiner, Jean Roubier).

Modern architecture was a favorite subject as well for these photographers. By giving up on the traditional frontal view, and due to their masterful balance of light and shadow, they placed the emphasis on shapes. Playing with distortion by taking high-angle or low-angle shots, they abandoned the parallel structure of architectural forms in favor of vast curves that seemed to topple space, thereby emphasizing both the new formal vocabulary of photography and the specific characteristics of the new architecture and of industrial architecture (Roger Schall).

In 1929, many of the photographers of the Paris School were prominently displayed in the "Film und Foto" (Fifo) exhibition in Stuttgart. The movement was crippled by the advent of World War II, when most of the foreign photographers were reluctantly forced to leave France for the United States.

FEMALE PHOTOGRAPHERS IN PARIS

By the 1920s, many women were discovering that photography was an appropriate medium for expressing their creativity, as well as their feelings and personal beliefs (Dora Maar, Germaine Krull, Laure Albin-Guillot, Claude Cahun). Some opened photo studios (Dora Maar, Yvonne Chevalier, Ergy Landau), some became eternal wanderers or photojournalists (Gisèle Freund, Juliette Lasserre), and others opened their own photo schools (Gertrude Fehr, with Publiphot). They were all able to explore the new possibilities offered by photography: experimental work (Laure Albin-Guillot, Florence Henri, Claude Cahun), portraits (Germaine Krull, Berenice Abbott, Rogi-André), male and female nudes (Ergy Landau, Nora Dumas, Laure Albin-Guillot), still life and advertising (Florence Henri), and, of course, reportage (Lisette Model, Germaine Krull). Between 1920 and 1940, these women photographers contributed to the strengths of the photographic new vision. They were able to assert themselves through the quality of their sensitive, intuitive, and generous work.

Laure Albin-Guillot, *Bathing Suit* (1937). Paper darkened in the development process

AUGUST SANDER
(1876–1964)

Born in Herdorf, Germany, August Sander began working in his father's mine at the age of fourteen. It was at this time that he discovered photography. He established a small studio for his first jobs as a photographer. After completing his military service, he studied painting in Dresden, and in 1904 he moved to Linz, in Austria, where he founded the August Sander art and painting studio. Returning to Germany in 1910, he opened a new photography studio in Cologne. After fighting in World War I, he stopped producing pictorialist images, preferring a more objective and descriptive style. It was at the beginning of the 1920s that he first conceived his grand scheme of photographing all of German society. The first survey was published in 1929, in *Antlitz der Zeit* (Face of Our Time), and included a preface by Alfred Döblin. In 1934, Sander's son Erich, who took a militant stance against the Nazis, was imprisoned. Two years later, the Nazis denounced Sander's vision of the

August Sander, *Young Farmers* (Westerwald, 1913)

One of the most famous portraits in the history of photography is this portrait of three young peasants heading to a ball in their dark suits. A few details reveal the personality of each man. The one on the left is casual and coarse, with a cigarette in his mouth and a hat that sits back slightly on his head. The relaxed grip of his cane and his eyes say all that the pose does. The others are more strict and have a certain elegance. The three stand confidently in the surrounding country landscape that is their own.

August Sander, *Hod Carrier* (Cologne, 1928)

This young laborer in the category of "worker" holds bricks on his shoulders with his left hand. One wonders if Sander asked this young mason to place his right hand on his hip or if the young man found this formal balance of triangles formed by his arms on his own. In any case, this photograph is solid and well composed, from the skilled piling of bricks to the rooted stance of the rough and severe man.

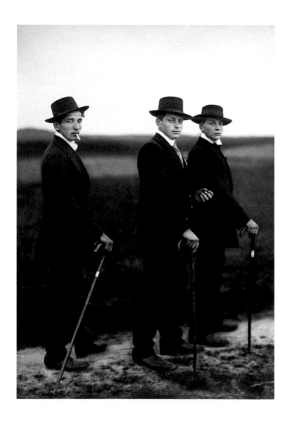

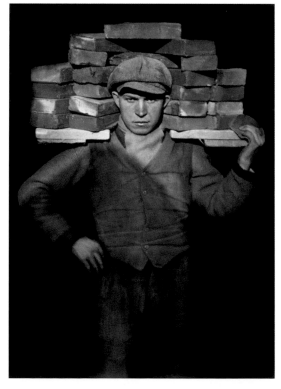

Germans, banning his book and destroying all copies. The photographer then turned to landscapes. In a fire that ravaged his studio in 1944, he lost all of his 40,000 negatives. When Steichen went to Germany to select photographs for "The Family of Man" exhibition, he chose forty-five portraits from Sander's personal archives. Sander died before completing his life's work, an encyclopedia of the German nation, which he divided into seven major categories: workers, peasants, trades, professions, intellectuals, artists, and the unemployed. Sander photographed his subjects at their workplace, with their daily tools and instruments, or in an environment that matched their social situation. From today's perspective, the "scientific" intention is touching.

People of the Twentieth Century was only published in 1980. At the turn of the twenty-first century, the seven-volume, 1,436-page *People of the Twentieth Century*, new edition, was published, finally presenting all the photographs Sander had taken for his ambitious and gigantic project.

August Sander, *Gypsy* (1930)

Traveling performers and gypsies would all be exterminated by the Nazi regime. Like Jews, they met their doom under Hitler's Final Solution just ten years after Sander took this picture.

WALKER EVANS
(1903–1975)

Born into a middle-class family in St. Louis, Missouri, Walker Evans moved to Paris after college in the hopes of becoming a writer. In France, he was part of the art milieu and read French writers. Flaubert's search for objectivity and Baudelaire's spiritual fervor would always be an influence on him.

It was not until he returned to the United States that he turned to photography, after years of working on his literary projects. He was impressed with Paul Strand's work as well as the formal studies of New Photography in Europe. Beginning in the early 1930s, his style became more simple and frontal. Laconically, he called it "documentary." Henceforth, Evans's photographic work oscillated between his commissions and personal endeavors. His principal subject was daily life during the Great Depression. Between 1936 and 1937, he worked for the Farm Security Administration, photographing farm workers in the South who had been devastated by the economic climate. In 1941, he and writer James Agee published a book of photographs and essays called *Let Us Now Praise Famous Men*. After the war, he spent twenty years working as a photographer for *Fortune* magazine (1945–1964). Toward the end of his life, he became enthralled with the new Polaroid technique and photographed the subjects of his younger years. He died in 1975. As the first photographer to be honored with a solo show at the Museum of Modern Art (1938), Evans plays an important and paradoxical role in twentieth-century photography. Together with Atget and Sander, he represents a clear documentary tradition with the perhaps impossible goal of objectivity.

Walker Evans, *Awning* (1931).

This image was part of Evans's first major commission, to photograph the Victorian-style buildings around Boston. The series is reminiscent of Atget, both in its methodical nature and the quality of its printing. Evans chose two perspectives—three-quarter and full-front—and sought to create as clean and legible an image as possible. Whether document or work of art, this ambiguous series helped forge the "Evans style." Several of the pictures were included in the 1938 exhibition at the Museum of Modern Art, "American Photographs," as well as in the accompanying catalogue.

Walker Evans, *Signs: South Carolina* (1936).

A large part of Evans's work is marked by his interest in popular American culture and its many forms, even those that are ephemeral and modest. Signs, inscriptions, images, and objects fill many of his photographs, especially those taken during the Great Depression of the 1930s. His photographic methods also fed his habit as a collector; in his travels, Evans had the opportunity to gather common objects from popular culture. In this regard, he can also be considered an influence on American Pop art.

Walker Evans, *Subway Passengers* (1938).

Between 1938 and 1941, Evans completed his last major series before the war. He went into the New York subway and took portraits of travelers, unaware and dazed, as if to push the documentary form to its limit. The absence of visible feeling in the expressions of the subjects is combined with minimal photographic intervention. Evans put the camera on his lap and took photographs at random. The series seems to explore Evans's concerns. As "anonymous and documentary" portraits, they are faithful to the objective realism hailed by one of his great influences, Gustave Flaubert. He continued in this vein between 1941 and 1946, photographing people walking in the streets of Bridgeport, New York, and Chicago.

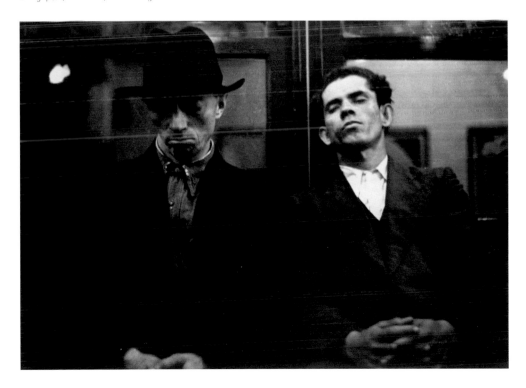

ANDRÉ KERTÉSZ
(1894–1985)

Born in Hungary, André Kertész began his career as an amateur photographer in 1912, while working for the Budapest stock exchange. He was wounded in World War I and lost a number of his negatives. Later, he published a few photographs in the press and moved to France.

In Paris, where he lived between 1925 and 1936, Kertész produced an essential part of his oeuvre. Frequenting the avant-garde circles, he began by taking several portraits of figures in the Paris art world—writers, sculptors, painters—before going to work for the press. He also worked as an independent photographer during those twelve years, publishing his photographs in most of the important newspapers and magazines of the time, in France as well as Germany and England. Kertész's publishers ran the gamut of political tone, from *Vogue* to *Rail de France,* from *Marianne* to *Regards.* He did several covers and stories for *Vu,* the magazine Lucien Vogel founded in 1928. Starting in 1933, he also printed books, including *Paris vu par André Kertész* (Paris as Seen by André Kertész), with an essay by Pierre Mac Orlan. He participated in over forty exhibitions in France and abroad, notably "Film und Foto" (1929) and "Modern European Photography" in New York (1932).

In 1936, undoubtedly because of Hitler's growing threat, Kertész left France for New York. Considered to be an "enemy alien" during the war because of his nationality, his was forbidden to publish his work. This did not change until 1944, when Kertész became an American citizen. He continued to work commercially during the 1950s—photographing for Condé Nast from 1949 to 1962—while continuing to pursue his personal work. He was celebrated in exhibitions at the Art Institute of Chicago (1946) and the Museum of Modern Art (1964). In 1984, a year before his death, he bequeathed his negatives and archives to France. Today, those are managed in Paris by the Mission du Patrimoine Photographique (Department of Photographic Heritage).

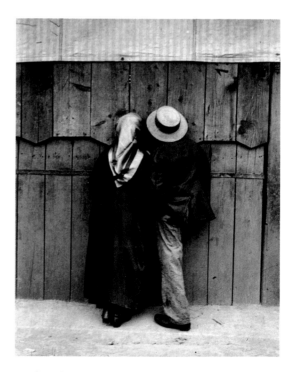

André Kertész, *The Budapest Circus* (May 19, 1920).

Chronicling daily life, Kertész took pictures the way some people might keep a personal journal. His enthusiasm for "small events" —as he would call them—surfaced early in his days in Hungary, but developed fully in Paris. In France, he was the quintessential strolling photographer who took purely composed pictures, lacking any ostentation, and often containing the formal qualities of abstract art.

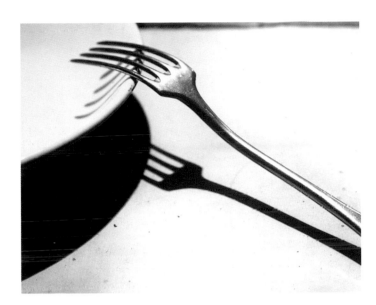

André Kertész, *The Fork* (Paris, 1928).

Kertész's photographs have a great silent quality. They ask for no discussion or anecdotal explanation. Simple and restrained, *The Fork* from 1928 perfectly expresses these qualities, which have often defined Kertész as a classic photographer. Kertész himself often considered that this image best represented his style. It was widely exhibited between the wars, notably at the "Film und Foto" exhibition in 1929. The silversmith Bruckmann used it for advertising; as such, this image is also a prime example of how personal and commercial work can overlap.

André Kertész, *Distortion No. 6* (1933).

The Distortion series consists of almost 200 photographs, including this one. This is one of Kertész's best-known images, but it is relatively atypical of his work. The result of a commission from the newspaper *Le Sourire*, which published twelve from the series in 1933 under the title *Window Looking Out to the Beyond*, these images were made with distorting mirrors. As a result, Kertész could obtain effects similar to some of the surrealist images of the time without manipulating the photograph in the slightest. Even in this work, therefore, he remained faithful to his desire to relate to the real, the basis of his photography. These fascinating images represent an important development in figurative work of the twentieth century. Similar to Picasso's nudes as well as Dalí's liquid forms, these images were to influence Bill Brandt after the war. Kertész would return to this theme in 1984, a year before his death.

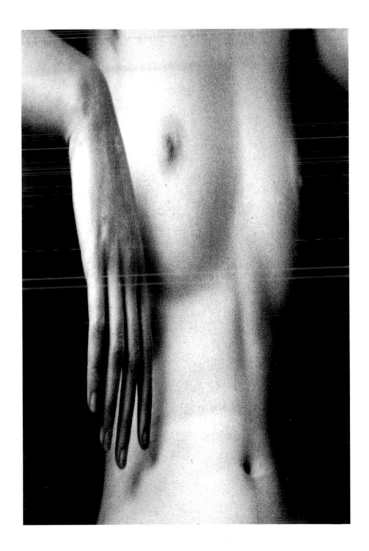

21: THE SPREAD OF THE PHOTOGRAPHIC IMAGE

PRINTED PHOTOGRAPHY

Photography is, by nature, a mode of reproduction. It was therefore natural that the photograph should find itself with a privileged place on the printed page. Invented around 1450 by Gutenberg, the printing press allowed for rapid mechanical reproduction of texts. Small books, newspapers, and brochures started to be successfully hawked in cities or peddled door-to-door in the country in the seventeenth century. Illustrations, which were an essential complement to the text, needed to be engraved on wood or brass to be printed. Later, because of the invention of lithography, or engraving on soft stone, it became possible to print in color. However, because until the early twentieth century the inking process was completely different for texts and engravings, text and pictures were printed separately.

PRINTING PHOTOGRAPHS

The invention of photography by Joseph-Nicéphore Niépce was born of this quest to reproduce pictures. Niépce's initial research led him first to the invention of a process called "photoengraving," in which a relief is created on metal that allows for the infinite and identical reproduction of an image.

From the moment photography appeared, engravers used daguerreotype plates as a medium for printing on paper. At the beginning of the 1840s, Hippolyte Fizeau perfected a technique that was used for the *Excursions daguerriennes* (Daguerreotype Journeys), published by Lerebours in 1840 and engraved from daguerreotypes. The first appearance in the press of an engraved reproduction taken directly from a daguerreotype came only in 1848, in the French periodical *L'Illustration,* and showed a barricade on rue Popincourt.

In the middle of the nineteenth century, the first photomechanical processes appeared and introduced the direct reproduction of images. In France, Charles Nègre and Édouard Denis Baldus attempted to invent their own technique; in England, William Henry Fox Talbot patented his method for "photoglyphic engraving," and Lemercier, who was a lithographer, succeeded in making photographic prints on stone around the same time. Louis-Adolphe Poitevin, the winner of the 1855 duc de Luynes Contest, perfected printing technique with his coal process, which produced intense, beautiful blacks.

In 1866, Walter Bentley Woodbury came up with a new process that allowed the near-perfect reproduction of photographs, the woodburytype (called "photoglyptie" in France, where it was marketed by the Goupil firm), which was widely used until the end of the nineteenth century. This very complex printing process required a lot of technical manipulations, but it resulted in a very faithful reproduction of top quality. Beautiful examples of the woodburytype can be found in the *Galerie contemporaine des illustrations françaises* (Contemporary Gallery of French Illustration), published in Paris by Goupil.

These first processes, no matter how efficient, did not allow for the simultaneous printing of text and image. This finally became possible in 1880, with the appearance of the halftone process. This letterpress process introduced the use of an engraving screen in relief. The invention of this screen with a grid of lines on it allowed for the reproduction of photographs by chemical means without relying on the interpretation of brass

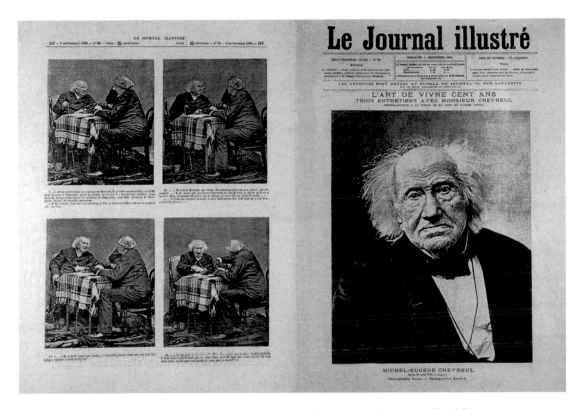

Nadar, *Nadar Interview with Mr. Chevreul, the Day of his Hundredth Birthday* (*Le Journal illustré*, September 5, 1886)

Nadar's photographic interview of Michel Eugène Chevreul, conducted for *l'Illustration* on the occasion of the chemist's 100th birthday, consisted of twenty-seven photographs taken on August 31, 1886. They were eventually published in *Le Journal Illustré*. Fascinated by science and its scholars, Nadar revived Chevreul's success by participating in the celebrations. The instant pictures taken by Ader's *photophone* helped Nadar achieve his ambitions as a photographer. The captions to the images, which Nadar wrote, are sometimes slightly whimsical.

engravers and stone draftsmen. Screening made it possible to reproduce an image down to its slightest nuance while simultaneously printing the text. By opening the world of photography to the printing press, the halftone process guaranteed itself overwhelming success. These screens would lead to the development of the offset and photogravure, two processes invented for the reproduction and printing of photographs that are still used today.

Now completely illustrated, books and the press offered the reading public unlimited access to the photographic image.

THE PHOTOGRAPH TAKES OVER THE PRESS

In 1928, Pierre Mac Orlan predicted that "in twenty-five years all journalists will know how to handle a camera."

The press called on photography early. As a truth detector and a means of providing documentary accuracy, a photograph made a story more objective. A single picture could summarize the dramatic reality of an event and lifted the photograph to the level of an icon. Or gave the photographer a scoop, which is what they were all after. Other approaches, such as making sequences of photographs, allowed for the narration of events. This was the case with Alexander Gardner's coverage of the execution of the anti-Lincoln conspirators, photographed on July 7, 1865, as well as Nadar's photographic interview on the

occasion of Michel Eugène
Chevreul's centenary, taken with
a Kodak "hundred-shot" and
published in the *Journal illustré*
on September 5, 1886.

THE FIRST STEPS OF AN
ILLUSTRATED PRESS

In March 1880, the *New York Daily Graphic* was
the first newspaper to use the brand-new half-
tone process to publish photographs. The
paper's editor in chief wrote, "To date, we have
only had drawings or engravings. We are now
in direct contact with nature." Similarly, *L'Illus-
tration* based its editorial policy on photographs.
The possibilities for the halftone process were
greatly increased in 1907, when Édouard Belin
demonstrated his Belinograph, a device for
telegraphic transmission of the photographic
image, before the Société Française de Photo-
graphie. This invention gave newspapers all
over the world the opportunity to receive photo-
graphic images that were ready to be printed.

 Thanks to its evocative power, photography
took a definite precedence over text in the 1920s.
The advent of light cameras, such as the Leica
(1925), offering thirty-six shots per roll of film,
made it easier for photographers to record major
events around the world. The dramatic impact of
these photojournalists' pictures sometimes
supplanted the text. Some papers relied on
photos to support theories and political
commitments through montage, retouching,
and sometimes even falsification, while others
instituted the novel editorial policy of allowing
the photographer, now promoted to the rank of
journalist, to be sole witness to an event. The
photographs *The Spanish Civil War*, by Robert
Capa (*Vu*, September 1936), *Spanish Village*, by
W. Eugene Smith (*Life*, April 9, 1951), and *Gang*,
by Bruce Davidson (*Du*, September 1960) all had
an impact on global politics.

A FEW EMBLEMATIC TITLES

L'Excelsior, the first daily illustrated entirely with
photographs, was founded in France by Pierre

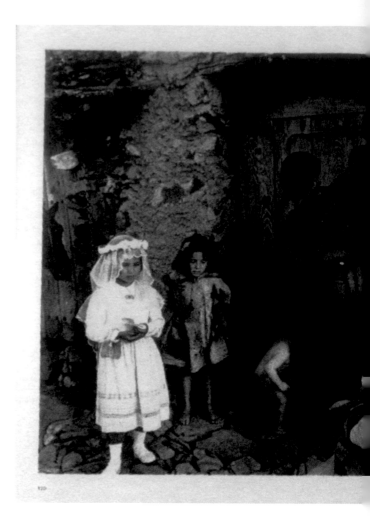

Laffitte in 1910. The printing of the photographs
took two days and was very expensive. After World
War I, however, technologies developed that
introduced the golden age of the illustrated press.
In 1928, Lucien Vogel launched *Vu*, which was
soon followed by *Voilà*, a periodical founded by
Gaston Gallimard and Florence Fels and imitated
throughout the world. Among the new releases of
the age were *AIZ* and *Uhu* in Germany; *Lilliput* in
England; *Lef* in the Soviet Union; the Henry Luce
publications *Time* and *Life* (inaugurated on Nov-
ember 23, 1936) in the United States; and, last but
not least, the French magazine *Paris Match* (1949).
All were emblematic titles that embodied the
jewels of the magazine press.

 Between the wars, Paris was the illustrated-
magazine capital of the world, a place where a
public hungry for news hurried to the newsstands
and purchased illustrated weeklies for a few cen-
times. These successes pushed photographers to
join up with agencies in order to keep their pic-

Spanish Village
IT LIVES IN ANCIENT POVERTY AND FAITH

[body text of reproduced magazine article, not legible]

W. Eugene Smith, *Spanish Village* (*Life* magazine, April 1951)

In 1950, W. Eugene Smith traveled hundreds of miles across Spain until he discovered the village of Deleitosa, which became the subject of a story for *Life*. His perspective on the inhabitants of this village and the quality of his personal and lively approach are seminal in photographic reportage.

THE BOOK: PHOTOGRAPHY'S PRIVILEGED SPACE

In 1844, Fox Talbot completed *The Pencil of Nature*, the first illustrated book in the history of photography, which presented his original photographs on bound plates. In the mid-nineteenth century in France, Louis-Désiré Blanquart-Evrard's "photographic printing press"—based on the same principles but more industrialized—produced an unrivaled catalogue of documentary works, including *Egypt, Nubia, Palestine, and Syria*, and *Photographic Drawings* (1852) by Maxime Du Camp. The 1885 invention of the halftone process allowed for photographs to be reproduced and printed at the same time as a book's text, and with this advance, the illustrated book rapidly expanded. Ten years later, the photogravure process was developed, producing results very close to manual printing, and quickly experienced a tremendous success.

tures flowing to the editorial offices. The great photo-press agencies were French, and the tradition attracted the greatest talents of the planet to Paris in the wake of persons such as Lucien Vogel or Henri Cartier-Bresson. Thus Kertész, Brassaï, and Capa launched their careers by immigrating to Paris. In the 1960s, the news magazines appeared. These were weeklies that covered the political and cultural events of the week, modeled on *L'Express,* founded in 1953 by Jean-Louis Servan-Schreiber and Françoise Giroud.

The mid-1970s saw the decline of the magazine press. Television grew to dominate the market with event coverage that was frequently live, and "paper news," which had not always succeeded in adopting a specific editorial policy, lost much of its audience, to the point that certain prestigious titles were closed down.

INVENTION AND CREATION, 1925–1935

Beginning in the 1920s, the book became a privileged space for photography. At first, photography was found mostly in informational works, such as encyclopedias or travel albums, whose formats had been inherited from the nineteenth century. Here, photographs were mainly used for illustrative purposes. These were followed by limited-edition volumes aimed at aficionados of poetry and art. In these books, photography replaced prints or lithographs. Next came photographers' books, which presented the work of a photographer along with text by a contemporary writer. In every case, photography was a document, a modern way of seeing the world and showing it.

Moholy-Nagy, who was the director of photography at the Weimar Bauhaus, published *Malerei Fotografie Film* (Painting Photography Film) in 1925, a book in which he revealed his conception of the photographer's role. In 1927 and 1928, Albert Renger-Patzsch's *Die Welt ist Schön* (The World Is Beautiful) and Karl Blossfeldt's *Urformen der Kunst* (Original Shapes of Art) were published. Both books praised the documentary work modern photography was doing based on the observation of plants and nature.

In France, Germaine Krull published *Métal* (Metal), in 1927, a veritable manifesto of the New Vision with sixty-four bold plates representing scrap metal, cranes, and machines. A year after *Métal*'s publication, André Breton sensed the important role photography would soon play in books and published his *Nadja* with photographs by Jacques-André Boiffard. The year 1930 was a crucial one for publishing. Léon-Paul Fargue's *Banalité* (Banality) was reprinted with sixteen new photographs by Roger Parry and Fabien Loris, specifically taken to accompany the writer's poetic and surrealist text. The book's coherence and perfect harmony ensured its success. *Micrographie décorative* (Decorative Micrography) by Laure Albin-Guillot featured twenty photographs printed on colored backgrounds, a design that cast a strange light on the artist's abstract and geometric shapes.

In 1931, the twenty-four-year-old Polish photographer Moï Ver conceived of a new book and gathered eighty photographs, with text by Fernand Léger, under the title *Paris*. With *Paris,* Ver inaugurated a new visual language, in which photography was autonomous and no longer needed text for elucidation. Brassaï's *Paris de nuit* (Paris by Night, 1932), with a preface by Paul Morand, opened a door to a new world, the world of night and its secret universe, which was laid bare by the photographer's lights.

THE PHOTO BOOK FLOURISHES, 1935–1970

Through photography, the surrealists found a means of illustrating dreams, the sleep of reason and poetry. In 1935, Man Ray published *Facile* (Easy), an exemplary success in the history of the photo book. Basing his work on poems by Paul Éluard and working in close collaboration with the poet, Man Ray illustrated Éluard's tribute to his female companion, photographing her in such a way that the text could be set as close as possible to the images. In 1939, Hans Bellmer's *La Poupée* (The Doll) demonstrated the total success of a completely surrealist work.

In the United States, Walker Evans's monograph *American Photographs* (1937) was far more than an anthology of the author's best photographs. With every picture spread over two pages, the book's design followed the visual evolution of thought and clearly defined the position of an artist committed to observing his country. The Lincoln Kirstein text published at the end of the book provided a critical dimension to Evans's work.

This fully developed dialogue between text and photography would be found later, in 1952, in Cartier-Bresson's first monograph, *Images à la sauvette* (The Decisive Moment). An essential landmark of photography, the book featured a cover by Matisse and "The Decisive Moment," a preface by Cartier-Bresson in which he defined his conception of photography.

The humanist photographers also played a part in this evolution. Artists including Robert Doisneau, Izis, Édouard Boubat, and Willy Ronis found a privileged medium for their photographs in books that were admittedly more conventional. However, the publication of two revolutionary books, William Klein's *New York* (1956) and Robert Frank's *The Americans* (1958) changed the photography book forever with their bold conceptions.

Brassaï, *Paris de Nuit* (Paris by Night), cover photo (1932; preface by Paul Morand)

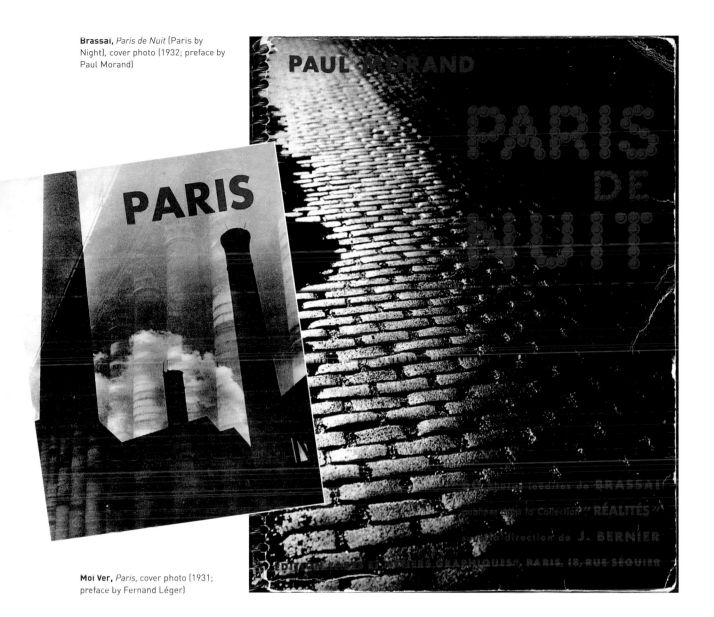

Moï Ver, *Paris*, cover photo (1931; preface by Fernand Léger)

22: BIRTH OF MODERN REPORTAGE

The development of news reporting is inextricably linked to the histories of photographic technique and of the press. The birth of the snapshot at the end of the nineteenth century represents the starting point of modern reportage, the moment from which a photographer was able to capture an action and tell a story in motion, as it unfolded. Before this, bulky equipment had made it impossible to photograph an event as it took place. The introduction of photographs in the media in the early twentieth century was another decisive step in the development of reporting. As a profession, photoreportage was to undergo tremendous growth until the Vietnam War, followed by a considerable falloff due to the expansion of television.

THE PHOTOGRAPHER'S COMMITMENT

Following the snapshot, the arrival of color in 1907 constituted another revolution for photography. Color allowed photographers such as Léon Gimpel, who published World War I pictures of French soldiers in *L'Illustration,* to focus on details such as the brilliant red uniforms that made French soldiers ideal targets for the enemy. In the United States, the appearance of the snapshot was accompanied by the aesthetic movement called Straight Photography, which stood in direct opposition to pictorialism and was no stranger to the evolution of photoreportage. In 1907, Alfred Stieglitz took one of his most famous photographs, *The Steerage*, which was both a social document and a Straight Photography manifesto, a statement for a direct type of photography aimed at recording everything the photographer's eye perceived at the instant of exposure. Other American photographers of the same generation became prominent as photojournalists, and some of their reporting even had political impact. Eight years after Lewis Hine's famous 1908 photographs of children at work led to popular outrage, U.S. president Woodrow Wilson began the steps necessary to outlaw child labor, but it wasn't until 1938 that protective laws were passed.

For these photographers, the point was not just reporting. It was also a matter of political or social commitment and a deep-seated belief that photography could change the course of history.

The question of photography's power has remained crucial to this day.

Countries torn by war and revolution were the training ground of the photojournalist. In Mexico, for instance, Augustin V. Casasola photographed the smile of counterfeiter Fortino Samano minutes before his execution (1913), and the body of the revolutionary Emiliano Zapata (1919).

FROM NEW TECHNIQUES, A NEW PRESS

Though photographers now had equipment that allowed them to instantaneously record events, they would soon have lighter and more easily handled models and formats. The Ermanox was released in 1924, with its 4.5 x 6 cm plate, and in 1925, Leica launched a camera that was loaded with photosensitive film instead of a heavy glass plate. The reduced size of the Leica's film, and therefore of the actual camera, allowed photographers even greater flexibility. In 1929,

Augustin V. Casasola, *Fortino Samano, Counterfeiter, Just before His Execution* (Mexico, 1917)

The casual, carefree haughtiness of this young crook lends a special quality to this image, making one think Samano was happy to pose for eternity. Another photograph shows him tipping his hat offhandedly.

Erich Salomon, *Meeting in Geneva of Delegates from the League of Nations* (1928)

Taken during the great international diplomatic conferences, Salomon's reports are today considered to define modern political photojournalism. He was able to steal unexpected, special moments from history using his Ermanox camera, which had no flash.

a completely new camera called the Rolleiflex offered a viewfinder that did not require the camera to be held to the eye, which meant photographers were able to take their pictures in a much more subtle fashion.

During the same period, a new French magazine called *Vu,* created in 1928 by Lucien Vogel, joined the ranks of the illustrated press. In Germany, the *Berlin Illustrierte Zeitung* hired one of the most daring photojournalists of the time— Erich Salomon, a photographer so audacious that some have even referred to him as the prede-

cessor of the paparazzi. Though he was more interested in political events than society life, he regularly staked out subjects in order to take photographs the likes of which had never been seen.

The last major step in the development of reportage was the 1936 founding of *Life,* an American magazine modeled after *Vu.* The year it was founded, *Life* published Robert Capa's photo of the battlefield death of a Spanish Republican soldier. This image, which single-handedly summed up the Spanish Civil War, became the symbol of modern photojournalism.

Weegee, *Harry Maxwell Shot in a Car* (1941)
Weegee began to work independently around 1935, photographing mostly at night in the streets. He was always on hand covering the latest crime for the tabloids.

Jules Beau, *Noël the Gallic* (1897)

23: PHOTOGRAPHY AND SPORTS

Until the 1880s, sports and photography were activities limited to a privileged minority. In the following decades, the two disciplines crossed paths more and more, and sports eventually became a favorite field for photographers to work and experiment in.

PARALLEL BEGINNINGS

Eugène Durieu's photographs of sideshow strongmen rippling their muscles for his camera—photographs that Eugène Delacroix would use as models—are considered the first examples of sports photography. Stereoscopy became very popular in the 1860s, and masters of the medium circulated their pictures of athletic games and spectacles on the street, in bowling alleys, and at boxing matches. In 1850, Eugène Chapus launched the first sports paper, *Le Sport, journal des gens du monde* (Sport: A High-Society Paper), whose title clearly indicated that sports were still reserved to the French aristocracy and bourgeoisie, who had picked them up from their British counterparts. In these circles, horseback riding was the fashion, so Nadar, Disdéri, Louis-Jean Delton, and Pierre Petit opened studios in the Bois de Boulogne in order to photograph riders with their horses. Those city-dwellers brave enough to attempt mountain climbing set off in roped parties with photographers such as the Bisson brothers, the pioneers of the field. But until the beginning of the 1880s, the majority of sports photography production was done for calling-card portraits made in studios by photographers such as Léon Crémière, a highly successful specialist in the form. The creation of the French Racing Club in 1882, closely followed by the creation of the Stade français (French Stadium) by footracers from the best Parisian high schools, inaugurated the practice of mass sports in France. Soon the French Automobile Club was started, and the first bicycle race on a road, between Paris and Rouen, took place in 1889. The audience for sports kept growing: the first modern Olympic Games took place in Athens in 1896, and gymnastics and physical fitness became increasingly popular. Photography was ready to capture the new wave of human activity; in 1882, the chronophotograph had been developed by Étienne Jules Marey, a physiology professor, and his assistant, Georges Demeny (considered the father of scientific physical education). Their invention captured motion in a series of photographs taken in rapid succession, allowing the stages of any particular activity to be frozen and analyzed.

VARIOUS ENCOUNTERS

The conditions were right for the appearance of a new character on the photographic scene: the sports photographer. From 1894 to 1913, Jules Beau documented the movements of swimmers, athletes, boxers, wrestlers, *pétanque* players, and cyclists, for the readers of *Vélo* and *La Vie au grand air*. After World War I, a closer relationship was formed among photography, sports, and the illustrated press, which was playing an increasingly important role. Throughout Europe, a generation of amateur sportsmen who were also photographers began creating agencies—in Austria, Phot-Rübelt was founded by Lothar

p.101:
Alexander Rodchenko, *On the Parallel Bars* (1938)

Rübelt and his brother—or collaborating with magazines (such as Martin Munkacsi with *A Z Sport* in Hungary, or Lothar Jeck with *Schweitzer Illustrierte* in Switzerland). Upon his arrival in Paris in 1925, Kertész worked for the same magazines, notably *Vu*, which also accepted contributions from Munkacsi or Robert Capa. The relation between speed and modernity and the relationship to the body were the foundation for many artists' formal research. Artists involved in this field included Moholy-Nagy from the Bauhaus, Willi Baumeister of the constructivist-cubists, and the Italian futurists Vinicio Paladini and Bruno Munari. The field was further expanded by Harold Edgerton and his student Gjon Mili's work on the application of stroboscopy to photography. Thanks to Edgerton and Mili, movements that were invisible to the naked eye could now be captured through a succession of flashes at a millionth of a second. Professional and artistic uses of sports photography coexisted with a thriving amateur practice, of which Jacques Henri Lartigue was an essential figure. Sports photography was also used to serve political or ideological purposes. Rodchenko searched for "a new aesthetic that could express through photography the bewitchment and pathos of [the] new socialist society," while Leni Riefenstahl glorified the cult of the body and fascist ideals during the 1936 Olympic Games in Berlin. Television would eventually modify the way these photographers worked, but it would not keep them off the playing field. The 1950s also saw the return of photographs covering popular fairs and sporting events, with the work of photographers such as Robert Doisneau and Cartier-Bresson, who did a photo essay on the final Six Jours in 1957, a bicycle race that took place at the Vel d'Hiv in Paris.

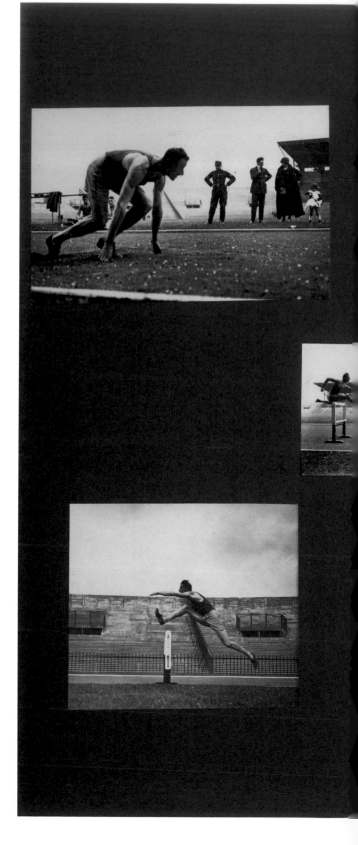

Jacques Henri Lartigue, *Pages from Olympiads: Géo André Trains at the New Colombes Stadium* (June 1924)

Lartigue brought his photographs together into large albums, completing 130 in all. He never stopped recording the sporting events he loved, the various eccentric inventions of his family, his vacations, his private life, and his social life.

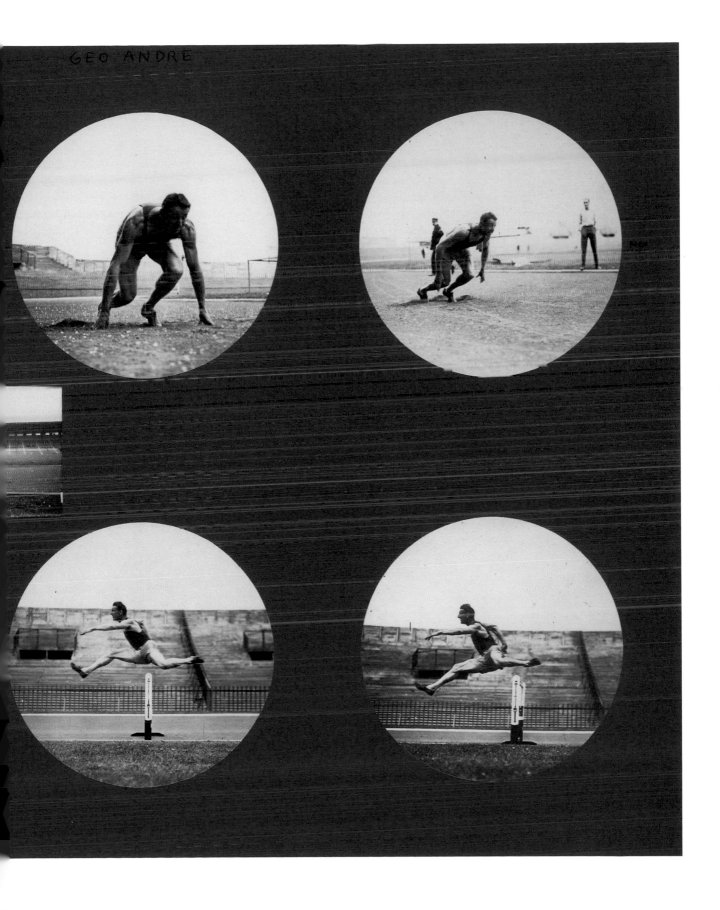

GEO ANDRE

24: FASHION PHOTOGRAPHY I:
A FULL-FLEDGED ARTISTIC MEDIUM

The history of fashion photography is the history of pictures taken to display and sell clothes and their accessories. Fashion photography also describes an era's way of life, as well as its aspirations, tastes, and taboos. In the nineteenth century, Paris boasted the finest couturiers and models. There, an outfit was considered an individual expression of personality. The photo albums that Mayer & Pierson (the partnership of Pierre-Louis Pierson and the Mayer brothers, Leopold, Ernest, and Louis) compiled of the Countess Castiglione posing in her sumptuous and refined dresses is the first photographic example of the outfit as extension of the personality. This was the time when André Adolphe-Eugène Disdéri, Adolphe Braun, Mayer & Pierson, and, a little later, Constant Puyo, Robert Demachy, and Jacques Henri Lartigue were photographing fashionable people, and beautiful high-society women or stage personalities were used as models. Real fashion photography—that is, photography that focused primarily on the style of the dress, not on the model, and was specifically taken for fashion purposes—developed slowly. The practice began in the 1850s and 1860s and became widespread in the 1880s. It wasn't until the rapid development of the big American magazines such as *Vogue* (and its British and French editions in 1916 and 1920, respectively) and *Harper's Bazaar,* however, that fashion photography would become a full-fledged artistic medium.

VOGUE AND *HARPER'S BAZAAR*:
ART DIRECTORS IN CONTROL

Condé Nast radically transformed *Vogue* when he bought it in 1909 and put in Edma Chase as editor in chief. *Vogue* intended to reach the elite and set about becoming the arbiter of good taste. At the time, the public still looked to fashion photographs for the traditional conventions of hand-drawn fashion pictures in the models' poses and facial expressions. With the hiring of Baron Adolf De Meyer in 1913, everything changed for *Vogue*. The simple publication became an artistic creation.

De Meyer, who belonged to the pictorialist movement, used back-lighting and soft focus to a degree that was then rarely found in magazine pages. He created intimate and highly subjective images of women. His style, which opened the doors to an unreal, ethereal world, was imitated around the world. In 1922, he left *Vogue* for its chief competitor, *Harper's Bazaar,* which William Randolph Hearst had taken over in 1913.

Hired by Condé Nast in 1923, Edward Steichen introduced a far less theatrical style, in which the sharp geometry of modernism predominated. Steichen was responsible for connecting fashion photography to the aesthetic currents of modern painting. More than just showing a dress, he created an atmosphere in the sober, elegant settings of his photos. He was also the first photographer to stress the choice of a model. Marion Morehouse, his favorite model, represented the self-assured woman, a real go-

Edward Steichen, *Lili Damita* (New York, 1928)

getter. It was essential to this idea of modernism that she be elegant without any overtones of romanticism, and feminine without sentimentality. Though Steichen's influence was heavily felt on both sides of the Atlantic, and *Vogue*'s management asked its photographers to emulate his style, it did not prevent new talents from blooming. Georges Hoyningen-Huene, who worked for the *Vogue* Paris studio in the 1920s, created a new style. This lover of ancient Greece played with subtle lighting and made subtle use of empty space and asymmetrical compositions. Like Steichen, he used plaster dummies and human models in combination. Huene inspired Horst P. Horst, whose photographs were distinguished by his use of a backlit three-quarters pose to emphasize the cut of the clothing. Horst was especially notable for introducing a sense of humor, something the genre had been lacking.

In 1932, Carmel Snow left *Vogue,* where she had worked since 1921, to become the fashion editor of *Harper's Bazaar.* Her power, like the power of all fashion editors through the late 1970s, was absolute. Snow chose the photographer, whose career she directed, chose the model, the outfit, the theme of the picture, and the location where it would be shot. It was also Snow who fired Baron De Meyer and, in 1933, hired Martin Munkacsi, along with Alexey Brodovitch as art director. Together, they gave the magazine an extremely original style. Brodovitch, a champion of the avant-garde, became the catalyst for new pictorial and photographic ideas. This "king of the image" passed his methods along to an entire generation of artists.

Martin Munkacsi, who was under contract, introduced a revolution, not only because of his outdoor shots—he wasn't the first—but also because he introduced movement and natural poses that made his photographs true snapshots. Their realism became the new style and the main rival to the studio set.

As for Paris, all the new ideas and trends came from there. Fashion photography was blooming, and artists were finding inspiration in the period's artistic ferment. Man Ray worked for fashion director Paul Poiret in the 1920s, then for *Harper's Bazaar* in the 1930s, mixing painting and photography and introducing artwork as back-

ground elements. Erwin Blumenfeld was similarly inventive in his efforts to capture a visually striking image. Unlike George Platt Lynes, whose love of surrealism gave his work a mysterious, fantastic, and dreamlike touch, Blumenfeld was not influenced by surrealism.

Cecil Beaton worked for English *Vogue* in the thirties. His work is a perfect illustration of

Martin Munkacsi,
Bathrobe in a Light Breeze
(June 1936)

the integration of the arts in photographic work. Beaton's photographs are described as those of a nineteenth-century photographer working in the twentieth century. Theater was present in every aspect of his work, and his models constantly seemed to be on stage. Working at the extreme opposite end of the spectrum from the Steichen aesthetic, Beaton succeeded in making a name for himself. The public's appetite for his baroque tastes disappeared in the late thirties and was replaced by realist photos.

When war broke out in 1939, fashion photography was severely affected. It was now seen as frivolous, a superfluous luxury.

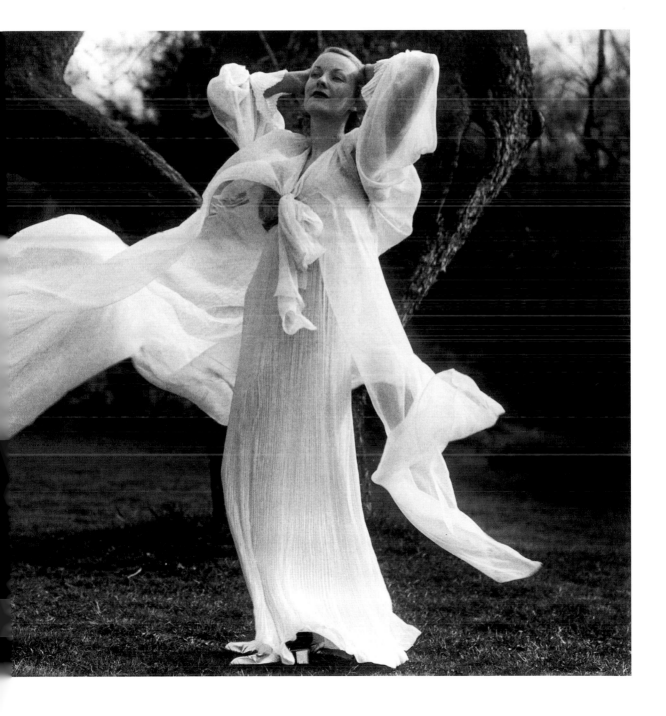

Man Ray, *Tears* (1932).

The glass beads on this face catch the light, adding a mysterious, dreamlike quality to this portrait.

25: PHOTOGRAPHY AND SURREALISM: A "STRANGE STRANGENESS"

In 1924, André Breton published the *Surrealist Manifesto,* which included his definition of the word "surrealism": a "psychic automatism by which one attempts to express…the actual functioning of thought." Numerous painters and writers were members of the movement. As for photographers, they were to play a determining role in surrealism. Man Ray has often been seen as the movement's "official" photographer, though his work extends far beyond it, and Brassaï, Hans Bellmer, and Dora Maar were very close to it.

A FASCINATION WITH PHOTOGRAPHY

Surrealist photography essentially consisted of the collage and montage techniques that the dadaists had already been using for some time. But surrealist photos were also based on experiments carried out in the darkroom. Put into the service of a completely unrestrained imagination, photography turned into an unusually rich instrument for expressing subconscious and hidden thoughts. Of course, all of these photographic manipulations were controlled to some degree in the interest of achieving relatively interesting results. Nonetheless, this approach also expressed something else, something that was unexpected and not consciously desired. Various elements took their place in the work as if guided by the artist's mind. This is what photographers were after: something beyond fabrication, the thing that happened even when they thought they were totally in control; the things that were beyond reason. Some of the most interesting surrealist works, including those by Maurice Tabard, Roger Parry, Henri Cartier-Bresson, Erwin Blumenfeld, André Kertész, and Pierre Boucher,

were produced by photographers and artists who sometimes only had the most distant relations with the actual surrealist movement. "The artist is free to choose his work," was the motto of these photographers, who allowed themselves to appropriate surrealist practices and claimed absolute freedom in their choice of subjects, tools, and creative media. They proclaimed the unrestricted availability of photographic or printed images and advocated the power of combining a preexisting image with whatever the imagination led to.

EROTICISM AND THE FAMILIAR

Eroticism was one of the major forces behind surrealism, and the same held true for the photographers. They tirelessly explored beauty and eroticism, particularly in their feminine aspects. Woman was celebrated in numerous surrealist photographs, and her sublimated body became a bare form to be transformed, played with, dislocated and distorted.

Every one of these photographers was interested in the real: reality served to fulfill their need

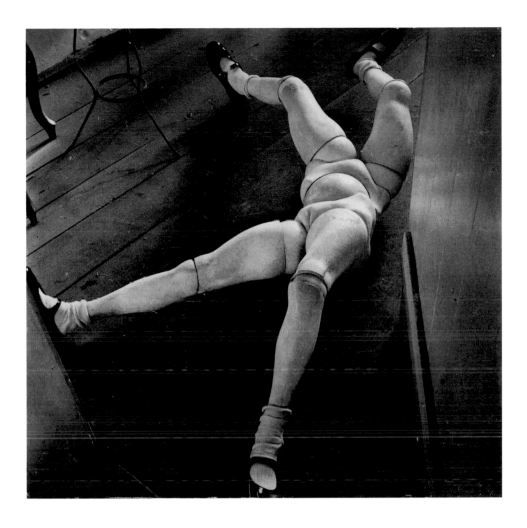

for the strange and the bizarre. They found un-
usual atmospheres and connections all around
them. All they needed to know was how to keep
their eyes open and when to release the shutter.
Around this time, Paris was becoming home to a
mysterious and eccentric nightlife that combined
the sordid and the magical. The dark was cloaked
in the slightly supernatural and shady atmosphere
of the newly fashionable crime novels that the
surrealists loved. Photographers had discovered
the unusual and the irrational in the everyday,
and transformed of streetlights into monsters
or gargoyles; graffiti on a wall into a prehistoric
drawing or the cabalistic sign of a secret society.

TECHNIQUES

Superimposition was achieved by overprinting two
or more elements from two or more negatives (as
in the work of Jacques-André Boiffard, Roger
Parry, and Maurice Tabard). The photocollage was
a composition of photographic images that were
cut out, reassembled, and glued (Georges Hugnet),
while photomontage consisted in the assembly of

Hans Bellmer, *The Games of the Doll* (1934)

Hans Bellmer first published in the surrealist magazine *Minotaure*
in December 1934 photographs of eighteen of his dolls made from
various materials. The artist celebrated their invention in a wild
essay entitled *Memories on the Theme of the Doll*. His entire oeuvre
draws on the mother and child relationship, the female body and
its transformations.

negatives (Raoul Ubac). The photogram was made
by the simple taking of an imprint without the use
of a photographic device or a negative (Christian
Schad and his schadographies, Man Ray and his
rayographies, and Moholy-Nagy and his
photograms). Solarization consisted of briefly
exposing a negative or a photographic print to light
during development, which led to a reversal of the
tones (Man Ray, Maurice Tabard). The *brûlage*
technique consisted of exposing the negative to
a heat source and progressively melting it during
development. This procedure led to unexpected
results through the gradual disintegration of the
image (Raoul Ubac).

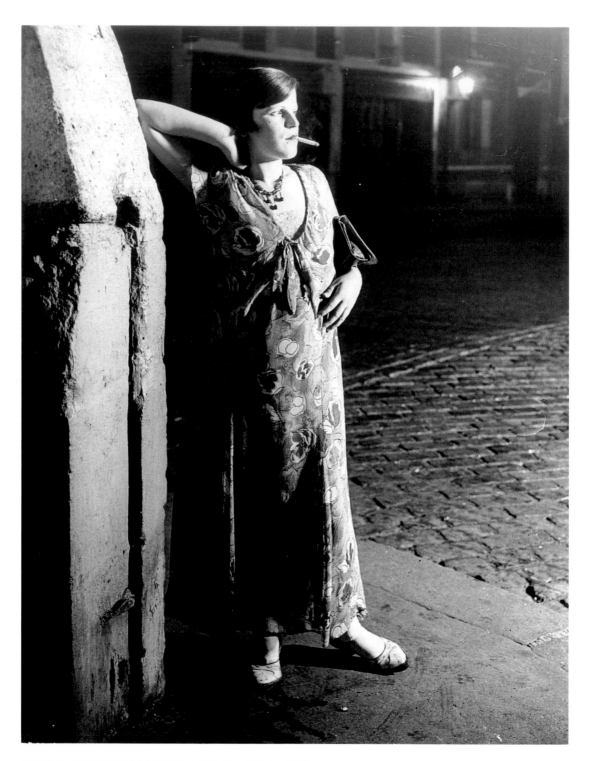

Brassaï, *A Lady of the Night in a Spring Dress, Near place d'Italie* (ca. 1931)

"Night is not the negative of day," wrote Paul Morand in the preface of *Paris by Night.* The characters from it take on another dimension, another face.

BRASSAÏ
(1899–1984)

Around 1932, Gyula Halász found his name as a photographer—Brassaï—which he took from Brasso, the name of his native city in Hungary. At age twenty, he studied fine art in Budapest and then went to Berlin for two years. He moved to Paris in 1924 as a journalist and future painter and artist. He met Atget who, along with Kertész, also from Hungary, would introduce him to the world of photography. What he liked most about Paris was its life at night, the life in the dark, a life of mystery and secrets, the forbidden Paris of the 1930s. He therefore began to take long strolls through the city at night. "The things of the night made an impression on me, and I thought that only photography could express them; a woman lent me a camera. For months, I only took photos at night. I know exactly the moment when I took my first picture. It was in February or March of 1930."

With his Voigtlander plates, Brassaï explored the possibilities of black and white and ventured to communicate the dark and secret atmosphere of the night. In 1932, he published *Paris de Nuit* (Paris by Night), which included sixty-two of his photographs.

Brassaï was one of the first to explore nocturnal environments, but, because of his bulky camera, he couldn't take snapshots. He worked more like a director, considering light, pose time, reflections, and fog as a filter of light. He got his assistant Kiss to post as a client at Chez Suzy, the Parisian bordello, and photographed there. He also took portraits of Bijou, the prostitute at the Bar de la Lune in Montmartre, covered in pearls. His heavy equipment and magnesium flash left little room for spontaneity.

During his wanderings, Brassaï found graffiti on walls—writings, words scrawled by impatient hands, memories of a brief encounter. These markings turned into works of art. In the depths of the dark were faces, strange figures, stories. His graffiti pictures were published in *Le Minotaure* in 1933.

Brassaï also worked during the day. He had a deep friendship with Picasso and took his portrait in his various studios. These were published in 1965 in *Conversations avec Picasso* (Conversations with Picasso). He was also friends with several surrealist artists and writers and seized their strong personalities in incisive portraits, all the while remaining on the margins of the movement. After the war, he worked for *Harper's Bazaar* until 1962, when he stopped photographing to devote himself to printing new editions of his work and books, and to drawing and sculpture. He published numerous articles and more than twenty books, including a brilliant analysis of the importance of photography to the work of Proust. "To become a definitive image, photography—the two-dimensional transcription of the world in black and white—must respect the balance that exists between the living thing and form, because what I strive for is to make something naïve and striking out of the banal and conventional." This confirms that he never wanted to define himself as either a photographer or journalist.

Brassaï's entire body of work was offered to France in 2002.

Brassaï, *Graffiti from Series VIII, "Magic,"* (ca. 1933–1956)
In his nightly walks, Brassaï found unexpected and unusual images on walls.

BILL BRANDT
(1904–1983)

Born in London into a family of Russian origin, Bill Brandt contracted tuberculosis in Switzerland at an early age. When he recovered, he began his training as a photographer. He met Man Ray in Paris in 1929 and worked in his studio for three months. An excellent teacher, Man Ray taught the young, inexperienced photographer to look at the world differently, in the light of the surrealist atmosphere of Paris in the 1930s. At the same time, Brandt discovered the photographs of Atget, Kertész and especially Brassaï, whose sensibility most closely matched his own.

In 1931, he returned to London to complete a report on the English at home. Already familiar with the many facets of this society, Brandt entered the private lives of the wealthy bourgeoisie and aristocratic classes. He went to the Ascot racetrack and at night strolled through the working-class East End neighborhood. He was there when maids drew their employer's bath and when a young girl performed the Lambeth Walk in the street, cheered on by laughing friends. In 1937, he traveled for the first time to the industrial cities of northern England and the Midlands, both great mining areas. He was struck by the poverty of the working class and produced a poignant report on coal miners.

Working in a new genre, Brandt was a unique observer of the society he photographed and worked with great freedom. Because of the fast films and flash that had been invented around 1930, he was able to work quickly by both day and night, inside and outside. Magazines increasingly wanted his work. They included the *New Chronicle,* the *Weekly Illustrated* (1934), the *Lilliput* (1936), which was more literary, and the *Picture Post* (1938). In 1936, Brandt published his first book, *The English at Home,* in which he combined clinical observation with poetry

and intense emotion. Two years later, in an echo of Brassaï's *Paris by Night,* Brandt published *A Night in London.* During World War II, he photographed the people who slept in the underground stations during the blitz bombings of London. These saturated and dense-black images present a strange and heroic subterranean life. He also photographed monuments that ran the risk of being destroyed. In the 1940s and 1950s, Brandt completed portraits of artists and writers for various magazines, his eagle eye capturing personality. Graham Greene's is filled with fear; Francis Bacon walks alone on a deserted street; Alec Guinness hides in the shadows. In a series of portraits of painters, Brandt concentrated on a single facial feature, the right or left eye, open, enormous, like a predator or serpent. When he photographed British landscapes, he found shadow and what it hides, what it suggests.

Brandt began an extraordinary series of nudes, which culminated in his 1961 *Perspective of Nudes.* He used an old Kodak camera he got from the police, which had a super-wide-angle lens set at infinity and an aperture the size of a pinhole. Using very fast film, he explored the world of the female nude. He came close to completely relinquishing control of the images, amplifying the beauty of the nude and deforming it to the point of abstraction. He later ceased using this camera and took his models to the beaches. The female body, fragmented by his angles, became a sublime and stupefying element of nature and landscape. On the beach, Brandt continued his explorations in isolating parts of the body. He saw the body as would a sculptor in the tradition of Henry Moore.

A reporter, portraitist, and discoverer of landscapes, Brandt reinvented the nude. His photographs are the fruit of deep consideration bolstered by inventive technique and photographic mastery. In his last photographs, details give way to black and white alone.

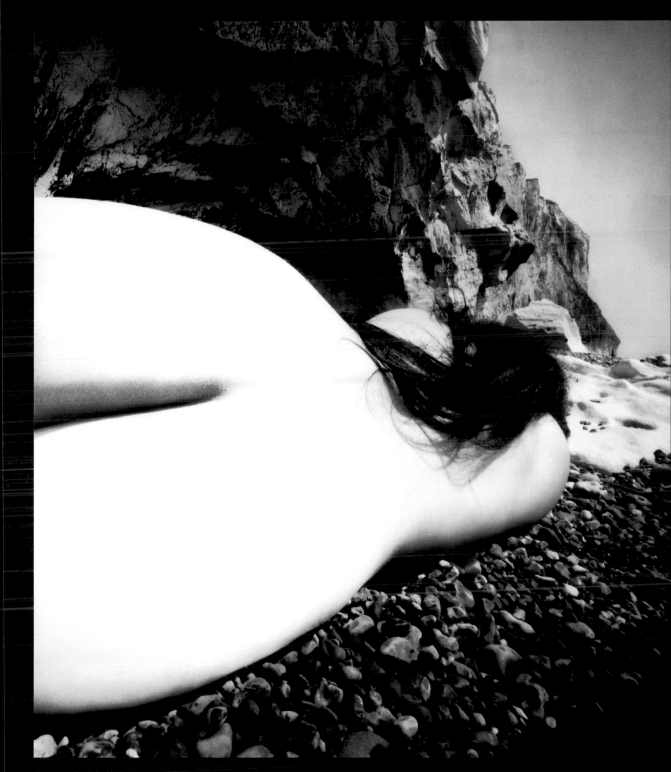

Bill Brandt, *Nude at the Foot of a Cliff* (East Sussex, 1953)

After fifteen years of exploration, Brandt began to work on the beach, where he completed his work on the female nude. Conscious of the deformations he could obtain with his camera, he invented this female body at rest on the sand, magnificent and grand. The black mass of her hair underlines the long white line of her back.

HENRI CARTIER-BRESSON

(1908–2004)

Henri Cartier-Bresson was the greatest photographer of his generation. In 2003, he became the first photographer in France to create a foundation bearing his own name. This institution conserves his photography and is committed to exhibiting and supporting other work in line with Cartier-Bresson's graphic and documentary approach.

Born into a middle-class French family in 1908, Cartier-Bresson studied at the Lycée Condorcet in Paris, graduating without any distinctions. His first love was painting and drawing, and he studied in André Lhote's studio. In 1931, he left for the Ivory Coast, where he took his first photographs, then for two years traveled around Europe, including Spain, where he produced his earliest masterpieces. His work was soon exhibited at Julien Levy's in New York, and in 1933 he was published by Charles Peignot in *Arts et Métiers graphiques.* In 1934, he lived for a time in Mexico, and the following year saw him in the United States, where Jean Renoir introduced him to the cinema. Returning to France, he became Renoir's

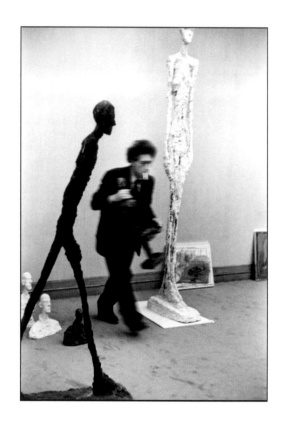

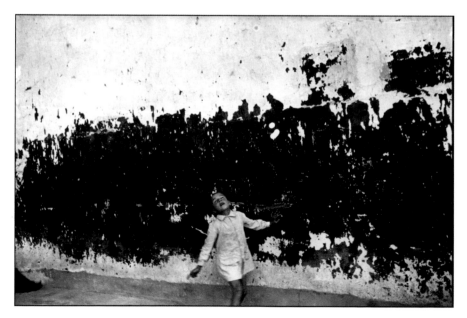

Henri Cartier-Bresson, *Valencia* (Spain, 1933)

This enigmatic image explains why the surrealists—to whom Cartier-Bresson was close, without actually belonging to their group—valued his work right from the start. The expression of the child photographed quickly against the flaking wall tells us nothing of the situation. This photograph will remain forever enigmatic, like many others collected from Spain and Europe during a long trip that Cartier-Bresson undertook with André Pieyre de Mandiargues and Léonor Fini. Its tones are comparable to those he took of Mexico, and this first period of his photographic work, before his evolution toward photojournalism, may be regarded as the most important.

p. 114: **Henri Cartier-Bresson,** *Alberto Giacometti in His Studio* (Paris, France, 1961)

Perfectly framed, the sculptor's moving profile as he carries one of his pieces around his studio belongs in Cartier-Bresson's category of famous men walking. The contrast between plaster and bronze, enhanced by the soft light, organizes the masses. Henri Cartier-Bresson no more regarded this picture, taken hurriedly, as a portrait than he did another snapshot showing Giacometti crossing the street, with his raincoat over his head to protect him from the rain. For Cartier-Bresson, a portrait required the participation of someone who knew that he or she was to be photographed.

assistant, and, in 1937, Cartier-Bresson made a documentary on the hospitals of republican Spain before once again collaborating with Jean Renoir in 1939. Taken prisoner by the Germans in World War II, he managed to escape in 1943, and in 1945 made a documentary about the return of prisoners of war. In 1946, his work was exhibited at the Museum of Modern Art, and he traveled widely in the United States.

In 1947, Cartier-Bresson founded the Magnum agency together with Robert Capa, David Seymour, William Vandivert, and George Rodger. Thus began his great years as a photojournalist, with trips to China, India, Bali, Russia, and elsewhere. Cartier-Bresson also regarded book publishing as very important. In his first book, *Images à la sauvette* (literally, Pictures Taken on the Sly, but published in English as The Decisive Moment, 1952), he defined his philosophy of photography, which, as he explained, was rooted in "the decisive moment" the phrase that provided the book's English title. His rigor, geometric sense, and quest for the perfect composition based on the Golden Number have deeply influenced several generations of reporters.

In 1966, he decided to leave Magnum—which continued to show his archives—and began to draw. Abandoning reportage, he turned to portraiture and landscape, and increasingly relativized the place of photography in his activities. The Bibliothèque Nationale de France hosted a very large retrospective of his work in 2003, which was organized by his friend and publisher, Robert Delpire.

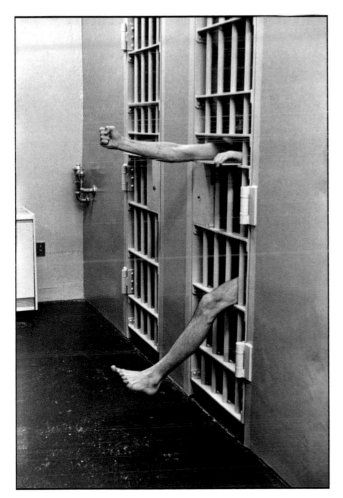

Henri Cartier-Bresson, *Leesbury Prison, New Jersey, USA,* 1975

This shot is entirely typical of Cartier-Bresson's rapid, geometric approach, but it is also a reminder of the committed stance of the work of a man who always fought for human rights. Instinctively he has caught the brief moment of the prisoner's protest by perfect use of the diagonal in the photo's composition, in a way that is both simple and effective. The angle of the shot and use of the bars give a perfectly balanced rhythm to the space.

MANUEL ALVAREZ BRAVO
(1902–2002)

Manuel Alvarez Bravo, who died at the age of one hundred in 2002, was historically the most important photographic author in Latin America and a founder of modern photography. While his unique, simple approach lacked the virtuoso centering of his friend Henri Cartier-Bresson, his vision had a poetic character akin to that of André Kertész, another friend. Born into a family of art lovers in Mexico City in 1902, he learned photography from Hugo Brehme before becoming acquainted with Tina Modotti and Edward Weston. Bravo was also very close to committed muralists, including Diego Rivera. The left-wing Mexican circles instantly appreciated his photographs, which successfully caught the capriciousness and diversity of Mexican culture, not least its Indian side, which he quickly went on to show. He enthusiastically devoted himself to the production of series of nudes, as well as to recording views of Mexico City that transcended the obviously everyday.

Better than anyone, Bravo knew how to capture the dreamlike dimension contained in minute instants of the everyday, how to change a glint in a puddle into pure poetry. He also produced a number of landscapes and pictures of cacti with a graphic quality that is found throughout his work. His commitment to the Mexican people found expression in his direction of a large project to document Mexican popular culture, and he compiled an extensive collection of photographs for the Fundación Televisa. Bravo's personal collection (including an astonishing group on the theme of the ladder) he bequeathed to the Museo de Arte

Moderno in Mexico City. An international prizewinner and a worldwide celebrity, he always said that he was no surrealist, despite having been taken up by André Breton. At the end of his life, the Museum of Modern Art devoted a substantial retrospective to Bravo's work, assembling period prints of most of his iconic pictures.

Manuel Alvarez Bravo, *Striking Worker Assassinated* (1934)

Though isolated within a body of work that does not portray current events, this particular photograph was very important to Alvarez Bravo, who had it figure in most of his exhibitions. This murdered worker on strike certifies Alvarez Bravo's progressivist commitment. But he kept this photo preeminently for its composition and aesthetic quality, which was very different from the usual documents provided by reporters at the time. Neither spectacular nor simply descriptive, it holds, in spite of the dramatic character of the situation, a mystery bathed in soft light and sensitive, yet not demonstrative, emotion.

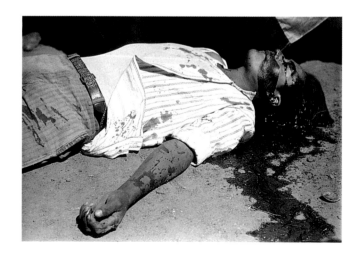

Manuel Alvarez Bravo, *Optic Parable* (1931)

In framing an optician's shop window in Mexico City and playing with the reflections, the artist invented a strange space that became—as is emphasized by the title—a metaphor of photography. It is easy to see how the surrealists were attracted to this image, which places the eye at the center of creation, is constructed on the theme of the mirror, and which rejects the obvious or ordinary perception of the everyday. There are clear links to the works of Joan Miró, Luis Buñuel, and/or Salvador Dalí. A print of this photograph figured in André Breton's collection.

Manuel Alvarez Bravo, *The Good Reputation, Sleeping* (1939)

This strange bandaged nude, portrayed on a Mexico City terrace, is one of the great Mexican photographer's most famous pictures, and it has been used as the cover picture on several monographs. It was commissioned by André Breton for his Mexican exhibition, the "Country of Real Surrealism," and it figures in the greatest world collections. This provocative "good reputation, sleeping" is, however, not typical of Alvarez Bravo's approach to the nude which, right up to his death, was progressively characterized by much more marked sensuality and graphic sense, elegance, and mystery than is evident in this picture.

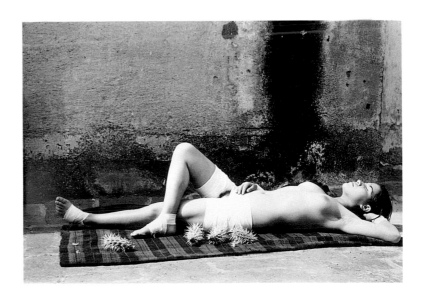

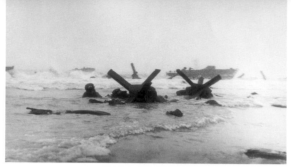

26: **WORLD WAR II**

Although the media has covered dramatic world events since it first became possible to collect and distribute pictures, only a few photographs really stick in the memory. World War II produced some emblematic examples, but it is those of the Liberation that represent the lasting memory of the conflict in Europe.

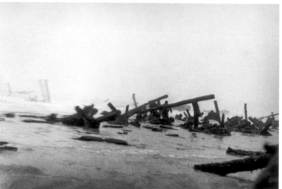

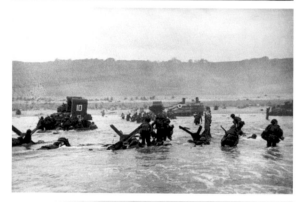

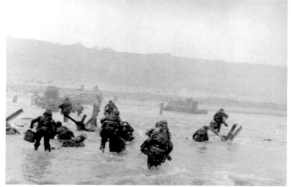

Robert Capa, *Omaha Beach* (June 6, 1944)

Robert Capa took these photographs, which he "saved from the waters" on June 6, 1944, at Omaha Beach during the debarkation.

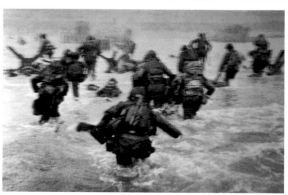

ROBERT CAPA: *OMAHA BEACH* (JUNE 6, 1944)

"If your photos aren't any good, it's because you weren't close enough." Faithful to his motto, Robert Capa took part in the first D-Day landing on June 6, 1944. He tells of the experience with his usual nonchalance. "It was pretty bad over there. I didn't have anything else to do, so I started taking photos."

Armed with two Contaxes loaded with Double-X Kodak film, and lying flat-down in water and sand for an hour and a half under German fire, Capa photographed everything in sight until his film ran out. Without reloading his cameras, he retreated into a barge that was taking away the earliest wounded. His film reached the London offices of *Life* the following evening, just as the magazine that had accredited him was closing. In order to speed up the drying of the developed negatives, the laboratory assistant raised the temperature in the dryer to the point where the emulsion on the precious documents literally started to melt. Of the seventy-two shots, only eight were saved from disaster! The poor definition due to the bad laboratory treatment, along with the murky, foggy aspect that came from the reticulated gelatin, endowed the photos with a unique "authenticity" or "miraculous realism" that corresponded particularly well to the dramatic power of the event and gave these D-Day images an iconic status. The product of a technical mishap, these photos passed into legend.

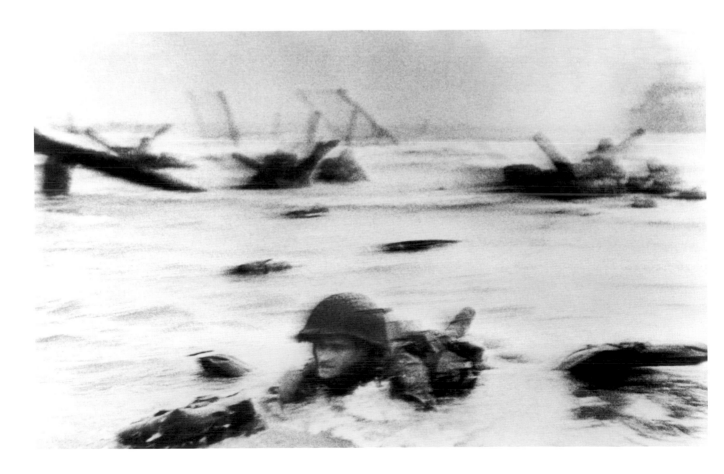

YEVGENY KHALDEI: *CAPTURE OF THE REICHSTAG* (BERLIN, MAY 2, 1945)

An official photographer of the Soviet state information services and of Stalin, as well as a Soviet Army war correspondent, Comrade Khaldei was dispatched to the front by special airplane to cover and witness the Soviet victory over Nazi Germany.

Khaldei was not expected to improvise but to bring back from his expedition an appropriate photograph, whatever the cost. During the night of May 1, he "borrowed" three red tablecloths from a restaurant and gave them to his sister, who made a good-sized flag on which she stitched a hammer and sickle, the Soviet emblems. Khaldei sped toward Berlin at dawn, with only a single day to work before him. The city was about to fall, but there were still pockets of resistance that made the approach dangerous. Khaldei knew what he had to do: get a picture of the Soviet flag flying over the Reichstag. Despite the machine-gun fire, he managed to recruit two soldiers to accompany him. Scaling the building was perilous, as there was still plenty of enemy fire. The photographer chose his setting, and his photographic stagehands managed with difficulty to oblige. Finally, the flag flew atop the building against a background scene of smoking city ruins. The shot was taken.

This "manufactured" image was to become not just a symbol of the war's end but, even more, of the Communist victory over fascism. It is said that when he looked closely at the picture he had taken, Khaldei noticed that the flag-waver's assistant, a Red Army sergeant, had two watches on his wrist—proof that he had been pillaging. Far from being an emblem, the photo was sullied with the sordid commonplace. But the master's retouching skill soon removed the embarrassing detail for the sake of posterity.

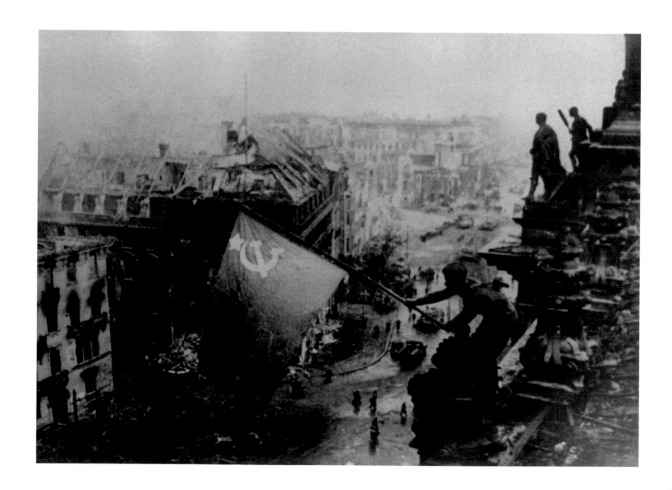

STANISLAW MUCHA: *THE ENTRANCE TO AUSCHWITZ-BIRKENAU* (FEBRUARY 1945)

The first discovery of the unspeakable took place on the Eastern front, when the Red Army entered the Madjanek camp in Poland in July 1944, and then on the Western front the following November, when the American army reached the camp of Struthof in the Vosges. These were the beginnings of a long journey into the horrific that would bring worldwide notoriety to the baleful names of Bergen-Belsen, Dachau, Büchenwald, Sachsenhausen, Ravensbrück, Mathausen, and Auschwitz-Birkenau. In order to capture the necessary record, photographers were sent to these places, where they did their duty as witnesses.

The pictures taken when the camps were liberated were those of the first eyes to look upon the indescribable. The documentation was abundant; its accumulation of brutal reality, its utter abomination was captured by some of the greatest photographers of the time—Robert Capa, Lee Miller, George Rodger, Germaine Krull, Margaret Bourke-White, and others—and it provided the prosecutors at Nuremberg with some of their evidence.

But perhaps the strongest image was Stanislaw Mucha's photo of the entrance to Auschwitz. It symbolized, without showing it, the absolute horror of the wasted bodies, the striped uniforms, the heaps of bones and piles of objects, the gas chambers and cremation ovens so familiar from other photographs and films, including Alain Resnais's famous *Nuit et Brouillard* (Night and Fog).

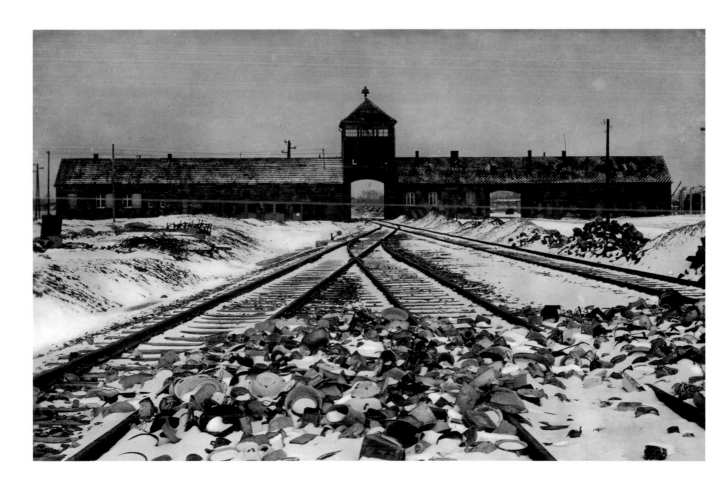

Messengers Leaving Agence France-Presse, Place de la Bourse (Paris, 1950)

The Photographers of VII (New York, January 2004)

27: **PHOTO AGENCIES**

Important magazines like France's *Paris Match* and its illustrious American model *Life*, whose photo archives are beyond reckoning, have always had sizable teams of photojournalists at their disposal. But much of our information about events around the world comes from news agencies, such as the one founded by Charles-Louis Havas in 1835. The Havas Agency, which changed its name to France-Presse upon the liberation of France in 1945, was the first to gather and sell news dispatches to newspapers. Following the same principle, agencies began to produce and distribute photographs that the newspapers were unable to get for themselves.

SELLING PHOTOGRAPHS

By the beginning of the twentieth century, the invention of the Belinograph had made it possible to transmit text and images around the world by telephone. International news agencies such as Reuters in London and the Associated Press in New York, all based on the Havas agency model, began to combine photographs with written dispatches. Certain agencies decided to specialize in photography. In 1928, the German photographer Umbo contributed to the creation of the first photo agency, the Dephot (short for "Deutsch Photodienst") agency. In 1933, in Paris, Charles Rado started the Rapho agency, whose name remains associated with the work of photographers such as Robert Doisneau, Willy Ronis, and Sabine Weiss. Focused on social subjects rather than on news features, these photographers' pictures were destined both for the press and for book publication. The next year, a group of photographers including Pierre Boucher, Pierre Verger, René Zuber, Emeric Feher, and Denise Bellon created the Alliance Photo, an agency that would eventually enjoy the collaboration of future Magnum agency founders Henri Cartier-Bresson, Robert Capa, and David Seymour. Meanwhile, the Black Star agency was founded in New York in 1935, of which W. Eugene Smith would be a member. With the founding of Magnum in 1947, photojournalism took a quantum leap. Magnum, which functioned as a cooperative in which the photographers were the owners, made the defense of photographers' rights its primary goal. The objective was to protect photographers' work from abusive use at the hands of its buyers. Magnum demanded that buyers respect photographers' framing and captions, and fought against the manipulation of photojournalists' work. Throughout this period, Magnum photographers documented the significant events of the postwar years, from the extension of the Cold War to the conflicts in Indochina, little by little building an exceptional archive.

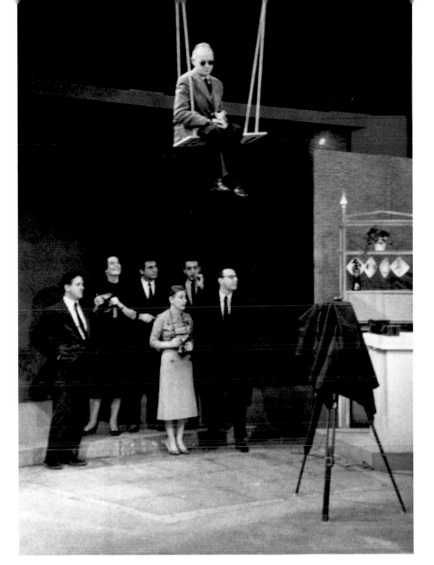

Magnum (New York, 1955)

Members of Magnum, in New York, at their annual meeting, interviewed by Arlene Francis for the *Today Show*. The photographers present on that day included Erich Hartmann, Inge Morath, Elliott Erwitt, Dennis Stock, Burt Glinn, Eve Arnold, and Henri Cartier-Bresson (on the swing).

MORE NEWS AGENCIES

At the end of the 1960s, several photo news agencies had been created and were growing rapidly, but they soon encountered fierce competition as the illustrated press suffered through its first crises as a result of the expansion of television news. In Paris, the Gamma agency was launched in 1967 at the initiative of Raymond Depardon and Gilles Caron, among others, and was followed by Sygma, which was started by one of Gamma's founders, Hubert Henrotte. A photographer of Turkish origin, Göksin Sipahioglu, founded Sipa in 1973. This agency would remain active in the news field for a very long time, while others, such as Sygma, slowly abandoned news to meet magazines' increasing demand for celebrity subjects.

Today, the drop in the press' financial means and the extremely high cost of digitalized images have forced many agencies to consolidate with bigger companies capable of distributing photography on a global scale. Hachette Filipacchi Media (HFM), for instance, has absorbed Rapho and Gamma, and Corbis has taken over Sygma. Getty Images has become one of the most important providers of not only news photography but magazine and advertising content as well.

Along with Magnum, some smaller independent companies have managed to survive. These include Contact Press Images, which has remained true to its photojournalist vocation since its founding in New York in 1976, and Vu, in Paris, which has undergone far greater diversification. In 2001, seven photographers boasting solid relationships with big magazines such as *Time* founded VII, an agency that meets the requirements of digital-image communication technology and maintains a minimal structure. In France, new groups of photographers such as L'Oeil Public and Tendance Floue have been started as collectives in order to preserve a greater degree of independence for their members.

28: MODERN JAPANESE PHOTOG- RAPHY

Following the European example, Japanese photography at the turn of the century was dominated by pictorialism. Photographers such as Teiko Shiotani and Shinzo Fukuhara— also known as one of the directors of the Shiseido cosmetics company—used land- scapes, nudes, and still lifes as their subject matter, and opted for effects that kept photography distinctly apart from a realistic, detailed vision of the world.

BIRTH OF MODERNITY

When European art journals began to circulate in Japan during the 1920s, photographers such as Shoji Ueda discovered the possibilities of using photography as a means of formal expression and of experimenting with new subjects. Chihiro Minato, a historian of Japanese photography, also stresses the importance of the earthquake that destroyed Tokyo in 1923 as an event that anchored documentary photography and clearly displayed its importance: photographers worked to show the consequences of the disaster, and to describe the ruined state of the city of Tokyo and the conditions in which its inhabitants were living. Finally, in 1931, the "Film und Foto" exhibition presented in Tokyo and Osaka revealed the different facets of a new type of photographic expression to Japanese audiences. Traditionally, photographers gathered together in Japan's various regions to form clubs participate in contests, and send shots to photography magazines, one of the most highly reputed, *Camera*, was published in Tokyo. Outside of the studio portrait, photography was an amateur's art. One of the first groups to form around a new concept of photography was made up of Ihei Kimura, Hiroshi Hamaya, and Ken Domon. The members of this group all followed a realistic approach, as opposed to the "poetic" vision of photographers such as Shoji Ueda. Hamaya used an anthropologist's eye to explore Japanese life outside the big cities, while both Ken Domon and Ihei Kimura were more closely associated with the representation of urban reality. Ken Domon was very interested in the world of children, and Kimura was one of the first 35mm enthusiasts. While many other photographers were still working in medium format, Kimura enjoyed the tremendous freedom of vision provided by the 35mm format.

THE UPHEAVALS OF WORLD WAR II

The war and its tragic outcome—the dropping of the atomic bombs on Hiroshima and Nagasaki— were tremendously difficult ordeals for the Japa-nese people to overcome. With the support of *Camera* magazine, then being run by the photographer Kineo Kuwabara, Japanese documentary photographers attempted an assessment of the country after the war. New photographers appeared to document the reconstruction of Japan. Tadahiko Hayashi photographed the new generation of Japanese writers, while Yasuhiro Ishimoto had a specific interest in the evolution of the urban landscape. Certain photographers even attempted to break the taboo surrounding the areas of Hiroshima and Nagasaki. Shomei Tomatsu worked with the survivors of Nagasaki and showed the terrible scars on their bodies. Ikko Narahara alluded to the war in his early pictures. Narahara joined Shomei Tomatsu and Eikoh Hosoe in creating the Vivo agency in 1959, but as they began to find their photographs moving away from a strictly documentary approach, the founders of Vivo quickly took back their independence. Ikko Narahara left Japan to work on a personal chronicle of his travels through the United States and Europe, while Eikoh Hosoe became known for very formal work, particularly in the domain of the nude. The beauty of his images rests on a perfect mastery of black and white. Another photographer from this generation, Kishin Shinoyama, stands out for his nudes in highly contrasted black and white, a practice that can also be found in the work of Daido Moriyama. Moriyama built a violent, occasionally insolent, body of work on the theme of the city: he showed a rebellious spirit in a period during which the country was content with the established economic and social mores. Moriyama allowed for the unexpected. He took countless pictures and published many books. His vision of the day-to-day city, his autobiographical writing, and the rhythm and general atmosphere of his work are reminiscent of the photographs of one of the most famous Japanese photographers, Nobuyoshi Araki.

Ikko Narahara, *Zen # 30* (1969)

29: SUBJECTIVE PHOTOGRAPHY

The origins of the subjective photography movement can be found in Fotoform. Organized around Otto Steinert, an ex-doctor who became a photographer, a teacher, and historian of photography, this group was largely made up of German photographers (Peter Keetman, Siegfried Lauterwasser, Wolfgang Reisewitz, Toni Schneiders, and Ludwig Windstosser, along with the non-Germans Heinz Hajek-Halke and Christer Strömholm). Starting in 1947, Fotoform attempted to revive prewar experimentation and to explore all the artistic possibilities of the photographic medium through various means, including but not limited to several exhibitions (such as those in Stuttgart and Neustadt).

BIRTH OF THE MOVEMENT

The official birth of the movement only came with the "Subjektive Fotografie" exhibition, organized in Saarbrucken at Steinert's initiative in 1951. Following in the wake of the New Vision of the 1920s and 1930s, particularly Moholy-Nagy, Man Ray, and Herbert Bayer, and intentionally rejecting documentary photography, Steinert intended to "present a selection of the creative spirits in modern photography." Beyond this vague statement, the show was conceived to rehabilitate the creative personality of the photographer and to promote a photography "in which the artist has subjected the facts of exterior reality to the transformations suggested by his personal vision of the world."

Featuring about 725 photos, "Subjektive Fotografie" presented itself as the most important postwar photography exhibition in Europe and included the work of other European groups: NFK (Netherlands), Groupe des XV (France), La Bussola (Italy), and CS Association (United Kingdom). This abundant selection was not entirely successful in concealing the frequently ambiguous character of the approach or the theme, particularly given that only about a hundred works on show could truly fit a definition of subjective photography. With the support of Franz Roh, an influential postwar proponent of New Photography, Steinert made his position more precise with two further exhibitions organized in 1954 and 1958.

Nonetheless, the Subjective Photography movement remained an ambiguous one throughout the decade. The movement's imprecise borders allowed for references both to New Photography and to surrealism. In retrospect, it seems that this largely European movement gathered highly diverse approaches and styles under the umbrella of a "subjectivity" that was very difficult to define. It included everything under the sun. There were experimental practices that leaned toward nonfigurative photographs frequently made without a camera (such as Pierre Cordier and his chemigrams, or Hajek-Halke and his light-drawings), and which could be associated with the renewal of abstract painting in postwar Europe, especially with regard to the Fotoform group's work.

There were also experiments in a more documentary, though poetic, vein (Izis, Robert Doisneau, Édouard Boubat), which had links with the so-called humanist photography. Mostly, there were highly individual and diverse works by photographers from several generations, including Bill Brandt, Brassaï, and Mario Giacomelli. Though the movement came to an end in the late fifties, it had a lasting influence on its contemporary generations as they came to photography, both in the United States (Duane Michals, Jerry Uelsman) and in France (Jean-Pierre Sudre, Jean Dieuzaide).

Otto Steinert,
Strenges Ballet
(1949)

For Steinert, photography is the means by which he expresses his creativity and imagination.

BETWEEN CREATIVITY AND DOCUMENTATION: THE AMERICAN SCENE, 1950–1970

Despite the fact that it was an essentially European movement, Subjective Photography had a definite impact in the United States. The movement's concerns were reflected in shows at the George Eastman House in Rochester (1953) and at the Museum of Modern Art in 1958 ("Abstraction in Photography") and 1960 ("The Sense of Abstraction"). In fact, the subjective movement maintained ties with the work of several American photographers who came together under the name Creative Photography (including Minor White, Aaron Siskind, Harry Callahan, and Frederick Sommer). Creative Photography was particularly fruitful at the Chicago School of Design, which was under the influence of the double modernist heritage of Moholy-Nagy (the school's founder) and the more specifically American work of Alfred Stieglitz and Edward Weston. With their radically stripped-down images relying on strong black-and-white contrasts, Aaron Siskind, who came from a documentary tradition, and Harry Callahan, who was a teacher at the School of Design, stand out as the major figures of this movement. Its

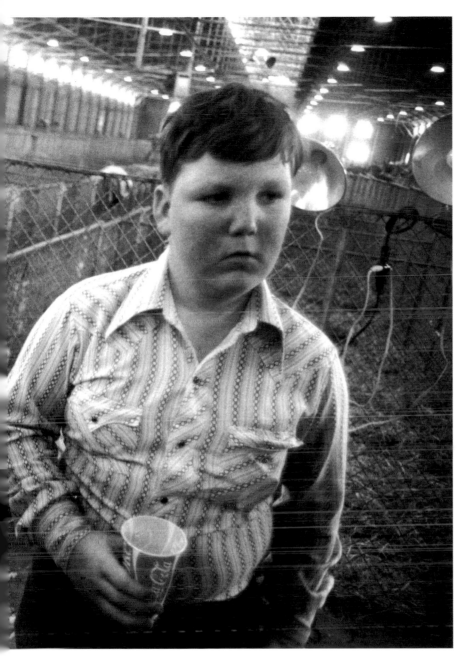

Garry Winogrand, *Fort Worth, Texas* (1975)

"I photograph to know what something looks like when photographed," said Garry Winogrand. Indeed, everything seems odd, incongruous, and unsettled in this photograph. Something strange seems to have just happened, something that can be seen in the animal's eye (a lamb?) and in the lost look of the young man. The photographer doesn't shy away from questioning the American conscience he seeks. Daily life suddenly turns worrisome.

influence would be felt well into the sixties, particularly on the work of their students (Ray Metzker, Barbara Crane, and Kenneth Josephson).

However, starting at the beginning of the sixties, under the twin influence of William Klein and, especially, Robert Frank, a new documentary tendency began developing in the United States. More specifically, this influence was felt around New York, in reaction to the clean conscience of a certain humanist tradition in photography. This new tendency, whose most illustrious representatives remain Garry Winogrand, Lee Friedlander, and Diane Arbus—all three of whom were gathered in the Museum of Modern Art's 1967 exhibition "New Documents"—along with Joel Meyerowitz and Danny Lyon. Together, they presented a new urban sensibility that was constantly critical toward American society. These photographers were all connected to another tradition in American photography (Weegee, the Photo League). Though they may have had stylistic differences, they all had a disquieting, sometimes ironic touch that was in clear conflict with the humanism of the Family of Man proponents and the bare-bones compositions of the Creative Photography group.

30: THE FAMILY OF MAN

In January 1955, the exhibition "The Family of Man" opened at the Museum of Modern Art (MoMA). Organized by Edward Steichen, who was MoMA's head curator of photography since 1947, the exhibition was the outcome of Steichen's many years of reflection about photography and its ability to transmit ideas. It was to be a landmark in the history of photography in the twentieth century.

A HUGE PROJECT

The scale of the project was exceptional. Steichen gathered 503 images from the work of 273 photographers from sixty-eight countries. The pictures covered 7,750 square feet of wall space and took up an entire floor of the museum. In two years of preparation, Steichen had reviewed 2 million prints. The photographs were printed in highly diverse formats, ranging from 5 x 7–inch prints to giant enlargements, and the visual organization of the show was spectacular.

The exhibition was laid out according to a double approach: chronological (all of life's important stages, from birth to death, were included) and geographic (all the areas of the world were shown without any distinction, from the most primitive to the most modern civilizations). The show was divided into about twenty-five sections, each of which was organized around a specific theme. The photos were accompanied by a completely heterogeneous mix of roughly fifty short quotes taken from great religious, philosophical, and literary texts, without any division according to religious or cultural origin. For Steichen, who believed that all men were brothers, no matter their culture, this was a way to bring the peoples of the world closer together in a single "family" of thought.

Though he did solicit work from the most famous photographers of his time, Steichen only selected those images that were linked to the exhibition's theme of family.

The exhibition went on the road in 1955. In its twelve-year travels around the world, it drew 9 million visitors; 3 million catalogues were sold. In keeping with Steichen's wishes, a version of the

Ezra Stoller,
"The Family of Man" at the Museum of Modern Art, New York (1955)

exhibition was donated to his birthplace, the Grand Duchy of Luxembourg. This version of the exhibition has been totally restored and has been on view in Luxembourg since 1994, at the Château de Clervaux. Recognition of the exhibition's continued importance can be found in the fact that in 2003, "The Family of Man" was added to the United Nations Educational, Scientific, and Cultural Organization (UNESCO) "Memory of the World" registry.

A HUMANIST, CHRISTIAN CURATOR

The famous verse from Genesis, "Let there be light," opened the exhibition. Steichen stated that he thought "love should be the dominant theme of 'The Family of Man,' as it is in any family." Steichen wanted to show that photography could carry an ecumenical message and that it possessed a real power: "The art of photography is a dynamic process which gives shape to ideas and explains man to man," he added.

"The Family of Man" has frequently been seen as an American attempt to pacify a world that was still reeling from World War II, but the show also displays its organizer's adherence to a brand of humanism tinted with positivism. Steichen believed in man and his ability to evolve, a profession of faith that would be difficult to adapt to a political agenda. Indeed, any picture showing an ideological commitment was rejected, and the exhibition contained only a single picture of the war, taken in the Warsaw Ghetto. Still, when "The Family of Man" was shown in Paris, Roland Barthes criticized it heavily on the grounds that it promoted an attitude that aimed to deny history.

HUMANISM AND PHOTOGRAPHY

The impressive list of photographers includes some names that have left their mark on twentieth-century photography: August Sander, Henri Cartier-Bresson, W. Eugene Smith, and Robert Frank, to name a few. Most of these photographers held man at the center of their concerns, and their approach was directly in line with Steichen's humanism. For photographer W. Eugene Smith, whose contribution to Steichen's exhibition was one of the most remarkable, anyone, no matter how humble, was a hero with a mission. The photos by Willy Ronis,

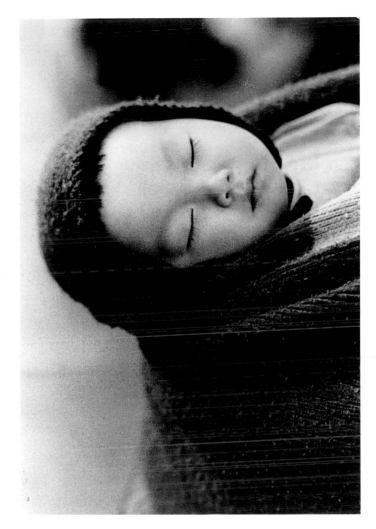

Eiju Ohtake, *Verro* (Tokyo, December 1953)

Although the photographer's name hasn't been preserved for posterity, the same is not true of his photographs. His images have been seen around the world, symbolizing childhood, happiness, and family. He represented a humanity that Edward Steichen wanted to bring to the fore.

Robert Doisneau, and Édouard Boubat, whose styles shaped twentieth-century French photography, are different. Though these photographers can also be referred to as humanists, their vision is more poetic, sentimental, and perhaps even humorous.

31: ROBERT FRANK AND WILLIAM KLEIN: THE "ENFANTS TERRIBLES" OF PHOTOGRAPHY

Take William Klein, an American in Paris who returned to the United States, and add in Robert Frank, a Swiss citizen who settled in New York. In this combination, we see the dual photographic fate of artists who entered the photo scene as rule-breakers and eventually reached the peak of their photographic achievement in the books they published. At a time when the Museum of Modern Art was showing "The Family of Man" (1955), an exhibition that glorified humanist reportage and idealized feel-good photography, Klein and Frank began to develop a subjective approach to America through their nonconformist photographs. In two books, *New York* (1956) and *The Americans* (1958), both initially published in Paris, Klein and Frank created a narrative space that radically broke with the period's editorial principles.

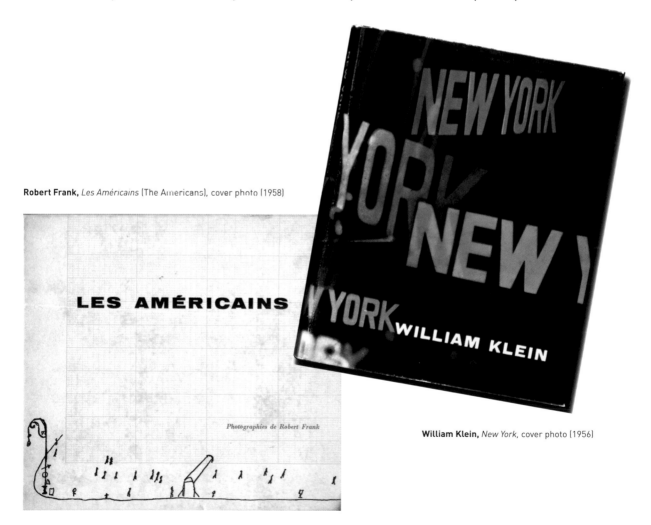

Robert Frank, *Les Américains* (The Americans), cover photo (1958)

William Klein, *New York,* cover photo (1956)

WILLIAM KLEIN'S *NEW YORK*

Klein moved to Paris at twenty to become a painter, and here found an outlet for his taste for photographic experimentation. He approached this new discipline without the slightest taboo, pertinently remarking that "painters have long since thrown off the rules; why shouldn't photographers?"

In 1955, he returned for the first time to his hometown, New York. Like a stranger looking at "his" town, he started keeping a sort of travel diary. He kept a daily chronicle of his stay, using the photographic gestures he had been experimenting with to catalogue the streets, the written and illustrated signs polluting the open spaces, and the massed crowds on the sidewalks who bunched together on the corner to wait for the "Walk" signal. To capture this frenetic spirit, Klein practiced a no-holds-barred form of photography. He took wide-angle snapshots in close-up; he accumulated blurry, shaky, off-center images sometimes without looking through the viewfinder; and he printed his images in very high contrast, as if they were mere outlines. In these pictures, characters emerge from the crowd like anonymous portraits, and children exhibit and manipulate plastic revolvers under the photographer's eye.

This photographic abundance was naturally reflected in the book, whose full title is *Life Is Good and Good for You in New York, William Klein Trance Witness Revels*. Klein took sole responsibility for the design and typographic choices of his book. The images unfurl in steady succession as if this were a long comic book, without interval or margins. The layout brilliantly but naturally reproduced the feeling of walking through a modern city in the midst of the crowd. Chris Marker, who was then an editor at the Éditions du Seuil, managed to get the book published. Bookstores shelved it in the "Travel" section.

ROBERT FRANK'S *THE AMERICANS*

"1955, I cross the States. For a year. Five hundred rolls of film. I work all the time. I don't speak much. I try not to be seen." Robert Frank set off behind the wheel of an old beat-up car to record the situations and events he encountered over the course of his journey. Holding the camera at arm's length, he frequently shot without looking through the viewfinder. This left him free to include off-center framing, blurry pictures, and on-the-fly snapshots, in which content was more important than form. This disregard of the stylistic dictates of the day showed a rejection of "the pretty picture" on the part of a photographer who seemed unwilling to find any validity in any existing aesthetic principles. Frank assembled a selection of eighty-three photographs, prepared a layout, and eventually met the young French publisher Robert Delpire. Three years after the series was complete, Delpire finally published Frank's work.

The book, which has attained legendary status and has frequently been reissued in revised editions, was initially a total failure: "1958, Delpire publishes *The Americans*. The reviews are bad. This book is 'sinister', 'perverse', 'anti-American.' I'm not hurt, rather disappointed, but glad my work was used. The best I could hope was that the book should be published."

Klein's frenzied photographic compulsion was the mirror image of Robert Frank's slow gait. Without ever blending together, these two approaches put generations of photographers on the path to a style and practice that broke with common methods. Any photojournalist who began working in the seventies considers him- or herself a follower of these two giants.

pp. 134–135: **William Klein,** *Gun Two* (New York, 1954)
Klein photographed "his" city, keeping a kind of log. He captured poses by taking shots without looking through the viewfinder, using the wide angle, the zoom, or the open flash technique. He sought to create images that were "as common and banal as those in the news." In the same vein as *New York*, he published *Rome* (1958), *Moscow* (1964), and then *Tokyo* (1964).

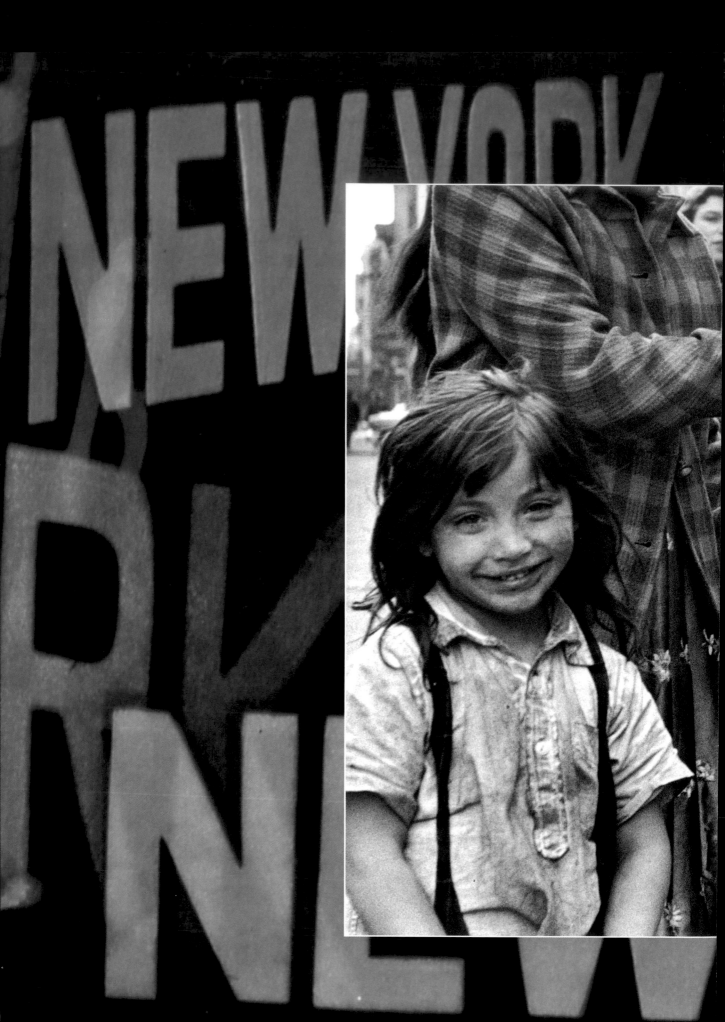

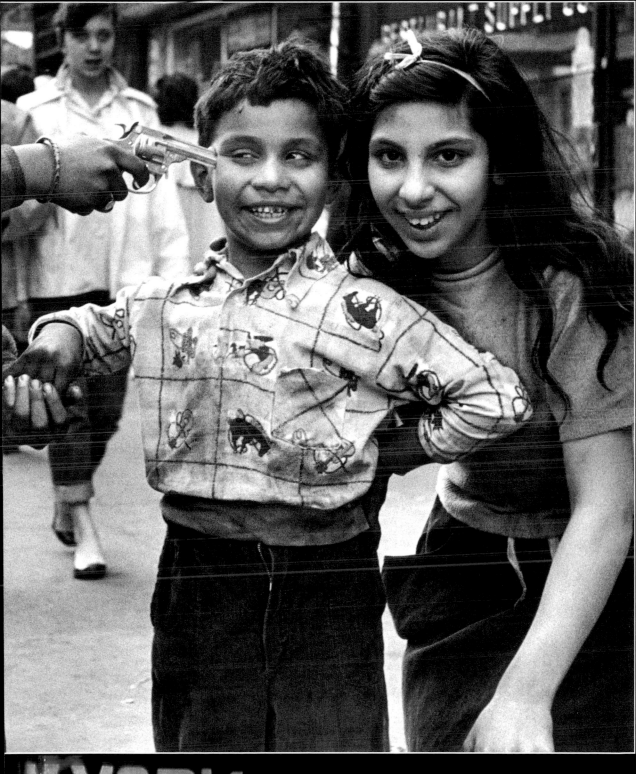

YORK WILLIAM KLEIN

32: FROM COLONIALIZATION TO INDEPENDENCE

In the history of photography, two modern conflicts stand out as opportunities for capturing the reality of colonialization and of war waged against a native people. The two opportunities were radically different. In Algeria, the photographic record was created almost completely under official control. In Vietnam, the photojournalists were free to tell their own stories of what they saw.

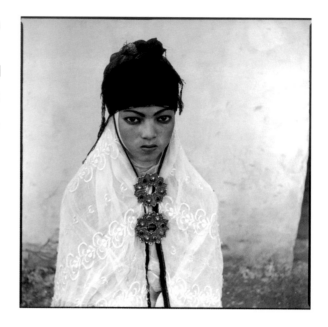

Marc Garanger, *The Algerian Woman* (1960)
During the Algerian War, Marc Garanger was with the task of photographing Algerian women for their identification papers. They had to take off their veils and show their faces to the French occupying forces.

PHOTOGRAPHERS AND THE ALGERIAN WAR (1954–1962)

Like the conflict itself, long played down and then ignored, the photographic remains of the war in Algeria have only lately begun to be rediscovered and appreciated. The way photographers covered Algeria is similar to media coverage of other decolonization wars of the same period: on the whole, photographs directly ordered by the army look more like propaganda than real documentation. The notable exception are the thousands of portraits of Algerian women that photographer Marc Garanger took for the purposes of making them new identity cards.

For a more candid view of the conflict, it is necessary to look toward professional reporters (such as Raymond Depardon or Marc Riboud), agency photographers (like those of the AFP), work ordered by the large news magazines (such as *Paris Match*), or amateur snapshots, especially those taken by fighters conscripted into action.

Despite these important contributions, most of the work being unearthed offers a one-sided, French point of view on the war, with little focus on the Algerian population itself. As a result, the reporting of Dutchman Kryn Taconis in 1957 on the Algerian combatants, which was censored by the Magnum agency, takes on an exceptional value, as does the reporting of the American Dicky Chapelle on the FLN (the separatist party Front de Libération Nationale).

THE VIETNAM WAR (1961–1975)

The war in Indochina began in 1946. It ended for France in the defeat at Diên Biên Phu in 1954, and France pulled out of the entire Southeast Asian region. Ten years later, South Vietnam appealed to the United States for help against the northern Vietcong, who were allied to Communist China and the USSR. U.S. troops arrived and began the first aerial bombardments of North Vietnam. The

subsequent conflict extended into Cambodia and Laos and lasted until 1975, leaving Vietnam in ruins. Towns were entirely destroyed in both the north and south; there were 2 million dead and 5 million wounded.

ONE OF THE GREATEST PHOTOGRAPHIC "COVERAGES" OF THE LAST CENTURY

The Vietnam War marked a turning point in photographic reportage. On the ground were several hundred photographers; one of them, Larry Burrows, was to devote seven years of his life to the conflict. Among the reporters in Vietnam were war specialists such as Larry Burrows and Don McCullin, sent out by their magazines, as well as young photographers such as Catherine Leroy. Leroy arrived in Vietnam in 1968 with just a few dollars, but went on to earn high praise with her courageous report made from the North Vietnam town of Hué. A number of other women, including Christine Spengler and Françoise Demulder, distinguished themselves alongside the men. The enormous photographic record of the Vietnam War we have today was made possible by the freedom reporters had, with the U.S. Army even giving them the means to move around on the front lines. The army believed the press would present a positive image of their presence and action. But this freedom backfired when all this publicity revealed the real horrors of the war.

In 1968, David Douglas Duncan, a former soldier who had also covered World War II, published a pamphlet called *I Protest*, denouncing what was going on in the ranks of the U.S. soldiers. The following year, *Life* magazine published an article by Larry Burrows voicing the soldiers' disillusion and exhaustion. Another reporter, Philip Jones Griffiths, published a book, *Vietnam, Inc.*, which amounted to a ringing denunciation of the conflict being carried on by the Americans.

Larry Burrows, *U.S. Air Force Helicopter during an Attack on North Vietnam* (Khe Sanh, Vietnam, April 1, 1968)

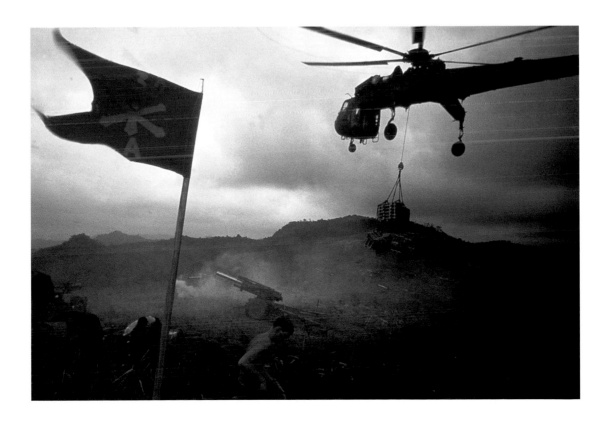

UNSPEAKABLE HORROR:
A MURDEROUS WAR

Larry Burrows, one of the Vietnam War's most persistent photographers, worked in black and white as well as color for *Life* magazine. One of the most tragic scenes that he captured took place in a U.S. Army helicopter—the helicopter that director Francis Ford Coppola would choose as one of the symbols of his film *Apocalypse Now.* Between battles, Burrows photographed situations that recalled what the soldiers had experienced in the trenches of World War I.

Because of their impact, two images of the Vietnam War were to play an important role in the process of American disengagement. The first, captured by Eddie Adams in 1968, showed a South Vietnamese officer executing a suspected Vietcong on the road. The second, caught by Nick Ut, was taken in 1972 on the road leading from a recently napalmed village. The fallout from these pictures legitimizes the belief that photography possesses real power, the power to contribute to a change in public opinion.

The Vietnam War was murderous to the reporters, too. One hundred and thirty-five died. One of their fellows, Tim Page, paid them homage in 1997, in a book and exhibition entitled *Requiem,* a tribute to those who died in Vietnam and to those who lost their lives in Cambodia and Laos, including Robert Capa (who died in Vietnam in 1954), Gilles Caron (Cambodia, 1970), and Larry Burrows (Laos, 1971).

With the end of the Vietnam War in 1975, the history of photojournalism changed as television assumed more and more importance. The freedom that photojournalists had been given in the Vietnam War would never be equaled. In the 1990 Gulf War, for instance, the reporter's work was monitored, sometimes directed and, on occasions, rendered impossible.

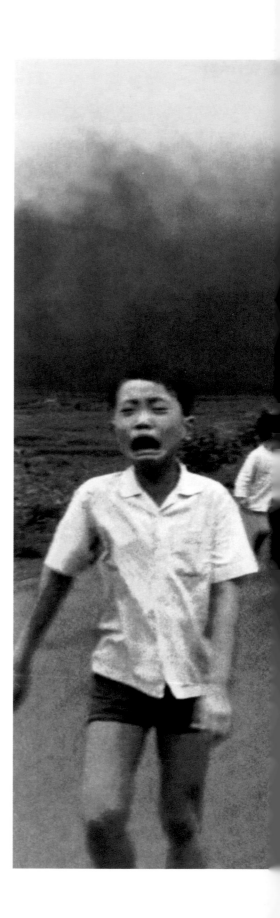

Nick Ut, *The Children of Trang Band* (Vietnam, 1972)

The naked little girl in the middle is named Kim Phuc. She is suffering from serious napalm burns on her back. Screaming with fear and pain, she runs to escape her village in flames with the other children in her family. In the back, American soldiers are trying to come to their rescue.

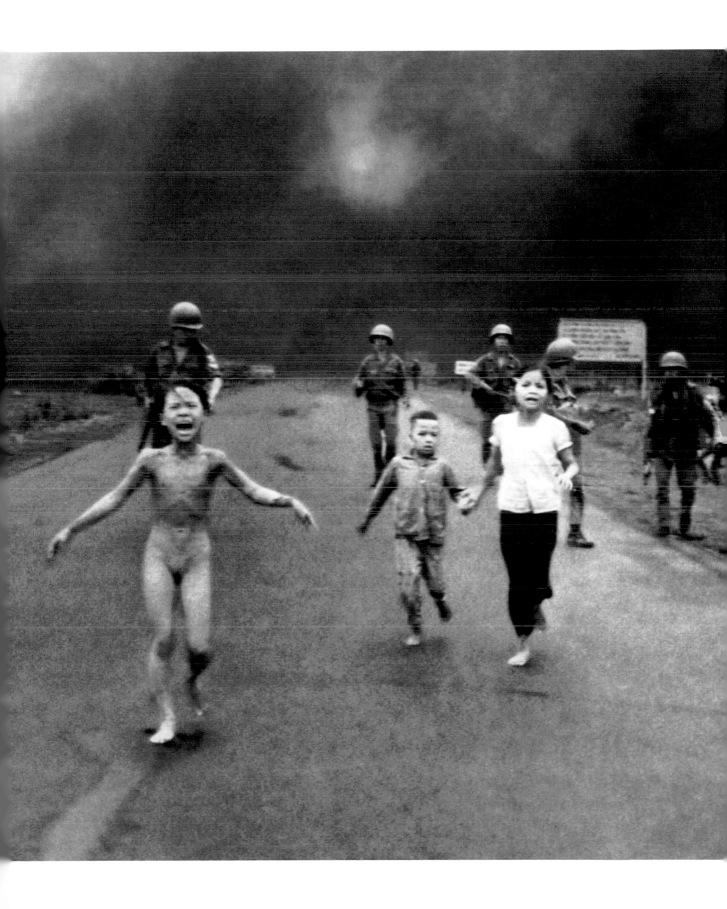

33: THE NEW AMERICAN COLOR PHOTOGRAPHY

In the 1970s, Stephen Shore, William Eggleston, Joel Meyerowitz, Joel Sternfeld, and Richard Misrach practiced a type of photography that radically broke with their famous predecessors, whose aesthetic values they expressly refuted. Gone were formalism, subjects and models, the supremacy of technique, black and white as a synonym for creativity, and homemade printing. These photographers freed themselves both from the Straight Photography introduced by Stieglitz and Steichen at the beginning of the twentieth century and from the New Vision of the 1930s. Without renouncing the work of their predecessors Walker Evans and Lisette Model, which they laid claim to, these photographers embarked on an approach that came to grips with their period. The street, bad taste, and the society of consumption were their favorite themes, and color was an obvious, and essential, factor.

Stephen Shore, *South of Klamath Falls* (Oregon, July 21, 1973)
Young American photographers radically revised the approach to landscape. They worked only in color, steering clear of narrative. Color itself becomes the subject of their photographs.

COLOR: AN OBVIOUS DOCUMENTARY DIMENSION

As Americans who were witnesses to (and participants in) the burgeoning consumer society, these photographers naturally placed the question of territory at the center of their preoccupations. They expanded the territory they dealt with to include the social context in which it was inscribed. They constantly observed their contemporaries, their behavior, their tics, and their destructive folly. Yet above all, it was the city that crystallized this notion of modern life and that became the favorite ground for these new conquerors.

Color was adopted as an unavoidable given, and it stressed the documentary commitment of the photos. William Eggleston definitively brought color photography to the fore with the catalogues of characters and objects from daily life that he presented in his 1976 solo show at the Museum of Modern Art. He extended this work in color in *Democratic Forest* (1989) by taking numerous snapshots that made real beauty surface out of the ordinary.

Joel Meyerowitz's work with a large-format camera (8 x 10 inches) underlines the artist's aesthetic commitment and provides a more contemplative approach to reality. He abandoned his initial black-and-white street photographs for seaside landscapes on Cape Cod and for vacation shots in which he is an actor. Meyerowitz published his first book, *Cape Light,* in 1978, and thus radically changed the conception of color photography. His pictures give a vibrant account of a society that consumes leisure activities.

In his *American Prospects* (1987), Joel Sternfeld did not turn his back on any of the greats who had come before—especially Walker Evans, whose influence was constant, all the way down to the itineraries Sternfeld followed and the subjects he photographed.

Color also had the power to give the image additional subjectivity. This troubling effect finds its origins in the experiments of Harry Callahan, whose color work was the only model for all these young photographers. Some had even been his students.

HARRY CALLAHAN: A UNIQUE CASE

A great photographer and, moreover, a well-known professor at the Art Institute of Chicago and later the Rhode Island School of Design, Callahan had begun working in color in 1941, and returned to it permanently in 1977. Neon lights; signs bearing words or graphics and invading urban space; passersby captured without the photographer looking through the camera in the highly contrasted light of New York; the beaches of Cape Cod; the colored houses of Ireland—all these were the subjects of Harry Callahan's project to reveal a place through color. His 1980 monograph, *Callahan Color,* is the basic template for any color photographer.

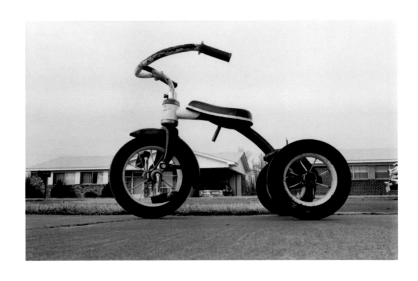

William Eggleston, *Untitled* (1970)

In 1976, William Eggleston published *William Eggleston's Guide,* with a photograph of a bicycle on its cover. Ever since, his color photographs have served as a reference point. They illustrate a world in which daily life could turn into a preposterous and unexpected story. Yet there is nothing that explains the key to this transformation.

34: THE POLAROID

After his 1937 founding of the Polaroid Company, which specialized in research on polarizing light, Edwin H. Land started working in 1943 on perfecting a photographic process that would allow for instant development of pictures. On February 21, 1947, Land presented the fruits of his labor to the Optical Society of America: the first camera to offer instantaneous development. A year later, crowds rushed to the doors of the Jordan Marsh department store in Boston to watch a demonstration. The camera sold for $89.75, and the eight-exposure rolls of film cost $1.75. By the end of the day, the fifty-six units available were already gone. From that point on, the Polaroid would elicit the enthusiasm of amateurs and professionals alike. Though numerous technical advances have improved the Polaroid's technology over the years, its basic technical principles have never been significantly altered.

THE PRINCIPLE OF INSTANT DEVELOPMENT

Land came up with the idea of exposing a silver emulsion to the effects of a reagent that included both a developer and a solvent, thus allowing a positive to be immediately developed. He then equipped a camera with rollers and attached a capsule of reagent to one of the light-sensitive coatings. When the capsule went through the rollers, it burst, releasing the reagent and allowing the picture to form instantly. As it went through a series of improvements, the image achieved greater fidelity, and the principle of the Polaroid was adapted to other media: black and white (1950), high-speed film (1959), color (1963), as well as slides and even instant motion-picture film.

Released in 1972, the SX 70 was a new camera that was both reliable and revolutionary. It was compact (0.6 of an inch thick), folding, and had reflex viewing. What was visible through the square viewfinder was exactly what you got, and the composition did not require the slightest manipulation. The camera focused the shot, automatically set the exposure, and ejected the picture, which then developed in broad daylight right before the photographer's eyes. The SX 70 system put a public spotlight on Polaroid. In 1977, instant cameras represented 40 percent of camera sales in the United States, and 4 million Polaroid photographs were being taken each day.

After having the instant-photo market to itself for many years, Polaroid was eventually joined by Kodak and Fuji. The brand's decline was not so much the result of competition as the public's shift of interest to new technologies, such as digital photography. However, Polaroid's instant-development film still plays a significant role in many fields, notably the technical and scientific ones.

ARTISTS AND POLAROID

Along with its use for ID photos and in fields as varied as medicine, fashion, and industry, the Polaroid also offered great photographers a new means of exploration and a different approach to photography. Aware of its process' potential in the art world, Polaroid supported many artists and built an important collection of their work.

Ansel Adams dedicated a how-to book to Polaroid (*Polaroid Land Photography*, 1978); at age eighty-four, André Kertész used a Polaroid camera to photograph the play of light in small glass sculptures placed on his New York windowsill (*From My Window*, 1981).

The freedom that came with instant development encouraged many photographers, along with unknown multitudes of amateurs, to explore personal work dealing with the self-portrait, the

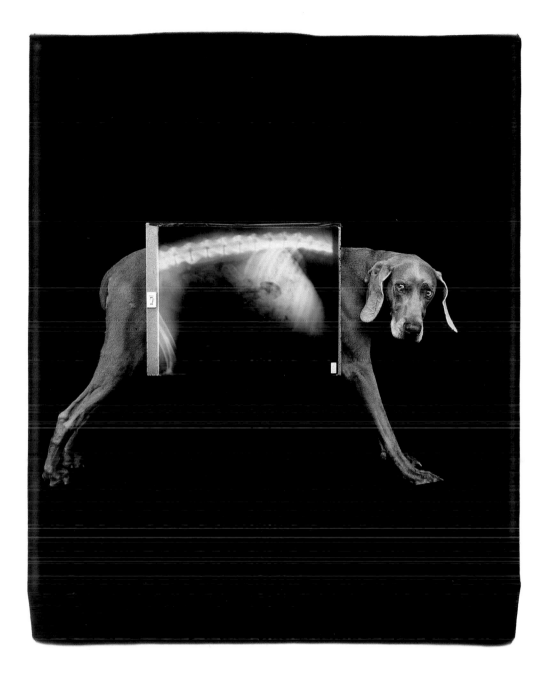

nude, and sexuality. In his *Photo-Transformations* (1973–1976), Lucas Samaras modified the Polaroid's still-wet prints in order to deform his self-portraits and create mutilated and altered, but somehow entertaining, representations of himself. With a very large-format Polaroid camera, John Coplans delved into the folds and details of his naked and aging body in close-up. In another approach, David Hockney broke down the subject he photographed into fragments (an eye, a nose, an ear) in order to reconstruct him by assembling these hundreds of Polaroids (*Portrait of David Graves*, 1982). By doing this, Hockney illustrated the complex relationship in his work between painting and photography. The work he now shows no longer merely consists of photos, but of assemblages that testify to photography's potential "to vividly represent on a flat surface the marvelous process of looking. That's what I'm searching for, and what I'm trying to transfer into my painting."

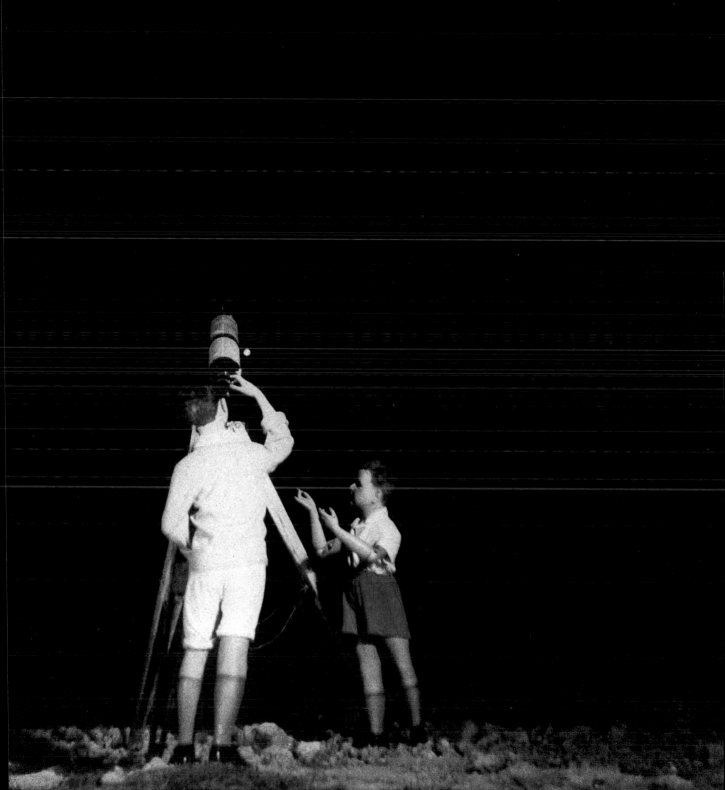

35: SPACE DISCOVERY: PHOTOGRAPHING THE UNIVERSE

The conquest of space began in the second half of the 1950s, when the first man-made satellites went into orbit around the Earth. *Sputnik 1,* the first-ever spacecraft, was launched by the USSR in 1957 and was followed a month later by *Sputnik 2.* Along with its technical equipment, *Sputnik 2* carried a live passenger, the first—Laïka, a female dog. America, too, at this time started up a huge space program. From their overflight of Venus in 1962 to Neil Armstrong's first steps on the moon in 1969 (a picture seen around the world) to the robots *Spirit* and *Opportunity* that landed on Mars in 2004, the Americans (like the Europeans with their *Mars Express* probe) have garnered a mass of photographs and scientific results. Space probes have been equipped since the 1990s with charge-coupled device (CCD) astronomical cameras. Modern robots are immune to the extreme atmospheric conditions of outer space and other planets, and can approach or even land on them. These new-style explorers depend on neither human hand nor eye, yet they are able to send photographs back to Earth that, beyond being scientific documents of the first order, are full of unexpected and stunning beauty.

THE NINE PLANETS OF THE SOLAR SYSTEM

The sun is a body of pure, unadulterated power: a nuclear core shaken by violent storms, which has been photographed by different probes since the end of the second millennium. These have revealed its flaring X-rays and the development of protuberances that resemble gigantic fireworks in space.

Since 1962, when the American *Mariner 2* was the first to fly over the red planet, Venus has been the most visited planet in the solar system. It is a furnace with an amazingly beautiful surface (as one might expect of the planet associated with love!). The *Magellan* probe infiltrated the planet's opaque atmosphere to photograph a variety of mountains, volcanoes, and craters with strange shapes.

Mercury was photographed by *Mariner 10,* which took a thousand shots of the planet between 1974 and 1975. Mercury is a wild planet; its Caloris Basin, the result of a huge asteroid impact, looks like a wholly abstract landscape.

Mars is undoubtedly the planet that has most inspired the human imagination. Being the closest to Earth, it has long been the object of speculation about the existence of a possible civilization. Its reddish hue is due to the oxidized deserts that cover a great deal of the planet. In 1971, the *Mariner 9* probe revealed how beautiful Mars was, and over the course of a year transmitted more than 7,000 photographs of fantastic landscapes disturbed by dust storms, spectacular canyons, canals, and floodplains, proving that water had once been present on the planet. In 1976, two *Viking Lander* craft put down on the planet and continued their photographic exploration until 1982. In 2003, the European space probe *Mars Express,* equipped with a high-resolution camera, sent back some arresting photographs of the whole planet and its varied terrain.

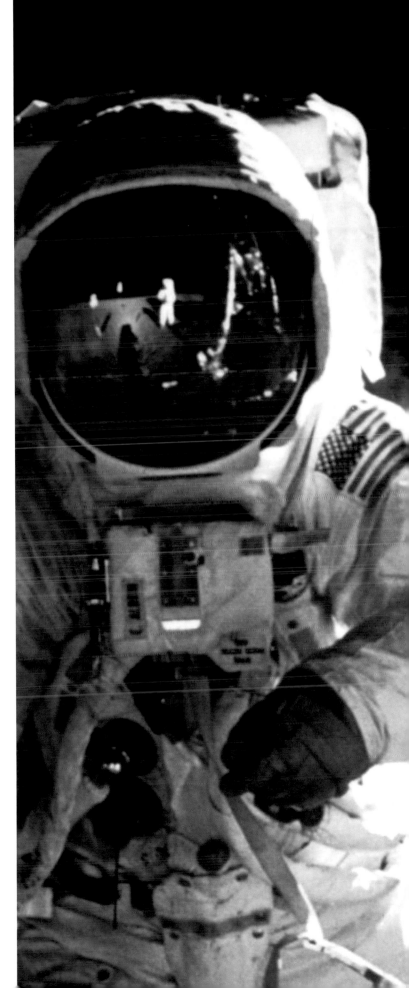

The fifth planet, Jupiter, reigns over a complex universe that includes six satellites, dimly visible rings, and dust. There, the *Galileo* mission revealed extreme storms, clouds, flares, and unexpected peaks and valleys.

Saturn's rings have made that planet famous, and its pristine appearance creates an appearance of perfection and mystery. When *Voyager 1* reached the planet in the early 1980s, the pictures it sent back showed that the planet was surrounded by thousands of rings of loose rock, dust, snow, and ice. *Voyager 1* took the most beautiful pictures of the ringed planet in November 1980.

Uranus, with its perfectly smooth surface and blue-green color, looks like an abstraction suspended in obscurity. *Voyager 2* is the only probe that ever captured any high-quality, high-speed pictures of this planet, which remains virtually unknown.

Neptune is navy blue and is currently the most distant planet to have been visited by a space probe. (Pluto, the farthest away, has never been visited.) *Voyager 2* discovered that Neptune had an internal source of energy. With its sharp peaks and two dark spots, it experiences the most violent winds in the solar system (1,179 miles [1,900 km] per hour).

Long after Ansel Adams had taken his serene photographs of Yosemite Valley, the space probes would take other pictures of nature unbound, this time tossed by violent storms, monstrous hurricanes, and gigantic eruptions. Though the products of state-of-the-art technology, these images of other worlds are a revelation of the profound beauty of the cosmos and the splendor of the heavenly bodies.

Astronaut on the Moon (July 20, 1969)

Though Neil Armstrong was the first man to step into another world, the man pictured here is in fact Edwin Aldrin.

Raymond Depardon, Françoise Claustre
on the cover of *Paris Match* (1975)

The archaeologist Françoise Claustre was a captive of the Tubu
in Tibesti for almost six months. After her release, Raymond
Depardon made a film, his 1989 *The Captive of the Desert.*

36: SOCIALLY AWARE PHOTOGRAPHERS

Issues raised by the colonial wars and the political and economic upheaval of the last decades have led a certain number of photojournalists to question their profession, their role in the information chain, and the influence their pictures have on their contemporaries' awareness of the world. By doing so, they are following in the footsteps of W. Eugene Smith, their senior by several decades. Smith created numerous photo essays about daily life and the disastrous conse- quences of industrialization, including a famous series about Manamata, a Japanese fishing village whose inhabitants were the victims of mercury pollution of the water. In 1968, *The Concerned Photographer,* by Cornell Capa (younger brother of Robert Capa), was published in New York, followed by a second volume in 1972. Both are essential reflections on these questions. Raymond Depardon, Sebastião Salgado, and James Nachtwey are among the witnesses of their times. Their photographs, initially intended for publication in periodicals, have slowly been emancipated from this mode of distribution and shown in exhibitions and widely circulated books.

THE SITE OF CONFLICT

Armed conflicts around the world have been a favored field of action for photojournalists of the last four decades. Raymond Depardon was in Chile during the 1973 coup d'état, then in Chad, where he was able to meet with Françoise Claustre, a French woman held hostage by the National Liberation Front from 1974 to 1977.

Depardon's way of dealing with the violence he witnessed was not strictly speaking that of a war photographer's. He preferred to focus on showing life in countries at war rather than on the actual field of operations. In 1979, he published *Notes,* a book that combines pictures from the field in Lebanon and then Afghanistan with notes detailing his thoughts, emotions, desires, and doubts. Its publication marked a turning point in Depardon's work, which was to remain separate from both the artist's photo essay and the practice of photojournalism. Sebastião Salgado covered the Portuguese revolution, the war in Angola, and events in Mozambique. According to Salgado, "the

quality of a photograph depends on the quality of the relationship you establish with your subjects." He was profoundly shocked by some of the journalistic practices he witnessed. Over the course of several weeks spent in an Ethiopian refugee camp, Salgado saw more than forty television crews come through, including one American crew that arrived in a government-provided bus and spent a grand total of two hours in the camp. He decided to stop working for magazines and to fully commit to in-depth reporting.

PHOTOGRAPHY AS ANTIDOTE

After four years of working as a press photographer, James Nachtwey went independent in 1980 and has ceaselessly covered the succession of conflicts and wars of the last two decades. He has roamed across Europe to cover IRA hunger strikes in Northern Ireland, the Balkan wars, ethnic conflicts in Eastern Europe from Bosnia to Kosovo, and the effects of the splintering of the Soviet Union on Chechnya and Afghanistan. On the African continent, Nachtwey has recorded the damage caused by famine and epidemics in Sudan and Somalia, tragedies equally due to rivalries between political and religious clans and to drought, and the 1994 genocide that led to the death of 800,000 Rwandan men, women, and children. Nachtwey is primarily a war photographer, as can be deduced from the titles of his first book, *Deeds of War,* and of the documentary film Christian Frei made by following him in the field for two years, *War Photographer.* Today, politicians and military authorities usually come together to keep photographers off the field of operations, or, at the very least, to seriously contain their movements. Paradoxically, and for completely different reasons than the technical constraints that plagued their colleagues at the time of the Crimean War, photographers now find themselves obliged to focus on the ravages, destruction, and

James Nachtwey, *Kabul* (1996)

A woman prays in a cemetery for her brother, killed during an attack by the Taliban in Kabul. Nachtwey's sophisticated framing and his use of light add an aesthetic dimension to his photographs. Nachtwey believes this aspect is indispensable to changing opinion, overturning ways of seeing, and even changing the world.

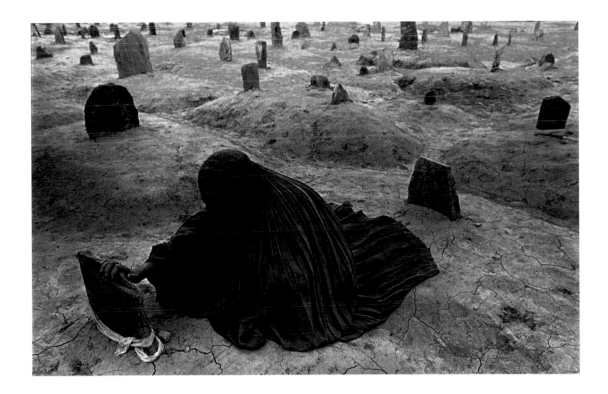

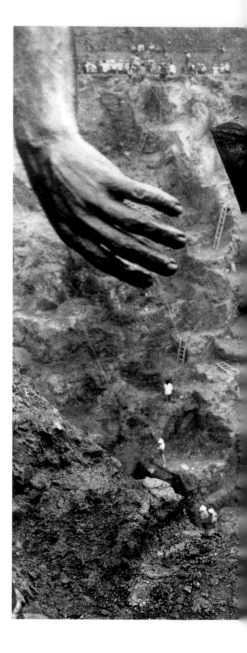

victims that war leaves in its path, rather than on war itself. For Nachtwey, "the strength of photography lies in its ability to evoke a sense of humanity. If war is an attempt to negate humanity, then photography can be perceived as the opposite of war and if it is used well it can be a powerful ingredient in the antidote to war." Nachtwey attempts to take pictures that will be symbols. His photographs are framed in order to produce images of suffering in general, not particular to any geopolitical context. By producing highly composed images with reference to historical painting (a subject the photographer knows well), Nachtwey introduces a time lag between the events he wants to portray in the immediate present and the time it takes to prepare these shots—the light, selection of pose, and so on. This gap has created lots of controversy and discomfort and has led to accusations that Nachtwey approaches suffering as a voyeur.

THE REJECTED, EXCLUDED, AND UPROOTED

"One day, I was surprised to find I wasn't experiencing any emotion while taking my pictures.... I wasn't scared of the insane anymore. I stopped immediately; I went back to Paris and never took another photo in San Clemente." So ended Depardon's experience with the patients of a psychiatric asylum near Venice. Social rejects and victims of injustice or discrimination never fail to attract the attention of committed photographers, who, in turn, attempt to attract the viewer's attention to their plight. Among the photos in James Nachtwey's exhibition "L'œil témoin" (Eyewitness; Bibliothèque Nationale de France, 2002) were pictures taken in 1990 in Rumanian orphanages and hospitals, which Depardon also visited, as well as photographs stigmatizing discrimination against ethnic minorities and the poor in the American penal system. For his part, Salgado decided to document the extreme poverty he found in Africa on a mission for his then-employer, the International Coffee Organization. He traveled to Latin America more than fifteen times in the early 1980s and completed an epic series about the situation of peasants there that took in the archaic nature of their living conditions, their working conditions, and the survival of their traditions, notably the omnipresent quality of the sacred and

of death. This series was the subject of a book, *Other Americas,* which was quickly followed by *Sahel: End of the Road,* dedicated to the tragic consequences of famine. *Workers,* published in 1993, came out of a long investigation of manual work in about twenty countries. Salgado, who considers mankind to be the central focus of his work, cannot avoid making the connection between his own history and the subject of his photos. "Migration is a story I know well: I was born on a farm in Brazil. At fifteen, I left my little town for a mid-sized city of about 120,000 inhabitants. This is where I met Lélia Deluiz Warick. Thirty-three years ago we went to live in São Paulo. Then, for political reasons, we had to leave our country for France." The wrenching separa-

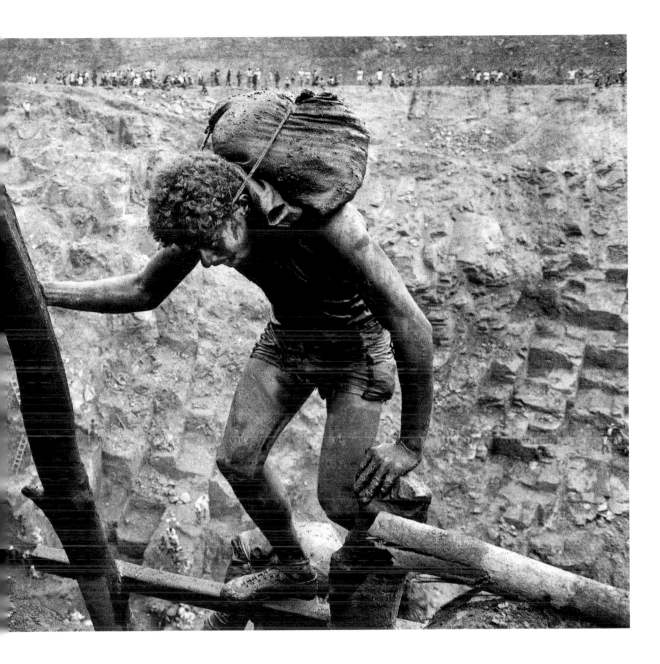

Sebastião Salgado, *Serra Pelada Gold Mine* (Pará, Brazil, 1986)

This man hunched under the weight of his burden, coming up from the depths of the mine, is reminiscent of Christ carrying the Cross. This iconography reinforces Salgado's work, which denounces labor in the Third World and human exploitation.

tions, both physical and emotional, caused by the economic or political necessity of having to leave one's country are at the heart of *Migrants* and *The Children,* which Salgado considers "a sampling of the human condition in the world today." On October 30, 2003, the French daily newspaper *Le Monde* published an eight-page portfolio entitled "The End of Polio," a collection of Salgado's pictures taken to raise public awareness and show the accomplishments of the World Health Organization's campaign. UNICEF, which supported the "End of Polio" campaign, appointed the Brazilian photographer as a special representative in 2001.

37: PHOTOGRAPHING WAR

Since the invention of photography, from the battlefields of the Crimean War to those of the twenty-first century, photographers have always flocked to the sites of armed conflict. Though they frequently put their lives at risk by doing so, photographers are the indispensable witnesses to the reality of war. War reportage went through a period of extraordinary development during the second half of the twentieth century, in part because photographers had specially adapted technical means at their disposal and enjoyed exceptional freedom to do their work. Yet both the historical context and the situation of the press soon changed, thereby significantly modifying the field's evolution.

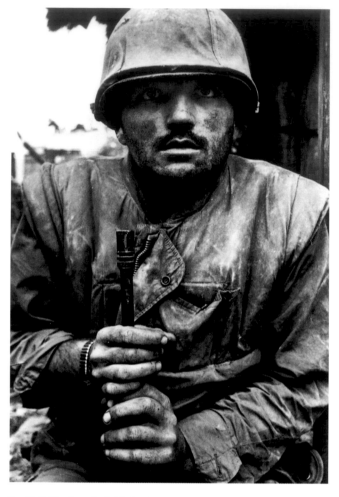

Don McCullin, *Portrait of a Marine during the Battle of Hue,* (Hue, Vietnam, 1968)

McCullin recounts how he took this picture, one of his most famous photographs, "I took about eight frames, and not once did he blink those eyes, and not once did he say anything to me, or move. And he was looking right through me, as if I was a ghost in front of him."

THE REALITY OF WAR: MCCULLIN AND CARON

Donald McCullin and Gilles Caron belong to the same generation. Don McCullin had an exclusive contract with the *Sunday Times Magazine* for eighteen years, until 1984, and Gilles Caron had a similar relationship as a reporter with the Gamma agency. Both men habitually got close to the reality of war, and even crossed paths while working on the same "story," the Biafra War, in May 1968.

The following quote by Robert Capa is often repeated: "If your picture is not good enough, you're not close enough." This was never Don McCullin's or Gilles Caron's problem. They were always as close as possible to combat, which they even photographed "from the inside," standing side-by-side with war's protagonists and its victims. They worked in the hell of Vietnam, where their experience, their daring, and their cool led them straight to the front lines. Yet they did not photograph war in the same way. Don McCullin is particularly sensitive to the challenges, pain, and fear that soldiers and civilian victims frequently endure.

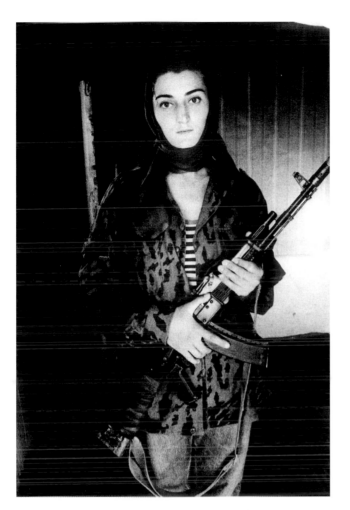

Stanley Greene, *Asia* (Grozny, Chechnya, 1996)

"High up in the Itum-Kale region, the Chechnyan rebels captured a patrol of Russian soldiers and took their wounded to the camp. While delirious, a Russian soldier began to recount the atrocities committed by his patrol. The story was too much for Asia to handle. She took a gun and shot the Russian. 'It wasn't terrifying to kill him because Russians have done far worse to us,' she remembers." Stanley Greene, *Fragments of War* (2004).

Gilles Caron seems to be more enthralled with the action, the movement of men over the battlefield, whether he is dealing with war being waged by the military or with civil wars. He photographed the conflict in Northern Ireland, in the streets of Londonderry, as if he were watching the evolution of American soldiers on the field in Vietnam. Caron looks for the best angles to convey a significant vision of what is happening. All this he does without the slightest concern for his own safety, while remaining attentive to the human dimension of conflict.

PHOTOGRAPHING WAR: ITS FRINGES AND EFFECTS

Don McCullin has twice been refused the authorization to cover a conflict: first in 1982, during the Falklands War, and second in 1990, during the Gulf War. In fact, McCullin represents a type of reporter that has become undesirable on today's battlefields, the type whose pictures show a reality that political and military authorities want to keep out of the public eye; a reality that has been given the name "collateral damage" during recent conflicts.

Since Vietnam, and extending to the most recent conflicts, wars have most frequently been fought by air (such as the bombings in both Gulf Wars, Bosnia, and Iraq). They are conducted by chiefs of staff safely installed thousands of miles from the battlefield, and information regarding their progress is censored by political and military authorities. At the same time, we have discovered a new aspect of war: refugee camps, deportation of entire populations, and all the difficult conditions of humanitarian aid.

Televised news has taken over from the daily press and magazines in accounting for the actual development of armed conflicts, and photographers have been forced to find new ways for their photographs to circulate. Some have created books and exhibitions, in which they reveal their point of view on war. Beyond traditional photojournalism, for which the immediacy of conveying an image remains the primary objective, new ways of seeing offer a more carefully elaborated reflection, a more aesthetic approach, or, through a greater awareness of ethical stakes, an overt political position. Representatives of this type of war photography include James Nachtwey, Gilles Peress, and Stanley Greene. Their work on the African continent or in countries such as Chechnya deals with continuing conflicts that are no longer headline material, if they ever were in the first place. These are conflicts whose reasons are not always commonly understood.

38: THE PORTRAIT

The portrait had already been well defined and thoroughly explored by painters by the time photography came along. Nonetheless, by creating its own perspective, photography has extended and developed the art of the portrait. Because portrait photography has not limited itself to a strict representation of appearances or to working on the surface, at least insofar as the art of the great portraitists is concerned, it has succeeded in enriching certain aspects of man's self-knowledge.

WELL-KNOWN OR UNKNOWN?

Nadar, the master of the nineteenth-century photo portrait, defined the basic tenets of a practice that tended to singularize the subjects photographed and to express something of the sitter's psychological essence. Nadar's approach also allowed the general public to associate a face with a body of work.

In the following century, August Sander adopted the opposite approach. No longer interested in the individual in and of himself, or in a definition of his personality, Sander turned instead to the elements that characterized the individual as a member of society, or as a representative element of a community or corporation. The subject was an anonymous being who participated in the social fabric of the period, in this case Germany between the world wars. By following this approach, August Sander put together a remarkably organized catalogue of photographs of emblematic figures.

In the second half of the twentieth century, the photographic portrait of well-known personalities came to the forefront, largely in order to satisfy the growing curiosity of the photography audience. Portraitists such as Richard Avedon continued to set their eyes on anonymous individuals. Famous for his caustic portraits of figures of the New York art and cultural worlds, Avedon was also responsible for a brilliant series covering workers in the west of the United States, which he called *In the American West* (1985).

Throughout his work in portraiture, Avedon adopts the same bare-bones style, devoid of the slightest staging or setting. Famous or unknown, all his subjects pose in front of a white, gray, or sometimes even black background. The pictures are given black borders, as if to keep the subject from escaping our gaze. Richard Avedon's work is the quintessential example of an approach to the portrait that is pure, even severe, but never boring, because his subjects completely give themselves over to the camera, and the photographer does not allow himself the slightest extravagance. Is Avedon's primary concern objectivity or authenticity?

From another continent, the work of portraitist Seydou Keita, which was discovered in Mali in the 1990s, gathers portraits of Africans that are brilliantly simple, or even truthful. These pictures were rapidly seen around the world, testimony to the fact that they do reflect an authentic and just relationship between the photographer and the subject.

ON THE ART OF STAGING

In parallel to this stripped-down aesthetic, a practice of elaborately staged portraits has developed, with more or less pronounced results. Arnold Newman's pictures are relatively sober, while Philippe Halsman's are far more eccentric. The former attempts to use set dressings that are harmonious with the subject's personality: this is the case with his famous, and very elegant, portrait of Igor Stravinsky with his piano. As for Philippe Halsman, he convinces his subjects to engage in an unusual exercise, which he has called "jumpology," that consists in photographing his subjects as they jump up in the air. Needless to say, the resulting picture has nothing to do with the subject's usual behavior.

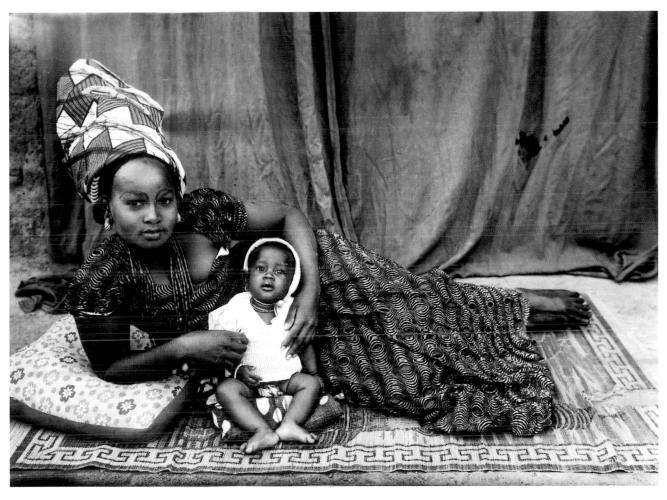

Seydou Keita, *Young Mother and Her Child* (ca. 1960–1964)

In the Harcourt studio (the success of the Harcourt studios, named after Cosette Harcourt who set it up during the recession, was phenomenal), light wraps around the subject and eradicates any imperfections, to the point that the Harcourt style completely overwhelms the personality of the person being photographed. Barthes said so in his *Mythologies* and detailed several of the characteristics specific to the Harcourt portrait, including the fact that the portrait contributed to the social consecration of its subjects.

Today, the photographic and lighting techniques used for most magazine portraits are no longer those of the Harcourt studio, but many principles have remained the same, starting with retouching, which is no longer done with a brush but on a computer screen, allowing the picture's "make-up" to blend with the face's. In another register, the portraits created by Pierre et Gilles, bursting with enhanced colors, brought the artificial, or even the out-and-out fake, to the level of artistic principle, but in an intentionally playful manner.

TIMELESS PERSONALITIES

The photographic portrait was fated to cross paths with history and politics. Thus photographs used in electoral campaigns are also part of the staging, the fabrication of a candidate's image, and will consolidate his image if he is elected to office. Yousuf Karsh spent the second half of the twentieth century assembling pictures of the world's most important figures. Karsh attempted

Richard Avedon, *Clarence Lippard, Drifter* (Interstate 80, Sparks, Nevada, August 29, 1983)

"The first part of the sitting is a learning process for the subject and for me. I have to decide upon the correct placement of the camera, its precise distance from the subject, the distribution of the space around the figure, and the height of the lens. At the same time, I am observing how he moves, reacts, expressions that cross his face so that, in making the portrait, I can heighten through instruction what he does naturally, how he is."

to transpose the official portrait from painting to photography and sought to produce a definitive image, impervious to time, which could fix the subject's qualities for posterity.

Yet the photograph that perpetuates a historical figure is not always the one that requires a set, elaborate staging, and an artfully conceived pose. On the opposite side of the spectrum from studio portraitists who make sitters come to their studios and endure occasionally constraining working methods, Henri Cartier-Bresson takes portraits with the sole objective of making himself invisible. Speaking as an ex-reporter, he expressed his conception of the portrait: "The viewer shouldn't think to himself, the Photographer was there. You have to catch the guy when he's inside himself. A portrait consists in sneaking the camera between the subject's shirt and his skin, without doing any harm." (Interview with Hervé Guibert, *Le Monde,* 1983.)

FROM THE FRINGES OF THE PORTRAIT TO CONTEMPORARY PRACTICE

Somewhere between studio and candid portraits, portraits of well-known personalities and portraits that have a social or documentary vocation, there are other works that are more difficult to classify. These photos are the expression of an approach that resists any categorization, the mark of a rebel spirit such as Diane Arbus's. Arbus's work can be placed in the portrait category, since her subjects, though

frequently anonymous and often uncommon, were generally people. Yet her photographs developed on the fringes of reportage, outside of any school or tradition, by mixing genres. Today, photographers such as Beat Streuli or Valérie Jouve isolate bodies, faces, and figures in movement in the urban landscape without indicating whether their work should be considered a social document, or whether it is connected to reportage or the portrait.

Nicholas Nixon works in series: since 1975, he has made an annual portrait of the Brown sisters (his wife and her three sisters), recording the traces of time and aging. The large-scale anonymous portraits made in color by Thomas Ruff in the 1980s refer to the objective ID photo, and are typical of the documentary coldness that characterizes Ruff's generation of German artists.

Rineke Dijkstra, *Yalta, Ukraine* (July 29, 1993)
In the 1990s, Rineke Dijkstra took portaits of teenagers at the beach, posing them before the big clear-blue sky. This series of portraits shows the tragility of the these teenagers, lost in this dominating space beaten by the wind.

The Dutch photographer Rineke Dijkstra has adopted an approach stamped with her appreciation of classical portrait painting, but she distinguishes herself by the choice to use very contemporary colors and large formats. Each portrait is like a painting, and the motif—the subject, in painting terms—is complex and ambivalent. The work has as much to say about a particular individual as about the society he or she belongs to. But, after all, isn't that every portraitist's goal?

39: OFFICIAL PHOTOGRAPHY: AN IMAGE FOR POSTERITY

Not only is France the birthplace of photography, but it can also pride itself on creating a genre, the official portrait, which it has exported with varying degrees of success. Napoléon III was the first French political figure to be immortalized in a photograph. This was not yet an "official portrait" but simply the application of a new technique to a "great man," with the goal of capturing the quickest, most faithful likeness of an individual. Among these primitive

Mayer & Pierson, *The Imperial Prince Posing on His Pony* (1859)

representations of power we find Mayer & Pierson's famous *The Imperial Prince Posing on His Pony.* The 1859 portrait shows the imperial child posing with his back to a taut white sheet as, miracle of miracles, the imperial father and his dog stand off to the side and watch the goings-on. This unusual and anecdotal presence is what makes the shot so interesting, particularly since it is so far removed from official sittings such as Napoléon III's last portrait, taken in 1870, in which it is only his white hair and the absence of his waxed and pointed mustache that reveal a certain weariness.

THE OFFICIAL PORTRAIT

In France, the Third Republic introduced the practice of producing an official portrait of the head of state in a solemn style derived entirely from the conventions of painting: uniform, medals, rigid pose, bookshelves, and prestigious setting. This very official portrait was meant to be duplicated and displayed in prefectures, city halls, and other administrative buildings throughout the country. In the days before it became possible to make numerous reproductions of photographic prints, the portrait of Adolphe Thiers was circulated as a lithographic print.

Until 1974, when Valéry Giscard d'Estaing called on Jacques Henri Lartigue to immortalize him in a more "modern" fashion with the tricolor flag as a background, the official pose had always been the same: the president sat for his portrait in the library at the Élysée palace, wearing a dark suit and the sash of the Legion of Honor. This official portrait is available to the whole country through the *Documentation française*, whose mission includes providing the portrait, at cost, to any citizen or institution who requests it. As for Jacques Chirac, he wanted something more relaxed, so he asked his friend Bettina Rheims to take his picture in the gardens of the Elysée.

The ritual of the official portrait has been taken up by many other countries, beginning with the ex-French colonies and, very early, by the Vatican, which is responsible for distributing the sole definitive picture of the pope throughout the world.

CONTROL OF THE OFFICIAL IMAGE

This definitive representation of those in power is now an integral part of the image of power. For the last twenty years, consultants and "communicators" have organized and constructed the image of candidates by presenting them as if they were already heads of state. Jacques Séguéla developed a political advertising campaign, "Peaceful France," for François Mitterrand that played an essential role in the election of the Socialist leader. Times have certainly changed since the days when electoral posters featured the candidate's platform accompanied by a black-and-white ID photo.

In order to better control political image, everything is done to limit photographers' access

Gisèle Freund, *Portrait of François Mitterrand* (1981)

François Mitterrand asked Gisèle Freund to take his official portrait, which he used throughout both of his seven-year terms of office. He chose to be remembered as a literary man holding an eighteenth-century volume, as if the writer and the cultured individual were more important, in his eyes, than the political figure.

to candidates. Political meetings are organized and staged as spectacles, and photographers are assigned specific positions in order to ensure that they are only able to reproduce the image carefully prepared by consultants. Today, it has gotten to the point that during official trips—particularly involving American presidents—journalists are given "itineraries" that go so far as to point out the most "photogenic" parts of the trip and to provide technical advice!

Despite attempts at modernization, the official portrait is still the vehicle for a conventional portrayal of an icon. Yet these conventions are no longer as important as the permanent control of a political figure's image, whether he or she is a candidate or already in power. Today, a very small distance separates the way celebrity photographs are controlled—and selected—from the handling of images of political figures.

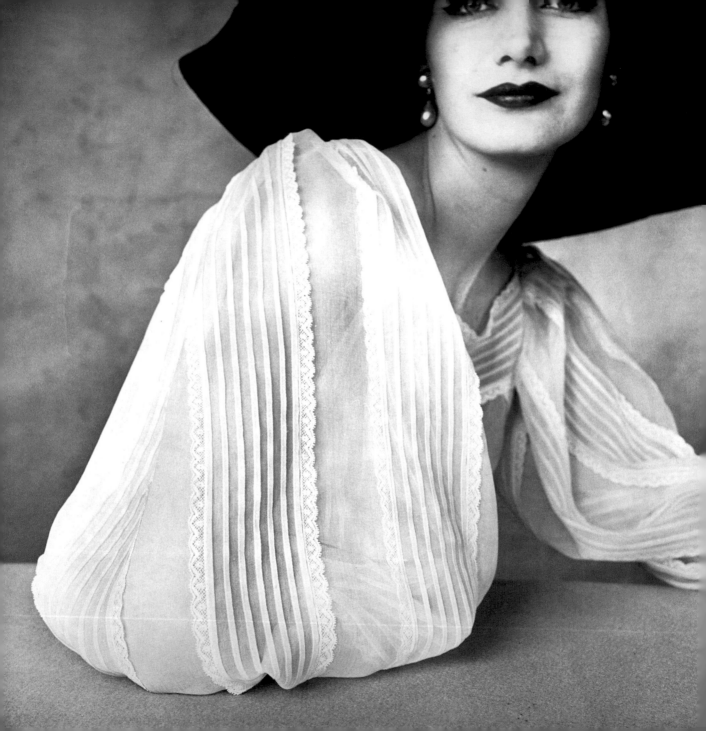

40: FASHION PHOTOGRAPHY II: "WHETHER THEY KNOW IT OR NOT, ALL THE PHOTOGRAPHERS ARE PUPILS OF BRODOVITCH."

In 1947, Christian Dior introduced his "New Look" with an electrifying, feminizing impact. It perfectly symbolized the end of wartime austerity. The years that followed began a new era in fashion photography, one of charm and elegance.

AVEDON AND PENN DOMINATE THE SCENE

The style of Richard Avedon, recruited very young by Carmel Snow and, like Irving Penn, a pupil of Alexey Brodovitch, perfectly suited a society exhausted by World War II. Avedon photographed women dancing, laughing, and running—like human beings. If women looked sporty in Munkacsi's images, they became carefree and vivacious in Avedon's. The life he portrayed was real but fascinating, with a romantic picture-story feel of dramatic action. His images simulated reporters' photos so successfully that the viewer almost forgot they were posed.

Though Avedon worked for American *Vogue*, Paris gave him an attractive setting for his stage effects. As his style developed, his photographs became genuine social documents of the 1960s lifestyle. He regarded the choice of model of vital importance. He no longer went for women of faultless beauty but preferred girls with exotic

Irving Penn, *Large Sleeve (Sunny Harnett)* (New York, 1951). 13.5 x 13.5 inches (34.5 x 34.5 cm). Published for the first time in *Vogue*

In this photograph, Irving Penn plays on the balance and harmony of curving lines: the mouth of the model, the line of her neck, the shape of her hat, and especially the sleeve of her blouse, which unfurls with great elegance. In cropping right over the eyes, he leaves out the model's head. As a result, her stare is stronger and the lines more supple.

charm, like Twiggy or Penelope Tree, or with natural charm, like Lauren Hutton. In later years, having revolutionized postwar fashion photography, Avedon abandoned daylight in favor of working in the studio.

The other great photographer of the 1950s, Irving Penn, founded his work on formal clarity. Penn's favorite model was his wife, Lisa Fonssagrives, and his photographs express a refinement and balance very different from the intensity evident in Avedon's shots.

FRENCH *VOGUE*: GREAT CREATIVITY

The elegance and spontaneity of the 1960s gave way in the following decade to themes that were either more exotic or in line with social change. London became the center of fashion photography. The 1970s were a conflicted decade. It was the period in which the highly innovative Japanese photographer Hiro created masterpieces of simplicity for *Harper's Bazaar*; it was also the period in which William Klein made over the style of French *Vogue*.

Diana Vreeland, the "empress of fashion" was still a legendary postwar figure. In 1935, she became an editor of *Harper's Bazaar* shortly after Carmel Snow. Vreeland left the magazine in 1963 for American *Vogue*, where she became chief editor. While *Harper's Bazaar* somewhat maintained its position under Alexander Lieberman,

it was French *Vogue* that became the more creative magazine in the 1970s. Its two finest photographers, Helmut Newton and Guy Bourdin, had a totally free hand in the selection of models, apparel, staging, and presentation. Though Avedon had introduced nudity, the 1970s sought to attract attention with new and more shocking forms of sexual expression: homosexuality, voyeurism, murder, and rape. Guy Bourdin's vision remained, despite its crudeness, a romantic one. He was among the first to introduce elements into his compositions that seemed like clues to a mystery, suggestive rather than expressive. He was fastidious about the placing of his pictures on the page: he would take details from one shot and place them in another; he created juxtapositions that amused and intrigued.

Over more than twenty years, Helmut Newton took huge numbers of fashion photographs. The essence of his style was to link sex, money, and fashion. His chosen settings were often those of European upper-class society, with its grand hotels and private pools. His highly aggressive conception of sexuality suggested relationships devoid of love or regrets. His women, unlike those of Guy Bourdin, were always sure of themselves.

The European editions of *Harper's Bazaar* and *Vogue* remained very elitist, and the postwar period saw the burgeoning in France of many other magazine titles. Founded by Hélène Lazareff, *Elle* was popular without being populist. It appealed to young, active women, defended their corner, and informed them not just about haute couture but about all the ready-to-wear fashions available, as well. Among these magazines, including *Jardin des Modes* and *Marie-Claire,* which worked hard to democratize fashion, *Elle,* with its weekly appearance and, more especially, its British, American, and Spanish editions, successfully gained an international position under the direction of Peter Knapp, followed by Gilles Bensimon.

Nowadays, fashion is covered as much by transcultural magazines like *Nest, Deutsch,* or *Purple* as by the specialist fashion press. The marketing people have now gained the upper hand, and female editors no longer play the same role that they once did—even if Italian *Vogue,* presided over by Carla Sostani, still sets the fashion.

Helmut Newton, *Rue Aubriot* (1975). Advertisement for Yves Saint Laurent

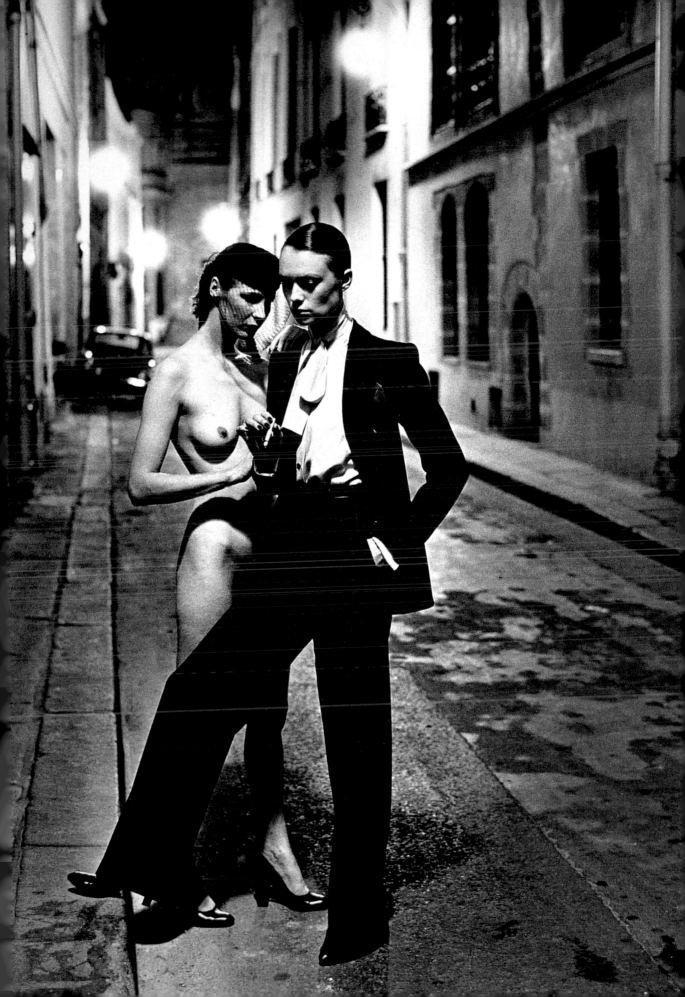

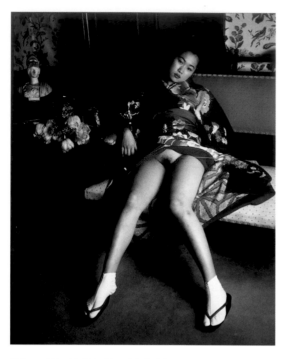

Nobuyoshi Araki, *Tokyo Nostalgia* (1997)

41: EROTICISM AND PORNOGRAPHY

The huge number of photographs created over the years has in no way diminished the fascination exercised by the nude. Through its diversity of approaches, the nude offers a level of variety not always found in other photographic subjects. Emmanuel Sougez's voluptuous women, Diane Arbus's nudists, Irving Penn's Dahomey villagers, and Robert Mapplethorpe's sculptural photographs all have an individual significance as they were all executed in very different circumstances and for very different reasons. Though most twentieth-century photographers took nudes, only a few, such as Robert Mapplethorpe, succeeded in permanently associating their name with a new vision and a personal aesthetic of the nude.

EROTICISM OR PORNOGRAPHY?

A sensual representation of the body is erotic; an obscene representation intended to be shared with others is pornographic. Of course, the criteria that defines nudity as either erotic or porno-graphic varies depending on the era. It is not sufficient for a body to be naked to make it erotic; the circumstances of the taking of the photograph and the viewer's gaze determine the picture's nature as fantasy. The autofetishistic photographs of Pierre Molinier, who asserts his sexuality as being intended for himself, and the sadistic stagings of the painter Charles Jeandel, which were not intended to see the light of day, are erotic due to their personal, intimate nature. But how should we categorize the photographs of the bound body of Unica Zürn by Hans Bellmer?

The close-up of the female genitals painted by Gustave Courbet in 1866 and belatedly called *L'Origine du Monde* (The Origin of the World) found its photographic equivalent in the work of Auguste Belloc, who showed the genitals of a woman without the slightest concealment, visible among the folds of a petticoat lifted up like a theater curtain being raised to uncover the stage. From 1969 to 1974, Henri Maccheroni worked on the series *2000 Photos du Sexe d'une Femme* (2,000 Photos of the Female Genitals) without using the slightest staging.

Here we are approaching the obscene and the pornographic that, until recently, had essentially flourished in the underground and in specialized

Robert Mapplethorpe, *Untitled* (1981)

magazines. In its constant quest for ever-stronger and even violent images, today's audience can go to galleries and museums to discover the occasionally brutal photographs of Helmut Newton, the elaborately staged photos of bound women by Nobuyoshi Araki, or the pornographic images that Thomas Ruff downloads from Internet sites in order to show them inordinately enlarged.

42: TEXT AND PHOTOGRAPH: A RICH AND COMPLEX RELATIONSHIP

From the very beginning, a complex set of relationships developed between text and photographs, always an imprecise means of delivering information. These relationships have become increasingly involved over time. We are not concerned here with critical texts, which are a specific case. It is worth mentioning, too, that some authors have enthusiastically adopted and used photographs with often felicitous results, including Émile Zola and Victor Hugo in the nineteenth century and Georges Simenon in the twentieth.

FROM CAPTIONS TO FICTION

The first pieces of writing that related to photographs were captions, short bits of text that gave the reader elements of information the picture alone could not convey. The first notable use of less than minimal captions was undoubtedly the "photographic interview" of the scientist Michel Eugène Chevreul by Paul Nadar on September 5, 1886. This was a genuine photographic essay, bordering on a storyboard, as it marked the passage of time and transcribed the scientist's words beneath the image in a beautifully cursive hand, written in black ink.

Newspapers would come to use captions most and in the most noteworthy way. Between them, the press and publishers were responsible for instituting the technique of photomontage, which sometimes used large amounts of text.

It was not until the 1970s, with the emergence of Duane Michals, that the presence of text assumed a truly determinant function in photographic presentations. Michals had already invented the "photographic sequence" to tell small, often humorous, stories exploring notions of the grotesque, narcissism, homosexuality, literature, mythology, and fantasy, the funny and derisive. Now he began to include text physically within his pictures. Duane Michals enjoys exploring the ambiguities of photography, its supposed reproduction of "truth" alongside its capacity to invent literary fictions that take advantage of our natural credulity. The title of his first book, *Real Dreams* (1976), says it all. Conceptual approaches, including those of Victor Burgin in the United Kingdom, have a natural attraction to textual elements. They establish a tension between the image and a text that seems to bear no relationship to it. In their analysis of contemporary systems of communication, these exercises are based essentially on semiology.

TEXT "WITHIN" THE PICTURE

Another aspect of the relationship between photograph and text concerns the presence of text within the picture. Such textual elements can be central to the picture's message, as much by what they say as through what they reveal of a society. This is very clear in much of Walker Evans's American documentary work during the Great Depression, but it also emerged, toward the end of his life, in the interest he showed in the physical presence of text in some of his Polaroid color shots. Similarly noteworthy is the importance of textual elements in William Klein's account of New York in the early 1950s. The new edition of his *New York* actually devotes an entire chapter to the city's omnipresent verbiage, from the newspaper headlines on billboards, to graffiti and words on restaurant windows.

In his unceasing search to push back the possible limits of what photographic expression is capable of exploring, Robert Frank has also

A LETTER FROM MY FATHER

As long as I can remember, my father always said to me that one day he would write me a very special letter. But he never told me what the letter might be about. I used to try to guess what I might read in the letter; what mystery, what intimacy we would at last share, what family secret could now be revealed. I know what I had hoped to read in the letter. I wanted him to tell me where he had hidden his affections. But then he died, and the letter never did arrive, and I never found that place where he had hidden his love.

Duane Michals, *A Letter from My Father* (1975)
Duane Michals handwrites short accounts or commentaries in black ink. They are enigmatic, for, although their purpose is ostensibly to explain the photograph's message, they play on the photograph's ambiguity.

confronted the word. He has taken pictures of prints, hung up with clothespins, scrawled with the word "Words." He has also written directly on negatives and then cut into them, thereby fixing the association between the text, which in a way becomes the picture, and the original image.

As for Bernard Faucon, the progressive refinement of his work has led him to include essential text in his last two series. For his "Les Écritures" (The Writings), he placed texts of light in the landscape, thereby making his questions about time, the aging process, childhood, and philosophy of life even more literally explicit.

He concluded with "La fin de l'image" (The End of the Image), philosophical texts written on the skin.

The book itself is another aspect of the relationship between text and photograph, especially the books of the 1950s, a time of remarkable collaborations between authors and photographers.

The strong presence of textual elements within and adjacent to photographs raises a more general question. Perhaps, contrary to currently received opinion, we continue to live in a text-dominated civilization, not an image-dominated one, even if the visual image is everywhere.

43: SELF-PORTRAITS AND PERSONAL JOURNALS

The practice of taking self-portrait photographs began very early. Some photographers were motivated by narcissism, others by the fact that it spared them from finding models to suffer through the long posing sessions. Most were following the self-portrait tradition established by painters. The seventies emphasis on authorial subjectivity even gave rise to the assertion that a photographer's entire corpus was no more than a simple self-portrait, whatever the particular themes or subjects chosen. During the 1970s, the young and painfully sensitive American photographer Francesca Woodman created a brief and intense collection of strange nude self-portraits, which expressed her anxieties and heralded her suicide before she'd even turned thirty. Larry Clark similarly compiled an intimate journal of great photographic quality, as he photographed the friends he took drugs with as he sought to deal with the boredom of small-town life in Tulsa, Oklahoma. His book *Tulsa* has become a cult classic.

AN EVERYDAY PORTRAIT

With Nan Goldin, the self-portrait changed status and became an essential practice of contemporary art. This young American woman recorded and represented her everyday life, not out of false modesty or a desire to shock, but simply to break down the barrier between the personal and the social. She rejected the convention that the intimate concerned only those who lived it. She exposed herself by recording, in subtle colors, her own day-to-day existence and that of her friends—people on the edge, drug addicts, homosexuals, transvestites, all of whom she approached with infinite tenderness, establishing moving portraits of them with great humanity and yet without voyeurism because she lived with them. It is not surprising that Goldin's work has most deeply captured the AIDS pandemic and has sensitively portrayed the world of drug taking and contemporary sexual practices. Goldin believes in correct distance, an absence of moralizing, and an artistic generosity that allows her even to ignore the thought that it would be unseemly for her to photograph her own bruises after being battered by her friend.

Nan Goldin's book, *The Ballad of Sexual Dependency*, is one of the most important books of the final two decades of the twentieth century. Exhibited and collected worldwide, she is at the top of her art and of the emotions that she transmits, in a mode of presentation—the projection of photographs—that she has done much to rescue from the art world's disregard. When she began her work, she did not have the financial means to make color prints. So she started projecting her pictures accompanied by a soundtrack mix of her favorite music: moments of pure emotion. She regularly produces new projected versions of the *Ballad* and, in collaboration with other artists, like Björk, creates thematic pieces in which she keeps faith with her determinant closeness to those she photographs. She does not say that her life is a work of art, but she affirms herself as an essential artist by photographing her life.

Nan Goldin, *Nan after Being Battered* (New York, 1984)

LIFE AS A WORK OF ART

It is not wholly inappropriate to consider the work of Sophie Calle under this heading. She focuses upon herself and does not hesitate to enter scenarios that are highly contrived and much more conceptual than those of Nan Goldin, insofar as they invoke less immediate emotion and link texts, images, and installations. From voyeurism to pain, she explores human feelings, or endeavors to articulate the point of view of blind people on the world. She incites her "subjects" to abandon their modes of protection in order to provide a profound revelation of the ambiguities of behaviors, and she scours the depths of human nature.

In her work, the performance artist Orlan treats her life and her body, which she has continually transformed by aesthetic surgery, like a genuine work of art.

Hervé Guibert is a case apart, insofar as he was a writer, critic, and photographer. The way in which his written and photographic work fits together is still under study, but we can presume they are connected, not least because he wrote about some of the "subjects" he photographed, such as his great-aunts "Suzanne and Louise," and because he collaborated with other photographers, such as Bernard Faucon and Hans Georg Berger.

p. 168:
Francesca Woodman, *House # 4*, Providence, Rhode Island, 1975–1976.

44: STAGED AND MANUFACTURED IMAGES

They did not know one another, but in the 1980s a number of highly individual artists scattered all over the world shared a common interest in producing photographic images through artifice. While each sought to express his or her particular feelings or emotions, they all constructed deliberately transient three-dimensional installations of characters and objects whose only purpose was to be photographed. They came together in a number of collective exhibitions: as "Tableau Photography" in the United States, "They Saw Themselves Painters, They Saw Themselves Photographers" in France. Though they cannot all be named here, it is impossible to ignore Cindy Sherman and Sandy Skoglund in the States, Boyd Webb in Great Britain, Jeff Wall in Canada, Ouka Lele in Spain, and Bernard Faucon in France.

THE VISUALIZATION, MATERIALIZATION, AND EXPLORATION OF FEELINGS

Bernard Faucon began using child models for his compositions in his very first exhibition. His motivation was not to reconstruct moments from his own early youth but to create a series of often-dreamlike scenes to reawaken the memories or feelings of childhood. Faucon took to staging his photographs because of difficulties he experienced when trying to photograph "live," which produced a photographic imprint of the real that to him seemed superficial, artificial, or "false." "I had the sense," he commented, "that the scenarios that used models were 'more real' than all the impromptu shots I could take." This explains the development of Faucon's work, which gradually refined itself over some twenty years before he eventually abandoned photography: working in series, he staged space in his "Chambres," then text in landscape in "Les Écritures," before finally expressing his doubt with "La fin de l'image," small prints reproducing texts written in white India ink on the skin. His purpose was the visualization of an inner world, the materialization of feelings he experienced in confronting time and the world.

Cindy Sherman explores different territory. Her most important series, Film Stills, captures her, in black and white, in roles inspired by female characters from B movies or television shows. The purpose is to draw attention to the image of the young American woman while indirectly pointing out male fantasies, from coquette to hitchhiker and nurse to starlet. Sherman is a remarkable self-directing actress. She continues to develop her work using large-format color shots and exploring a wide range of feelings, from pain to joy, from the picturesque snapshot to a violent series of disjointed dolls that have been subjected to sexual violence. Fame came quickly to her, and she has become a true star of the international scene.

A PHOTOGRAPHIC TRADITION

With their offbeat potential, these productions generally look much like very contemporary re-workings of the well-known surrealist approaches. But they also have a place within a photographic tradition that is older still. Nineteenth-century photographers such as Hippolyte Bayard, Oscar Gustav Rejlander, Henry Peach Robinson, Julia Margaret Cameron, or Frederic Holland Day also worked with models whom they directed like actors in staged scenes inspired by classical or biblical literature. Several decades later, Baron von Gloeden would also contrive photographs of adolescents "in the Antique style." However, the inspiration behind 1980s practi-

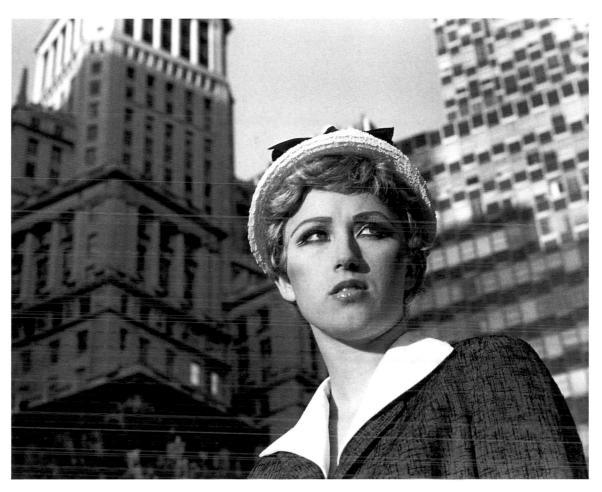

Cindy Sherman, *Untitled, # 21* (1978)
Since 1976, Cindy Sherman has posed as the anonymous heroine of American B movies and black and-white films. By doing so, she has challenged the image of women in television and cinema. These self-portraits question society and scoff at the media.

tioners comes most directly from Man Ray (Marcel Duchamp in "Rose Sélavy"), the self-portraits of Claude Cahun, and the erotic montages of Pierre Molinier.

The series of a photographer like Duane Michals, who stages all his work, could also be included in this category. On the other hand, the importance he attributes to the use of text has tended to take him in other, more clearly literary, directions. Today, Philip-Lorca diCorcia makes

intelligent use of lighting techniques to create street scenes that become unreal or definitively mysterious, making for another, very individual, development of the photographic-staging "school."

This is an apparent paradox and yet an impassioned exploration of the nature of photography. The skilled, totally artificial staging of scenes, be they dreamlike, critical, or ironic, represents an important advance in photographic thinking about the tension between the real and the imagined.

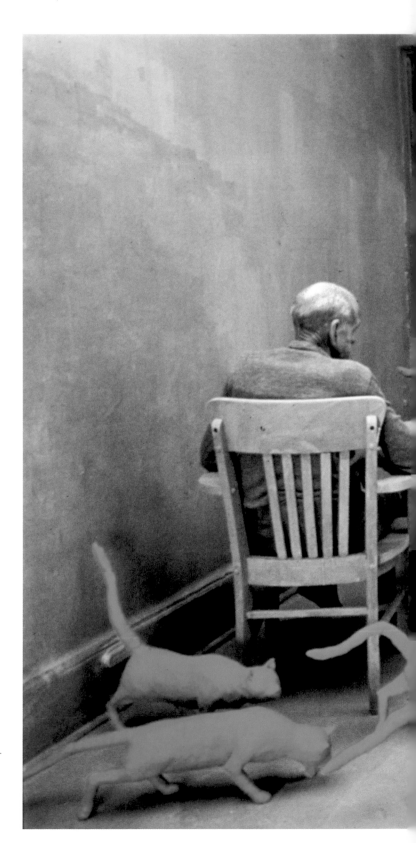

Sandy Skoglund, *Radioactive Cats* (1980)

Sandy Skoglund's staged settings are complex, sophisti-
cated, and surreal. They are true installations, in which
every detail is considered. It would take her six months
to a year to build them in her studio in Soho, New York.
Fluorescent-colored cats, crows, fish, squirrels, and
babies take over the space. Indifferent humans come
second in this artist's wild imaginings.

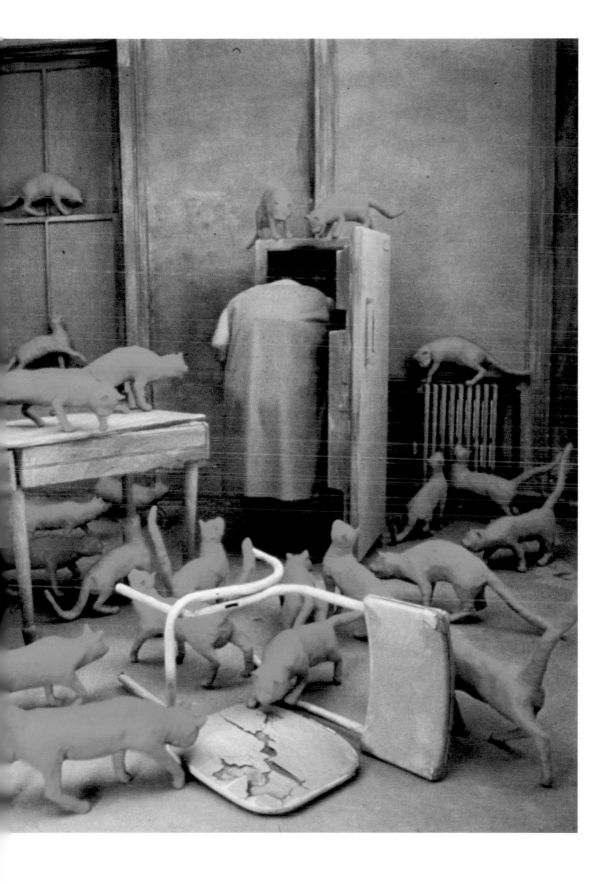

45: BETWEEN ART AND DOCUMENTATION: LANDSCAPE PHOTOGRAPHY

The photographic landscape belongs to a double tradition. This is the tradition of the precise, intimate description of the landscape in the vein of seventeenth-century Dutch painting or of contemplative and romantic Italian *vedute* (vistas), but it is also the tradition that considers the landscape from a specific scientific point of view and exalts "the language of nature." When he made "a view after nature" appear on a pewter plate, Joseph-Nicéphore Niépce invented photography. Nature was now captured in its every detail, and the landscape was faithfully reproduced in its picturesque dimension. The beauty of the world—of the elsewhere and the far-away—that photography attempted to inventory from its very beginnings was thus invited into bourgeois drawing rooms. Travel and picturesque vistas constituted spectacular developments for photography. This new dimension of photography convinced states and decision-makers to make official commissions, of which the Heliographic mission of 1851 revealed the documentary importance. In the United States, explorers of "the new territories" enrolled the services of the most celebrated photographers to document their new conquests.

BEFORE THE MASTERS' GAZE: THE CONTEMPLATION OF SPACE

Through his grandiose and wild landscapes of the American West, Ansel Adams has become a mythical figure of the American landscape. Edward Weston and Paul Strand followed another approach. In their attempts, they testified to the beauty of the industrial landscape, and they imbued their pictures with the emotions they experienced when in contact with nature. In the 1960s, the poetic or mystical experiments of photographers such as Minor White or Paul Caponigro paid tribute to the harmony of the world and the force of nature.

With the advent of the 1970s, the great American colorists began to represent man-made environments such as the edges of cities—"in-between places" and "non-places"—in order to uncover modern society and its failings. Robert Adams placed the American landscape at the heart of his teachings, using photography to forcefully defend his own philosophy of landscape while maintaining a line of reference to the work of great poets of the American space such as Henry David Thoreau. Adams participated in the 1975 "New Topographies, Photographs of a Man-Altered Landscape" exhibition held in Rochester, New York, which constituted an essential taking-stock of contemporary photography.

Adams's theoretical work influenced artists such as Richard Misrach and Joel Sternfeld. Linda Connor hunted for the remains of pioneer civilizations with large-format cameras; John Pfahl and his *Power Projects* documented the impact of large power plants on the landscape; and Edward Ruscha tried to describe the conquest and management of the landscape by modern man through his *Sunset Strip* (an exhaustive panorama of Sunset Boulevard).

EUROPEAN PRACTICES

In Europe, photographs by the Bechers documented the industrial landscape. They would prove to have a lasting influence on all of German photography through the work of Bernd Becher's students at the Düsseldorf Academy.

In France, the DATAR (French regional planning committee) Photographic Mission (1984–1988) gave twenty-eight photographers (including Gabriele Basilico, Sophie Ristelhueber, and Alain Ceccarolli) carte blanche to create a portrait of the French landscape in the 1980s, a real "encouragement to landscape culture in France." This initiative was a direct descendant of the Helio-graphic Mission (1851) and of the American "Frontier Photographers'" expeditions. Photographers were provided with plenty of resources, and the mission gave rise to numerous comparable initiatives: the "Four Seasons of the French Territory" and the "Photographic Conservatory of the Landscape" in France; in Italy, the "Viaggio in Italia," headed by the Italian photographer Luigi Ghirri; the commission of a noted photographer to document the region of Luzzara every ten years (so far including Paul Strand and Gianni Berengo Gardin); "Saint-Gothard Mission" in Switzerland; "04°–05°" in Brussels; and "Madrid Seen By…" in Spain.

 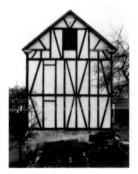
 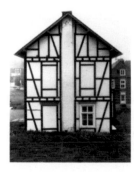 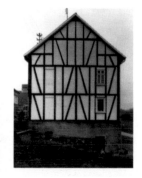

Bernd and Hilla Becher, *Typology of Half-Timbered Houses* (1959–1974). One of four panels, 16 x 12 inches (40 x 31 cm)

Bernd and Hilla Becher work with architecture, homes—like the one in this photograph—and industrial buildings. The former includes factories, warehouses, blast furnaces, and silos. Each structure is photographed frontally from the same angle.

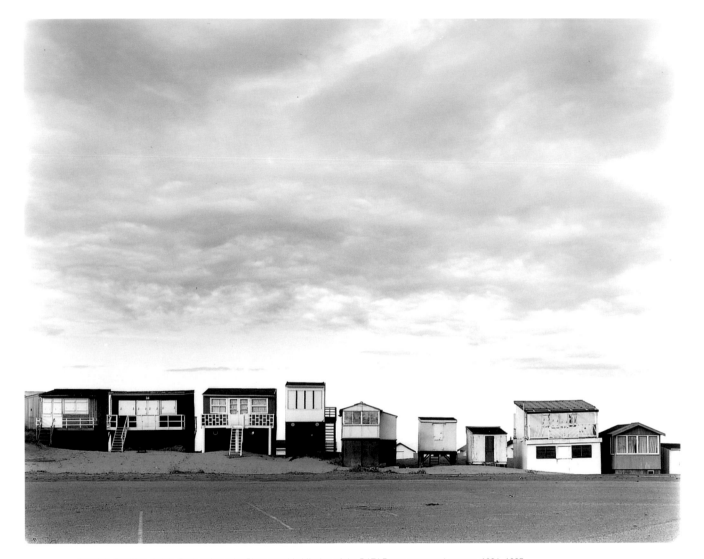

Gabriele Basilico, *Calais*. Project from the Photographic Mission of the DATAR governmental agency, 1984–1985

PERSONAL INITIATIVES

In Europe, Gabriele Basilico, the great Italian master of the urban landscape, tirelessly documents the city through a rigorous photographic observation while maintaining his emotional relationship to the man made landscape. With his color diptychs "Corsica and Its Origins" (1996), Walter Niedermayr has taken an interest in a remote area of the Corsican high plateaus, the Niolu, to draw attention to the fragile beauty of this area that is now threatened by the irreversible damage man has done to it.

For Massimo Vitali, the ordinary landscape is the place for leisure, as well as a practical space adapted to the new standards of existence. His jam-packed beaches, which he photographs from a shelter-blind over the water with a large-format camera, turn out to be symbols of modern life. The English photographer John Davies and the Belgian Gilbert Fastenaekens have a romantic way of showing industrial landscapes with the striking contrast of a strongly asserted aesthetic. Thierry Girard, who has been building a solitary body of work for over twenty years, experiences the landscape by crossing it. He is heavily influenced by the Land Art artists, who intervened directly in

situ on nature, leaving their personal imprint on the land they dug up, moved, and transformed through actions that only photography could record. For Girard, landscape photography cannot express itself through a blissful and strictly contemplative attitude. His pictures are always the fruit of experiences such as walking.

Finally, the German photographer Elger Esser totally distinguishes himself from the Becher heritage, though he was also one of their students. He is one of the rare contemporary artists to be following the traditions of the Italian renaissance painters. His photographs, published in the book *Veduten und Landschafte* (Landscape Views, 2001), are very large images of lakeside landscapes and the deserted seaside in translucent, milky colors and brown monochromes that reveal the mystique and the silent beauty of nature.

Richard Misrach, *Pyramid Lake # 5* (1988)

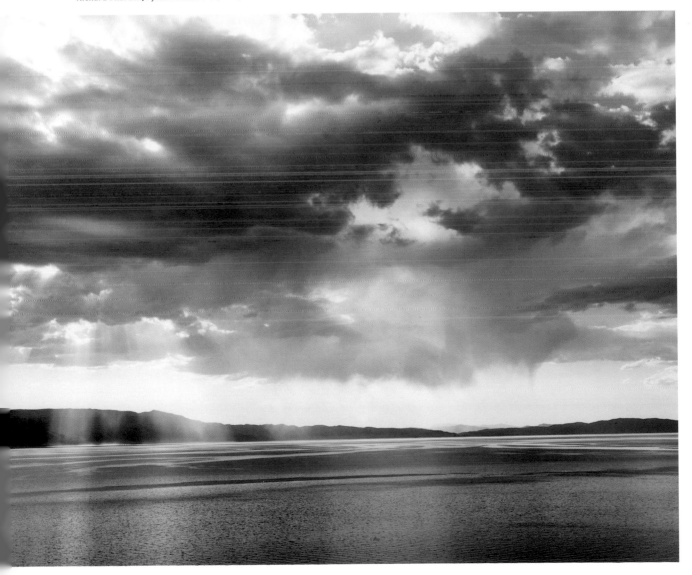

46: THE GREAT SPECTACLE OF THE WORLD

National Geographic (June 1985)

From its very beginnings, photography has been the traveler's companion. A source of precious documents for the scientist, photography is, first and foremost, evidence of those "faraway places" that fascinate us and unleash our imagination. Since the incredible "Around the World" program was started in 1908 to constitute Albert Kahn's "Archives of the Planet," countless photographic missions have continued to make us dream. Gathered in books and published in magazines (such as *Life, VU,* or *Regards*), these photographs are accompanied by captions and travel accounts. Travel, photography, and text are thus linked to serve the curiosity of the insatiable viewer.

THE NATIONAL GEOGRAPHIC MAGAZINE

The National Geographic Society was founded in Washington in 1888 with "the increase and diffusion of geographical knowledge" as its objective. It sponsored expeditions, and published ever-increasing numbers of photographs in its magazine, for which it gained an ever-increasing audience. "The *National Geographic* magazine has found a new universal language that does not require in-depth study...the language of photography" (1915 advertising leaflet). The magazine followed scientific advances, publishing the first underwater photos and the first photos of space flights, and also covered conflicts. The famous cover photo on the Afghanistan issue is one of the most striking in the magazine's history. It also comes with a beautiful story since, after a long hunt, Steve McCurry finally found Sharbat Goula again in the Afghan mountains, and was thus reunited with the young woman he had photographed in a refugee camp seventeen years earlier.

TO KNOW THE WORLD

Different landscapes, new architecture, other cultures: a new genre had appeared. Known as the "Connaissance du monde" (Knowledge of the World), this work was published in Switzerland by Clairefontaine, La Guilde du livre, or Ides et Calendes. The black-and-white, then color, books that these publishers released always followed the same formula: a country, photographs, a factual or literary text. The photographs were by Pierre Verger (*Au Mexique* [In Mexico], 1949), Hélène Hoppenot (*Extrême-Orient* [Far East], 1951; *Rome,* 1952) or Fulvio Roiter (*Andalousie* [Andalusia], 1957; *La Perse* [Persia], 1966). Slowly, the travel genre evolved, and the photographer became more of an "auteur," recounting his life experience and his human adventure. Around the same time, the publisher Robert Delpire was publishing photography books by Henri Cartier-Bresson (*D'une Chine à l'autre* [China in Transition], 1954), Inge Morath (*Guerre à la Tristesse* [War on Sadness], 1954) and Werner Bischof (*Carnet de Route* [The World of Werner Bischof], 1957). They were certainly travelers, but they were travelers whose primary concern was to document current events. In this context, the figure of the photographer-adventurer of the 1960s would sometimes appear alongside the photojournalist.

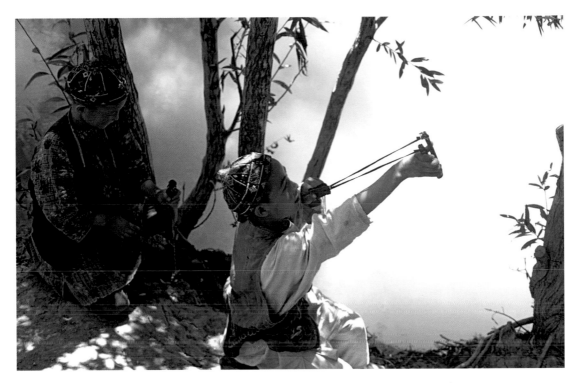

Roland and Sabrina Michaud, *A Young Student Hunting Birds* (Alti Bulaq near Andkhoy, Afghanistan, June 1967)

DAY-TO-DAY ADVENTURE

The most famous adventurers may be Roland and Sabrina Michaud. The first time they traveled to Afghanistan in 1964, the Michauds were powered by an enthusiasm to discover the world, to meet the inhabitants of remote places, and to account for what they saw. The couple planned to share their adventures and capture novel images of areas most people didn't know existed. They showed Tartary and its astonishing caravans of camels moving across a backdrop of glaciers; Kazakhstan and its eagle hunts; and Afghanistan and the violence of *buzkashi* (the exclusively Afghan game of horsemanship). For years on end, the Michauds took off on these quests to immerse themselves in a new country. Talking about a trip that lasted four-and-a-half years, Sabrina Michaud recalled that "we would go to Asia to get to know the people and their pleasures, to try and exchange skins." Roland Michaud was not a reporter. His photographs escape time and space; they are archetypes, timeless visions. Throughout India, Michaud rediscovered *The Thousand and One Nights*, and he played at mirroring Oriental miniatures in the situations he photographed. The Michauds are idealistic storytellers whose ambition is to reproduce the best that humanity has to offer. They have never hesitated to magnify mankind through superbly crafted color photographs.

The adventures of this couple have been a model for the many other photographers who offer a vision of a picturesque, even magical, world in "spectacle-books" (Eric Valli, Olivier Föllmi, among others): "Pure adventure based on intelligence, complicity, athletic exploits, and, of course, a little bit of luck," *National Geographic* boasts.

But the world evolves very quickly and, today, the situation has changed. Unknown subjects are becoming rare, and the crucial issue is no longer to discover but to safeguard a world that is increasingly endangered. In this spirit, Yann Arthus-Bertrand conceived of *La Terre vue du ciel* (Earth From Above), a book that has been translated all over the globe, which offers the spectacle of an unexpected Earth seen through colorful images full of infinitely varied, even abstract, shapes. Yann Arthus-Bertrand's goal in producing this book was not only to take pleasing photos but to help "build a [necessary] eco-economy" by raising his audience's awareness through a new approach to the earth. Arthus-Bertrand shows us a vulnerable Earth that, with a little distance, we can now see in its entirety. It is an Earth whose fate we are all responsible for.

pp. 180–181: **Yann Arthus-Bertrand,** *Flight of the Red Ibis Near Pedernales, Amacuro Delta, Venezuela* (9° 57' N – 62° 25' W)

The book *Earth From Above*, which includes this photograph, is a best seller that has been translated and sold throughout the world.

Bernard Plossu, *The Mexican Journey* (1965–1966)

For nearly a year and a half, while visiting his family in Mexico, Plossu experimented with photography. The area was completely unknown to him. For many years after, Plossu took photographs based on his complicity with the people and things he met on his journeys. His work reinvents conventional ideas of travel souvenirs.

47: TRAVEL DIARIES

If photography is that "mirror we hold up along a path" that Stendhal used to define the novel, there are undoubtedly multiple directions in which to hold it. In the 1970s, some travel photographers tilted the mirror to the point that it was reversed, allowing their own images and personal histories to slip into their photos. This approach quickly asserted itself in certain travel diaries through the pronounced use of subjectivity and the photographer's individual point of view. The work of French photographer Bernard Plossu or of the Australian Max Pam, for example, were particularly characteristic of the subjective travel-diary genre. For these photographers, their work was no longer a question of revealing the world to spectators who didn't travel but of giving an account of their emotions, their private experiences, and their experience of a world that they did not consider exotic. *Le Voyage mexicain* (The Mexican Journey) by Bernard Plossu is an undisputed landmark in this self-centered approach to travel. Bill Burke's impassioned approach to Asia went even further by combining photographs, handwritten text, and collages of travel mementos including bank bills, beer labels, and cigarette packs in a graphic approach that truly resembled the travel diary.

THE ADVENTURES OF MAX PAM; PETER BEARD'S AFRICAN BUSH

Max Pam left Australia to discover India and Asia. Rather than telling these area's histories, he recounted his daily adventures and was present in every one of his photographs in spirit. The photographs became elements in a private journal in which he made a daily inventory of the day's events, of the good photos taken, and of the photo opportunities seen but missed. Day by day, these entries allowed him to construct a story, or rather a network of stories. The photographer let himself wander, at the mercy of detours and impromptu events, until text and photo wound up on the same page. *Ethiopia* and *Tibet* are Pam's two travel notebooks, his "private diaries," which, like Bill Burke's books, contain alien elements such as visas in Pam's name, foreign postage stamps, boarding cards glued around and onto the photographs, creating a visual game with the colors, and various typographies that initiate a dialogue between the pictures.

A completely different, highly unusual approach is Peter Beard's, whose work largely consists of a fabulous sketchbook of life, a historical series of illuminated agendas that are full of imagery. Beard has been ritualistically filling the pages of his *Diaries* for more than forty years. Along with his composite tableaux, which are spattered and soiled mixes of words, paintings, and photographs enhanced with drawings, the crucial element of Peter Beard's body of work are these *Diaries*. Peter Beard has also chosen a territory for himself, Africa, which he discovered through Karen Blixen. He initially settled in Africa and now divides his time between Kenya and New York, the two worlds that cheerfully rub shoulders throughout his work. Africa and the world of celebrities share an exoticism, but Beard's photos of dead elephants are not there for purely decorative purposes. They are a call to order, a commemoration, and a denunciation. In his book *The End of the Game*, which is a sort of diary of the faraway, Peter Beard describes the tragedy of the end of wildlife, which he powerlessly witnessed after having fought for

its preservation for years. Here, Africa becomes a symbol; the extinction of these species is a forerunner of the inescapable fate of mankind. According to his friend Francis Bacon, "Peter Beard's work carries the trace of the vanity and tragedy of life." His *Diaries*, a compulsively tangled collection of everything under the sun, is also an obsessive challenge to the passage of time.

This manner of dealing with travel in the first person can be found in the work of most contemporary author/ photographers. It is worth mentioning Denis Dailleux's work in Cairo, Claudine Doury's work in Siberia, Bernard Descamps's work in Morocco and Japan, and Raymond Depardon and his call of the Sahara. In fact, there are endless examples of this tendency to combine explorations of the world and unusual personal universes. They are endemic to authors who consider that, above all, no matter what their work shows or seems to show, it is above all a vast self-portrait that merely uses the world as a pretext to situate the author and express his beliefs.

Peter Beard, *I'll Write Whenever I Can* (Lake Rudolf, 1965)

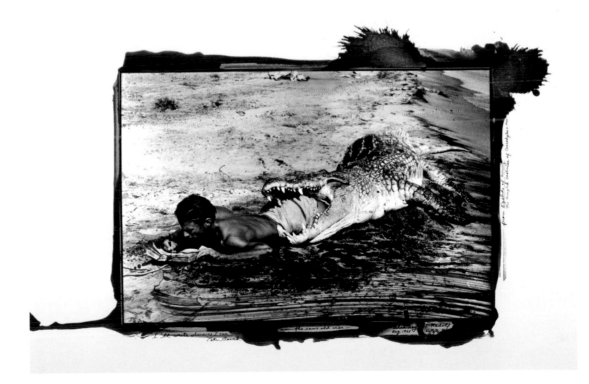

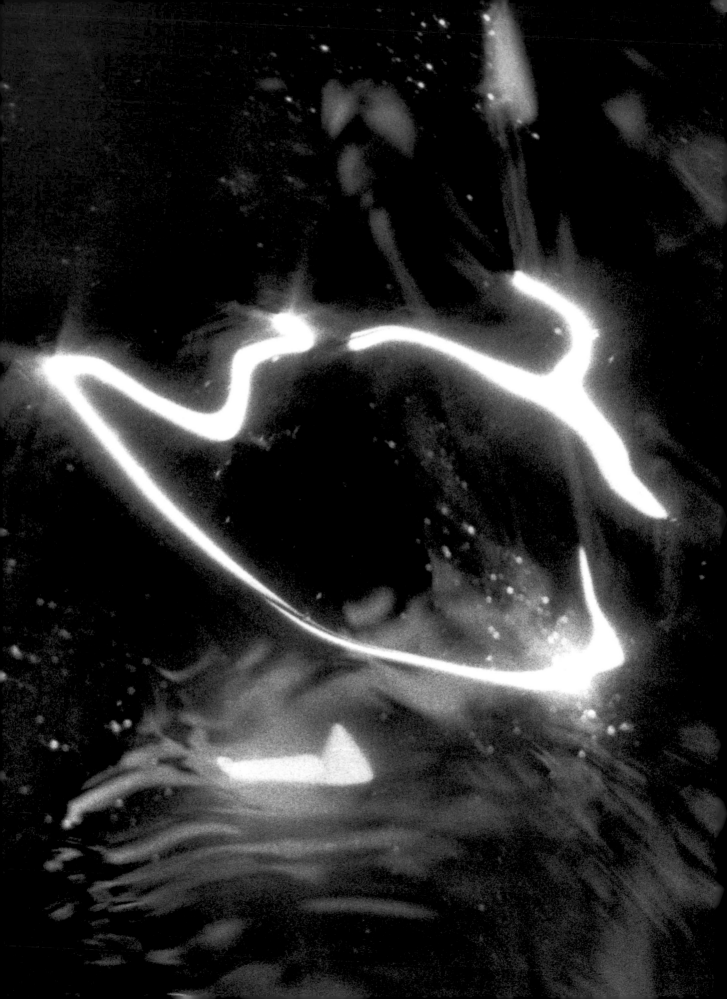

PHOTOGRAPHY
TODAY

48: A "GOOD" PHOTOGRAPH?

A Missed Shot (Venice)

ALTERNATIVE PERSPECTIVES: THE SPOILED SHOT

In photography, as in so many other areas, a number of rules govern what passes and what fails—or, to be more precise, what passes for a "good" photograph as opposed to a "bad" or "spoiled" one. There is so little disagreement about this that big commercial developers do not bill their customers for blurred photographs, not to mention double exposures.

The determining criteria are technical ones, which have come down from the beginnings of photography, and derive from a representational ideal that stresses reliability and "faithfulness" to reality. The quest for clarity encouraged progress in optics, and the desire for deeper blacks and more subtle contrasts led chemical research into the properties of silver salts. Hence the rise of a number of criteria of "quality," whose influence was increased by international competitions organized by photography clubs and publications of "best photos of the year." In this way, what had been simply conventional became mandatory.

Viewing this trend as a value-laden celebration of the technical and of bourgeois notions of the "beautiful," many photographic artists were tempted to break out of the norm. The surrealists began using double exposure and photomontage;

the avant-garde refused head-on or "well-balanced" shots in favor of "dynamic" views that reneged on well-behaved horizons; and increased use was made of foreground fuzziness to enhance the other spaces in a picture. Provocative practitioners like Helmut Newton gained respect for their Polaroid "sketches" or for the red eyes produced by using direct flash. Indeed, the Russian Boris Mikhailov continues to practice such approaches among the other offenses he commits against photographic good taste.

While artists are able to overturn received values and pervert the notion of the "spoiled shot" to their own ends, the received norms continue to wield great power over amateurs. Hence the increasing automation of cameras that can take only "good" shots, all identical, and every one as bland as the last.

At once screamingly funny and highly serious, Thomas Lélu's *Manuel de la photo ratée* (Manual of Missed Shots) is not simply an inventory of spoiled photos but remains an invaluable guide to how photographers can continue to successfully spoil their shots.

ALTERNATIVE PERSPECTIVES: NEW AUTHORS

Over the past 150 years or so, photography—or rather its practitioners, the photographers—has defined its own etiquette, laying down rules for what constitutes a "good" photograph. Though they may change from time to time, the rules have acquired an authority that makes them difficult to break.

In the field of professional photography, including reporting, the notion of the frame and of geometric composition has become standard; its somewhat dogmatic guardian is Henri Cartier-Bresson. With its direct reference to the Golden Number and the rules of classic painting, this approach, which draws the viewer's eye into the rectangle and keeps it there as it ranges over the selected elements, is a way of reducing the world to the photographer's image. The intention is to

induce the viewer to forget all that might have existed outside the frame at the time the selected detail was photographed. Deliberately ignoring, as it does, any existence outside the frame, this practice creates the impression of trying to substitute itself for the reality that feeds it.

In the 1950s, photographers such as Robert Frank and William Klein entered the scene with more liberal notions that challenged what had become just as much a dogma as the tenet of the clear image. Freed by this approach and explicitly referring to it, these two were among others who spectacularly spread radical suggestions through their books and exhibitions. Even so, such contrary opinion remained tentative, and, however subjective the suggestions were, they continued to respect the received, or classic, form. In the 1990s, the American Michael Ackerman and the Frenchman Antoine D'Agata simultaneously dealt the conventions a serious blow. With their imprecise, motile, lively centering, which did not respect the balancing of masses, they managed to acknowledge the diffuse space outside of camera vision—unconsciously reconstituting the viewer. In more precise terms, we have the sense that the photographer has chosen certain visual fragments for their capacity to transmit the emotions he or she has experienced.

While these two authors have certain formal elements and a great freedom of tone in common, their attitude is quite different. Michael Ackerman searches the outside world for correspondences to his inner world, to his tempered pessimism or sense of aloneness, and he cultivates a stylistic notion through his explorations and developments. Antoine D'Agata, on the other hand, regards photography as a life experience, as a way of keeping track of his own life, his excesses, his chaotic nights. Stylistic effect is not what he is after, and he practices an impertinent sort of photography that concentrates on the socially marginalized and excluded.

Widely distributed through books and exhibitions, these two approaches have not been slow to catch the attention of a large, often quite young public. They have also influenced a fair number of young photographers, some of whom have come together in collectives like Tendance Floue.

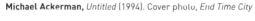

Michael Ackerman, *Untitled* (1994). Cover photo, *End Time City*

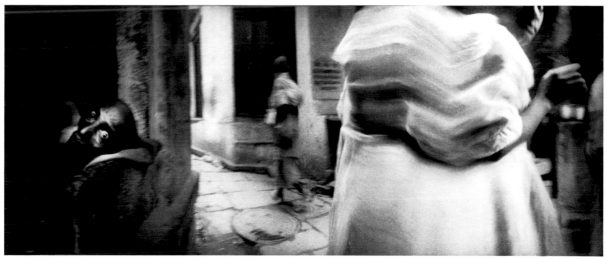

49: PIXELS AND SILVER DUST

It is hard to judge the relative reality of changes that come from technological developments, especially those of recent times. Historically, the invention of the Leica, so much more handy than its predecessors, allowed new aesthetics to emerge in the fields of reportage and photojournalism. But the appearance of digital photography some ten years ago signaled an unprecedented revolution.

NEW TRADES FOR NEW TECHNOLOGIES

While digital technology has thus far had only a minimal aesthetic effect on the photograph itself, it has transformed the trades associated with photography. The most important change has been in the area of the archiving, storing, and transmitting of photographs, which has affected the worlds of newspaper and magazine printing, advertising, communication, and book publishing. In earlier times, the archiving of photographs was a skilled trade that required a physical location, since prints and slides take up considerable space once they start to accumulate, and this is expensive. In order to be distributed these images had to be printed and duplicated. With digital technology, however, it is enough simply to scan a photograph (following all the appropriate technical steps enabling it to be printed) in order for it to become available to millions of potential users through electronic transmission. It can also be made available on agency or independent photographers' sites and become available to users of the Internet worldwide.

Organizations with large, not to say unlimited, financial resources (Corbis, Getty Image) are now able to market photographs digitally and are on the way to becoming hegemonic suppliers. Although this is high-performance technology, the material handled is often very mainstream, with the object being to satisfy the largest number of customers. For the moment, then, these distributors do not provide the most

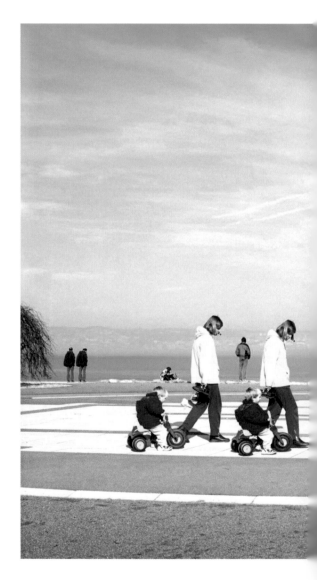

creative photography, and it does not seem that the photographic hypermarket is on the verge of putting craftsmen and specialty shops out of business.

THE ERA OF SPEED AND VIRTUALITY

From the point of view of professional photographers, especially those covering the news, digital technology makes it possible for them to transmit their pictures so fast that it is almost like freeze-frame television. In other words, photography has entered a contemporaneous environment that, according to Paul Virilio's analysis, is dominated by speed. The break with heavy equipment and lengthy processes—inherent in the invention of photography and the use of silver salts—is thus complete. Today's reporters may choose to work in either silver or digits; that is, either they come to terms with a lengthy process, or they dedicate their efforts to the immediacy of the news and information media. The current state of the new technologies leaves room for doubt about the conditions under which digital images can be conserved, since CDs and hard disks have a limited lifespan. We will need to figure out what kind of record the digital photograph actually is, as well as what is likely to happen to the pictures of conflicts that have already largely been captured digitally. No going back will be possible.

The digital image is a virtual image, a combination of electronic information easily modified by a computer with software like Photoshop, a point that creates doubts about its news capabilities. On the other hand, although it is easier and quicker now to manipulate images, the technique is an old one, and manual photomontage has had its historical function. There remains the professional code of ethics between the distributor of the information and its receiver, the only guarantee of trustworthiness.

A last, rather more positive, aspect is that the circulation of photographs in digital form has brought home to people that the photograph is a rectangle of paper carrying an image, an object that has its place in a fast-developing marketplace of photograph collectors.

So, if the image is only virtual, what will become of the shoeboxes in which family memories and holiday photographs pile up higgledy-piggledy? Will future generations simply have CDs and hard disks to riffle through to find their memories?

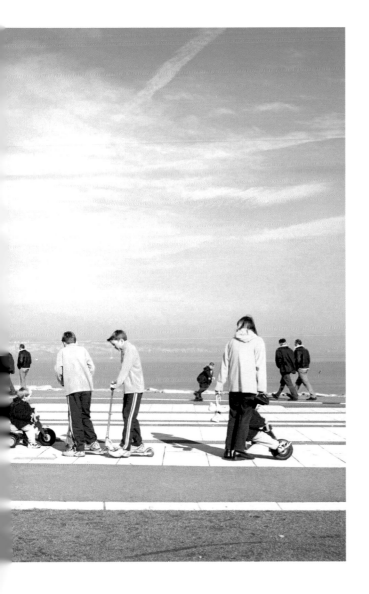

Mathieu Bernard-Reymond, *Untitled, # 23, Intervals* (2002)

The photographs from the series "Intervals" are filled with clones. The artist digitizes his photographs, using his computer to create a single image. The works depict characters reproduced several times, in various poses, like in film frames.

50: ART PHOTOGRAPHY

The increasingly frequent use of photography by fine artists began in the 1960s, along with the medium's gradual escape from the exclusive domain of reportage and photojournalism. Photography was now being used as a critical instrument, a tool for distancing, a machine for vision and fiction, and a referent for the new conceptual and semiotic processes. In this period, photography distanced itself from the objeclive criteria that had been fundamental to the documentary and descriptive traditions, thereby fully integrating itself into the field of contemporary art. Photography was no longer confined to a supposedly pure and autonomous history of the medium. On the contrary, it was combined with fine art to become a part of the generalized hybridization of art practices and the increasingly manifest decompartmentalization of the fields of artistic production. Three exhibitions attested to this shift of photography toward fine art: in 1980, Michel Nurisdany organized the exhibition "Ils se disent Peintres, Ils se disent Photographes" ("They Call Themselves Painters, They Call Themselves Photographers") in Paris and, in 1989, two manifesto-shows were mounted: Une autre objectivité (Another Objectivity) in Paris, and Photokunst in Stuttgart.

Jeff Wall, *A Sudden Gust of Wind (after Hokusai),* 1993

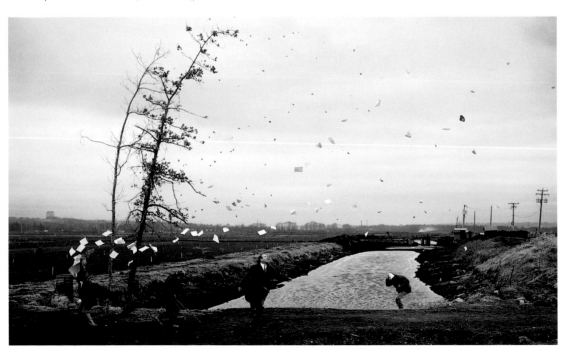

WHAT IS FINE ART PHOTOGRAPHY?

This type of photography is no longer a simple reproduction of the real. The artwork now involves a vast range of elements, including exposure, print, format, medium, staging, film alterations, digital retouching, and the use of photomontage and photocollage. Large formats and the use of color are often favored. The picture is based on an artistic project and its conceptualization, implementation, and mode of exhibition. The notion of the artist-creator is privileged. Those artists referred to as "art photographers" come from two backgrounds: those whose photographic process links them to contemporary art practices, and those who integrate photography into their practice. The results are comparable.

These profound transformations of photography's status are due equally to technological revolutions (the advent of the digital) and to the evolution of the market. Photography now has a place in the art market (a limited run of prints of a given photo are signed and sold). Art collectors and amateurs testify to the increasingly seductive powers of a medium that dealers and experts have embraced in a firm grasp.

Around 1962, photography was first used as a "trace" of the work of the Viennese actionists. Otto Muehl, Hermann Nitsch, and Gunther Brus were among the first artists to include photography in their performances. These proponents of a frequently violent and aggressive body art did, however, make a clear distinction between pictures of actions specifically performed for the camera, which they considered works of art, and pictures taken during public actions, which were considered documentation.

In the 1970s, the same approach was taken by Gina Pane and Michel Journiac, who referred to his performances as "photographic actions." These artists used photography to leave a trace of their happenings. Today, Orlan is probably the most representative artist of this movement. She modifies her body and remodels it through multiple transformations, using it as her only medium. She provides photographic prints as the sole representation of her work.

For the artists of the Land Art movement (Richard Long, Robert Smithson, Robert Morris, Dennis Oppenheim), which developed in the United States in the late 1960s and in Europe in the early 1970s, photography was an integral part of a project, of its conceptualization, implementation, and mode of exhibition. Their interventions on the landscape were connected to an understanding of ecology and ancestral cultures. Photography served as the memory of these sculptures that were, by their very nature, ephemeral.

Conceptual artists such as Edward Ruscha and Dan Graham reflected on the art object in and of itself, borrowing Walker Evans's idea of photography as the vector of the art work. Beginning in 1963, Ed Ruscha set his sights on American vernacular culture. He defined his photography as a "totally neutral medium," one of the constituents of the picture books he published (*26 Gasoline Stations; Various Small Fires; Nine Swimming Pools; A Few Palm Trees*). Dan Graham started working on the concept of repetition and series in 1965, frequently alternating text and image. Graham was a part of the movement toward a semiotic analysis of photography. The British artist Victor Burgin followed in this direction a few years later by focusing on photography's critical expression. In the 1970s, Jan Dibbets also took pictures from a frontal position, then quickly became interested in the complexity of perspective (*Perspective Corrections, Spoleto Duomo*).

At the beginning of the 1970s, with the work Bernd and Hilla Becher undertook on industrial buildings and landscapes, photography attained the level of artwork itself by overexposing the real. Though the Bechers referred to the documentary photography of the end of the nineteenth century, notably the work of August Sander and Eugène Atget, the intentional neutrality of the photographs likened them to an objectivist scientific inventory. The Bechers' prints belong to the class of photography that reports and archives. The shot is always frontal, and the juxtaposition of pictures of a single site removes any notion of subjectivity from the shot. In 1992, they were awarded the grand prize for sculpture at the Venice Biennale, which definitively confirmed their work's status as fine art.

For fine artists such as Christian Boltanski and Roman Opalka, photography is a complement to memory. Starting in 1969, Boltanski used

snapshots as an infinitely interchangeable neutral medium for collective memory. With his series of photo albums and his stereotyped "model images," Boltanski attempted to demonstrate the vacuity of the notion of the individual. He created environments in which photography engaged a reflection on absence, memory, and death. Every day since 1961, Roman Opalka has taken a photograph of his face after work and under the same lighting conditions, with the same facial expression and while wearing the same clothes. He projects his life into an existential quest of which the pictures are the measure of time passed. His photographic self-portraits extend his fine art practice and are elements of his "Life project," to the same extent that are his paintings and sound recordings.

Photography also holds an important place in the work of Italian artists Giulio Paolini and Michelangelo Pistoletto, who use it as a document integral to their creative work.

Gilbert and George, *Necked* (1991). Mixed media, 89 x 100 inches (226 x 254 cm)

THE EIGHTIES

During the 1980s, art photography emerged as a full-fledged art form. In Germany, a school of photography called the Düsseldorf School appeared in the wake of the Bechers. Düsseldorf's defining characteristic is large-format photography that is documentary and objective. Thomas Ruff blurs the original notion of the photograph's authenticity by working on his images on a computer, by superimposing several pictures, or by compiling different elements of information. Andreas Gursky makes nearly systematic use of large formats, grid patterns, and lines to create a sensation of emptiness and giddiness. Thomas Struth explores contemporary social and cultural situations through large-format photographs that are devoid of human presence.

In the United States, Richard Prince (who worked in 1980 in the Time/Life research department) produced a virulent critique of representation with his "rephotographs," collections of ordinary iconographic documents and images connected with advertising eroticism. Barbara Kruger attacked media manipulation through work dealing with the relationship between

images and power. The Canadian artist Jeff Wall tackled an explicitly social subject matter using photographic processes reminiscent of the construction of movie shots and with techniques borrowed from advertising (light boxes), while occasionally expressly referring to masterpieces of Occidental painting. Along with Jean-Marc Bustamante, Wall was one of the first artists to use the term "photo tableau" in reference to his work, a term that Jean-François Chevrier has defined as "a certain photographic form conceived in reference to the pictorial model without the actual gesture of painting."

Photography is also a diary. In 1986, Nan Goldin created her *Ballad of Sexual Dependency*, a slide-show chronicle of her daily life through portraits both of herself and her intimate circle. And let's not forget photography as disguise, evidenced in the work (for example) of Urs Lühti or Cindy Sherman.

THE NEW GENERATION

In the twenty-first century, more and more artists define themselves not as photographers but as contemporary artists for whom photography is as viable a medium as painting on canvas. The variety of approaches and of questions being investigated is vast. This abundance of contemporary practices is testimony to photography's entry into the history of art.

Andreas Gursky, *99 Cent* (1999). 42 x 52 inches (107.5 x 131 cm)
The most expensive living photographer. Gursky prints his work in giant format.

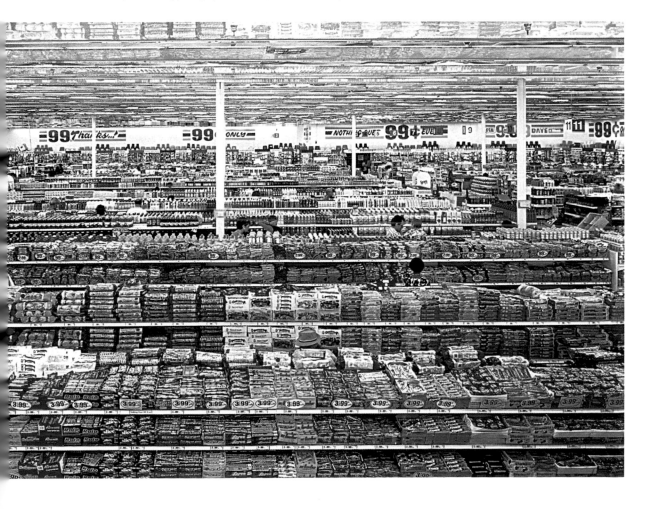

51: RIGHT OF PERSONAL PORTRAYAL

Over the last two decades, the number of lawsuits filed by individuals against publications or photographers for "infringement of the right of personal portrayal" (in French, *droit à l'image*) has considerably increased. For example, the following suits in France are based on the Constitution's recognition of the fundamental rights of an individual, including the recognition that "everyone has the right to respect for his private life."

APPLYING THE LAW

Because legislation on this issue remains ambiguous, judges generally rely on jurisprudence to make their decisions. Given that they are overwhelmed by the number of lawsuits and rarely aware of a photographer's professional imperatives, it is perhaps not surprising that their decisions are almost always in favor of the plaintiff, to the detriment of publishers and photographers. Judges limit themselves to mechanically applying legislation that requires that in the case of any publication, the publisher and photographer should be able to provide the written authorization of the person(s) represented in a photo.

Obviously, such authorizations are difficult to obtain in reportage situations, where a photographer frequently attempts to be as discreet as possible in order to avoid modifying a subject's attitude by his presence. After a long period of severe sentences, a few recent examples seem to indicate a better understanding of the situation on the part of the legal system. They therefore dismissed the case of a young woman who had become a heroine of May '68 by being photographed on a friend's shoulders brandishing a flag. She had filed a suit for infringement of the right of personal portrayal…thirty years after the fact.

NO MORE CANDID SNAPSHOTS

It is clear that most cases go to court because people are lured by big financial settlements and tempted to take advantage of muddy legislation, whose unqualified application can result in a big payoff. Nowadays, candid snapshots such as those taken by Cartier-Bresson, Willy Ronis, or Robert Doisneau would be extremely risky for any editor who dared to publish them. By doing so, they would open themselves to a potential lawsuit. Thus, many photographers remove these shots from their archives or endeavor to take photos in which the characters are not recognizable. These choices deprive us of those snapshots of daily life that still make 1950s photography so delightful and replace them with bland illustrative shots staged with actors or friends in order to avoid any nasty surprises. Doisneau's most famous picture, *Le Baiser de l'Hôtel de Ville* (The Kiss at City Hall) gave rise to the most famous of these court cases. A couple who "recognized" themselves in the photo lost their case when the photographer proved he had created his series using actors from a theater school—for the very purpose of avoiding any such problems.

EVEN THE VOLCANOES OF AUVERGNE

An equally disturbing trend is the proliferation of lawsuits being filed by individuals or architects who want to prohibit the unauthorized reproduction of their property or their designs. A beach, a cabin in Brittany, a volcano in Auvergne, the pyramid at the Louvre, and the Grande Bilbliothèque François-Mitterrand have all been the objects of court cases. Unfortunately, these cases have had contradictory outcomes, which contributes to complicating French jurisprudence in this area. It is urgent that we turn our full attention to what appears to be a privatization of public space for financial reward.

Imagine a mass of tourists thronging around the pyramid at the Louvre. In the midst of the crowd stands a model wearing an Yves Saint Laurent dress and a Picasso brooch. Now try to imagine what would happen to any photographer who dared to publish such a shot in our day and age.

Frédéric Achdou, *Crowd* (n.d.)

52: MAJOR PHOTOGRAPHY EVENTS AROUND THE WORLD

Festivals and institutions devoted to photography proliferated in the 1970s. Since then, the general public has begun actively participating in these events, which give the photo world an opportunity for serious debate, as well as for encounters, exchanges, and innovations. One of the major goals of photography festivals is to ensure that photography remains at the heart of the human dialogue with reality. All these events share a focus on bringing the work of acknowledged masters to their cities, giving exposure to young artists (often chosen by juries), and exploring serious issues in photography. They transform numerous public spaces into art galleries, lending, indeed, a festive tone to urban life.

Serge Gal, The first team at the Rencontres Internationales de la Photographie d'Arles, in 1970: Todd Webb, Jean-Claude Lemagny, Michel Tournier, Jean-Claude Gautrand, Lucien Clergue, Jean-Pierre Sudre, Denis Brihat, Édouard Boubat, Jean-Maurice Rouquette, Jean Dieuzaide.

"My first visit to Arles in 1986 was a special time in my life.... I saw original and stimulating images, met other photographers and exhibition curators. An adventure.... The Rencontres launched me onto the international scene. Since, I've become a regular, both as an artist, studio visitor, and presenter." —Martin Parr, 2004

When they gathered on July 1, 1970, in Arles, France, to enjoy the prints of Edward Weston, the small group of passionate photo amateurs led by Lucien Clergue (still vice president of the festival), Jean-Maurice Rouquette (the curator of the Réattu museum), and the writer Michel Tournier was far from imagining that Les Rencontres internationales de la Photographie d'Arles (Arles International Photography Encounters) would become one of the world's essential photo events.

Arles was quick to find its modus operandi, which has succeeded in maintaining the event's populist focus. Exhibitions are spread throughout the city's most prestigious sites: thematic evenings are held in the Théâtre Antique; courses taught by photo professionals are held at the École Nationale de la Photographie; and portfolios are presented in the Hôtel Arlatan. Prizes are awarded—Arles is where Kodak awarded its European Grand Prize, Leica awarded the Oscar Barnack prize, and François Hebel launched six new prizes—and an off-festival is held.

Over the more than thirty years of its existence, Arles has become a gigantic gallery that has presented the work of thousands of photographers. The early years are rich in memories: the visits of Ansel Adams, W. Eugene Smith, Brassaï, André Kertész, Duane Michals, Willy Ronis, Henri Cartier-Bresson, and Robert Doisneau; the somewhat stormy evenings dedicated to young French photography in 1979 or the German New Vision in 1981; "Jazz and Photography," organized by Guy Le Querrec and Michel Portal in 1983; the ninetieth birthday of Jacques Henri Lartigue; the special events devoted to Latin America; and the reception given to China and its strong photographic identity.

The success of the Arles festival spawned others around the world. In 1980, Jean-Luc Monterosso founded the first "Mois de la Photo" (Month of Photography) in Paris, a generalist biennial that presents a selection of exhibitions and encounters based on three different themes in public spaces, private galleries, and cultural centers—creating a model that was soon followed elsewhere. In 1983, photographers Frederick Baldwin and Wendy Watriss, along with gallery owner Petra Benteler, founded Fotofest in Houston, Texas, which held its first biennial in

1986. Vox Populi, an artists' collective in Montreal, launched its first "Mois de la Photo à Montreal" in 1989, another multi-site biennial event. That same year, Jean-François Leroy started "Visa pour l'Image" in Perpignan, France, an event focused on photojournalism, with exhibitions, screenings, panels, and prizes. Reporters who document the state of the world with their camera lenses speak out about their concerns at Perpignan, and by attracting professionals from around the world, Visa has become a very important photojournalism market.

In the 1990s, photography festivals spread throughout the world. By the end of the century, the Festival of Light, an international collaboration, enlisted the participation of twenty-two photography festivals from sixteen countries in a two-year long program of monthly events. Its organizers announced, "At the beginning of this century, photography heralded a new form of art and popular communication. At the end of the century, festivals and museums of photography have become focal points of popular culture around the world."

PhotoEspaña, which has been held annually in Madrid since 1998, is the most ambitious newcomer to the photography festival circuit. Encompassing about fifty exhibitions displayed in the city's most prestigious exhibition spaces, the festival is organized according to a different theme each year, aimed at clarifying the relationship between photography and visual media in general. The theme of the 2004 edition is "Historias," a rubric for exploring both fictional narratives and documentary photography. Another significant entrant in the 1990s was Moscow. The Moscow House of Photography has sponsored a biennial since 1996, exposing Russians both to the archives of prominent Russian photographers and to an international roster of stars. As the organizers report, "The festivals have not only been widely acclaimed by the general public and the media, they have restored the artistic and social value of the phenomenon of photography in the Russian social perception." In Buenos Aires, Los Encuentros Abiertos enters its thirteenth edition in 2004 as an annual festival encouraging exchange and communication between photographers "of all disciplines." African

Photography Encounters, held in Bamako, Mali, since the mid-1990s, displays the wealth and vitality of African photography and seeks to define its leading visual identities. By including the diaspora in the Caribbean, the Americas, and North Africa, the festival has quickly become the site of passionate exchanges and encounters.

The creation of museums devoted to photography has meanwhile kept pace, challenged only by the expansion of the role of photography and the influence of photography departments in traditional art museums. As the Arles festival was being launched, the photographer Cornell Capa was developing his plans to open a museum dedicated to the legacy of "Concerned Photography" in New York City. The International Center of Photography, which opened in 1974, has broadened its mission to encompass all photographic expressions in the following decades. It recently hosted a series of exhibitions devoted to science and photography. In 1982, the Centre National de la Photographie opened in Paris. The National Museum of Photography, Film & Television opened a year later in Bradford, England, to quickly become the most visited national museum outside London. Jean-Luc Monterosso founded the Maison Européenne de la Photographie in Paris in 1996, dedicating its exhibition spaces to historic photography, large single-artist retrospectives, and new talents. In 2004, a new Museum für Fotografie, sponsored by the State Museums of Berlin and the Helmut Newton Foundation, became only the latest of many such institutions around the world.

This international ferment, encouraging photography in all its many forms and breaking down the barriers between different ways of thinking about it, has made the past thirty-five years one of the most exciting periods in the history of the medium.

Juan Alberto Garcia de Cubas, *PhotoEspaña* (Madrid, 2003)
Between June and July, Madrid turns into the world capital of photography. Several exhibitions throughout the city are on view.

Bernard Descamps, *Bamako African Photography* (Mali, 1996)

In just a few years, Bamako has become the capital of African photography. Established in 1994, the biennial, which takes place between the end of October and the end of November, has turned into a place of intercultural dialogue. It presents a record of many faces, a reflection of the diversity and creativity of the African continent. Since 2001, different areas within the capital have invested in the festival, as have other cities in Mali.

RT ADAMS • OLYMPE AGUADO • LAURE ALBIN-GUILLOT • MANUEL ALVAREZ BRAVO
JANE EVELYN ATWOOD • RICHARD AVEDON ••• ÉDOUARD DENIS BALDUS • GABRIELE
BERND AND HILLA BECHER • HANS BELLMER • ALPHONSE BERTILLON • ILSE BING
RÉ BLANQUART-EVRARD • KARL BLOSSFELDT • ERWIN BLUMENFELD • CHRISTIAN
RANDT • BRASSAÏ • WYNN BULLOCK • VICTOR BURGIN • RENÉ BURRI • JEAN-MARC
GARET CAMERON • ROBERT CAPA • PAUL CAPONIGRO • ÉTIENNE CARJAT • GILLES
LARK • LUCIEN CLERGUE • ALVIN LANGDON COBURN • JOHN COPLANS • IMOGEN
NDÉ DAGUERRE • BRUCE DAVIDSON • ROBERT DEMACHY • ADOLF GAYNE DE MEYER
ROBERT DOISNEAU • FRANTISEK DRTIKOL ••• HAROLD E. EDGERTON • WILLIAM
KER EVANS ••• BERNARD FAUCON • ANDREAS FEININGER • ROGER FENTON • LARRY
••• CRISTINA GARCIA RODERO • LUIGI GHIRRI • MARIO GIACOMELLI • GIBSON RALPH
GRIFFITHS • ANDREAS GURSKY ••• ERNST HAAS • PHILIPPE HALSMAN • RAOUL
ND ADAMSON • LEWIS W. HINE • DAVID HOCKNEY • HORST PAUL HORST • FRANK
S ••• YOUSUF KARSH • GERTRUDE KÄSEBIER • SEYDOU KEITA • ANDRÉ KERTÉSZ
RULL • HEINRICH KÜHN ••• DOROTHEA LANGE • SERGIO LARRAIN • JACQUES HENRI
RI LE SECQ • HELEN LEVITT • EL LISSITZKY • HERBERT LIST • LUMIÈRE BROTHERS
Y • CHARLES MARVILLE • RALPH EUGENE MEATYARD • RAY K. METZKER • DUANE
ERRE MOLINIER • SARAH MOON • INGE MORATH • MARTIN MUNKACSI • EADWEARD
• JOSEPH-NICÉPHORE NIÉPCE ••• JOSÉ ORTIZ-ECHAGUË • PAUL OUTERBRIDGE
LLES • BERNARD PLOSSU • CONSTANT PUYO ••• MARKUS RAETZ • ARNULF RAINER
ERI RENGER-PATZSCH • MARC RIBOUD • JACOB AUGUST RIIS • DENIS ROCHE
S RUFF • EDWARD RUSCHA ••• SEBASTIÃO SALGADO • ERICH SALOMON • AUGUST
O • DAVID "CHIM" SEYMOUR • CINDY SHERMAN • STEPHEN SHORE • MALICK SIDIBÉ
NUEL SOUGEZ • EDWARD STEICHEN • OTTO STEINERT • ALFRED STIEGLITZ • PAUL
SUDEK • HIROSHI SUGIMOTO ••• MAURICE TABARD • KEIICHI TAHARA • WILLIAM
••• RAOUL UBAC • SHOJI UEDA • UMBO ••• JEFF WALL • ANDY WARHOL • WEEGEE
OR WHITE • GARRY WINOGRAND • JOEL-PETER WITKIN • WOLS ••• WILLY ZIELKE

Berenice Abbott
b. 1898, Springfield, Ohio;
d. 1992, Monson, Maine

After studying fine arts in New York, in 1921 Berenice Abbott went to Europe—first to Berlin, and then to Paris, where she spent two years as Man Ray's assistant. There she opened a photography studio, where she captured the images of a succession of artists and writers, including James Joyce, André Gide, and Jean Cocteau. She met Eugène Atget in 1925 in his rue Campagne-Première studio. It was a life-changing experience for her. Realizing the exceptional dimension of the aging photographer's work, she purchased from him a portion of his prints and negatives. Back in New York and inspired by Atget's work, Abbott undertook a major project to document the city and its architecture. She became a witness to the city's changing appearance, and her photographs capture its dimensions in the windows of stores or the facades of buildings. Following a photography exhibition, her *Changing New York* was published in 1937. Abbott taught and went on with her portrait work, becoming interested in the connections between science and photography. In 1964, she published *The World of Atget* before donating her collection to the Museum of Modern Art.
See pp. 60, 77, 83.

Michael Ackerman
b. 1967, Tel Aviv, Israel

As soon as his first book, *End Time City*, appeared in 1999, it became clear that this young New York-based photographer was a revelation. His ability to use all formats and to photograph reality at the limits of personal safety; his sense of timing and space; his very personal style of portraying the outcast, with their ambivalent expressions, lost in their own internal worlds—all this has the effect of immediately engaging the viewer. Ackerman's lack of respect for the geometric conventions of the frame assists him in transforming the city into a floating world about to disappear, a phenomenon illustrated to perfection in his second book, *Fiction* (2001).
See p. 187.

Ansel Adams
b. 1902, San Francisco, California;
d. 1984, Carmel, California

Ansel Adams had two great loves: piano, which he studied at the San Francisco Conservatory of Music, and photography, which he began practicing at fourteen during vacations in the Yosemite Valley, a place he would return to throughout his life. He met Paul Strand in 1930 and decided to make a career of photography. Adams shared with Strand an idea of "pure photography": the objective recording of nature, perfectly framed and without manipulation or added touches. In 1932, he joined Imogen Cunningham and Edward Weston in founding the Group f/64. The wonder and emotion that Adams found in the wild and grandiose landscapes of the American West inform all his work. He would devote more than twenty-four albums of photographs to the American national parks. Every photograph communicates the sheer size of the natural world and aims to transcribe its lights and multiple subtleties, celebrating the immensity of the mountains, the unique complexity of roots and trees, and the splendor of the clouds and sky. From the originating shot to the printing and reproduction, Ansel Adams demanded total perfection of each image.
See pp. 19, 77, 142, 174.

Ansel Adams, *Half Dome, Merced River* (Yosemite Valley, n.d.)

p. 202:
Berenice Abbott, *7th Avenue, 35th Street* (New York, December 1953)

Robert Adams
b. 1937, Orange, New Jersey
Not till he was thirty did Robert Adams choose photography to document the deterioration of his native Colorado, a landscape he knew well. He went on to photograph America's great sites in series, always in black and white, exploring the beauty of the landscape and seeking personal reconciliation with nature wounded by human presence. In 1980, he published *From the Missouri West*, a testament to the violence that man has done to the earth through various interventions. The disasters Adams records are thrown into relief by his photographer's eye, which seeks to rediscover the reality and beauty of a lost paradise. His theoretical writings, published in 1981 as *Beauty in Photography: Essays in Defense of Traditional Values*, defend a particular philosophy of landscape photography.
See p. 174.

Olympe Aguado
b. 1827, Paris, France;
d. 1894, Compiègne, France
Son of the marquis de las Marismas, a figure of the Restoration aristocracy and of the July Monarchy, Olympe Aguado was one of the well-heeled amateurs who, in the early 1850s, became enamored of the daguerreotype and photography on paper. Introduced to the imperial court, he left a series of often humorous portraits and *tableaux vivants* of the high society of his times, as well as landscapes and studies from nature undertaken on his estate at Grossouvre in the Cher department. To his fellow members of the Société Française de Photographie, Aguado was the very model of the amateur photographer—with none of the financial worries of the professional, and whose career of fifteen or so years was more like a sport or pastime.

Laure Albin-Guillot
b. 1879, Paris, France;
d. 1962, Nogent-sur-Marne, France
An accomplished pianist and painter, Laure Albin-Guillot began her photography career with what she called her "micrographies," which she created for her husband, a microscopic-preparations specialist. In 1922, she won the gold medal award in the Revue Française de Photographie competition. Albin-Guillot became chief archivist to the photography service of the Beaux-Arts in 1932. The following year, she organized the national Cinémathèque in the Chaillot palace. Photographic work claimed much of her professional life. Essentially a portraitist, she stayed close to pictorialism in her personal interests, and illustrated poetic works, including Paul Valéry's Narcisse and Pierre Louÿs's *Douze Chansons de Bilitis* (Twelve Songs of Bilitis).
See pp. 82–83, 94.

Manuel Alvarez Bravo
1902–2002, Mexico City, Mexico
See pp. 116–117.

Dieter Appelt
b. 1935, Niemegk, Germany
After studying music in Leipzig and Berlin, Appelt devoted himself to photography, which he learned at Berlin's Hochschule der Bildende Kunst from the photographer Heinz Hajek-Halke, an important figure on the postwar German scene and in the movement of New Subjectivity. Like many artists of his generation, Appelt began in the mid-1960s to devote more and more of his portfolio to photography. The common denominator of his work, outside of technique, remains the importance attributed to the body—here, the artist's own—as well as to the natural elements and landscape he merges with. His early photographs were exhibited in Berlin in 1973. Mainly, these photographs create a documentary impression—as if, with their objective composition, they endeavor to give witness to the physical reality of the ritual actions they portray (lacerations, hangings, embalmings). If at first sight the brutality of some of his images is reminiscent of the body art of his contemporaries, the

Dieter Appelt, *Self Portrait in a Convex Mirror* (1978)

Diane Arbus, *Untitled (4)* (1970–1971)

"I do feel I have some slight corner on something about the quality of things. I mean it's very subtle and a little embarrassing to me, but I really believe there are things which nobody would see unless I photographed them."

—Diane Arbus, 1971. From a course Arbus taught at the Rhode Island School of Design.

Vienna Actionists, his purpose is noticeably different. like Joseph Beuys, Appelt is much more interested in metamorphosis and the passing of time, from one state to another, than in the act itself. His practice of photography has become increasingly sophisticated, not to say experimental, using long exposures to take account of the very materiality of the photographic act in what he himself describes as true "time sculptures."

Nobuyoshi Araki
b. 1940, Tokyo, Japan

Araki was twenty-three when he joined Dentsu, the Japanese advertising agency, as a photographer and cameraman. He left ten years later to work independently. In 1971, he published his first book, *Sentimental Journey*, a photographic account of his honeymoon travels with his wife, Yoko, who is also his muse and inspiration; the book combines love scenes with details of everyday life. Araki's photographic corpus is a blend of his private life, female nudes, and his city of Tokyo, a compilation of thousands of images that amount to the vastest autobiography ever compiled. Influenced by the masters of Japanese prints, Araki belongs to the line of artists who have depicted suffering, cruelty, and the grotesque. He sees his work as one of collaboration with the tied, often hanging women whom he photographs in suggestive and often perverse poses: "The ropes are like a caress; they enlace the model as my arms would." Araki is fascinated not only by female bodies but also by flowers, the city, clouds, and children. His practice of photography is compulsive; he accumulates images, publishing dozens of works annually, and organizing exhibitions worldwide. In Japan he is regarded as a living treasure. *See pp. 125, 164–165.*

Diane Arbus (née Nemerov)
1923–1971, New York, New York

Born into a New York milieu, Diane Nemerov was very young when she opened a fashion photography studio with her husband, Allan Arbus. In 1959, she studied under Lisette Model and abandoned fashion to pursue her own interests. She directed her attention to those on the very margins of society in order to create her startling portraits. People of color, drug addicts, the very small and the very large, fairground curiosities, transvestites, the mentally disabled—all these figured among the human beings who touched and moved her. She wrote to a friend that she found everything "breathtakingly beautiful." Her journalist status was like a passport, giving her access to offbeat encounters, from a nudist camp to a family of Russian Lilliputians. Among all the people she met and with whom she identified, she sought to discern the cracks, the terrible destinies, the personal

tragedies. Never guilty of treachery toward these "lost souls" of society, she was able to reveal their secret truth and restore them a real dignity. She committed suicide in 1971. Her photographs are exhibited all over the world. Her "psychoanalytic" vision of humanity marked a turning point in photographic history.
See pp. 129, 156, 164.

Eve Arnold
b. 1913, Philadelphia, Pennsylvania
Eve Arnold came to photography by chance. A pupil of Alexey Brodovitch—an influential figure in the fashion world—her first photographic work was on fashion in Harlem. In 1957, she joined the Magnum agency. Her interest in people from all walks of life brought her close to personalities such as Marilyn Monroe, the queen of England, and Richard Nixon, as well as American religious minorities and the veiled women of the Arab world. She reported on apartheid in South Africa and visited China in 1979. Although her portraits are characterized by an apparent simplicity due to their head-on approach, they are nonetheless extremely intense.

Eugène Atget
b. 1857, Libourne, France;
d. 1927, Paris, France
See pp. 47, 60–61, 74, 112.

Jane Evelyn Atwood
b. 1947, New York, New York
To approach, encounter, testify—such words describe Jane Evelyn Atwood's purpose when she photographs those who live on the edge of society: the blind, prostitutes, or women in prison the world over. Her unyielding eye and reports compiled in the tradition of documentary photography have been recognized many times. In 1980, she was the first W. Eugene Smith Memorial Fund winner for her work on the blind. Her *Too Much Time: Women in Prison* was published in 2000.

Richard Avedon
b. 1923, New York, New York
Richard Avedon's father owned a women's store in New York, and the young Richard papered the walls of his bedroom with photographs by Munkacsi and Man Ray, cut out of fashion magazines. In 1945, at the age of twenty-one, he published his earliest fashion photographs in *Harper's Bazaar*, where he stayed until 1965, when he joined *Vogue*. Avedon's photographic style was from the outset a novel one that emphasized spontaneity and nonchalant charm. Aided by his exuberant models, who dance and move with natural grace, he has become, alongside Irving Penn, the most important photographer of his generation. Inventing engaging episodic scenarios that are the result of extremely well-crafted staging, Avedon photographs his models on location or in the studio, where they dance and laugh against a white or neutral background.

Portraits of both celebrities and unknown individuals constitute a second side to Avedon's work. For the most part, the individual is presented in full frame, on a white background, in artificial light that records every detail of the person's emotion and features. Avedon monitored the progress of the cancer of his father, Jacob Israel Avedon, and created seven portraits that punctuated his passing from life into death. According to Avedon, "All photographs are accurate. None of them is the truth." Among his numerous publications are *Observations* (1959), *Portraits* (1976), In the *American West* (1985), and *Richard Avedon Portraits* (2002). Avedon has remained close to his times, unceasingly renewing himself, and risking everything to avoid incarceration within a system.
See pp. 154–157, 161.

Édouard Denis Baldus
b. 1813, Grünebach, Prussia;
d. 1889, Arcueil-Cachan, France
Arriving in France at twenty-five, Baldus first took up portrait painting before turning to photography in the late 1840s. His public commissions were numerous: in 1851, he was one of the five photographers chosen to participate in the Mission Héliographique; in 1856, the Beaux-Arts administration commissioned him to photograph the Rhône floods in Lyons, Tarascon, and Avignon; he also documented the building of the new wing of the Louvre, with more than 1,200 images taken between 1855 and 1858. Baldus also undertook private commissions. Baron Rothschild engaged him to produce, as a gift to Queen Victoria, an album of the building of the railroad in the north of France from Paris to Boulogne, and in 1859 he produced a second rail album, this time on the line from Paris to Lyons and the Mediterranean, coinciding with the line's extension to Marseille and Toulon. Baldus participated in the major international exhibitions of London (1862) and Paris (1867), as well as several exhibitions organized by the Société Française de Photographie, of which he was a member.
See pp. 22, 90.

Gabriele Basilico
b. 1944, Milan, Italy
Gabriele Basilico became an architect in 1973 and used black-and-white photography to capture the industrial districts of his native Milan in stark, documentary style. Through technically authoritative photography, he has continued to reflect on industrial culture, its aesthetics, and its representation, using structural, spatial elements as quasilinguistic components. The first exhibition of his urban landscapes at the Padiglione d'Arte Contemporanea won him instant recognition, leading to numerous institutional commis-

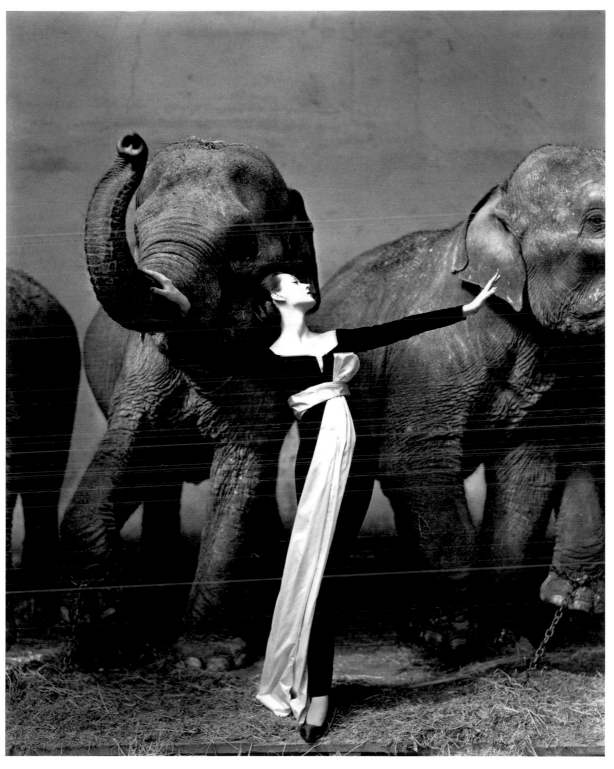

Richard Avedon, *Dovima with the Elephants* (1955)

Herbert Bayer, *Self-Portrait* (1932)

sions (the Photographic Mission of DATAR [French regional planning committee] in 1984–1985), exhibitions and publications (Porte di Mare in 1990, Gabriele Basilico Cityscapes in 1999, Gabriele Basilico Berlin in 2002).
See pp. 175, 176.

Hippolyte Bayard
b. 1801, Breteuil-sur-Noie, France;
d. 1887, Nemours, France
A Parisian civil servant in the finance ministry, Bayard declared as early as March 1839—barely two months after announcement of the invention of the daguerreotype— that he had invented an original procedure for photography directly on paper. Despite support from the Académie des Beaux-Arts, Bayard's unperfected procedure did not share the daguerreotype's success. Bayard himself eventually abandoned it in favor of rival procedures, which included not just the daguerreotype but more especially William Henry Fox Talbot's calotype, which Bayard mastered in the early 1840s. His

work is rigorously formal; most of it can be found today in the collections of the Société Française de Photographie, which he helped found.
See pp. 19, 22, 23.

Herbert Bayer
b. 1900, Haag, Austria;
d. 1985, Montecito, California
Schooled at the Bauhaus, a designer and typographer as well as painter, advertiser, architect, and sculptor, Herbert Bayer began photography within the stimulating environment of the Bauhaus art school, where he taught from 1925 to 1928. Settling in Berlin in the early 1930s, he became art director of German *Vogue*, blending words and images on magazine covers as "typophotos." Influenced by surrealism, he manipulated his photographs with both a sense of humor and a kind of amazement, which is evident in his *Self-Portrait* (1932), where he displayed his arm roundel-sliced. In the *Fotoplastiken* (1936), he placed fragile volumes before distant landscapes. He emigrated to the United States in 1938 to flee Nazism. In addition to organizing exhibitions, he practiced sculpture.
See p. 74.

Felice Beato
b. ca. 1825, Venice, Italy;
d. 1906, Burma
Felice Beato took his first photographs in 1850 in Malta. There he met and became assistant to an English photographer, James Robertson. Later, in 1860, he went to China, hard on the heels of the Second Opium War. He was one of the earliest photographers to tackle the theme of warfare, including showing battlefields. In Peking, he became a friend of the sketcher Charles Wirgman, acting correspondent for an English

newspaper, whom he rejoined in Japan in 1863. Here, at Yokohama, he opened a studio, and compiled an invaluable documentary record of the landscape, its population, and the country's way of life. His black-and-white images, touched up with watercolors, were sold singly or in albums to foreign visitors or local people. After war reportage in the Sudan, he ended his days in Burma.
See p. 31.

Cecil Beaton
b. 1904, London, England; d. 1980, Broadchalke, England
This famous English portraitist, renowned for the glamour and elegance of his photographs, long held sway over fashion photography. From his meeting of the influential Sitwell family in 1929, Beaton obtained commissions that proved decisive for his career, including a contract with *Vogue;* his association with the fashion magazine lasted over five years. In the years between

Felice Beato, The Way of the Sword (1867)

the world wars, famous actors and artists such as Gary Cooper, Marlene Dietrich, Coco Chanel, and Jean Cocteau posed for him. In 1939, he became official photographer to the British royal family. After the war, during which he continued to take photographs in the army, his models included French intellectuals such as Camus and Sartre, as well as movie stars like Marlon Brando, Greta Garbo, and Elizabeth Taylor. In 1960, he updated his style with portraits of Rudolf Nureyev and Mick Jagger. *See p. 107.*

Bernd and Hilla Becher
Bernd Becher: b. 1931, Siegen, Germany
Hilla Wobeser Becher: b. 1934, Postdam, Germany
From the start of their collaboration in 1959, Bernd and Hilla traveled first around Europe, then North America, to photograph the disappearing industrial landscape. They systematically inventoried blast furnaces, gasometers, cooling towers, and the abandoned facades of other industrial plants. Although their shots refer to those of nineteenth-century Édouard Baldus or twentieth-century August Sander, they cannot be reduced to the simple archiving or nostalgic imaging of an era. Their work brings out the formal variations and narrative qualities of an industrial landscape still in living memory, and in 1970 they published their *Anonyme Skulpturen: Eine Typologie technischer Bauten* (Anonymous Sculptures: A Typology of Technical Construction). Their photographic modalities are almost always the same: use of the darkroom; long exposures;

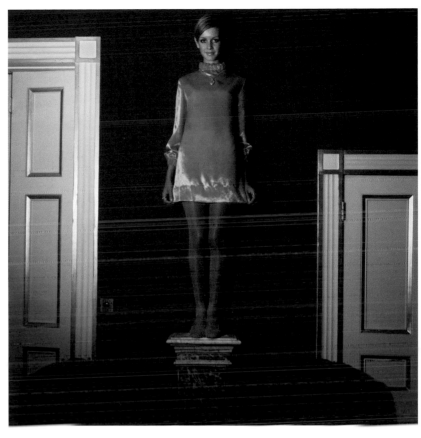

Cecil Beaton, *Twiggy at 8 Pelham Place* (*Vogue,* October 1, 1967)

lack of human presence; diffused, even light; and a slightly elevated viewpoint (frontal centering is a frequent choice, to detach the object from its surrounding). The Bechers' work has often been compared to conceptual artistic practice. In 1992, they won the sculpture Grand Prix at the Venice Biennale.
See pp. 175, 191.

Hans Bellmer
b. 1902, Kattowitz, Germany; d. 1975, Paris, France
Hans Bellmer soon gave up his engineering studies. In 1923, he became an apprentice typographer and subsequently opened a design agency. In 1933, he made a wooden articulated doll, of which he produced a variant in 1935. He put the doll through a vast number of changes, which he photographed and published in 1934 in *Die Puppe* (The Doll). The construction of the doll was accompanied by a plethora of precise drawings that betray Bellmer's obsessions: the multiplication of breasts and orifices, the confusion in the functions of bodily organs. Though isolated in Berlin, Bellmer made contact with the surrealists, who published his photographs in the review *Le Minotaure*. Bellmer settled in France, where he photographed set pieces with the doll, designing and illustrating works such as Georges Bataille's *Histoire de l'œil* and Irène d'Aragon's *Le Con* or *Justine de Sade*.
See pp. 94, 108–109, 164.

Alphonse Bertillon
1853–1914, Paris, France

In France, the name of Alphonse Bertillon is equated to the early use of photography for police work. A trained anthropologist, Bertillon invented the first system of anthropometric analysis through photography. Head of the photography service at Paris police headquarters, he established the "Bertillon" system of identification, which advocated the systematic and rigorous use of photography, including double portraiture (full-face and profile). Bertillon's methods were expounded upon in his *La Photographie judiciaire* (Judicial Photography), which appeared in 1890.
See p. 210.

Ilse Bing
b. 1899, Frankfurt, Germany;
d. 1998, New York, New York

Dubbed the "Queen of the Leica"—in 1928, she was one of the Leica's earliest users—Ilse Bing was connected with avant-garde artists in Frankfurt, and discovered that photography resonated with her own quest for modernity. Her use of perspective, bold centering, and manipulation of light and shadow dominated her photographic experimentation. She settled in Paris in 1930, where her work comprised self-portraits, reportage, and fashion and advertising photos. In 1941, she emigrated to the United States, where she continued her work on portraiture and still life. By 1957, she was using only color photography, and two years later she abandoned photography altogether in favor of painting and poetry. Her work was rediscovered thanks to an exhibition of her photographs at the Museum of Modern Art in 1976.
See p. 80.

Werner Bischof
b. 1916, Zurich, Switzerland;
d. 1954, The Andes, Peru

Werner Bischof studied photography in Zurich, where he worked on light and the graphic aspects of objects. After World War II, his search for documentation took him all over the world, and he joined the Magnum agency in 1949. His 1951 photographs on the famine in Bihar province, India, amounted to an appeal for help, and they triggered a response of American humanitarian aid. His humanitarianism led him to photograph children worldwide. In 1954, he published his work on traditional Japan, a subject of fascination for him. That same year, he was killed in an automobile accident in Peru.
See p. 178.

Louis-Auguste Bisson
1814–1876, Paris, France
Auguste-Rosalie Bisson
1826–1900, Paris, France

As early as 1841, the two Bisson brothers established a daguerreotype business in Paris, producing mostly portraits and still lifes. They quickly moved on to the use of glass negatives and albumin paper. Their photographs of members of the National Assembly led to their being entrusted with the photography of machines, instruments, arms, and objets d'art under the heading of "ministerial photographs." The brothers launched into photographic reproduction of the finest architectural and sculptural models. The shots they achieved during various ascents of Mont Blanc, despite physical difficulties, are the earliest of the type.
See pp. 20, 34, 100.

Louis-Désiré Blanquart-Evrard
1802–1872, Lille, France

Scientifically trained and a founding member of the Société Française de Photographie, Blanquart-Evrard improved William Henry Fox Talbot's calotype and contributed to its increasing use in France. In September 1851, he opened a "photographic printing-house" in Loos-lès-Lille with the aim of publishing high-volume, inexpensive prints on paper from negatives. In addition to some fine series devoted to architecture, sculpture, and painting, he was

Alphonse Bertillon, *Delinquent Photographed in 1881.* Published in *Dissemblances Physionomiques.* Albumin print on plate, 16 (31)

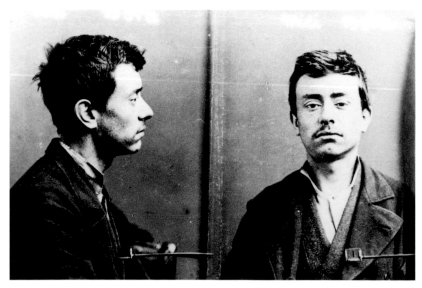

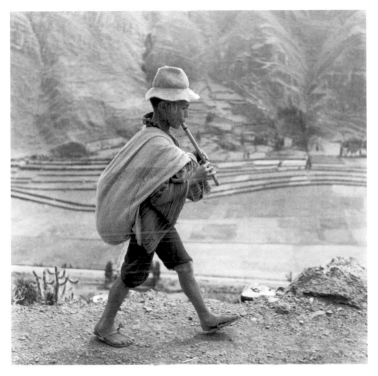

Werner Bischof, *On the Way to Cuzco, Peru* (1954)

The main books illustrating his thesis, namely his *Urformen der Kunst* (Art Forms in Nature), presented in plates like a botanical study, and his *Wundergarten der Natur* (Natural Art Forms), published in 1928 and 1932 respectively, have remained in print ever since.
See pp. 72, 94.

Erwin Blumenfeld
b. 1897, Berlin, Germany;
d. 1969, Rome, Italy
In 1915, Erwin Blumenfeld met Georg Grosz, and through this association became an active member of the dada group in Berlin. He painted, wrote, made collages, and experimented with photography. In 1935, he settled in Paris, where he became close to the surrealists and published in the review *Le Minotaure* and in *Verve*. Blumenfeld became a professional photographer for *Vogue* and *Harper's Bazaar*, and in 1941 emigrated to New York. The excellence of his images, along with their inventive character, elegance, and charm, communicates a very personal vision of fashion. He introduced novelty with his use of color and manipulated his photographs by

also responsible for the first book illustrated with original photographs on Egypt, Nubia, Palestine, and Syria, which included 125 plates executed from negatives assembled by Maxime Du Camp.
See pp. 19, 93.

Karl Blossfeldt
b. 1865, Schielo, Harz, Germany;
d. 1932, Berlin, Germany
Having studied drawing and modeling at the Royal School of Applied Arts in Berlin, Karl Blossfeldt became one of the botanist Meurer's modeling assistants, and had the task of assembling a large collection of teaching materials executed from nature. This was Blossfeldt's opportunity to take his earliest photographs of plants gathered in the Roman countryside, using a simple camera that he made

himself. His first pictures were published in 1896. Shot in close-up and head-on, against a white or gray background, his photographs reveal the "wonders of nature" through their extreme starkness. Amassed over three decades, they constitute an exceptional archive and are a considerable botanic collection in their own right. For Blossfeldt, photography was a valuable aid, an apt and convenient means of providing data through the collection of examples for teaching form. Following his professorial appointment, he taught at the Royal School of Arts in Berlin, where plants were central to his teaching of modeling and decoration.

Karl Blossfeldt, *Plate #58, Aristolochia clematitis* (1928)

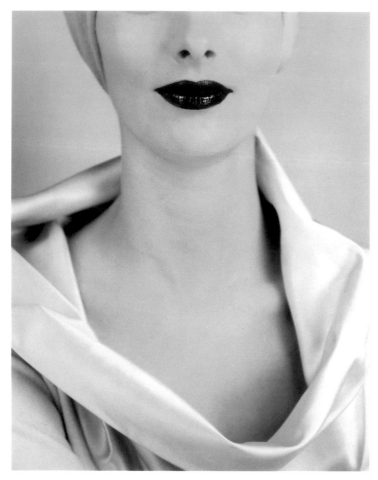

Erwin Blumenfeld, *Decollete* (ca. 1950)

playing with mirrors, overprinting, and photomontage, all of which set off the strict style and poetry of his compositions.
See pp. 106, 108.

Christian Boltanski
b. 1944, Paris, France
Although Christian Boltanski is not a photographer as such, his photographs (in black and white) occupy an obvious place in his work, which centers on the relationship between the absence and presence of man, memory, and the loss of identity. As early as 1972, he photographed a dozen children and presented the shots as if of his own childhood in his *Album de la famille D* (Album, Family D). Starting in 1976, he developed series that he presented in frames lit by electric light bulbs in the style of a votive offering. In the 1980s, these walls of images became "Monuments," environments concerned with absence, death, and the dramas of the last century (the Holocaust), whose dramaturgy is communicated through the raw accumulation of the anonymous photographs. *Menschlich* (Humanity, 1994) is a monumental document made up of approximately 1,500 photographs of anonymous human beings (souvenir photos or memoirs of dead people) that

have provided the material for several of the artist's works.
See pp. 191, 192.

Édouard Boubat
1923–1999, Paris, France
Édouard Boubat was a pupil at the École Estienne during World War II. There he learned photoengraving, and began work in 1945. Simultaneously, he discovered photography, exhibiting for the first time in 1949 with Robert Doisneau, then two years later at La Hune bookshop. His first reporting work was for the review *Réalités;* he then joined the magazine's team in 1953, after which he traveled all over the world. Whether he was in the Middle East, Mexico, Portugal, Africa, India, China, or elsewhere, the world endlessly intrigued him. Always emotionally involved, he chose as occasions for photography "those moments in which nothing happens beyond everyday life." Ultimately, it is of such minutiae that Boubat's photographs are composed: a woman looking at the sea, another nursing her child or shaking her hair in a cascade of light, a small girl dressed in dead leaves in the Jardin du Luxembourg in Paris, a child doing handstands, and such. *C'est la vie*—with tenderness, warmth, peace.
See pp. 94, 126, 131.

Guy Bourdin
1928–1991, Paris, France
During his lifetime, Guy Bourdin never tried to exhibit or publish his photographs, although for more than thirty years between 1955 and 1985 his fashion and advertising photos appeared in Vogue. Through advertising commissions for beauty products, perfumes, or Charles Jourdan shoes, he directed his own complex and menacing universe, one dominated by sex and violence. Bourdin's women are the vulnerable and mysterious protagonists of dis-

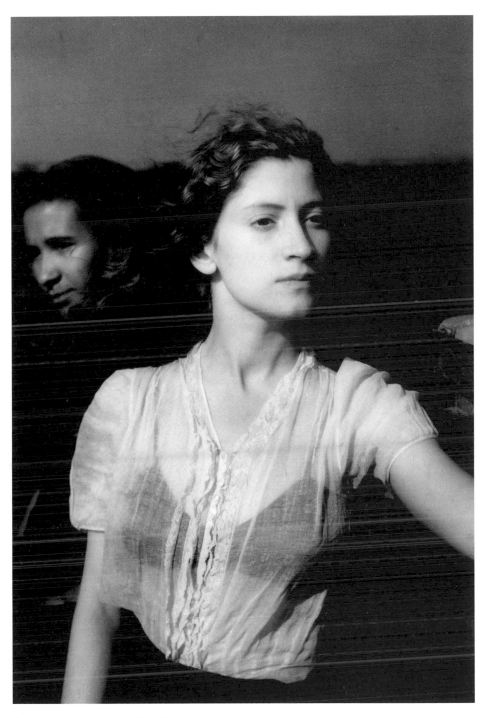

Édouard Boubat, *Lella, Brittany* (1947)

turbing adventures. The strength of every photograph lies in the force of its composition, its structured page set-up, and the full, bright colors, which reveal a world altogether outside the realm of fashion and advertising.
See p. 162.

Margaret Bourke-White
**b. 1904, New York, New York;
d. 1971, Stanford, Connecticut**
After studying biology and philosophy, Margaret Bourke-White took a course in photography. In 1930, she started work for the great U.S. magazines *Fortune* and *Life* and from there went on to pursue a long career as a photo-

journalist, which was finally ended with her illness in the late 1950s. In 1931, she visited the USSR; back home in America, she testified to the Depression with her

pp. 214–215:
Guy Bourdin, Publicity for Charles Jourdan (1975)

publication, *You Have Seen Their Faces*, in 1937. At the end of the war, she covered the liberation of the Nazi concentration camps, and in India she met Gandhi, who posed for her with a charkha, the ancient spinning wheel that symbolized the Indian struggle for independence. In 1950, she was in Africa, and in 1952 she reported on the Korean War. Her well-balanced photographs, with frames that hug faces and gestures, are scenes caught from some of history's biggest moments. *See p. 77.*

Bill Brandt
b. 1904, Hamburg, Germany;
d. 1983, London, England
See pp. 89, 112–113, *126.*

Brassaï [Gyula Halász]
b. 1899, Brassó, Hungary;
d. 1984, Beaulieu-sur-Mer, France
See pp. 80, 93–95, 108, 110–111, *112, 126.*

Wynn Bullock
b. 1902, Chicago, Illinois;
d. 1975, Monterey, California
Wynn Bullock is the photographer of the fleeting, a witness to the changes of nature and of the landscape, which he explores in order to reveal their secrets. Originally a musician, he made a living as a commercial photographer up until the 1940s. At this point he carried out research into solarization and other experimental procedures, perfecting a patent to control the effects of solarization upon the image. Influenced by Edward Weston, he abandoned his research for some years, but in 1960 he reopened his study of transformation, luminous abstraction, contrast, and overprinting.

Victor Burgin
b. 1941, Sheffield, England
After studying painting at the Royal College of Art in London and Yale

University in New Haven, in 1970 Victor Burgin became interested in the medium of photography as an aspect of the connection between text and image. From then on, his works have taken the form of panels uniting words and photographs (*Performance Narrative*, 1971). His highly conceptual work is enriched by a narrative and fictional dimension, with links to French structuralism and semiology. Since 1974, Burgin has drawn his images from advertising (*Framed*, 1977), adding monochrome flat tints to his shots (the series Office at Night, 1985–86), articulating a series around three identical elements (*The End*), or making reference to the cinema (*Vertigo, Film Fiction*). His photographic work opens conceptual art to the imaginary and subjective. *See pp. 166, 191.*

René Burri
b. 1933, Zurich, Switzerland
René Burri studied photography in Zurich, becoming a correspondent for the Magnum agency in 1956. He undertook several current-affairs reporting jobs in Europe

and the Middle East before actually joining the agency in 1959. His portrait of Che Guevara has become a famous poster. Burri went to Dallas in 1963 for the funeral of John F. Kennedy, has traveled all over the world, and has taken photographs in all the major conflicts of the second half of the twentieth century. In 1967, he made a film on China with his wife. His drawings and collages express the same graphic and design talents that are evident throughout his photographic works.

Jean-Marc Bustamante
b. 1952, Toulouse, France
In 1975, Jean-Marc Bustamante became William Klein's collaborator and then took a series of landscape photos in the region of Barcelona (*Tableaux*). In 1983, he began three years of work with the sculptor Bernard Bazile, under the name Bazile Bustamante, on installations bordering on conceptual art. On his own again in 1987, he treated his prints as pictures and created representations of an abandoned world. Bustamante

René Burri, Home of Architect Luis Barragan built in Tacubaya (1976)

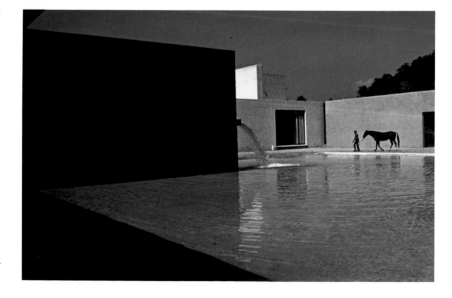

works the image like a material (large photographs of landscapes with perfect clarity; landscapes that are luminous and everyday; "high-definition" images executed in the darkroom; serigraphs on Plexiglas; panoramas), which he integrates into three-dimensional installations (*Lumières*, 1987–1991; *Something Is Missing*, 1995). He represented France in the fiftieth Venice Biennale in 2003.
See p. 193.

Claude Cahun [Lucy Schwob]
b. 1894, Nantes, France;
d. 1954, Jersey, England
After studying at Oxford and the Sorbonne, Claude Cahun settled in Paris after World War I with her companion, Suzanne Malherbe (who signed herself "Marcel Moore"). Cahun's self-portraits constituted, from 1919, the most important part of her photographic work. In them she expressed the ambivalence of her eccentric and narcissistic personality, with her hair short or shaved, outrageously made up, bewigged, often masked. A friend of André Breton, she was one of the few women to take part in the activities of the surrealist group. Also a poet and writer, she published her autobiography *Aveux non avenus* (Avowals Not Admitted, 1930), alongside photomontages, photos of assembled objects, and souvenir photos of the surrealists (1938). Her work, rediscovered only comparatively recently, has inspired plenty of contemporary photographs.
See pp. 83, 171.

Harry Callahan
b. 1912, Detroit, Michigan;
d. 1999, Atlanta, Georgia
An engineering graduate of Michigan State College, Harry Callahan began photography as an amateur in 1938. After discovering the work of Ansel Adams, Callahan decided to devote himself entirely to photography. Three great themes were to characterize his work,

which is highly organized and resolute: landscapes, urban studies, and portraits of Eleanor, his wife and muse. Simplicity and austerity are the keywords that describe his images and their stark, minimalist, almost abstract lines. From their first meeting, Steichen became a source of encouragement to Callahan, and he exhibited Callahan's photos at the Museum of Modern Art. Callahan taught at the Chicago Institute of Design, then from 1961 to 1977 at the Rhode Island School of Design. Only in 1977 was he able to resume his hitherto sketchy work on color and continue his personal research.
See pp. 128, 141.

Sophie Calle
b. 1953, Paris, France
Sophie Calle is the daughter of a doctor and collector of contemporary art. In approaching the autobiographical, the strict association of photographic images and texts, and installations, she has developed strategies that question the notion of the personal, the distinction between private and public. She plays endlessly with the limits and ambiguities of photography, investigating its margins and its documentary fragility as much as its representational strength. She arranged for herself to be followed by a private detective, who was instructed to keep a photographic record of his sight-

Harry Callahan, *Eleanor* (n.d.)

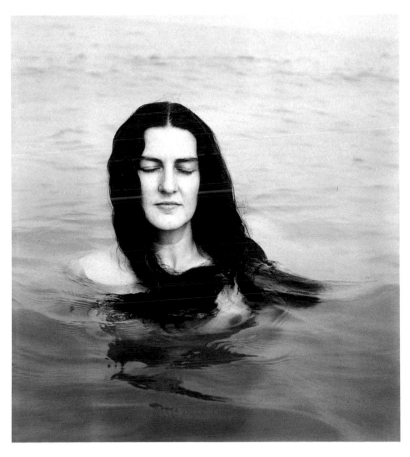

ings for her "self-portrait"; she invited "sleepers" to use her bed one after another; she has taken jobs as a hotel chambermaid in order to get portraits of the guests without their knowledge; she has gotten her friends to tell her their most painful moments as a means of relieving her own. Using such strategies, Calle constructs visual and literary accounts that can be uncomfortable. Without always telling the truth, she explores the real at the point where it disturbs, from blindness to death. Her work, published in the form of elegant notebooks, was recognized in a large retrospective exhibition at the Centre Georges Pompidou in Paris in 2003.
See p. 169.

Julia Margaret Cameron
b. 1815, Calcutta, India;
d. 1879, Kalutara, Ceylon
Born into an aristocratic family, Julia Margaret Cameron was married at twenty-three to a British diplomat. The couple, who had five children, settled in England in 1848, and their house became a meeting place for artists. Soaked in pre-Raphaelite aesthetics, Cameron came rather late to photography. Self-taught, she photographed staged scenes, allegories, and portraits of members of her family, in particular of her niece, Julia Jackson (who would one day be Virginia Woolf's mother), of her servant Adriana, and of the personalities in her circle, including the painter Watts, the writers Carlyle and Tennyson, and the astronomer Herschel. At Tennyson's request, she provided twenty-four illustrations for his work *Idylls of the King*. Her own work, a large portion of which is preserved by the Royal Photographic Society at Bath, has attracted the particular attention of pictorialists, and several of her portraits were published by Alfred Stieglitz in the periodical *Camera Work*.
See pp. 29, 170.

Robert Capa
[Endre Erno Friedmann]
b. 1913, Budapest, Hungary;
d. Thai-Binh, Vietnam, 1954
Robert Capa took his new name in 1936. A Hungarian exile, Capa settled in Berlin in 1931. There, he began his photographic career with the Dephot agency. Moving to Paris in 1933, he met David Seymour ("Chim"), the good friend who introduced him to Henri Cartier-Bresson: all three would later found the Magnum agency in New York in 1947. In Paris he also met Gerda Taro, who would share his enthusiasm for reportage until her death in 1937, in the midst of a Francoist offensive. A year later, Capa became famous when his photo of a republican soldier shot dead in action during the Spanish Civil War was published on September 2, 1938, in the magazine Vu. As a war photographer, Capa covered the Sino-Japanese War in 1938, disembarked with the Allies on Omaha Beach on June 6, 1944, and spent time in Israel from 1948 to 1949. On May 25, 1954, on the road to Thai-Binh in Vietnam, he took what was to be his last photo: he crossed a ditch and stepped on a mine.

For Capa, if a photo was a failure, it was because the photographer was not close enough, not sufficiently engaged with the action. Though in the front line and at the heart of conflicts, Capa denounced warfare, took risks, and was committed to freedom—he founded "photojournalism."

Cornell Capa (b. Budapest, 1918) was also a photojournalist. He took responsibility for publishing his brother's work, and in 1974 founded the International Center of Photography (ICP) in New York, which holds the Capa archive.
See pp. 92–93, 98, 102, 115, 118–119, *122, 138, 148.*

Paul Caponigro
b. 1932, Boston, Massachusetts
After studying music in Boston, Caponigro became a U.S. Army photographer from 1953 to 1955, and then a pupil of Minor White. Having lived in Santa Fe, New Mexico, since 1973, he envisages photography as a means of contact with an imperceptible reality, that which sustains the world's strength and harmony. His photography combines poetry and landscape—all landscapes, whether those of Connecticut or the wilder ones of New Mexico. He is particularly drawn to megaliths in Ireland (*Stonehenge*, 1978) or in Brittany, as well as rivers and plants—all of nature in sum, which he celebrates for its beauty and diversity.
See p. 174.

Étienne Carjat
b. 1828 Fareins, France;
d. 1906, Paris, France
The friend of many writers, actors, painters, and musicians, Étienne Carjat opened his first studio in 1860. He worked alone and used neither accessories nor sets, just dark, uniform backgrounds and sober frames. He labored to produce a Panthéon parisien (Parisian Pantheon) in 1863 and a *Galerie des Célébrités contemporaines* (Gallery of Today's Celebrities) in 1869. Baudelaire, Rimbaud, Victor Hugo, Sarah Bernhardt, and Gustave Courbet all posed for him, as well as numerous opponents of Napoléon III's regime—republicans such as Jules Ferry or Léon Gambetta.
See p. 24.

Gilles Caron
b. 1939, Neuilly-sur-Seine, France;
d. 1970, Phnom Penh, Cambodia
A great traveler from the age of fifteen, Gilles Caron discovered war during his military service in Algeria. After studies at the École du Louvre, he became a photog-

rapher first in advertising, then fashion, and finally the press. In 1967, he founded the agency Gamma with his friend Raymond Depardon, who has said of him: "Caron was a meteoric witness of three years of life." True enough, in just three years he worked on eight war fronts, amid clashes and violence—Israel and the Six Days' War in June 1967; Vietnam in the same year; Paris in May 1968; Biafra at the end of that year; Northern Ireland and Prague in 1969; Chad in 1970; and Cambodia, where his life ended, in April 1970. In three years, Caron captured the closest possible views of world events and their protagonists: Moshe Dayan before the Wailing Wall in Jerusalem on June 6, 1967; the French riot police at the Sorbonne in May 1968; the students of Prague confronting the guns of repression with their bare hands.
See pp. 123, 138, 152.

Lewis Carroll [Charles Lutwidge Dodgson]
b. 1832, Daresbury, England;
d. 1898, Guildford, England
There is no more astonishing and eccentric character in the history of photography than Lewis Carroll, the shy, stuttering professor of mathematics who became a clergyman so as not to abandon Oxford and his students. His enthusiasm for photography, which he discovered at his uncle's house, dates from 1856. Until the summer of 1880, he created portraits mostly of small girls, devising sophisticated staged scenes that enabled him to express the passion he felt for them. Among the 720 photographs that he judged worthy of preservation, many were of the little girls he adored. In costume, in states of slight undress, and eventually entirely nude, these little girls posed for him, assumed disguises, and became the innocent interpreters of the photographer's dreams and obsessions. He penned them genuine love letters, full of eccentric notions, and nothing so absorbed him as planning his next posing sessions—until July 15, 1880, the last day that his journal ever mentions photography or anything related to it.

For his favorite girl, Alice Liddell, he wrote his *Alice in Wonderland* (1856), followed by *Hunting the Snark* (1870), and *Through the Looking-Glass* and *What Alice Found There* (1871), three masterpieces of English literature.

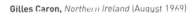

Gilles Caron, *Northern Ireland* (August 1969)

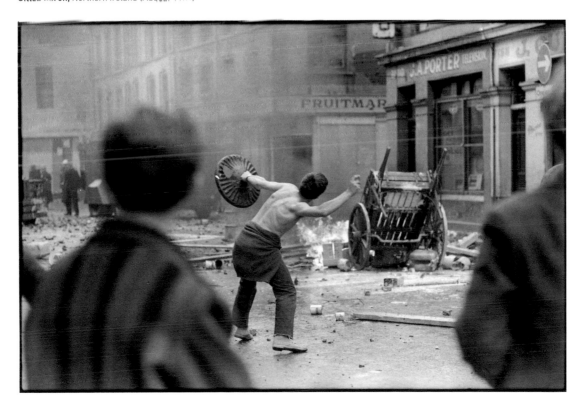

Lewis Carroll, *Christie Kitchin (XI^e) in Mandarin* (n.d.)

Henri Cartier-Bresson
b. 1908, Chanteloup, France;
d. 2004, Céreste, France
See pp. 93, 94, 102, 108, 114–115,
116, 122–123, 156, 178, 186.

Martin Chambi
b. 1891, Coaza, Peru;
d. 1973, Cuzco, Peru
It was while laboring in a British goldmine that Martin Chambi, the son of an Andes peasant family, first came across a camera. His fascination with this object spurred him to learn photographic technique and, in 1909, he entered the studio of Max T. Vargas at Arequipa. In 1920, he opened his own studio in Cuzco. There, he assembled an impressive collection of portraits of Indians as well as an impressive documentation of the ancient capital of the Inca empire and its stone buildings. Comprising wedding photographs, group portraits, and genre scenes in local villages, Chambi's work was direct, simple, and deeply respectful of his fellow Indians. He left behind a unique record of a population that had so far been despised or simply regarded for its exotic ethnology. After Chambi's death, the historian Alejandro Castellote and the photographer Juan Manuel Castro Prieto stayed some months in Cuzco, making prints and publicizing this immense body of work. As a result, the work of Malian Seydou Keita and the Galician Virxilio Vieitez was also discovered. Both photographers at the studio, their portfolios are essential to the history of twentieth-century portraiture.

Larry Clark
b. 1943, Tulsa, Oklahoma
Published in 1971, Larry Clark's first book, *Tulsa*, caused a scandal and was partly pulped, banned on account of its pictures of a young female drug addict whose baby died. *Tulsa* chronicled the life of young people in a small town in middle America who dealt with their boredom through sex and drugs. Larry Clark was one of them. Using a Leica camera and black-and-white film, he photographed his daily life and that of his friends with both incredible proximity and a total absence of voyeurism. With its strong images, a statement rather than an accusation, the book quickly drew a cult following and put its creator on the map. Clark's run-ins with the law (he was imprisoned after a murder in a bar) further nurtured his image. He went back to photography on his release from jail and in the 1980s published another legendary work, *Teenage Lust*, in which he brought together his photos of adolescent sex and of the teenage male prostitutes of New York's Forty-second Street. He also produced collages, again around adolescent sex, and this too was the subject of *Kids*, a film that introduced him to a wider public in the 1990s.
See p. 168.

Lucien Clergue
b. 1934, Arles, France
Through *Née de la vague* (Born of the Wave), the sum of twenty years' work published in 1968, Lucien Clergue is known and celebrated as the photographer who skillfully matches the naked female body with light and the sea, spiced with a frank, bright eroti-

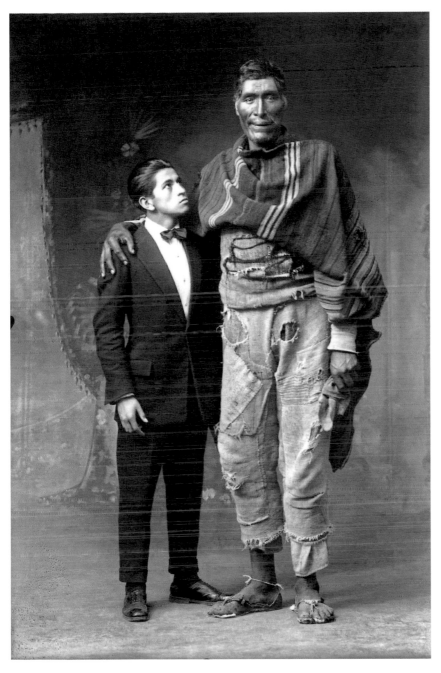

Martin Chambi, *Two Cuzco Giants* (Cuzco, Peru, 1925)

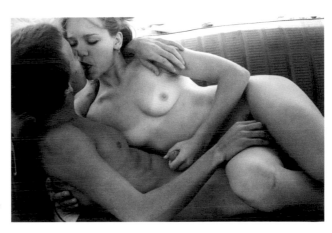

Larry Clark, *Coming from Lake Oklahoma* (from *Teenage Lust*, 1982)

cism. Yet Clergue's photographic work is not limited to this aquatic approach to beauty. At the age of fourteen he was already celebrating the wildness of the Camargue, the fights and deaths of bulls in the ring, the secret forms of nature. A friend of Picasso's, in 1970 Clergue made a film for the famous painter. At the same time, with his friends Michel Tournier and Jean-Maurice Rouquette, he had just founded the Rencontres Internationales de la Photographie at Arles, of which he is currently vice president.
See pp. 196–197.

Alvin Langdon Coburn
b. 1882, Boston, Massachusetts;
d. 1966, Colwyn Bay, Wales
Coburn began photography at the age of eight, and in 1898 his cousin, Holland Day, encouraged him to become a professional photographer. The following year, his photographs were presented at the London exhibition, "The New School of American Photography." A member of the Photo-Secession, he was elected to the Linked Ring in 1903. In 1904, he learned the techniques of photoengraving and gum bichromate on platinum. His photographs were published in *Camera Work*, and he produced an important series of book illustrations such as *London* (1909), *New York* (1910), and *Men of Marks* (1913). After developing a passion for vorticism, Coburn devoted himself to occultism, and after 1918 he virtually stopped taking photographs.
See pp. 23, 55, 65.

John Coplans
b. 1920, London, England;
d. 2003, New York, New York
John Coplans began as a painter in London, then Paris. In the 1960s he lived in the United States, taught at Berkeley, and became chief editor of the contemporary art review *Artforum*. He was also a curator, exhibition organizer, and

museum director. At sixty, he devoted himself solely to photography; his work, which he called *Self-Portrait*, centered entirely on his own body. These images of anatomical fragmentations, from which the face is excluded, are a reflection upon nudity and the representation of the aging body. Coplans created a personal language served by the precision of his images, which was due to use of a large Polaroid camera, the systematic use of black and white, and exaggerated enlargement of the print.
See p. 143.

Imogen Cunningham
b. 1883, Portland, Oregon;
d. 1976, San Francisco, California
Starting out as an assistant to Edward S. Curtis, Imogen Cunningham opened a photography studio in Seattle in 1910. Influenced by the pictorialist photography of Gertrude Käsebier, she produced numerous female and male nudes in misty landscapes. In 1915 she married her model, the engraver Roi Partridge, and her nude photographs caused a scandal. In the 1920s, she forsook pictorialism in favor of Straight Photography. Her large-scale pictures of flowers and her sensuous, voluptuous female nudes reveal the modernity and strictness of her work on light and the construction of forms. Ten or so of these photographs were presented at the 1929 exhibition "Film und Foto." In the same year, she joined Edward Weston and Ansel Adams in founding Group f/64, and subsequently opened a photography studio in San Francisco. She excelled in the art of the portrait, whether of her photography friends, writers, painters, or, much later on, those people older than herself whom she chose to photograph and whose portraits were brought together a year after her death in the publication *After Ninety*.
See pp. 77, 203.

Edward Sheriff Curtis
b. 1868, White Water, Wisconsin;
d. 1952, Los Angeles, California
Curtis trained as a photographer in a Minnesota studio before moving to Seattle. He took his earliest portrait photographs of Native Americans on the Tulahip Reservation, near Seattle. In 1899, at the request of his friend the ethnologist George Bird Grinnell, he agreed to join a mission to Alaska (financed by the industrialist Edward Henry Harriman) as the official photographer. Curtis would devote the next thirty years to compiling photographic documentation on the life, customs, and folklore of the Native American tribes, and to recording their oral traditions, songs, and legends. He visited more than eighty tribes: the Apache, Cheyenne, Navajo, Comanche, Mojave, and Sioux all welcomed the "Shadow Catcher," who took more than 50,000 photographs. Between 1907 and 1930, Curtis published the twenty volumes that constituted his great work, *The North American Indian*.

Antoine D'Agata
b. 1961, Marseilles, France
Having come late to photography after years of drifting between punk music and alcoholic trips to Central America, D'Agata built up an explosive body of work during the 1990s that gained immediate recognition. In 2003, ten years of experimentation concluded with an exhibition, "Mille et Une Nuits" (Thousand and One Nights), and a book, *Insomnia*. His direct, unconventional photography is presented on panels that portray the chaos of the world he has experienced: drugs, alcohol and sex, social outcasts, and nightlife. Photography has been his life's partner, and it bears the mark, whether in black and white or color, in square or rectangular frame. From those who taught him at New York's International Center of Photography (ICP), Nan Goldin and Larry Clark, D'Agata retains a

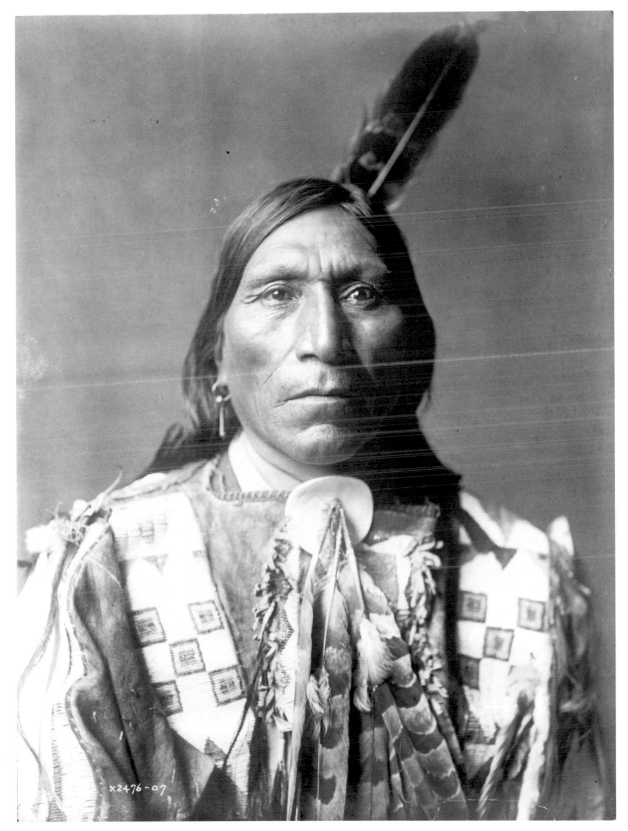

Edward Sheriff Curtis, *Little Hawk* (1907)

Antoine D'Agata, *Untitled* (Mexico, 2000)

deep commitment to freedom and to the exploration of the margins of society, as well as to the boundaries of photography itself. *See p. 187.*

Louis Jacques Mandé Daguerre
b. 1787, Cormeilles en Parisis, France; d. 1851, Bry-sur-Marne, France
Chief decorator at the theater of the Ambigu-Comique and subsequently the Opéra, as well as founder in 1822 of the Diorama, Louis Jacques Mandé Daguerre built his reputation as a showman on his knowledge of lighting and mastery of light. This led him, starting in 1826, to become interested in the research being carried on by Joseph-Nicéphore Niépce, who was then perfecting the first photographic process in the world—called *Héliographie* (Heliography)—a well-kept secret. After four years of association, from 1829 to Niépce's death in 1833, Daguerre continued the

research alone, and around 1837 he perfected a separate process, which he himself dubbed the "daguerreotype." Bought out in 1839 by the French government, the procedure was made public in that same year, marking the official birth of photography. *See pp. 16–18, 32, 42.*

Bruce Davidson
b. 1933, Oak Park, Illinois
Bruce Davidson started taking photographs at age ten. In the early 1950s, he studied photography at the Rochester Institute of Technology, then Yale University. In 1956, he discovered Paris on a scooter, and did his first study, "The Widow of Montmartre," a subdued, nostalgic portrait of a painter's widow photographed in her husband's studio. In 1958, he joined the Magnum agency and worked for all the big U.S. magazines (*Life*, *Vogue*, *Esquire*, and so on). After photographing a small New Jersey circus and encountering the dwarf Jimmy, Davidson

worked on series on laborers, the forgotten, and drug addiction in sordid suburbs; his subjects included Welsh miners and the Brooklyn Gang. A discreet, attentive witness, he spent two years in close contact with the blacks of Harlem, then regarded as a ghetto, and in 1970 published his *East 100th Street*. Besides chronicling the subway, Central Park, or his private life, Bruce Davidson has also made films that have been applauded by American critics. *See p. 92.*

Robert Demachy
b. 1859, Saint-Germain-en-Laye, France; d. 1936, Hennequeville, France
Son of a rich banker and well trained, Demachy began his photographic practice in 1880. Two years later, he became a member of the Société Française de Photographie, and in 1894 he was one of the founders of the Paris Photo-Club, along with Constant Puyo and Maurice Bucquet. A member of the editorial committee of the *Revue de photographie*, he started using the gum bichromate process, which his own writings subsequently popularized. This uncontested leader of pictorialist photography in France was admitted to the Linked Ring in 1895. In 1905 he became an honored member of the Royal Photographic Society alongside Alfred Stieglitz, with whom he carried on a friendly correspondence. In 1914, he abruptly and unexpectedly ended his photographic career. *See pp. 47, 54–55, 104.*

Adolf Gayne De Meyer
b. 1868, Paris, France; d. 1946, Hollywood, California
A sulfurous and extravagant personality of uncertain origins, Baron Adolf De Meyer gave fashion photography a new dimension in the years around 1900. In 1895, he was a member of the

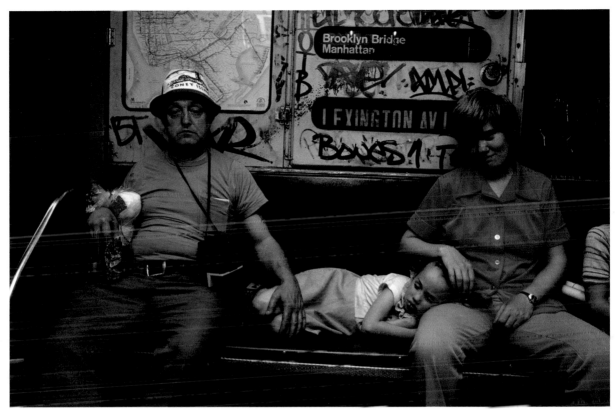

Bruce Davidson, *Subway* (New York, 1980)

Prince of Wales's entourage, and in 1899 he married the future Edward VII's goddaughter, Olga Caracciollo. A flamboyant society couple, they traveled all over Europe attending society celebrations and receptions. De Meyer took up photography in 1903, exhibited his photographs at 291 (the Photo-Secession gallery) in 1909, published photos in *Camera Work* in 1912, became the titular photographer of *Vogue* the following year, and worked for *Harper's Bazaar* from 1922 to 1934. Working in a pictorialist and subjective vein, he interpreted fashion with an aristocratic sense of elegance and refinement. He used back-lighting to imbue his models with romantic charm, placed silk over his filters, and draped his female subjects in satin and transparent tulles. Imitated and copied all over the world, the De Meyer style

came to look run-of-the-mill and overdone by the early 1930s, when it fell into disuse. Its importance is, however, generally acknowledged today.

Raymond Depardon
b. 1942, Villefranche-sur-Saône, France

Depardon became a photojournalist at the age of seventeen, when he joined the Dalmas agency. In 1966, having learned his profession and been all over the world, he joined forces with other photographers to found the Gamma agency, which has become one of the most important agencies in world photojournalism. In 1973, Depardon abandoned the lens for a while to manage the agency. Thereafter he traded his very economical, documentary style for

a more intimate approach. Blending his own personal journey with the news, he focused increasingly upon the text/image nexus; this involvement can be seen in his *Notes*, published in 1979, his collaboration with *Libération* in 1981, and his involvement with *Le Monde* in 1988. During the 1980s, an increasing proportion of his professional activity was devoted to documentary cinema and the cinema of fiction (*Reporters*, 1981; *San Clemente*, 1984; 50.81%, on Valéry Giscard d'Estaing's electoral campaign in 1974). Depardon has found a new connection in the cinema, that between himself and the moving image, and in 2002 made *Un Homme sans l'Occident* (Untouched by the West), the story of a guide who rejected colonization in the Sahara of the early twentieth century.
See pp. 123, 136, 148, 150, 183.

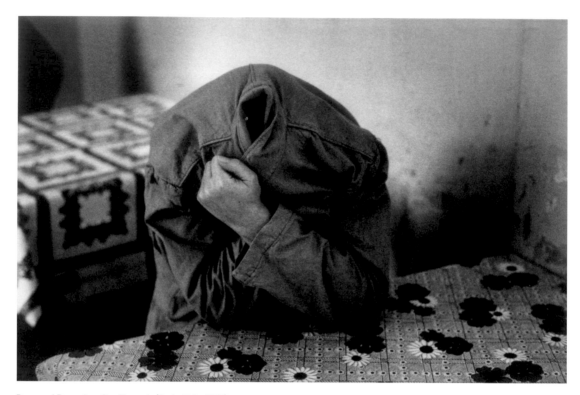

Raymond Depardon, *San Clemente* (Turin, Italy, 1979)

Jean Dieuzaide
b. 1921, Grenade-sur-Garonne, France; d. 2003, Toulouse, France
A reporter who hid the beginnings of his career under the name Yan so as not to dishonor his family, Jean Dieuzaide was a passionate defender of photography and one of French photography's historic humanitarians. His career began in 1944, with the Liberation of Toulouse, which he was the only one to photograph, executing at that time the earliest official photograph of General de Gaulle. As an independent photographer he reported across Gascony, Spain, and Portugal to garner illustrations for books on Romanesque art in southern Europe. He shot the wedding of two trapeze artists on a wire, which earned him two pages in *Life* magazine; he immortalized Dalí's mustache, documented the Concorde project, and photographed *corridas*, Romanesque architecture sculpted by light, and nature in

a poetic and sensuous way when he made use of the offbeat viscous medium of pitch. In 1974, he founded the municipal Galerie du Château d'Eau in Toulouse, the first institution in France permanently devoted to photography, a splendid venture that he directed until 1996.
See p. 126.

André Adolphe-Eugène Disdéri
1819–1889, Paris, France
Disdéri opened a studio in the rue Vivienne in Paris in 1854, moving subsequently to the boulevard des Italiens. He wasted no time in filing his patent for the photographic calling card, and he founded the Société du Palais de l'Industrie, the only company legally empowered to take photographs at the Exposition Universelle of 1855. In 1859, Napoléon III was photographed in Disdéri's studio, thereby guaranteeing the

photographer's celebrity, and between 1860 and 1862 Disdéri gathered a number of portraits of famous people with a view to publication of the *Galerie des Contemporains* (Contemporary Gallery). He opened branches in Saint-Cloud, Nice, Madrid, and London, before dying in Paris, a ruined man. In addition to his vast body of work, Disdéri left behind several books, including *L'Art de la Photographie* (The Art of Photography), published in 1862. A sizable portion of his archives is today shared among various French institutions: the Bibliothèque Nationale de France, the Musée d'Orsay, the Musée de l'Armée, and the Château de Compiègne.
See pp. 25, 26–27, 62, 100, 104.

Robert Doisneau
b. 1912, Gentilly, France;
d. 1994, Paris, France

A graduate of the École Estienne, in 1931, Robert Doisneau became assistant to André Vigneau, one of advertising photography's pioneers. Engaged by the Renault automobile company as an industrial photographer, Doisneau worked for five years in what he found to be a "hard school" before finally getting fired for poor timekeeping. After a period of independence, he entered the Rapho agency in 1946. Doisneau was a familiar figure at the bistro, a common traveler around the suburbs of Paris, the popular quarters where every street corner had a story to tell. He produced a flow of images that portrayed a smiling, sentimental Paris: a long, daily, good-humored promenade that lasted half a century. Emotions, smiles, charm—these break through at every moment. Children were the first subjects of focus in his work, those of years ago, with their shorts and crumpled socks, their innocent games, or the child with the pigeon that followed him everywhere. These were followed by nuns in their habits; husbands and wives living it up; and couples dancing, lovers kissing, and automobiles going round the place de la Concorde. Doisneau's photographs are mischievous anecdotes, light-hearted, discreet, modest, unforgettable "minor miracles." From the 1980s on, they would touch and move the general public and be sold, exhibited, and reproduced all over the world.
See pp. 94, 102, 122, 126, 131, 194.

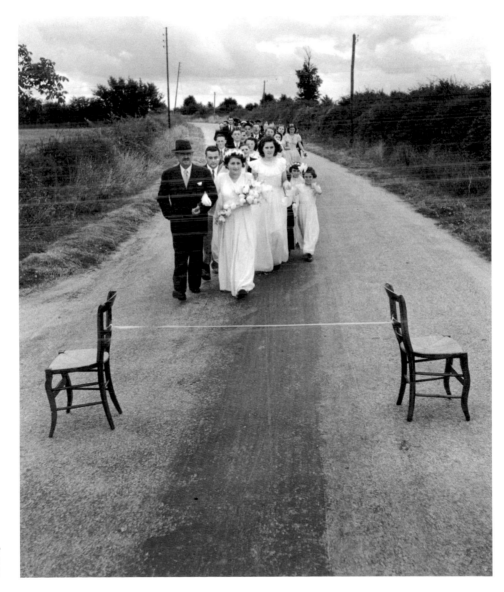

Robert Doisneau, *The Bride's Ribbon* (France, 1951)

Frantisek Drtikol
b. 1883, Pribram, Czechoslovakia;
d. 1961, Prague, Czechoslovakia
Drtikol wanted to be a painter, but he obeyed his father's wishes and went for two years to a photography school in Munich. He discovered artistic photography and opened a studio in Prague, where all the celebrities of his period sat. Regarded as one of the founders of modern Czech photography, he continued to paint, notably for the backgrounds and decors of his photographs. He subsequently abandoned portraits to create female nude photographs influenced by art nouveau, cubism, and futurism. At the height of his career, around the mid-1930s, he stopped taking pictures. He gave many of his prints to the Museum of Decorative Arts in Prague and devoted himself to philosophy and Buddhism.

Harold E. Edgerton
b. 1903, Fremont, Nebraska;
d. 1990, Cambridge, Massachusetts
Initiated into photography by his uncle at age fifteen, Edgerton used the family kitchen for his earliest photographic experiments. After graduating with a degree in electrical engineering, he taught at the Massachusetts Institute of Technology (MIT) from 1926, dividing his time between research and teaching. It was within this context that he studied the rotation of electric motors, using a stroboscope to monitor the machine's movements and make them perceptible to the human eye. Later, he adapted his discoveries to the photography of moving objects. In 1931, he perfected the first stroboscopic process: dozens of light-flashes per second made it possible to photograph objects moving at ultrahigh speeds. It enabled him, for example, to photograph the impact of a scorer's foot on a rugby ball (1934), the famous fall of a drop of milk in color (1934), or the apple struck by a bullet (1950), all images that gained him worldwide fame. The same research led to the electronic flash in 1958.
See p. 102.

William Eggleston
b. 1939, Memphis, Tennessee
Eggleston studied at Vanderbilt University, where enthusiasm for the work of Henri Cartier-Bresson (the decisive moment), and for Walker Evans (documentary style) set him on the photographic road. Far distant from his masters, he adopted color to photograph the everyday and broke with the American tradition of landscapes and wide-open spaces. He devoted himself to the frantic recording of his immediate environment, of which he created a kind of inventory. With crude colors, he captured bad-taste America, the run-of-the mill, and places of no importance. He acquired the accolade of "inventor of modern color photography" in the now-classic *William Eggleston's Guide*, which appeared in a 1976 exhibition at the Museum of Modern Art.
See pp. 140–141.

Alfred Eisenstaedt
b. 1898, Dierschau, Western Prussia;
d. 1996, Oak Bluffs, Massachusetts
At the beginning of the 1930s, Eisenstaedt joined the Berlin office of the Pacific & Atlantic Picture Agency (later to become Associated Press) as an associate, where he took on a number of reporting jobs. He paid attention to the rise of Nazism in Germany in 1933, and his critical eye forced him to emigrate to the United States in 1935. In New York, he participated in the launch of Life magazine, tracked the Italo-Abyssinian War, and immortalized the end of World War II with a famous kiss: "VJ Day in Times Square." A great reporter, he earned the nickname "Father

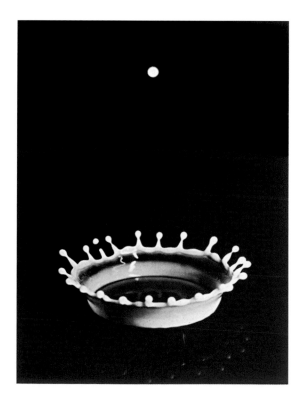

Harold E. Edgerton, *Milk Drop Crown* (1957)

of Photojournalism" in recognition of sixty years of reporting worldwide.

Peter Henry Emerson
**b. 1856, Sagua-le-Grande, Cuba;
d. 1936, Falmouth, England**
Emerson was a scientist who studied medicine and natural sciences. Settling in London, he took an interest in photography in the early 1880s. He quickly expressed his intention to practice "naturalist" photography, that is, an approach that took account of the whole of the visual experience. This outlook found authoritative expression in his first collection, *Life and Landscape on the Norfolk Broads*, published in 1886. Several other collections were to follow, as well as theoretical writings that included *Naturalistic Photography for Students of the Art* (1889). Emerson had a great impact on pictorialist photographers, whose spiritual father he appears to be.
See p. 54.

Elliott Erwitt
[Elio Romano Erwitz]
b. 1928, Paris, France
From Italy, where he spent his childhood, Elliott Erwitt went to live with his family in Los Angeles in 1940. Though he started out as a printer and portraitist, a photo by Henri Cartier-Bresson set him on his photographic career. He went to New York, where he met Robert Capa and Edward Steichen. Steichen found him his earliest commissions in advertising. In 1953, he joined the Magnum agency. Erwitt continued his commercial career in advertising. His work casts a humorous eye toward the everyday, whose ordinariness, absurdity, and unexpectedness he photographed straight on. His famous dog photographs, assembled in the book *Son of Bitch* (1974), were shot close to the ground, providing a caustic view of the world of human beings and animals, pointing out the coincidences, similarities, and

the funny things. As a reporter for American television, he has made films on majorettes as well as on the world of cinema.

Walker Evans
**b. 1903, Saint Louis, Missouri;
d. 1975, New Haven, Connecticut**
The name of Evans is associated today with the notion of "documentary style," to borrow his own term, a subtle alliance of objective vision and concern for aesthetics. His body of work, one of the most important in twentieth-century photography, is essentially preoccupied with description of America's daily realities.
See pp. 77–78, 86–87, 94, 141, 166.

Bernard Faucon
b. 1951, Apt, France
Bernard Faucon won the immediate acclaim of international critics when his models were first presented. He is famous in Japan and

Elliott Erwitt, *New York* (1974)

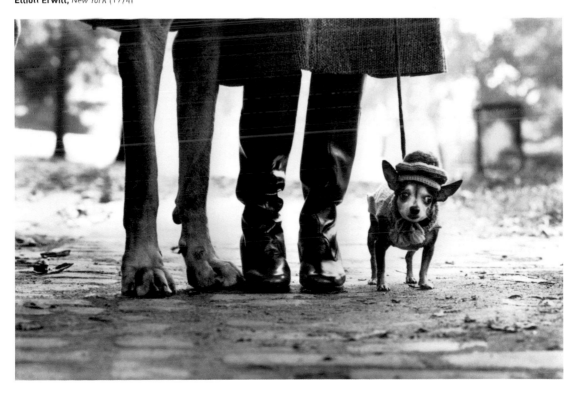

well known in the United States, and his very handsome Fresson prints, with their subtle colors, figure in the collections of the most important museums. His compositions exploring the temporality and universe of childhood have largely been published. In 1997, deciding that he had said everything he had to say about photography, he ended his work in the silver image with a series entitled *La Fin de l'Image* (The End of the Image). A large retrospective exhibition is due to tour the world, accompanied by a critical catalogue of his work. *See pp. 144–145, 167, 170.*

Andreas Feininger
b. 1906, Paris, France;
d. 1999, New York, New York
A graduate of the Weimar Bauhaus, Feininger's first profession was architecture. Not until about 1930 did he begin his work in photography, first in France with Le Corbusier and then in New York, where he settled in 1939. A pioneer of the documentary press, he worked for *Life* magazine from 1941 to 1962, after which he devoted himself entirely to publication of his books (including *Roots of Art*, 1975, a photographic collection organized around themes such as sculpture, color, and texture). As a constructor of images, Feininger defined his work through obedience to criteria that he considered fundamental: clarity, simplicity, and organization, all of which are evidenced in his architectural shots of New York. As a photojournalist, his aim was to achieve a perfect match between the narrative content of his images and the perfection of the composition.

Roger Fenton
b. 1819, Crimble Hall, England;
d. 1869, London, England
Like his contemporary and friend, Gustave Le Gray, to whom he is

sometimes compared, Fenton first trained as a painter, in France and England, before turning in 1844 to photography. A cofounder in 1853 of England's first photographic society, the London Photographic Society, a photographer to the royal family, and a regular exhibitor at photographic exhibitions, Fenton worked hard for photography to be recognized as an artistic discipline. His architectural views, still lifes, and reproductions of art works constitute the essence of his portfolio, to which must be added the approximately 350 shots taken of the Crimean conflict in 1854–1855. He quit photography in 1862 to become a lawyer.
See pp. 23, 30.

Larry Fink
b. 1941, Brooklyn, New York
A student of Lisette Model and Alexey Brodovitch, Larry Fink used square formats for his photographic exploration of the Manhattan well-to-do and their country neighbors in Pennsylvania. Shooting in black and white, and not hesitating to use the flash to devastating effect, he first snapped these society types at night and at parties. He then moved on to build up a portrait of the worlds of boxing and fashion, including behind-the-scenes explorations. Fink is a remarkable teacher; while sometimes collaborating with the press (subject Wall Street), he remains faithful to his own critical sense and progressive values, and casts a caustic gaze over the contemporary world. His book *Social Graces* is uncompromising, and it shows us an America unseen elsewhere. Fink is a singular figure in contemporary American documentary photography.

Alain Fleischer
b. 1944, Paris, France
Before he started teaching at the university, Alain Fleischer studied

literature, linguistics, semiology, and anthropology. A filmmaker (with more than ninety short- and medium-length films to his credit) and author (*La Pornographie, une Idée fixe de la Photographie*, 2000 [Pornography: Photography's Obsession]; *Les Trapézistes et le Rat*, 2001 [The Trapeze Artists and the Rat], a plastic artist and photographer (*Voyages parallèles*, 1991 [Parallel Voyages]; *Écrans Sensibles*, 2000 [Sensitive Screens]; *Autant en emporte le Vent*, 2001 [Gone with the Wind]), Fleischer currently manages the Studio National des Arts Contemporains du Fresnoy in the north of France. As with the other media he experiments in, his photographic work explores the possibilities and limits of the image. His work on colors makes reference to art history, childhood, the female body, and has recourse to doubling, mirrors, simulation, and installations.

Joan Fontcuberta
b. 1955, Barcelona, Spain
This amazingly precocious photographer (whose first exhibition was at age seventeen) was the first Spanish photographer to realize, when Francoism came to an end, that the future lay in international expression. Teacher, exhibition organizer, publisher of books and of the review *Photo-Vision*, Fontcuberta is the Iberian Peninsula's best ambassador. His personal work comes out of the Catalan surrealist tradition, which the complex nature of photography allows him to develop with humor. He is an inventor of preposterous stories that photography is supposed to prove as true, and he moves from photomontage to rayogram and from color manipulations to Braille texts transformed into lunar landscapes. As essentially serious as his forms are uproarious, the portfolio Fontcuberta is developing is a remarkable analysis of the photographic medium.

Andreas Feininger, *Photojournalism* (1951)

mental autobiographical body of work. Frank is attempting new experiments with Polaroid negatives, which he engraves with inoffensive words. His retrospective "Moving Out" in 1995 marked the donation of his work to the National Gallery in Washington. Since then, he has again traveled, doing reportage work and taking fashion photographs. *See pp. 94, 129, 131, 132–133, 166, 187.*

Lee Friedlander
b. 1934, Aberdeen, Washington
Lee Friedlander studied photography at the Los Angeles Art Center. An admirer of Eugène Atget, he sees himself carrying forward the tradition of Walker Evans and Robert Frank. Friedlander belongs totally to the generation of 1960s photographers proclaimed in the 1967 "New Documents" exhibition, whose aim was to convey the everyday without artifice, as a document or statement. The town, with its shop windows, automobiles, and concrete landscapes, serves to construct Friedlander's photographs. The elements slot into one another; thus, the photographer's shadow appears silhouetted on the fur collar of the woman passing in front of him. Friedlander works by series or themes: rearview mirrors, television screens that reveal pathetic faces in empty bedrooms, nudes, workmen at work, ridiculous monuments. There is no action, but an apparent coldness in his views, in which the world of the photographer takes its place. *See p. 129.*

Cristina Garcia Rodero
b. 1949, Ciudad Real, Spain
Cristina Garcia Rodero studied painting at the School of Fine Arts in Madrid, where today she teaches photography. This background is the foundation of the classicism of her early visual investigation into Spain's tradi-

Robert Frank
b. 1924, Zurich, Switzerland
Robert Frank began photography by exploring Swiss reality. He traveled to Peru and in 1947 settled in the United States, where he worked as a fashion photographer and reporter for the big American magazines. In 1955, a Guggenheim Foundation fellowship enabled him to travel across North America. In 1958, Robert Delpire published his *Les Américains* (the English-language edition, The Americans, was published in 1959), an entirely subjective report on the nation. Little by little, experimental cinema came to influence his outlook, which witnessed the Underground movement of the 1960s (*Pull My Daisy*, 1958; *Me and My Brother*, 1969). Since 1969 he has lived in Canada, where he is compiling an experi-

Lee Friedlander, *New York* (1966)

de Chirico or Giorgio Morandi. A master of color—he published his *Kodachrome* in 1978—he employed irony, delicacy, and subtlety when experimenting with the optical illusions that he found in nature or landscapes, and parodied the snapshot of Italy with its flashy colors. His photographic approach sought, as he himself explained, "the exact identity of man, things, life." As professor of photography at Parma, he exercised a strong influence on the next generation of Italian photography.
See p. 175.

Mario Giacomelli
1925–2000, Senigallia, Italy
Mario Giacomelli belongs in a class of his own, being responsible for one of the most original bodies of photographic work of the twentieth century. Born into a humble family, he never left his birthplace, and it was there that he created his essential images. At thirteen, he started work in a printing house and became enthusiastic about typography. The physicality of the letters and his own work led him into writing poems, something he continued throughout his life. He bought his

tional practices in the 1970s. She spent fifteen years traveling the country and recording all its rituals, pilgrimages, carnivals, and holy weeks, as well as practices connected with the toro (not simply the *corrida*), and cults relating to water, fertility, and death. With its straightforward, efficient centering, her self-evident documentary style came through strongly in her *España oculta* (1989). Since then, she has been exploring the role of the body in human society across the world. Immemorial rituals and contemporary practices, trances and love parades have all come within the orbit of her inquiry; the section devoted to Haiti has already been shown (*Ritos en Haïti*, 2001). Presented at the 2001 Venice Biennale, this ensemble, with its impressive graphic power, signals recognition of documentary practices by the world of contemporary art.

Luigi Ghirri
b. 1943, Scandiano, Italy;
d. 1992, Reggio Emilia, Italy
Luigi Ghirri took up photography in 1970 and exhibited three years later at Modena. The description "metaphysical photography" could sum up his approach, his research, and the references he makes to the paintings of Giorgio

Luigi Ghirri, *Capri, Italy* (1981)

first camera in 1953 and fixed it
in such a way that he could cap-
ture the images that haunted his
mind. His earliest subjects, for
which he used a direct approach
and flash, were the pensioners
in the old folks' home where his
mother worked. His hard, con-
trasting prints provided a pro-
foundly human and lucid portrait
of the degeneration that great age
brings. He worked in cycles, one
of which was devoted to land-
scapes imprinted with an intense,
dark poetry, marked by the
scars of plowing, with complex
graphism, like circuits in the brain.
His beaches seen from above are
no less graphic and abstract. Mys-
terious and chaotic, they give the
impression of swarming humanity.
It was a spectacular moment of
grace when he immortalized the
games of young seminarians in
a snowy courtyard. Obsessed
by the idea of the dream, of the
mental, his work is a rare example
of what can be described as
photographic poetry.
See p. 126.

Ralph Gibson
b. 1939, Los Angeles, California
Assistant to Dorothea Lange at
twenty-three, then to Robert
Frank in 1968 for his film *Me and
My Brother*, Ralph Gibson estab-
lished Lustrum Press in the same
year in order to publish his own
and his friends' photographic
work. Shooting in black and
white, he worked with the grain of
his photographs and delighted in
the use of the wide angle, which
distorted the geometric balance,
adding a hint of the fantastic and
a touch of surrealism (*The
Somnambulist*, 1968). Of the slim,
diaphanous, ravishing female
nudes sensually photographed
by him, he shows us only extracts:
a back, hair, a breast in a halo of
white light emphasizing the ten-
sion of line and form, strengthen-
ing contrasts.

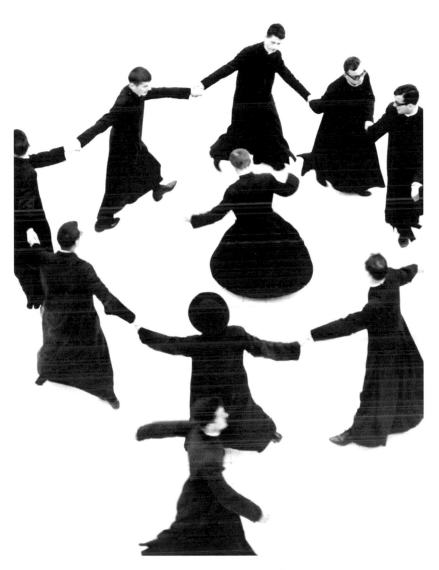

Mario Giacomelli, *There Are No Hands to Caress My Face* (1962–1963)

Gilbert and George
Proesh, Gilbert:
b. 1943, Dolomites, Italy
Passmore, George:
b. 1942, Devon, England
Gilbert Proesh and George
Passmore met in 1968 at the Saint
Martin's School of Art in London,
and together they began creating
their "sculptures," a mix of dif-
ferent pictorial techniques and
performances. From the 1970s on,
they constructed a series of large
scale installations of black-and-
white photographs, or photomon-
tages with color interspersed, on
the hardest and most taboo
themes in society, such as
poverty, exclusion, homosexuality,
and scatology—*The New Demo-
cratic Pictures, The Naked Shit
Pictures* (1990s). Gilbert and
George continue to provoke and
base their work on reflection

about the human condition. Their creations figure in the most prestigious contemporary art collections.
See p. 192.

Wilhelm von Gloeden
**b. 1856, Mecklenburg, Germany;
d. 1931, Taormina, Italy**

After studying art history at the University of Rostock, von Gloeden turned to painting. In 1878, to treat his lung problems, he settled in Taormina, a small town in Sicily, where he received all the famous people who passed through in his vast mansion. In the early 1880s, he specialized in the photography of nude youths in graceful, bucolic poses, paying them well for their modeling and justifying their nudity as illustrations for Homer. He went professional only in 1895, when the financial ruin of his stepfather lost him his allowance. The commercial trading of his photographs of anatomically perfect fishermen and shepherds, which were evidently erotic even though not explicitly claimed as such, was quite open, with most of them being published and exhibited. After the war, his photographs no longer aroused the same interest.
See p. 170.

Nan Goldin
b. 1953, Washington, D.C.

At eight years of age, Nan Goldin wrote a secret journal; at fifteen, she took photographs to better express her relationship with the Other; at twenty, she exhibited her black-and-white photographic work on drag queens, transvestites with uncertain identities. Settling in New York, she visited nightclubs and set up her first "diaporama," a projection with soundtrack that, with its dense, acidic colors falls halfway between photography and cinema. This eventually became *The Ballad of Sexual Dependency*, published in 1986.

The 1980s were stormy years. Wrecked by drugs, Nan Goldin revealed in her series of self-portraits, *All by Myself, 1995–1996*, how she emerged a changed woman. With her *Grids*, she created huge assemblages of small photographs, and on her Walls, supports with vivid colors, she placed photographs of all formats. When her friends were struck by AIDS, she accompanied them to death: her *Cookie Portfolio* detailed thirteen years of unbroken friendship. After AIDS and drugs, friends remain whom Nan Goldin has never ceased to photograph. In 2003, she published *The Devil's Playground*, in which she gathered together all who have meant something to her, a personal journal in images, full of contrasts, colors, and feelings.
See pp. 169, 193.

Philip Jones Griffiths
b. 1936, Rhuddlan, Wales

After pharmacy studies in Liverpool, Griffiths joined *The Observer* in 1961. He became an independent photojournalist and covered the war in Algeria, followed by Vietnam. After three years of on-the-spot reporting and investigation, he published his *Vietnam, Inc.*, in 1971, illustrating the infernal stupidity of the war that had bogged down the American government. The same year, he joined the Magnum agency. In 1980, he settled in New York and was elected president of Magnum for a period of five years. In his *Dark Odyssey*, published in 1996, he retraced the journey he had undertaken as a photographer through many countries, armed only with his cameras and convictions.
See p. 137.

Andreas Gursky
b. 1955, Leipzig, Germany

Andreas Gursky is the son and grandson of commercial photographers; he studied photography

in 1970 with Otto Steinert, the father of subjective photography, before becoming Bernd Becher's student at the Beaux-Arts Academy in Düsseldorf. As a master, Becher has been a key influence on Gursky, whose work betrays its origins in his teacher's documentary realism. With large-format color photographs, Gursky finds his themes in the city: the landscape; the signs of the contemporary world, dominated by money and consumption; the world of shops, fashion, nightclubs, Nike shoes, and so on. In the colorful immensity of what he himself describes as his "pictures," he combines monument with fragment, the simple structure of a piece of contemporary architecture with the busy detail that gives the illusion of reality. The objective reality and clarity due to strong design combine to make Gursky's an almost perfect world.
See p. 192–193.

Ernst Haas
**b. 1921, Vienna, Austria;
d. 1986, New York, New York**

Ernst Haas's enthusiasm for photography started early, and he was still under thirty when his pictures of the first World War II prisoners of war to return home—with a woman proffering a photograph of her son—made him internationally famous. He joined the Magnum agency, abandoned black-and-white photography, and began collaborating with the big U.S. magazines (*Life*, *Look*, *Vogue*, and so on). Whether the subject was New York or sports, he had a nose for the spectacular photograph, the universal dimension of which is epitomized by his *The Creation* (1971), shot after working with John Huston on his film *The Bible*. He also had an interest in audiovisual techniques, which was cut short abruptly by his death.

Wilhelm von Gloeden, *Taormina* (1911)

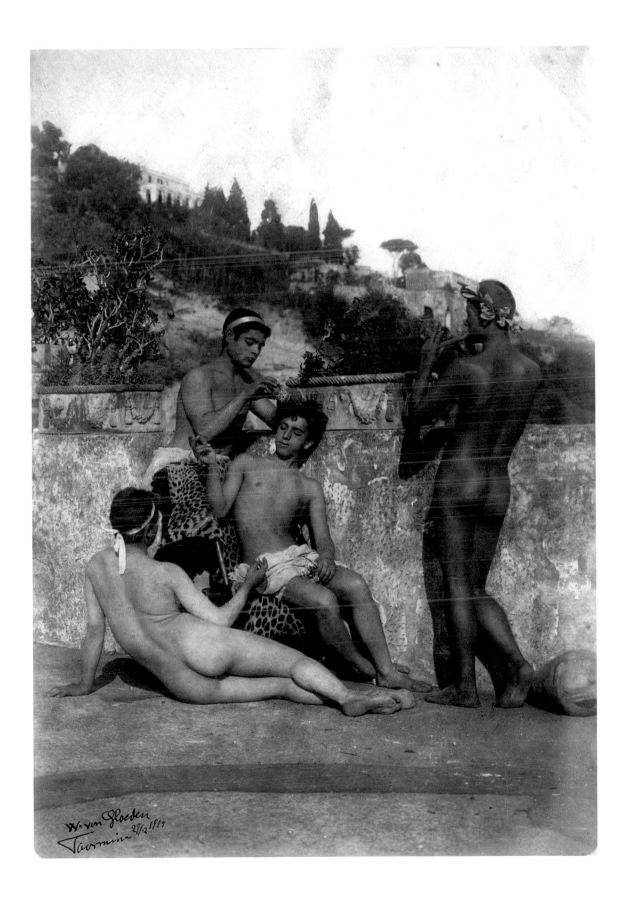

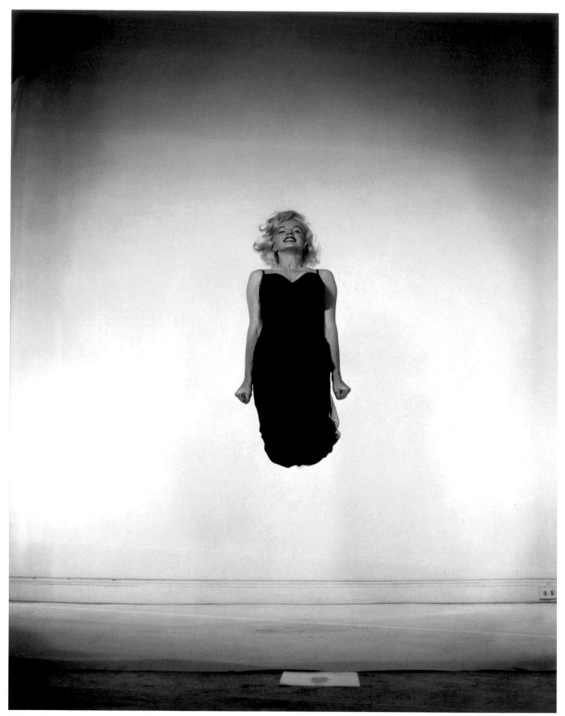

Philippe Halsman, *Marilyn Monroe* (New York, 1959)

Philippe Halsman
b. 1906, Riga, Latvia;
d. 1979, New York, New York
Having been an electronics student in Dresden, Philippe Halsman settled in Paris in 1928, and became a portraitist and fashion photographer. He emigrated to the United States in 1940, where he worked for *Life*. You need a good sense of humor to dare to ask personalities to jump in front of the lens. Halsman did so with stunning success, seeing this very particular technique of "jumpology" as a means of unlocking "the essence of what it is to be human." In 1959 he published his *Jump Book*, which included, for example, Dalí, paintbrush in hand, jumping with three cats and a chair. The master of surrealism was won over, and there resulted thirty years of friendship and some memorable pictures immortalizing the painter's mad moments. Where *Life* magazine is concerned, Halsman still holds the record, with more than one hundred famous cover portraits.
See p. 154.

Raoul Hausmann
b. 1886, Vienna, Austria;
d. 1971, Limoges, France
After learning painting from his father, Raoul Hausmann took classes in Arthur Lewin-Funcke's academy in Berlin. He frequented expressionist circles, and in 1918 established the dada movement in Germany with George Grosz and John Heartfield. He was active in organizing soirées and demonstrations, published *Der Dada* until 1920, and founded the review De Stijl. An engineer as well as an artist, he began in 1923 to design and develop the optophone, a machine intended to convert sound into color and vice versa. Not until 1927 did he take up photography. In 1933, he left Germany for Ibiza, which he used as the subject of an ethnophotographic fresco. He settled in Prague in 1937, where his work was regularly shown, and

took refuge in France at the start of World War II. The photographic work of this eccentric, monocle-sporting, beret-wearing artist, eclectic in his plastic choices and genially "into everything," ever at odds with the expression and fashions of his times, bore an intimate, personal imprint. His photocollages, self-portraits, and laboratory experiments (photograms, solarizations, double exposures), which he continued after the war, are a testimony to his originality.
See p. 67.

John Heartfield
[John Herzfelde Helmut]
1891–1968, Berlin, Germany
In 1912, Heartfield began his career as a model-maker and illustrator. A cofounder in 1918 of the dada movement in Berlin (along with George Grosz and Raoul Hausmann), "to organize

the destruction of bourgeois art," he campaigned within Berlin revolutionary circles, joined the Communist party in 1919, and remained very committed politically. The advent of National Socialism in Germany turned him into a bold combatant of Nazism, against which he used photomontage, which he regarded as one of the most effective means of propaganda. Though he did not invent it, he was incontestably its master. His original photomontages were presented in Paris in 1935 and became known worldwide. His work was censored and then banned in his own country. Forced into exile in England, he was confined as an "enemy of the British Empire" from 1940 to the end of World War II. Not until 1950 did he agree to return to (Eastern) Germany, on an invitation from Bertolt Brecht to be a set designer for the Berliner Ensemble.
See pp. 66, 67, 74.

Raoul Hausmann, *The Art Critic* (1919)

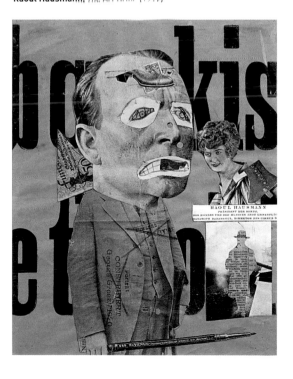

Robert Heinecken
b. 1931, Denver, Colorado
Robert Heinecken has taught drawing, design, and engraving in American universities and has been a photographer since the early 1960s. He uses a variety of techniques, including printing with silver bromide gelatin, collage, double exposure, photograms, lithography, and the projected image. His compositions have as their theme violence and sexuality, mixing photographs of sex and of current events, to which texts are sometimes added. Making use of advertising sales methods, he inserts his pictures into newspapers, television, and even mail-order catalogues. His complex, disturbing work is a denunciation of the behavior of a society that has lost its bearings.

Florence Henri
b. 1893, New York, New York;
d. 1982, Compiègne, France
Originally a pianist and painter, Florence Henri was a student in 1927 at the Dessau Bauhaus, where, thanks to Moholy-Nagy, she discovered the modernity of photography, with its new perspectives, superimpressions, montages, and the like. In Paris, she opened a photographic studio. She placed her models in mysterious half-lights, creating unanticipated perspectives and stark cut-outs. While working in advertising, she continued her experiments with her *Compositions au Miroir* (Mirror Compositions), real twentieth-century still lifes revisited by cubism and constructivism: ringed by mirrors, spools of thread, fruit, and geometrical forms topple in the depths of space with complete disregard for perspective. After the war, Henri abandoned photography and returned to abstract painting.
See pp. 73, 81–83.

David Octavius Hill
1802–1870, Edinburgh, Scotland
Robert Adamson
1821–1848, Edinburgh, Scotland
The association of the painter David Octavius Hill and the young chemist Robert Adamson created one of the weightiest photographic collections, in quality as well as quantity, of nineteenth-century Britain. Using the calotype, the technique developed by Talbot, in a very short time (1842–1848) these two men created a large body of work comprising essentially hundreds of portraits, mainly of members of Scottish upper-class society but also of Newhaven fishermen, as well as a number of landscapes and architectural shots. Their work was forgotten, then rediscovered at the end of the nineteenth century by the pictorialist movement. Since then it has been regarded as a model of artistic photographic practice.
See p. 19.

Lewis W. Hine
b. 1874, Oshkosh, Wisconsin;
d. 1940, Hastings-on-Hudson, New York
When he discovered photography in 1903, Lewis Hine, a trained sociologist, took as his earliest subject the living condition of immigrants disembarking at Ellis Island. From 1908, he traveled the United States for the National Child Labor Committee, photographing children at work. In 1928, he joined the American Red Cross and took photographs showing the ravages of the war in Europe. *Men at Work*, published in 1932, brought together the various photographs Hine took during the construction of the Empire State Building. He attempted in vain to get himself employed by the Farm Security Administration, and ended his life in poverty. His work was rediscovered later thanks to Berenice Abbott and the other members of the Photo League.
See pp. 51, 96.

David Hockney
b. 1937, Bradford, England
Trained at the Royal College of Art in London, Hockney is best known for his drawings and painting and is often classed as an English Pop artist. In 1964, he settled in Los Angeles. During this period he took his first Polaroid photographs, which he began to exploit in the early 1980s. Adopting multiple points of view, he made reference to the cubism of Picasso and Braque in the realm of perspective, applying it to photography. He created photocollages with Polaroids that he placed side by side to produce vast, elaborately structured mosaics. It was a technique that enabled him to open up the field of his subjects and to practice the obverse of classic perspective: the image was no longer based on a departure point but on convergence toward the artist, whose presence was emphasized by the presence of his hands, feet, or legs, giving the composition an anchoring point.
See p. 143.

Horst Paul Horst
[Horst Bohrmann]
b. 1906, Weissenfels, Germany;
d. 1999, Palm Beach, Florida
Originally a student of decorative arts in Hamburg, and subsequently in Le Corbusier's Paris studio, Horst met George Hoyningen-Huene in 1929 and became his model and friend. Horst took up photography, and in 1932 he was taken on by *Vogue*. Two years later he replaced Hoyningen-Huene as chief of the *Vogue* Paris studios. He settled for good in the United States in 1939, just before the war. Influenced by Hoyningen-Huene's purism, he had a conception of beauty that was nurtured by the 1930s and by numerous references to antiquity and classic painting. He used backlighting to spectacular effect in creating elegant and sophisticated settings. Horst was also

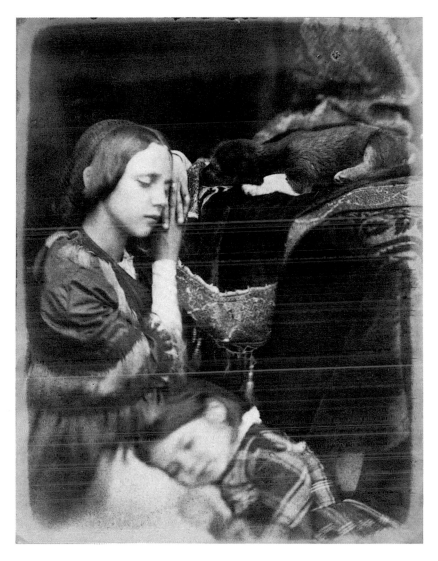

David Octavius Hill and Robert Adamson, *The Three Sleepers: Sophie Finlay, Annie Franey, and Dog Brownie* (ca. 1845)

a photographer of nudes. He created portraits and internal architectural views, and also took advertising commissions. *See p. 106.*

Frank Horvat
b. 1928, Abbazia, Italy
Frank Horvat bought his first camera at age sixteen, and was successful while still very young with a report on southern Italy,

followed by one on India. In 1956, he worked for *Jardin des Modes*, and by 1964 had published in Elle, *Vogue*, and *Harper's Bazaar*, importing the fresh air of spontaneity into his settings, spiced with a hint of elegance. Interested by the numerous possibilities and novelties of photographic language, he put a good deal of effort into the new techniques made available by computers and digital imaging. To mark the arrival of the

year 2000, he created a *Journal Photographique* (Photographic Journal) between January 1 and December 31, 1999, taking a photo every day in the hopes that he would "save something from the wear and tear of time."

Eikoh Hosoe
b. 1933, Yonezawa, Japan
Hosoe decided at eighteen that he would be a photographer. He exhibited for the first time in Tokyo in 1956 and took part every year in the "Eyes of the Ten" exhibition, which brought together as a group the generation of postwar Japanese photographers. Hosoe was one of the group that founded the Vivo agency in 1959. In 1963, he published *Ordeal by Roses*, about the strange world of the writer Yukio Mishima. Between 1965 and 1968, he worked with Tatsumi Hijikata, founder of the Butoh dance movement, capturing, in a process that was both documentary and highly individual, this extraordinary dancer's return to his native land. Through the naked bodies of a man and woman represented in the series Embrace, in 1971, Hosoe asserted his belief in the possibility of dialogue between the sexes, in the fusion of these diaphanous, almost abstract bodies, symbols for him of the essence of life. Impressed by the work of Antonio Gaudí in Barcelona, he published in 1984 his *Cosmos of Gaudí*, the result of more than ten years' research on the Spanish architect's creations. *See p. 125.*

George Hoyningen-Huene
b. 1900, St. Petersburg, Russia;
d. 1968, Los Angeles, California
A Russian aristocrat who came to Paris during the 1920s, Hoyningen-Huene studied painting, worked as a movie extra, drew, and joined *Vogue* in 1925 as an illustrator. A year later, he started taking photographs in his own right and

quickly became head of the Paris office. In 1935, he left Paris for the United States, where he directed *Harper's Bazaar* for ten years. Though originally influenced by Edward Steichen, he developed his own very individual style. He used subtle lighting, played with dissymmetry and emptiness when preparing his compositions, and placed dummies close by his living models, thereby giving his photographs a surrealist dimension. His beach scenes—studio photographs taken in 1930 to promote sports clothes—epitomize his perfect mastery of style. His photographs re-create the power, harmony, and perfection of Greek classicism, which for him was the ideal of beauty. In 1943, tired of fashion photography, he published his photographs on Greece and Egypt. Shortly after, he settled in Los Angeles, where he taught photography at the Art Center School, took portrait photographs of several leading stars (including Greta Garbo), and made some short films.
See p. 106.

Graciela Iturbide
b. 1942, Mexico City, Mexico
After her university studies, Graciela Iturbide decided to devote herself to cinema, and in 1969 she made a semifictional documentary film on the life of the artist José Luis Cuevas. In the early 1970s, she worked for the Instituto Nacional Indigenista. It was here that she met Manuel Alvarez Bravo, whose assistant she became, and decided to devote herself exclusively to photography. She soon exhibited, and was immediately recognized for the essential view she provided of Latin America. Her major ensemble on the Indians of Juchitán, in Oaxaca province, became the subject of a book in 1982 and was exhibited worldwide. Her portraits of women and transvestites and of the relationships between humans and animals are informed by a magic that connects her work with

the continent's literary movements, including the "magic realism" exemplified by Gabriel Garcia Marquez, to whom she is close.

Eikoh Hosoe, *Kamaitachi #17* (1965–1968)

Izis
[Israel Bidermanas]
b. 1911, Mariampolé, Lithuania;
d. 1980, Paris, France
Israel Bidermanas learned photography at the age of thirteen, and started working as a

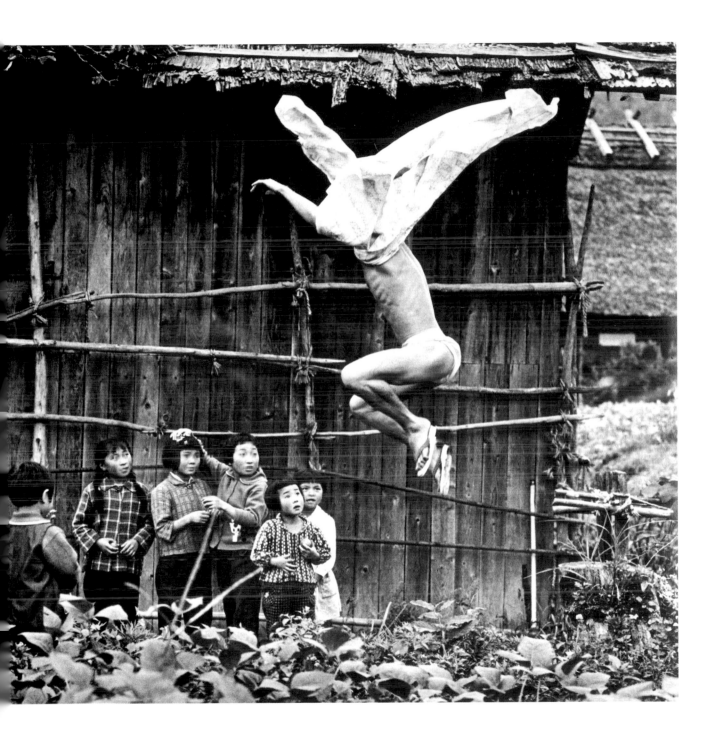

photographer in a portrait studio on his arrival in France in 1931. After the war, he took the name Izis and discovered photography as a true means of artistic expression. *Paris des Rêves* (Dream Paris) appeared in 1950.

He became a friend of Marc Chagall as well as of Jacques Prévert, who wrote the text of Izis's books such as *Le Grand Bal du Printemps* (The Grand Spring Ball, 1951), or *Le Cirque d'Izis* (Izis's Circus, 1965). During his

"walks" about the streets of Paris or London, Izis sought to capture an emotion: "The people I photograph are often dozing or looking into the distance.... In my photos, even the animals dream." *See pp. 94, 126.*

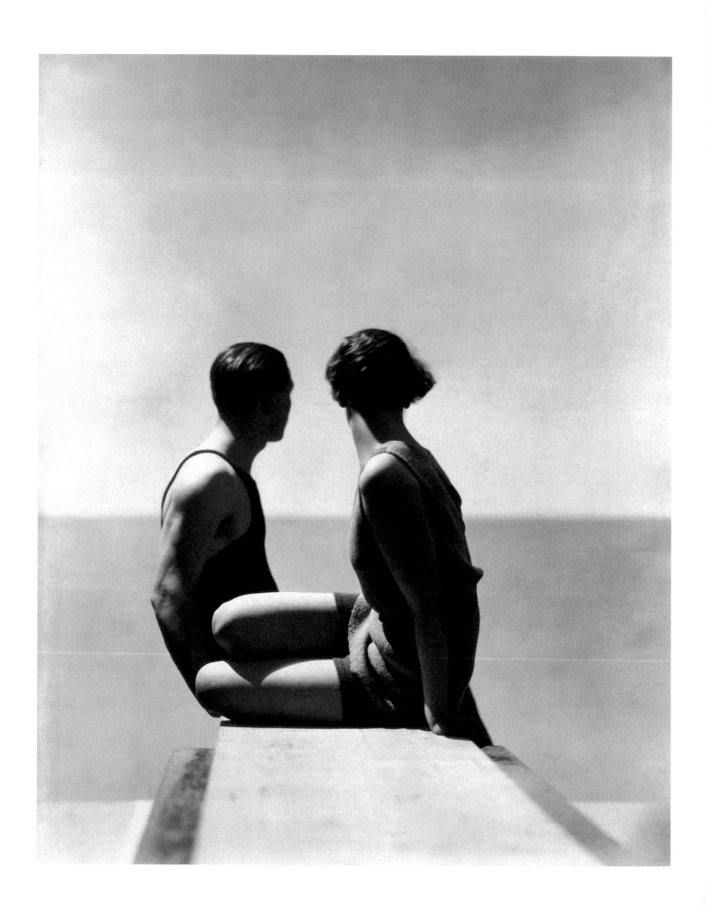

Yousuf Karsh
b. 1908, Mardin, Armenia
d. 2002, Ottawa, Canada
Yousuf Karsh emigrated to Canada when he was sixteen to live with his photographer uncle, George Nakash, with whom he served his apprenticeship. In Boston, he studied with the portraitist John H. Garo, who taught him techniques of art photography. In 1932, he opened his own portrait studio in Ottawa and very quickly attracted the world's greats. His 1941 portrait of Winston Churchill, which made the cover of *Life* magazine, identified him as a great portraitist of his powerful contemporaries. Whether in his studio, or in his clients' own familiar surroundings, Karsh was able to capture his models' personality or individuality in a look, a pose, or a hand gesture, which he considered no less expressive than the face.
See p. 156.

Gertrude Käsebier
b. 1852, Des Moines, Iowa;
d. 1934, New York, New York
Aged thirty-six, having made sure of her children's education, Gertrude Käsebier began her artistic studies at Brooklyn's Pratt Institute. A stay in Germany helped her further her technical knowledge, after which she opened a portrait studio on Thirty-second Street in New York. Her portraits and personality studies were characterized by the inventiveness and elegance of the poses. Her work attributed importance to the mother/child relationship and betrayed very Japanese-like influences. She was the first woman to be admitted to the Linked Ring in 1900, and she figured among the founding members of the Photo-Secession in 1902. However, her friendly relations with Alfred Stieglitz broke down in 1910, and in 1916 she helped found a new, competing group, the Pictorial Photographers of America.
See pp. 55, 56.

Seydou Keita
1923–2001, Mali
Originally a cabinetmaker, Seydou Keita received his first camera in 1935. He enjoyed photographing people, learned processing, and became the most sought-after photographer in Bamako. Between 1945 and 1962, when he was commandeered by the government, he took almost 30,000 shots. Armed with a 13 x 8 camera and ignorant of photographic history, he reinvented the art of the portrait (poses, centering, accessories) with simplicity, genius, and grace. In the early 1990s, he was discovered by a number of Westerners, who brought his work recognition. One such was André Magnin; he bought prints from

Izis, *Whitechapel, London: Man Blowing Soap Bubbles, Petticoat Lane, Middlesex Street* (1950)

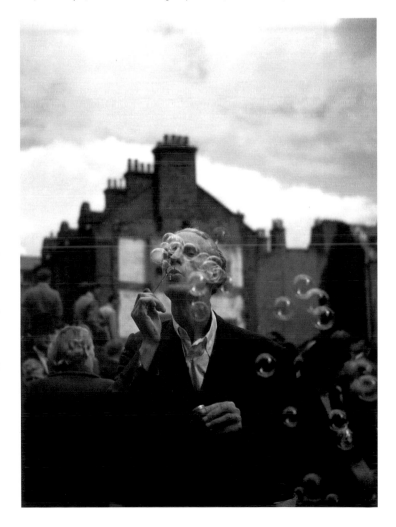

p. 242:
George Hoyningen-Huene, *Comrades* (ca. 1930)

Keita for the Contemporary African Art Collection, promoted exhibitions (Paris, 1994; New York, 1995), and published a monograph on Seydou Keita in 1997.
See pp. 154–155.

André Kertész
b. 1894, Budapest, Hungary;
d. 1985, New York, New York
See pp. 47, 74, 80, 83, 88–89, 93, 102, 108, 112, 116, 142.

William Klein
b. 1928, New York, New York
Arriving in Paris in 1948, Klein began training as a painter and became interested in photography in connection with his research into abstracts. Returning to New York in 1954, he worked for Vogue until 1965. He experimented with wide angles and multiple flashes and brushed plenty of fashion photography shots. At the same time, in the streets of New York, he was compiling an everyday photographic journal that was published as *New York* in 1956; it was a novel approach that he applied to Rome—where he assisted Fellini—followed by Tokyo and Moscow, in each case publishing his work in book form. Deserting photography for the movies, he made documentaries (*Mohammed Ali*) and several films, including *Who Are You, Polly Magoo?* (1966) and *Le Couple témoin* (A Couple of Witnesses, 1976), which broke with the language of more traditional cinema.
See pp. 94, 129, 132–135, 161, 166, 187.

François Kollar
b. 1904, Szenc, Hungary;
d. 1979, Créteil, France
François Kollar played an important role in 1930s French photography, having quickly adopted the New Vision style that was influenced by modern art and industrial civilization. He gave it full measure in the report commissioned in

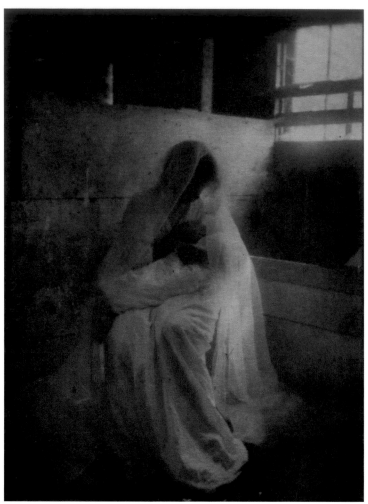
Gertrude Käsebier, *Maternity* (*Camera Work,* January 1903)

1931 by Horizons de France and published as *La France travaille* (Working France), with a preface by Paul Valéry. For over three years, Kollar went all over the country, garnering more than 10,000 shots of contemporary technology, the workers, and their environment, shedding new light upon French society between the wars. His contribution to photography extended to portraits of art and fashion personalities (Jean Cocteau, Coco Chanel), and inventive work in advertising (Christofle, Hermès). He also collaborated with *Harper's Bazaar, Vu,* and *Plaisir de France.* The war interrupted his

activity. In 1987, the French state was the beneficiary of many of his prints and negatives.
See pp. 72, 80.

Josef Koudelka
b. 1938, Boskovice, Czechoslovakia
Koudelka started taking photographs at the age of fourteen, while studying to be an engineer. He undertook a project on gypsies, actors in a theater troop, then exhibited and published it. In 1968, he closely followed the events of the Prague Spring, for which he anonymously received an award in the United States. His photographs

were distributed by the Magnum agency, and he joined the agency in 1971 after leaving Czechoslovakia for good. In 1975, he exhibited at the Museum of Modern Art and published his book *Gypsies: Photographs*. To obtain these pictures, the exiled Josef Koudelka backpacked all over Europe. In black and white, with sharp contrasts, they are both stark and poetic, tragic and yet full of joie de vivre. In 1986, responding to a commission on the part of the DATAR (French regional planning committee), Koudelka began to use panoramic formats in order to photograph big open spaces devastated by industry. In 1999, he published *Chaos*, followed by *Limestone* in 2001.

Les Krims [Leslie Robert]
b. 1943, New York, New York

Radical when it comes to exploiting photography's possibilities as an art of created scenarios, Les Krims has invented a satirical and exuberant world that lambastes stereotypes of American society: its sex, violence, religion, consumption. He has created whole series on off-beat themes, including *The Little People of America* (1971), a gathering of happy dwarves, and *The Deerslayers* (1972), portraits of deer hunters. Another much more disturbing series, *Chicken Soup* (1975), showed his mother preparing chicken soup in the nude. With his wild, provocative photographs and black, caustic humor, Les Krims is not slow to parade his fantasies in scenes overloaded with images, a veritable Aladdin's cave of multiple interpretations.

Germaine Krull
b. 1897, Wilda-Poznan, Poland;
d. 1985, Wetzlar, Germany

Germaine Krull studied photography in Munich, and was very involved in revolutionary movements when she married the filmmaker Joris Ivens and settled with him in Amsterdam in 1925. There she did her earliest photographic work on modernist metal architecture (*Métal*, 1927). In 1927, she went to Paris, and with her photographs of the Eiffel Tower, Pigalle, and series of nudes she

Josef Koudelka, *France* (1973)

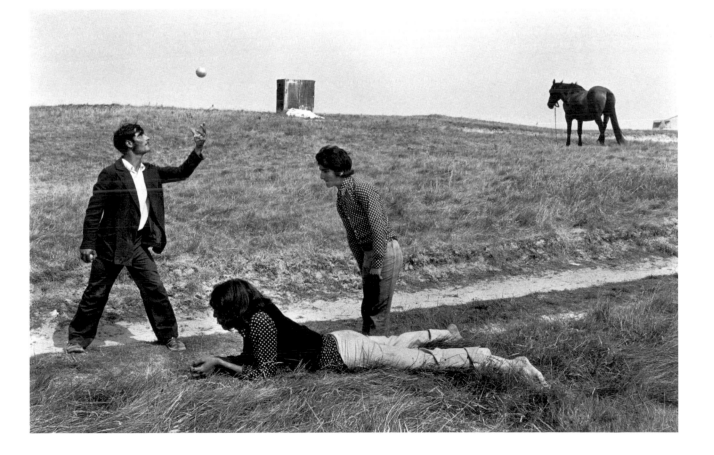

Germaine Krull, *View Taken from the Transporter Bridge* (Marseilles, France, 1926)

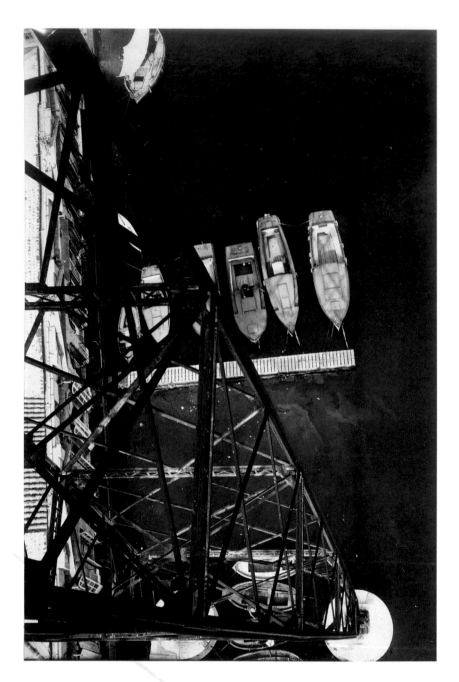

became the principal representative in France of New Vision's German wing. She then reported on minorities (*100 x Paris*, 1929), and was among the first to design travel books of photos accompanied by descriptive text (*La Route Paris-Méditerranée* [The Road from Paris to the Mediterranean] with Paul Morand). After the Liberation, she went to live first in Bangkok, where she met up again with her friend André Malraux in connection with illustrations for a book on Buddhist art, then moved on to India. *See pp. 80, 83, 94.*

Heinrich Kühn
b. 1866, Dresden, Germany;
d. 1944, Birgitz, Germany
For health reasons, Kühn undertook his medical studies at Innsbruck, Austria, where he settled for good without ever practicing as a doctor. From 1888, he was much occupied in taking photographs and, together with Hugo Henneberg and Hans Watzek, established Das Kleeblat (the Cloverleaf Group), which founded the Viennese art photography school. Together, these photographers studied the multiple possibilities of the gum bichromate process. In 1896, Kühn was admitted to the Linked Ring. He was strongly influenced by Stieglitz, whom he met in 1904 and who published Kühn's photographs in *Camera Work*. His portraits, personality studies, and especially his still lifes betray great sensitivity. He published many books on optical problems and development techniques. *See pp. 55, 58.*

Dorothea Lange
b. 1895, Hoboken, New Jersey;
d. 1965, San Francisco, California
Dorothea Lange dropped out of college to devote herself to photography and study under Clarence H. White. She opened her own San Francisco studio in 1919 and worked there for over ten years. When Wall Street crashed in 1929, shaking the country to its core, she took a stand on behalf of all those who were suddenly thrown into destitution. Appalled by their living conditions, she met with strikers and mingled with the crowds of poor people whom she immortalized in *White Angel Breadline* (1933). From 1935 to 1939, she was a photographer for

the Farm Security Administration and produced one of the most famous portraits of the century, *Migrant Mother*. In 1939, she published *An American Exodus*, and during the war visited the internment camps for Americans of Japanese origin. Urged on by a belief in the ability of her photographs to bring about change, Dorothea Lange documented social deprivation, and the distress, poverty, and isolation of victims of crisis.
See pp. 78–79.

photographer father, by the age of seven he had developed a remarkably precocious enthusiasm and talent for photography. From then on his approach to the medium was based on a desire to hold on to every memory by using his camera to preserve moments of happiness. He continued this almost neurotic quest throughout his life, not only by exploring dif-

ferent techniques and formats (stereoscopy, the panoramic camera, autochrome, black and white, then color), but also by collecting thousands of images in large albums that let him look back as a spectator on his own existence. This autobiographical dimension to his work is reinforced by the diaries and calendars he used to record all the details of his every

Sergio Larrain, *Valparaiso* (Chili, 1957)

Sergio Larrain
b. 1931, Santiago, Chile
Sergio Larrain took his first photographs at the age of eighteen, when he was a student at U.C. Berkeley. He traveled to Europe and the Middle East, and at twenty-three became a freelance photographer for the Brazilian magazine *O Cruzeiro*. In Valparaiso, Chile's largest port, he took one of his most famous photographs, which shows two little girls going down some steps. He spent time in London and Paris, joined the Magnum agency in 1961, and in the same year returned to Chile. In his wanderings through cities all over the world, he captured images that show time slowing down, then stopping, over the children and people of the city, one in front of the other, one after the other, just at the moment when poetry takes over from reality. The many books devoted to his work include *El Rectangulo en la Mano* (Square in Hand, 1963), *Chile* (1968), and *Valparaiso* (1991).

Jacques Henri Lartigue
b. 1894, Courbevoie, France;
d. 1986, Nice, France
Jacques Henri Lartigue is now seen as the unrivaled representative of a century of amateur photography. He came from one of the wealthiest families in France. Under the influence of his amateur-

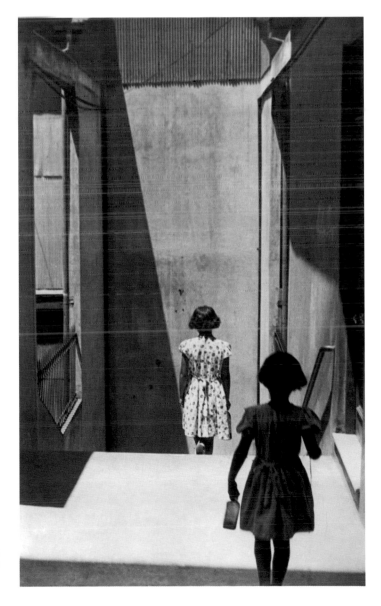

day life. He always remained an amateur and preferred to describe himself as a painter; he painted all his life, and even enjoyed a spell in the years between the world wars as quite a highly regarded society portraitist. At the beginning of the 1960s his photographic work was suddenly and belatedly discovered by the Museum of Modern Art. In 1979, he donated the whole of his work (130 albums, thousands of prints, 100,000 negatives, and some archives) to the French state. This donation is managed by the Association des Amis de Jacques Henri Lartigue (Society of Friends of Jacques Henri Lartigue).
See pp. 102–103, 104, 159.

Clarence John Laughlin
b. 1905, Lake Charles, Louisiana;
d. 1985, New Orleans, Louisiana
After the death of his father, Laughlin left college and took various jobs to help support his family, who had lived in New Orleans since 1910. He began to take photographs in 1934, and in the same year he also met Alfred Stieglitz. In 1940, he got his first job as a professional photographer, charting the progress of civil-engineering works being carried out on the Mississippi. At the same time, he exhibited his photographs of architecture, cemetery sculptures, and shop fronts. These fantastical, baroque images, often paralleled with the novels of William Faulkner, were published in *New Orleans and Its Living Past* (1946), a collection of photographs of the city's oldest neighborhood, the Vieux Carré, and in *Ghosts along the Mississippi*, which shows his images of the Louisiana plantations. From 1949 to 1969 he took photographs for magazines devoted to the contemporary and Victorian architecture of Louisiana.

Gustave Le Gray
b. 1820, Villiers-le-Bel, France;
d. 1884, Cairo, Egypt
Gustave Le Gray studied painting in Paul Delaroche's studio, alongside the other future photographers Charles Nègre, Henri Le Secq, and Roger Fenton. For a few years he focused on daguerreotypes, then in 1851 made a major contribution to the evolution of photographic technique by inventing the dry wax paper process. He was a founding member of the Heliographic Society and the French Photography Society, and throughout his career was involved in both the theoretical and the practical side of photography. He tackled every genre: portraits, landscapes, seascapes, reporting (of maneuvers at the Chalon military camp), and art reproduction (with his views of the Salon des Beaux-Arts in 1852). Le Gray had a particular interest in architecture, as was shown by his participation in the Heliographic Mission of 1851. In 2002, the Bibliothèque Nationale mounted a complete retrospective of his work.
See pp. 22, 40.

Annie Leibovitz
b. 1949, Waterbury, Connecticut
Annie Leibovitz trained at the San Francisco Art Institute and quickly became successful after her photograph of John Lennon and Yoko Ono was published on the cover of *Rolling Stone* magazine. In the 1980s she was the photographer most regularly sought after by celebrities, whom she liked to show in an everyday setting, for example in their homes or cars. She has produced many portraits of American stars, and also of French actresses such as Catherine Deneuve. Since the retrospective of her work that was shown in Paris in 1992, she has photographed a number of subjects, including athletes preparing for the 1996 Olympic Games in Atlanta.

Henri Le Secq [Henri Le Secq des Tournelles]
1818–1882, Paris, France
Le Secq was trained as a painter, but he practiced photography for about ten years, working exclusively with paper negatives, which he used primarily to record scenes

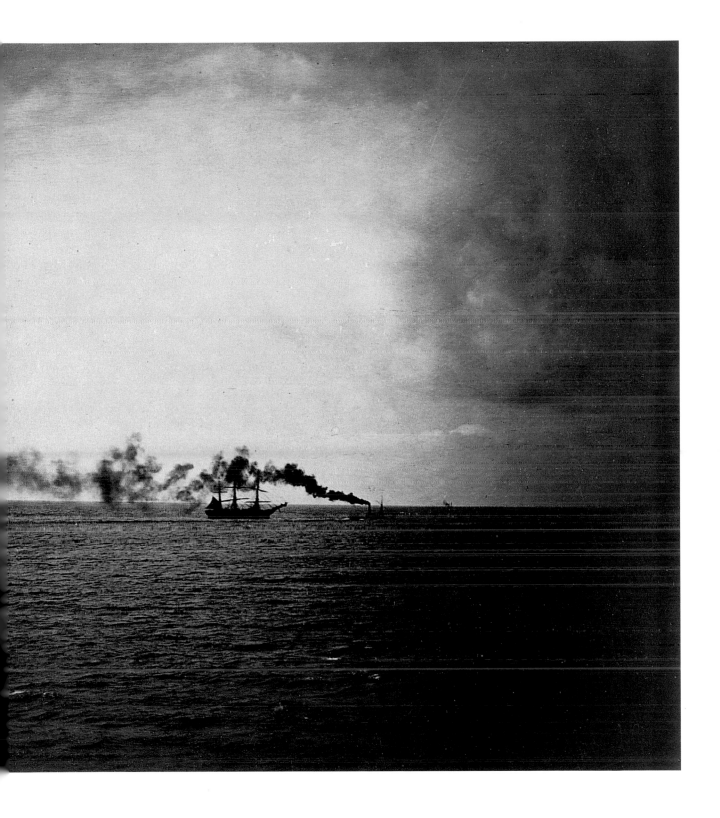

in preparation for his paintings. Because of his series of negatives of the Amiens Cathedral, he was selected in 1850 to take part in the Heliographic Mission, and as a lover of architecture he became interested in the changes that were taking place in Paris. He also produced studies inspired by the countryside of the Marne area (the Montmirail forest). His studio collection was bequeathed by his descendants to the Bibliothèque des Arts Décoratifs and the Bibliothèque Nationale de France. *See pp. 22, 40.*

Gustave Le Gray, *Seascape with Sailing Ship and Tugboat (Le Vapeur),* (Le Havre, France, 1857)

Helen Levitt
b. 1913, Brooklyn, New York
Starting out as a young photographer in 1940, Helen Levitt sought out her subjects in the poor neighborhoods of Harlem and Brooklyn, and among the people living on the street there she found the children who would provide the material for the whole of her work. She dropped out of college and discovered photography through an exhibit of Henri Cartier-Bresson's work. Like him, she bought a Leica, and photographed the street children without being seen by them or disturbing their games. She saw them dancing, kissing, climbing trees, or taking showers under the spray from fire hoses, and with humor, affection and a great deal of restrained emotion captured these privileged moments set apart from everyday life. In 1943, she showed her work at the Museum of Modern Art in an exhibit entitled "Children: Photographs of Helen Levitt." Still in the street, she started using color in the 1960s, and published *A Way of Seeing* in 1965.

El Lissitzky
[Lazar Markovich Lisitskii]
b. 1890, Polschinok, Russia;
d. 1941, Moscow, USSR
El Lissitzky was a major figure in the Soviet avant-garde and was close to dada circles. Like many of his contemporaries he believed that photography, as a mechanical, infinitely reproducible medium, was the perfect artistic technique to meet the needs of the modern world. In the 1920s and 1930s he made particularly innovative use of it in photomontages, books, and most unusually in exhibit scenography.
See pp. 67, 71–72, 74.

Herbert List
b. 1903, Hamburg, Germany;
d. 1975, Munich, Germany
Herbert List was destined for a career in the family business, and

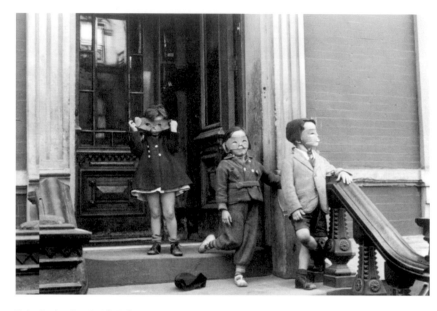

Helen Levitt, *New York* (1938)

only began working as a photographer after a decisive encounter with Andreas Feininger, a member of the Bauhaus who helped him finally make his choice. Being part Jewish and homosexual, he decided in 1936 to relocate from Germany to Paris, where he produced his first series, entitled *The Tuileries Mythology*, as well as some still lifes of surrealist inspiration. In 1937 he made his first visit to Greece and was captivated by the poetry of its ruins and sculptures. On his return to Paris he exhibited photographs of this trip, and his work *Journey to Greece* attracted the attention of the publisher Charles Peignot, who commissioned the work *Lumière sur l'Hellade* (Light above Hellas, 1953). He moved to Greece, but when it was invaded was forced to return to Germany, which he left again for France in 1949. He continued to visit the south on trips to Greece, Italy, and Spain, produced portraits of artists and

writers, and became a member of the Magnum agency. List gave up photography in the mid-1960s, and from then on devoted himself to his collection of Italian drawings.

Lumière brothers
Lumière, Auguste:
b. 1862, Besançon, France;
d. 1954, Lyons, France
Lumière, Louis:
b. 1864, Besançon, France;
d. 1948, Bandol, France
After 1870, Antoine Lumière settled in Lyons, where he soon earned a reputation as a portrait photographer. The business grew quickly, thanks to the research of his younger son, Louis, a physics graduate who perfected an industrially prepared gelatin silver bromide dry plate. The whole family became involved in the enterprise. Auguste worked with his father in the studio, Mme. Lumière worked at the retouching stage, and the two sisters, Jeanne and Mélanie-

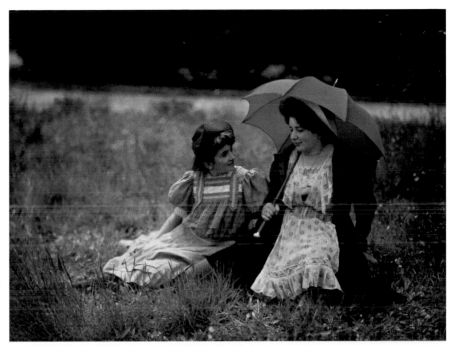

Louis Lumière,
Madeleine
Koehler and
André Lumière
(1910).
Autochrome

Juliette, worked in the newly built factory. From 1885 on they manufactured the first soft film, and in 1903 they introduced the autochrome plate. They were inventors, innovators, and good managers in the photographic industry and also pioneers in the cinema. In 1895 they patented a motion-picture camera that they named the "cinematograph," and on March 22, 1895, they showed the first film, entitled *La sortie des usines Lumière* (Workers Leaving the Lumière Factory). The eclectic creativity of the Lumière brothers left its mark not only on the fields of chemistry, electricity, and acoustics, but also on automobiles and pharmacy. The last years of Auguste's life were devoted, with less success, to medical research. *See p. 52.*

Donald McCullin
b. 1935, London, England
For thirty years, Don McCullin de-

voted his life to war photography: on the front lines, camera in focus, face to face with fighting, suffering, and death. He could have been a painter or a designer, but chose a career in photography after working in the medium during his military service in the Royal Air Force. In 1959, the *Observer* published his first reports, and in 1964 he received the World Press Photo of the Year Award for his work in Cyprus. He then covered the war in Vietnam for the *Sunday Times* and denounced this appalling conflict and its huge death toll. He bore witness to the terrible consequences of famine in Biafra, the troubles in Northern Ireland, and the war in Lebanon. Today, he tries to exorcize the ghosts of war by photographing landscapes, which he hopes will help him rediscover his lost serenity. A full account of his work can be found in *Don McCullin, a Retrospective* (2000). *See pp. 137, 152–153.*

Man Ray
[Emmanuel Rudnitsky]
b. 1890, Philadelphia, Pennsylvania;
d. 1976, Paris, France
Man Ray studied at art school in New York, then worked for an engraver and an advertising agency. Having started out as a painter, he discovered photography at 291 (once the Little Galleries of the Photo-Secession). He took the name "Man Ray" in 1913 and produced some photographs in the dada style, experimented with the *cliché–verre* in *Man*, also known as *The Eggbeater* (1918–1920), and *Dust Breeding* (1920). In 1921 he moved to Paris and established himself as a fashion photographer for *Vogue* magazine and a portrait photographer for the intelligentsia of the time. While developing one of his negatives, he created a photogram (which he called a "rayogram"), simply by placing the object between the bromide paper and the source of light. He then

produced his most famous photographs: *Champs délicieux* (Delicious Fields,1922), *Violon d'Ingres* (Ingres's Violin, 1924), and *Noire et Blanche* (Black and White, 1926). Regarded as the surrealists' own photographer, he was published in their journals (*La Révolution Surréaliste* and *Le Minotaure*), and tried his hand at cinema. In 1930 he rediscovered solarization, which enabled him to achieve special effects by exposing the photographic paper during development. In 1940 he returned to the United States where he began to paint again, and then in 1951 moved back to Paris for good. *See pp. 47, 60, 61, 68, 74, 80, 83, 94, 106, 108–109, 112, 171.*

Robert Mapplethorpe
b. 1946, New York, New York;
d. 1989, Boston, Massachusetts
After studying at the Pratt Institute, Mapplethorpe met the singer Patti Smith and moved into the Chelsea Hotel with her in 1969. He started to take black-and-white Polaroid photographs, including many self-portraits, some of them nudes, as well as portraits of Patti Smith, and his friends and a number of still lifes. His discovery of twentieth-century French photography confirmed for him his liking for the gelatin silver technique, which he began to work with more and more seriously. In the square format he produced not only numerous portraits of artists and celebrities on the New York scene, but also male nudes and images of flowers, whose graphic aspects and sexual connotations he emphasized. In 1972 he met Sam Wagstaff, who became his friend and patron, and persuaded him to collect photography; Mapplethorpe went on to put together one of the world's finest private collections of photographs, from the beginnings of the medium to the contemporary image.
 Mapplethorpe began to exhibit in 1973 and became known for his erotic images of black men and

sadomasochistic scenes. His work was classical, well composed, and carefully lit, and all his "subjects" were treated without lyricism and with the same sense of balanced composition. In exhibits throughout the world he showed unique pieces in frames that he had created for them. By the time of his major retrospective at the Whitney Museum in New York, he was severely debilitated by AIDS. He attended the opening in a wheelchair and died a few weeks later. His work was attacked by the American right, and in June of 1989 the Corcoran Gallery (a publicly funded organization) canceled his posthumous exhibit, "The Perfect Moment." The Washington Project for the Arts picked up the exhibit instead, at its own expense, and thousands of people crammed and shuffled through its tiny gallery to view this important show. *See pp. 164–165.*

Étienne Jules Marey
b. 1830, Beaune, France;
d. 1904, Paris, France
Like Eadweard Muybridge, his exact contemporary, Marey is known for his work on the problem of capturing rapid movement. As a physiologist and professor at the Collège de France, Marey worked throughout his life to perfect methods of breaking down the movements of people and of animals such as horses and birds. His first method was drawing, using the graphic method he developed in the 1860s. Then, influenced by Muybridge's work, which itself had been inspired by Marey's drawings, he used the chronophotographic, or fixed-plate, camera that he invented in the 1880s. His work revolutionized the representation of movement. It was a major influence on the scientists, photographers, and artists of his time and an important milestone on the way to the birth of cinematography. *See pp. 41, 42–43, 49, 64, 100.*

Charles Marville
1816–1878, Paris, France
As an engraver and illustrator, Marville was unusually quick to appreciate the advantages offered by the paper negative in the reproduction of images. He worked with the printer Louis-Désiré Blanquart-Evrard, notably producing calotypes for *Architecture et Sculpture, Paris Photographique* (Architecture and Sculpture: Photographic Paris), and *Les Bords du Rhin* (The Banks of the Rhine). As the official photographer of the Musée Impérial du Louvre and other national museums, he made reproductions of the works there throughout his career. He is especially famous for his 425 views of the streets of Paris, taken while he was working as official photographer for the City of Paris, in which he documented the destruction that took place at the time of Baron Georges-Eugène Haussmann's modernizations.

Ralph Eugene Meatyard
b. 1925, Normal, Illinois;
d. 1972, Lexington, Kentucky
Meatyard was a great lover of the theater. In 1950 he bought a camera to photograph his son. Having enjoyed playing with technique to create double exposures and out-of-focus effects, he began to explore the subject more deeply, and in 1956 worked with Ansel Adams and Edward Weston on the *Creative Photography* exhibit. He photographed the people around him wearing masks, for which he used paintings and objects with ever-increasing inventiveness. He produced several series of images entitled Lite/on Water, Zen Twigs, and Motion-Sound, in which he created a whole poetic and dramatic universe. In 1959, *Aperture* magazine published a portfolio of his work, and Meatyard took part in the "Sense of Abstraction" exhibit at the Museum of Modern Art. He was a fervent defender of creative American photography and went on to become an exhibit organizer.

Ray K. Metzker
b. 1931, Milwaukee, Wisconsin
Ray Metzker was a pupil of Aaron
Siskind and Harry Callahan, and
exhibited for the first time in
1959 at the Art Institute of Chicago.
Today he has a double career as a
photographer and teacher in Phil-
adelphia, and is regarded as one
of the most inventive and innova-
tive photographers since World
War II. He explores the possibil-
ities of black-and-white photog-
raphy by superimposing negatives
and then printing them on a single
sheet, thus disturbing our percep-
tion of these multiple images. His
complex compositions completely
alter the notion of space and time,
and refer to painters such as J. M.
William Turner, François Boucher,
and Claude Monet. This is especi-
ally true of his work with land-
scape, his subject for about forty
years. *Ray K. Metzker: Landscapes*
(2003) questions the traditional
idea of landscape, taking it into
the realm of the surreal or even
mysterious abstraction.
See p. 129.

Duane Michals
b. 1932, McKeesport, Pennsylvania
Michals adhered to Henri Cartier-
Bresson's idea of form, but he
rejected Cartier-Bresson's belief
in photography as a true-to-life
medium that proved the existence
of the real world. On the contrary,
he decided to use it as a means of
creating fictions that were in con-
stant dialogue with literature.
Thus, he found that he was able
to invent narratives. He went to
Russia, where he took portraits
with an unreal atmosphere, then
created little dramas known as
"sequences"; these were succes-
sions of poetic but also humorous
images in which he often ap-
peared. Very soon he began to
accompany them with the hand-
written texts on the print itself, a
technique that would become his
signature. He acknowledged his
homosexuality early on, but in a
highly literary manner; for him the
book was of central importance.
From *Real Dreams* (1976) to *Eros
and Thanatos* (1992), he has
created a refined and highly
unusual body of work.
See pp. 126, 166–167, 171.

Lee Miller
b. 1907, Poughkeepsie, New York;
d. 1977, Sussex, England
Lee Miller posed as a model for
the photographer Edward Steichen,
and it was through him that she
met Man Ray. They became
friends, and she worked for a
while as Man Ray's assistant
before returning to New York to
open a studio, which was very
popular among well-known
actresses and in the world of
fashion. She then went to Egypt
for five years with Aziz Eloui Bay,
whom she married in 1934. During
this trip she took landscape pho-
tographs, then on returning to
Paris became closely linked with
the surrealists. She worked as a
fashion photographer for *Vogue*,
and subsequently became a war
correspondent. In 1947 she mar-
ried the collector Ronald Penrose.
See p. 121.

Lisette Model
b. 1906, Vienna, Austria;
d. 1983, New York, New York
Lisette Model, née Elise Seybert,
studied music and painting, then
left Austria for France and trained
as a photographer alongside
Florence Henri and Rogi-André.
She spent time in Paris, then in
Nice, where she produced one of
her first series, showing people
walking along the Promenade des
Anglais. She then went to New
York, where the main part of her
career developed. She worked at
magazines, including *Harper's
Bazaar*, and also exhibited and

Ralph Eugene Meatyard, *Romance (N) (from Ambrose Bierce #3),* (1962)

took on students, one of whom was Diane Arbus. Her photographs centered on individuals, whose main interest for her was their relationship to the city; she captured them in their own environment, in the street, in bars, in gambling houses, and at racetracks. This approach is particularly well illustrated by the photographs in her *Shadows* series, where the composition establishes a close link between the tarmac on the sidewalks and streets, the glass of shop windows, and the shadows of people.
See pp. 83, 141.

Tina Modotti
b. 1896, Udine, Italy;
d. 1942, Mexico City, Mexico
At the age of twelve, Tina Modotti was working in a textile factory; she emigrated to the United States in 1913, and lived for a time in San Francisco. She married in 1917, moved in artistic circles, and acted in films. In 1921 she decided to study photography with Edward Weston in Los Angeles. They became lovers and left for Mexico, where Tina was an active leftist militant along with artists such as Diego Rivera and David Siqueiros. In 1924 she exhibited for the first time jointly with Edward Weston, spoke about the *campesinos* (Indians), and produced some symbolic still lifes on the subject of communism and the struggle against fascism. Weston taught her the platinum printing technique, which she would later pass on to Manuel Alvarez Bravo. After joining the Communist party, she was deported from Mexico in 1930. In Berlin, and then in Spain during the Civil War, she worked in turn as a journalist and stretcher-bearer. In 1939, she went back to live in Mexico, where she died in obscure circumstances. After an adventurous life as a militant and feminist, she left behind a graphically powerful body of work.
See pp. 77, 116.

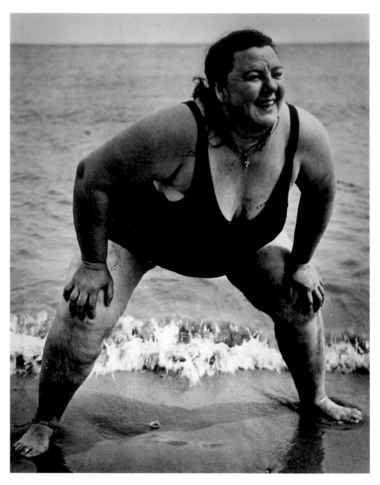

Lisette Model, *Coney Island Bather* (New York, ca. 1944)

László Moholy-Nagy
b. 1895, Borsod, Hungary;
d. 1946, Chicago, Illinois
László Moholy-Nagy was a great constructor of images, a theoretician and critic, and is still regarded as the most important figure in the New Vision movement, which grew up in Europe in the years between the world wars. He helped to make the movement known in both Europe and the United States, where he emigrated in 1937.
See pp. 66–69, 71, 74, 94, 102, 109, 128.

Pierre Molinier
b. 1900, Agen, France;
d. 1976, Bordeaux, France
Pierre Molinier came from the southwest of France. He moved to Bordeaux in 1923, where he lived until his death. His main interest

was painting, and he worked in that medium throughout his life. He became close to André Breton and the surrealists in 1955, at a time when his painting had strong erotic and fetishistic resonances. It was only at a late stage that photography, mainly self-portraits and photomontages, entered his work. It deserves recognition, however, as due to its preoccupation with transvestism, fetishism, and the questioning of gender identity it quickly attracted research interest among the artistic avant-garde of the 1970s. Molinier took his own life in 1976.
See pp. 164, 171.

Sarah Moon
[Marielle Hadengue]
b. 1938, England
Sarah Moon studied art and then became a professional model. She

began to take photographs in 1966, and her work was immediately noticed by the leading magazines. She worked for *Marie Claire*, *Harper's Bazaar*, *Vogue*, *Elle*, and *Stern*, and right from the begin-

ning developed a very personal style. She became known to the general public through her advertising campaigns for Cacharel, which were highly contemporary but also had a timeless quality.

Alongside her work in fashion she carried out her own research and built up an original body of work, full of poetry and subtle evocations of the dream state, an exploration made possible by the vibrations of light and the fine texture of the Polaroid negative. Her great work, *Coïncidences* (2001), is a seamless combination of commissioned and experimental work in which she subtly creates a timeless world of evolving fairy-tale characters. She ranks with Guy Bourdin, Jeanloup Sieff, and Helmut Newton as one of the most important fashion photographers of her time.

Inge Morath
b. 1923, Graz, Austria;
d. 2002, New York, New York
At the age of twenty-three, Inge Morath was working as an interpreter when she discovered photography through Ernst Haas. In 1949 she started to work for Magnum as a researcher and editor, eventually becoming Henri Cartier-Bresson's assistant. She moved to London in 1951, and after publishing her first photographs became a member of

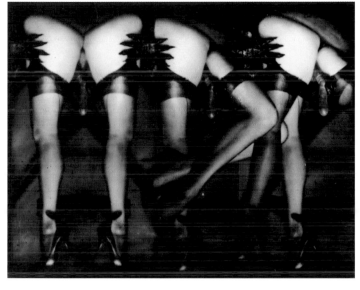

Pierre Molinier, *The Shaman and His Creatures* (1969)

Sarah Moon, *Beauty Contest* (*London Sunday Times*, June 1973)

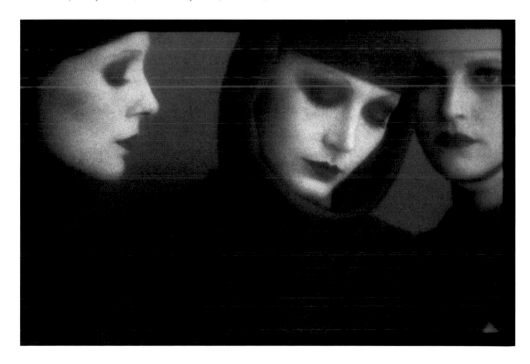

Magnum in 1955. During the filming of *The Misfits* she took Marilyn Monroe's portrait, and then married the film's screenwriter, Arthur Miller. She traveled in Spain, Iran, and the USSR, learned Mandarin (one of her seven languages, which also included Rumanian), and visited China in 1978. With her keen, benevolent eye she immortalized Mrs. Nash, a plump millionairess in luxurious furs, and in a more comical vein worked with Saul Steinberg to create *Mask* (1967), for which she designed and photographed funny paper masks. *See p. 178.*

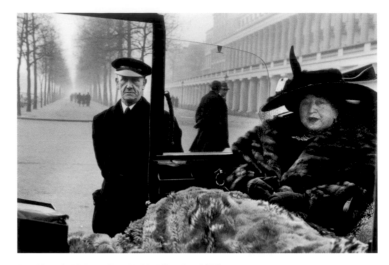

Inge Morath, *Madame Eveleigh Nash* (London, 1953)

Martin Munkacsi [Martin Marmorstein]
b. 1896, Kolozsvar, Hungary (now Cluj in Rumania); d. 1963, New York, New York

Munkacsi worked in Budapest as a house painter as well as a sports journalist for the daily newspaper *Az Est*, then at twenty-five became a sports photographer. Success took him to Berlin to work for various newspapers, including the *Berlin Illustrierte Zeitung*, which sent him to New York in 1933. There he met Carmel Snow, the editor of *Harper's Bazaar*, and this proved decisive; he moved from sports into fashion, bringing with him his sense of action and realism. In 1933, the December issue of *Harper's Bazaar* showed a young American woman—smiling, beautiful, and muscular—running along a beach with her cape floating down her back...and this was a fashion photograph. It was also the new woman as seen by the artist, tanned and natural, elegant and sporty, spontaneous and exuberant. In 1943 his work was interrupted by a heart attack. He then wrote his autobiography, *Fool's Apprentice* (1945), became interested in cinema, and wrote poetry. Munkacsi was to influence a whole generation of young photographers, including Richard Avedon. *See pp. 102, 106–107, 161.*

Eadweard Muybridge
1830–1904, Kingston upon Thames, England

Muybridge is known for his work on the technique of capturing rapid movement in photography. He moved from his native England to California in 1851, and in 1872 started to produce series of animals and people in motion. These became widely known through publications, such as his *Animal Locomotion* (1887), and led to numerous photographic experiments including those of his contemporary, Étienne Jules Marey. *See pp. 35, 41, 42–43, 64.*

James Nachtwey
b. 1948, Syracuse, New York

James Nachtwey studied art history and political science and was strongly influenced by images of Vietnam and by the American civil-rights movement. In 1976 he began his career as a press photographer in New Mexico, then moved to New York. His first foreign assignment was in Northern Ireland, where he photographed the IRA hunger strikers. From that time on he covered the world's major conflicts, wars and famines, from Latin America to Africa and from Asia to Eastern Europe. He worked for the Black Star agency from 1980 to 1985, was a member of Magnum from 1986 to 2001, and cofounded the VII agency. He has

received many awards, including the Robert Capa Gold Medal, which he has won five times. *See pp. 148–151, 153.*

Nadar [Félix Tournachon]
1820?–1910, Paris, France
Nadar Jeune [Adrien Tournachon]
1825?–1903, Paris, France

Working as a journalist and satirical caricaturist for political publications such as *Le Charivari*, Nadar produced more than 200 caricatures of famous people, then in 1854 decided to become a photographer. For several years his studio was visited by the leading personalities of the time, such as Baudelaire, Honoré Daumier, Hector Berlioz, and Sarah Bernhardt. He was a great ballooning enthusiast and took the first aerial photographs from the basket of his balloon, *Le Géant*; he also photographed the catacombs and sewers of Paris. With Nadar's encouragement, his brother Adrien took up photography and worked with Duchenne de Boulogne, a physiologist who had developed a grammar of human expression by using electrical charges to cause contractions of the facial muscles. Adrien took magnificent portraits of the mime artist Debureau, but the relationship between the brothers turned sour, and they became involved in a legal battle over the use of the pseudonym

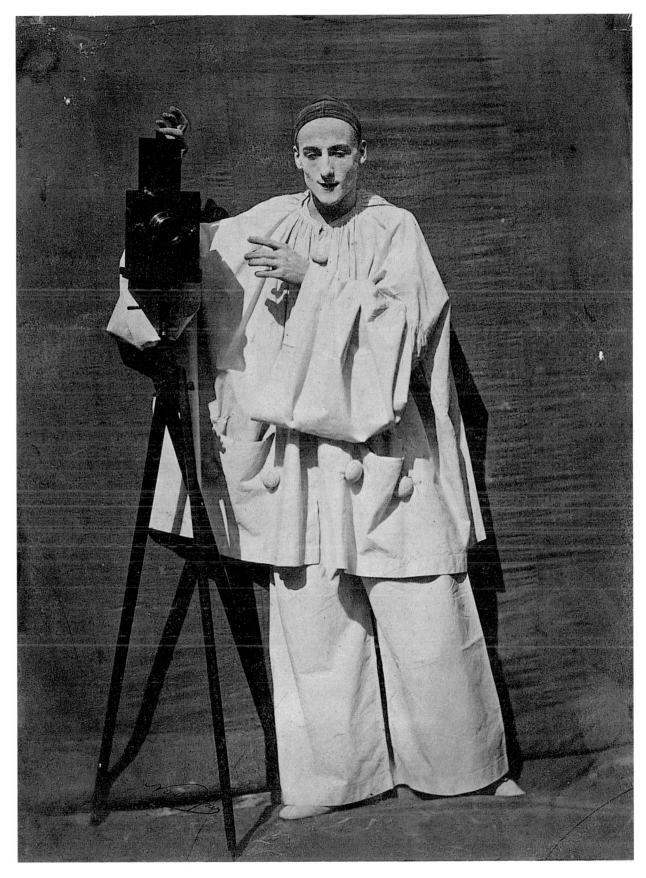

Félix Nadar and Adrien Tournachon, *Pierrot the Photographer* (1854–1855)

Nadar. Adrien pursued an independent career before developing mental-health problems and being institutionalized in 1886. Meanwhile, Nadar was driven by competition to adopt a more commercial attitude and reluctantly started to produce visiting-card portraits. This soon turned into a real business, which he ran with his wife and son Paul until 1886, when he passed it down to Paul for good. At the age of eighty, Nadar published his memoirs, entitled *Quand j'étais Photographe* (When I Was a Photographer).
See pp. 24, 27, 28, 91, 100.

Charles Nègre
1820–1880, Grasse, France
In 1839, Charles Nègre went to Paris to study under Paul Delaroche. He then joined Ingres's studio and exhibited in the Salons until 1853. At the same time, he started taking his first photographs, which initially were simply intended to help his painting. His photography work then became important in its own right, and he took portraits and genre scenes, the most famous of which show chimney sweeps and ragmen on the banks of the Seine in Paris. In 1852 his predilection for photographs of architecture took him to the South of France, where he created a collection of 200 views of buildings. In Paris he photographed Notre-Dame and the play of light on its roofs, and also went to Chartres, where his main subject was the cathedral. In response to an official commission, Nègre produced a series of photographs of the Imperial Asylum at Vincennes, built for Napoléon III. His most important achievement on the technical side was the improvement he made to the heliographic printing process by using gold plating. In 1863 he returned to the South of France to teach art at the lycée in Nice and open a studio there.
See pp. 42, 90.

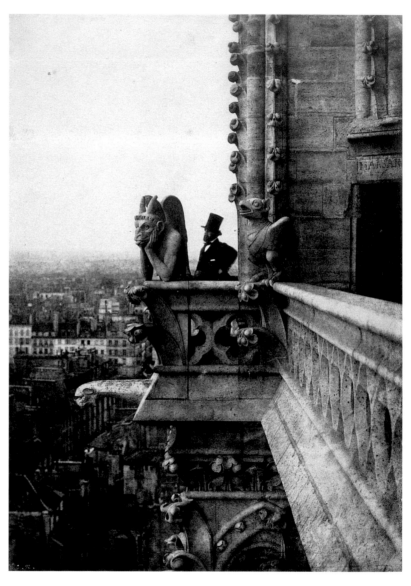

Charles Nègre, *Upper Gallery of Notre-Dame* (known as *Le Stryge*, 1853)

Helmut Newton
b. 1920, Berlin, Germany;
d. 2004, Los Angeles, California
Helmut Neustadter came from a middle-class Jewish family, and at twelve years of age bought his first camera, an Agfa Tengor box model. He wanted to be a reporter, and at that time modeled himself on the American photographer Weegee. He left school to become an assistant to Yva. In December 1938, his parents urged him to leave Germany, and he set off from Trieste for China, stopping off at Singapore. He was eighteen years old and had two dollars to his name. Two years later he arrived in Australia, where he was to live until 1957. He joined the army, changed his name, and became an Australian citizen. In 1948 he opened a studio and married June Brunelle, better known as Alice Spring. Newton was given a one-year contract by

British *Vogue*, and worked for *Jardin des Modes* before embarking on a tumultuous career with French *Vogue*. He moved to Paris, where he demolished the classic codes of fashion photography, going against the prevailing hippie atmosphere of the 1960s to set down on paper the image of a woman who was submissive to his desires.

Around 1975, he moved away from fashion photography into exhibits and publications (*Sumo*, 1999), which enabled him to explore other photographic issues. *See pp. 162–163, 165, 186.*

Joseph-Nicéphore Niépce
b. 1765, Chalon-sur-Saône, France;
d. 1833, Saint-Loup-de-Varennes,
France
Niépce was the inventor of what appears to have been the first photographic process, which in 1827 he himself named heliography, or "sun writing." This invention marked the conclusion of his research, begun in 1816, on the production of durable images by the action of light alone. Between 1829 and 1833, when he died, Niépce worked in partnership with Louis Daguerre on further research into ways of improving his process. Partly through the theoretical and practical contribution made by Niépce's earlier work, Daguerre was able in 1837 to perfect the daguerreotype process, to which he gave his name. *See pp. 16–17, 42, 90.*

José Ortiz-Echagüe
b. 1886?, Guadalajara, Mexico;
d. 1980, Madrid, Spain
Ortiz-Echagüe was an engineer and pilot who made his career in the aeronautical and automobile industries. He started taking photographs at a very early age and continued to do so throughout his life, although never in a professional capacity. He traveled all over Spain, hearkening back to the traditional aspects of the country

by photographing landscapes and castles, and also toured Morocco, where he admired the Moorish architecture and the draped figures of the nomads. He developed his negatives himself and took great care over his choice of paper, finally producing a new type called "Carbonit." Following in the pictorial tradition, he reworked his images; he was more concerned with the aesthetic quality of his work than with its documentary aspects.

Paul Outerbridge
b. 1896, New York, New York;
d. 1958, Laguna Beach, California
Outerbridge took his first photographs in the U.S. Army in 1917, then entered the Clarence White School in 1921. His work was immediately characterized by his love of still lifes and nudes. He gave an almost abstract vision of everyday objects (a bowl, eggs, a stiff collar), working on every detail of the composition and light and producing remarkably beautiful platinum prints. In 1925 he went to Paris, where he participated in the artistic life of the avant-garde along with figures such as Man Ray, Marcel Duchamp, and Picasso. When he returned to New York in 1929, he worked for *Vogue* and successfully experimented with color; using the carbro-color process, he was able to develop his nude photographs with subtle, refined, coldly sensual tints. In 1940 he published *Photography in Color*. Some of his more surrealistic and fetishistic nude images were very badly received by the American public. *See pp. 76–77.*

Martin Parr
b. 1952, Epsom, England
After training for three years at Manchester Polytechnic, Martin Parr became a photojournalist and also started to teach in 1974. He was a great lover of books, collecting them compulsively. In 1982

he published *Bad Weather*, which, like the rest of his work, clearly places him within the British documentary school. From 1980 on he explored color with virtuosity, always dealing with social themes (the English by the seaside, tourists, a working-class neighborhood), and using copious detail and harsh colors to emphasize the tastes of the working- and lower-middle classes. His excessive, jubilant approach sometimes borders on caricature in its use of very full, unashamedly garish shades of color. Despite having developed a market for his work on the art circuit and being happy to work for advertisers, he joined the Magnum agency. He is a remarkable collector of everything to do with photography, and every time he travels he has his own portrait taken in a typical local studio.

Irving Penn
b. 1917, Plainfield, New Jersey
At the age of seventeen, Irving Penn went to study art with Alexey Brodovitch, and in 1941 began his career as artistic director for Saks in New York. For two years

Paul Outerbridge, *Ide Collar* (1922)

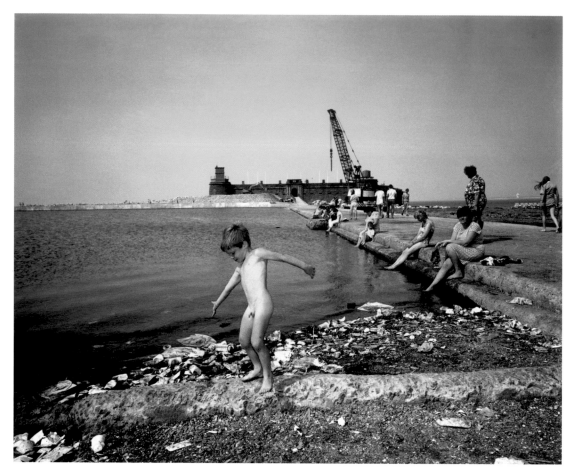

Martin Parr, *GB England, New Brighton, Mereyside* (from *The Last Resort*, 1983–1986)

he worked as a freelance artist for *Harper's Bazaar*, and it was not until 1943 that his photographs appeared for the first time in *Vogue*, thus marking the start of his long association with Condé Nast publications.

He is an extraordinary portraitist who combines simplicity of camerawork, natural lighting, and straightforwardness with a remarkably modern formal sophistication. Wherever he was—in Morocco or Peru, taking almost anthropological portraits, or back in the United States—he produced uncluttered, admirably composed images. For his fashion photographs, he adhered to the same concepts: formal rigor, monumentality, apparent simplicity in the

rendering of line and volume. In addition to this mastery of the image, his photographs had natural elegance, refinement, and something of the sublime. Penn never stopped innovating (photographs of still lifes or cigarette butts) and experimenting with different techniques (platinum and palladium printing). Constantly imitated and copied like Richard Avedon, he plays a major role in the history of photography. *See pp. 160–161.*

Gilles Peress
b. 1946, Paris, France
Having had close links with extreme left-wing politics in his student days, Gilles Peress joined the

Magnum agency in 1972. By this time, he had already undertaken one of his great photographic ventures, the chronicling of the civil war in Northern Ireland in carefully centered images; he is still working on this project today. His book *Telex Iran* (1983) documents the return of the Ayatollah Khomeini to his homeland and gives a complex portrait of the time, accompanied by reproductions of tumultuous exchanges with his agency. He has also published major works on Rwanda and the former Yugoslavia. He is a very cerebral figure and a sharp, radical analyst of the position of the press and contemporary approaches to the use of photography. He has distanced himself

from most magazines, concentrating on books and also on exhibits; he takes great pains to organize exhibit space himself. He has received a number of awards, including the very prestigious W. Eugene Smith Grant in Humanistic Photography in 1984. Although no longer a member of Magnum, he has entrusted the distribution of his archives to the agency.
See p. 153.

Anders Petersen
b. 1944, Stockholm, Sweden
When he was eighteen, the young Swede decided to go to Hamburg for three months on a trip that ended up having a decisive influence on him, introducing him to music, dropouts, drugs, and sex. Haunted by the experience, he looked to photography for a means of expressing himself. He was admitted to the legendary Christer Strömholm's school in 1966, where he became Strömholm's favorite student and eventually friend. In 1967, he founded the Saftra agency in order to devote himself to socially committed photojournalism. Later he returned to Hamburg, where he lived for two years and produced the images for what was to become a cult book and a watershed in documentary photography: *Café Lehmitz* (1978). His humane, affectionate, unvoyeuristic approach to the down-and-outs, prostitutes, and drunks in this café has influenced generations of young reporters. He went on to produce further exemplary collections shot in prisons, an old-folks' home, and a psychiatric hospital. He then fell into obscurity for nearly twenty years, but has now made a brilliant comeback on the international scene, and in 2003 won the Grand Prix de la Photographie des Rencontres in Arles (France).

Pierre et Gilles
working together since 1977, France
Since they met in 1976, Pierre and Gilles have lived and worked together: Pierre takes the photographs, and Gilles retouches them. This partnership has enabled them to create a paradisiacal world full of perfect creatures, pop idols, film stars, handsome boys, and charming girls which was initially intended for fashion magazines but then moved on to record sleeves and finally to the walls of contemporary art galleries and museums.

They cover themes ranging from religious imagery—with Saint Sebastian taking pride of place—to sailors, bullfighters, and soldiers; to the gods, goddesses, and boys of India. Always very colorful and attractive, with the emphasis on sleek images and dream worlds, their work is completely out of the ordinary: a sort of kitsch world that parodies (or appropriates) the codes of advertising and rejects (or celebrates) their sleek, clean, idealized aesthetic.
See p. 155.

Pierre et Gilles, *Allyson and the Dove* (1981). Airbrush print

Bernard Plossu
b. 1945, Dalat, South Vietnam

Bernard Plossu took his first photograph in the desert when he was thirteen, and became a professional photographer at twenty when he traveled to Mexico. Since then, all his work as a photographer has been inspired by his passion for the American West, India, Africa, the desert, by everything he has discovered while traveling beyond borders—predictable and unpredictable, known and unknown—in search of the freedom he encountered with the hippie generation of the 1970s. Rejecting the technical perfection that sets things in stone, he captures nomadic atmospheres and settings. From *Le Voyage Mexicain* (The Mexican Journey, 1979) to *Paysages intermédiaires* (Middle Landscapes, 1988), the catalogue of his exhibit at the Centre Georges Pompidou, Plossu is in direct touch with the rhythm of his own life, which he documents in a rapid, clear movement, with a little blurring here and there to confuse the issue.
See p. 182.

Constant Puyo
1857–1933, Morlaix, France

Puyo graduated from the École Polytechnique and became an artillery officer, then took up photography as a hobby in about 1889. In 1894 he cofounded the Photo-Club de Paris with Robert Demachy and Maurice Bucquet and in 1896 was admitted to the Linked Ring. He very quickly became one of France's major pictorial photographers. His photographs of young women posing in idyllic landscapes or in richly decorated interiors have an eminently sensual character, sometimes straying into the superficial and formulaically decorative. After his retirement in 1902 he devoted himself almost exclusively to his hobby, which had become a real passion. He published books and specialized articles on a process of printing with rubber and also invented some lenses.
See pp. 55, 104.

Markus Raetz
b. 1941, Buren, Switzerland

Raetz cannot strictly be classed as a photographer, given the wide range of activities he has been involved in, which include painting, video, and sculpture as well as photography. Nevertheless, the photograph, as a double image or an illusion, is very much at the center of his preoccupations. He received no artistic training, but since the mid-1960s has been engaged in a polymorphic project focused on the appearance and perception of forms. In playing on the material of the work and its mode of presentation (particularly from the spectator's point of view), the express intention is to create a confusion of ideas and techniques. In 1988 Raetz represented Switzerland in the Venice Biennial.

Arnulf Rainer
b. 1929, Baden, Switzerland

Rainer used the photographic medium in association with other graphic techniques. His training as a painter was influenced by surrealism, but he soon distanced himself from the movement. Photography was the starting point for many of his works, notably the self-portrait project that he

Arnulf Rainer, *View in Perspective of the Palace and the Jardin des Tuileries* (1992)

undertook in the mid-1950s. Later (1965–1969) he used photo machines for a series entitled Face Farces, variations on the theme of the grotesque. In Totenmasken (Death Masks, 1977) he photographed the death masks of famous deceased artists, writers, and musicians, then covered the photographs with paint, scratches, or scoring. This, he explained, was intended not to destroy but to perfect.

Henri Victor Regnault
b. 1810, Aix-la-Chapelle, France;
d. 1878, Paris, France
Henri Victor Regnault was a chemist, physician, professor at the Collège de France and director of the Sèvres porcelain factory. From the time of its founding, he was involved in the work of the Heliographic Society, and from 1855 to 1868 he was president of the Société Française de Photographie (SFP). He worked in calotype as an amateur photographer, choosing his subjects from his immediate surroundings: friends, colleagues, the factory, his family. Regnault

was the central figure in the "Sèvres group," which notably included Louis-Rémy Robert (1810–1882) and Jules Ziegler (1804–1856). He also started the SFP's collection of images, texts, cameras, and documents relating to photography.

Oscar Gustav Rejlander
b. 1813, Sweden;
d. 1875, London, England
Rejlander was a Swedish painter who trained in Rome. He went to England to work as a portraitist and became the leading figure in the artistic photography movement, which began in England in the 1850s. He used photography in his day-to-day work as a painter, then in 1855 took it up commercially and opened a studio. Taking painting as his model, he specialized in dramatized images of historical or religious subjects and genre scenes that he recreated in the studio or put together using the photomontage technique. In 1857 he produced *The Two Ways of Life*, a huge allegorical composition inspired by Raphael's *School*

of Athens, and the enormous success of this one photograph put the rest of his work somewhat in the shade. He was passionately interested in matters relating to the search for the correct facial expression, and he also illustrated Darwin's work, *The Expression of the Emotions in Man and Animals* (1872).
See pp. 42, 170.

René-Jacques [René Giton]
b. 1908, Phnom Penh, Cambodia;
d. 2003, Paris, France
René Giton moved to Paris with his family in 1924. He studied law, then became a photographer and opened a studio in 1932 under the name René-Jacques. He shot portraits, plate photographs, and night scenes, and published in *Harper's Bazaar* and *Arts et Métiers Graphiques*. In 1946 he founded the Association Nationale des Photographes Publicitaires (National Association of Advertising Photographers), whose aim was to win recognition for the rights of photographers. In the same year he became a founding

Oscar Gustav Rejlander, *The Two Ways of Life* (1857)

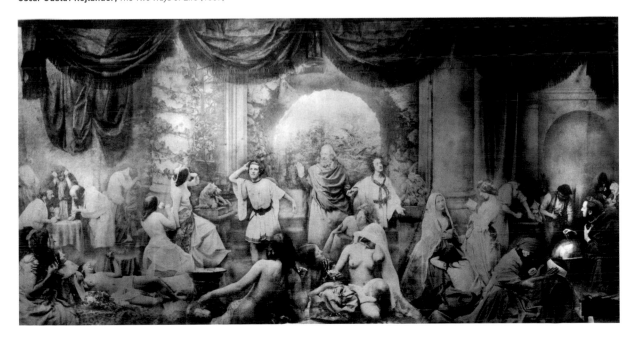

member of the Groupe des XV. Much of his work is linked with the writers of his time, such as Léon-Paul Fargue, Henry de Montherlant, Albert t'Serstevens, and Francis Carco, for whom he illustrated *Envoûtements de Paris* (Paris Enchantments). He published several monographs, including *La France* and *Les Vignobles de Bordeaux* (The Vineyards of Bordeaux). In 1975, René-Jacques closed his rue du Printemps studio, which had been open since 1947.

Albert Renger-Patzsch
b. 1897, Würzburg, Germany;
d. 1966, Wamel, Germany
After studying chemistry in Dresden, Renger-Patzsch became director of the photographic archive at the Folkwang publishing house, then opened his own studio in 1925. His work was a reaction to pictorialism, which was still prevalent; he believed that the secret of good photography was its realism, and in keeping with this dogma he built up a sort of visual encyclopedia of the world, *Die Welt ist Schön* (The World Is Beautiful) published in 1928. The book contains 100 photographs and gives a view of the world just as it is, with no intervention except from the machine that implacably records it. This was a kind of manifesto, intended to start a vast artistic movement that would emphasize the specific qualities of the photograph as a clear, reproducible document. Renger-Patzsch's viewpoint was very influential, and it marked the beginning of the New Objectivity that was to become the basis for much of contemporary photography. There have been numerous exhibits of Renger-Patzsch's work, most of which appears in books, since he regarded these as an especially suitable place to present photography. His masterpieces include *Eisen und Metal* (Iron and Metal, 1930), *Deutsche Wasserburgen* (German Water-Castles, 1939), and *Der Baum* (The Tree, 1962).
See pp. 72, 94.

Marc Riboud
b. 1923, Lyons, France
Marc Riboud graduated in engineering from the École Centrale de Lyon, but he abandoned his initial career choice and opted for photography instead. He had already taken it up while very young, when in 1939 his father gave him the Vest Pocket Kodak camera that he had used during World War I. Riboud joined

Albert Renger-Patzsch, *Pine Trees During Winter* (1956)

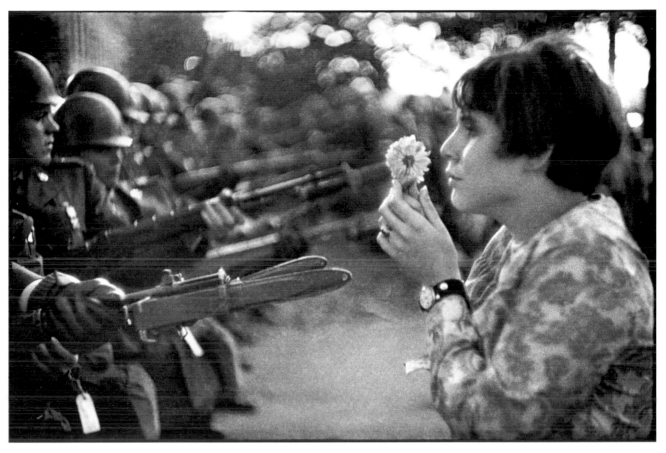

Marc Riboud, *Peace March* (Washington, D.C., 1967)

Magnum in 1953, became its vice president in 1959, and was then president from 1975 to 1980, at which point he decided to continue his career as a freelance photographer. Riboud is an insatiable traveler with a particular attraction to Asia. He covered the war in Vietnam, first in the South and then alongside the combatants in the North. He also spent time in India and Cambodia, then went to China where he took the photographs that were part of the 1996 "China 56–96" exhibition shown in Paris and Beijing. He has published a large number of books, notably *Femmes du Japon* (Women of Japan) (1951), *Visages du Vietnam du Nord* (Faces of North Vietnam) (1970), and *Gares et Trains* (Trains and Stations, 1983). *See p. 136.*

Jacob August Riis
b. 1849, Ribe, Denmark;
d. 1914, Barre, Massachusetts
Riis was born into a poor family in Denmark and emigrated to New York in 1870. Working as a police reporter, he was particularly sensitive to the difficult living conditions that immigrants suffered, especially those of children at work. He took up photography in order to show this poverty to his contemporaries, and his book, entitled *How the Other Half Lives*, helped improve conditions in the tenements of New York.
See p. 50.

Denis Roche
b. 1937, Paris, France
In Denis Roche's work, photography is closely linked to writing. He was a member of the management committee of the literary review *Tel Quel* from 1962 to 1972, then joined the Éditions du Seuil publishing house, where he became a member of the editorial committee and director of the Fiction & Co. collection, as well as one of the founders of the photography journal *Cahiers de la Photographie*. In 1978 he began to exhibit, and published his photographs in *Notre Antéfixe* (Our Antéfixe), regarded as the cornerstone of photo-autobiography. Roche photographs himself, alone or with his wife, using a delay mechanism that lets him play on the themes of presence and absence, space and time. He also takes photographs at the same place several years apart. In 1982, he published a collection of writings on the photographic act, *Disparition des Lucioles* (Disappearance of the Fireflies), which won him international critical attention. He has produced a steady stream of exhibits and publications: a special issue of *Cahiers de la Photographie*, a monograph, and retrospectives.

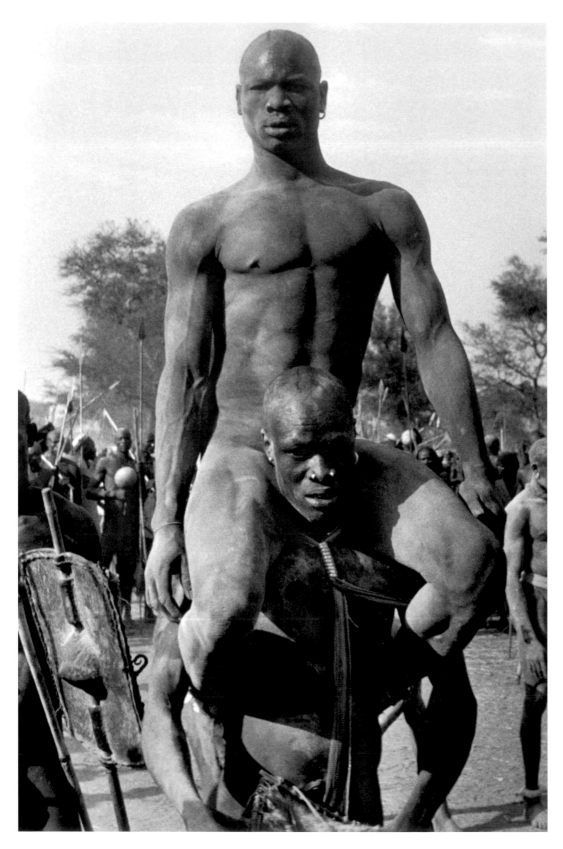

George Rodger, *Nouba Wrestler in the Korongo of Kordofan,* (Southern Sudan, 1949)

Alexander Rodchenko
b. 1891, St. Petersburg, Russia;
d. 1956, Moscow, USSR
From the second half of the 1920s on, this highly versatile Russian artist made photography the main focus of his work. He initially limited himself to photomontage, but he then gradually diversified and moved into a modernist phase that is sometimes wrongly regarded today as the sum total of his work. *See pp. 67, 70–72, 101.*

George Rodger
b. 1908, Hale, England;
d. 1995, Smarden, England
George Rodger first discovered photography when he went to work in the United States. On his return to England in 1935 he was taken on by the BBC. He then became a photographer for the Black Star agency and won fame through his photographs of the London Blitz during World War II. Working for *Life* magazine, he covered the war all over the world. He wrote the articles that accompanied his photographs and at one point faced the absolute horror of the Bergen-Belsen concentration camp. In 1947 he became a founding member of the Magnum agency. He then traveled to Africa, where he went to meet peoples who were still little known, such as the Bari in Uganda, the Nuba in Sudan, and the Masai in Kenya. He brought back extraordinarily beautiful images, all of which showed sensitivity and respect for other people and places.

Rogi-André [Rosa Klein]
b. 1905?, Budapest, Hungary;
d. 1970, Paris, France
In 1925, Rosa Klein arrived in Paris, where she took the name Rogi-André. After meeting André Kertész a year later, she studied his photography and lived with him until 1933. Her work consists mainly of portraits of painters, sculptors, and actors in various spheres of cultural life. Her most

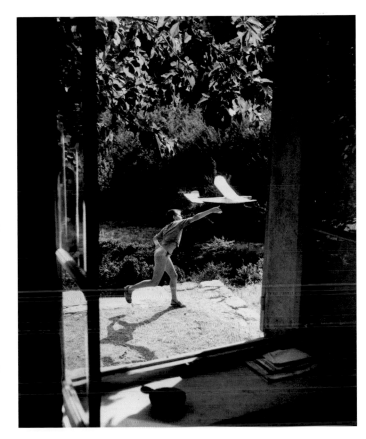

Willy Ronis, *Vincent (son of the Nu Provençal,* Gordes, summer 1952)

notable subjects included Pierre Bonnard, Pablo Picasso, Marc Chagall, Jean Cocteau, and Antonin Artaud. She captured her models in their everyday surroundings and became so close to them that she sometimes photographed them on their deathbed, as she did for Chaim Soutine and Wassily Kandinsky. In the last twenty years of her life, Rogi-André devoted herself to painting, and it was not until 1981 that tribute was paid to her work in a book entitled *Portraits de Peintres* (Portraits of Painters), and a year later in an exhibit at the Musée National d'Art Moderne in Paris. *See p. 83.*

Willy Ronis
b. 1910, Paris, France
Willy Ronis has no specialty; he regards himself as a "polygraph photographer." He started learning photography in 1932, in his father's studio, and has never ceased (except during World War II) to stay on the alert for the everyday, real-life situation that he might happen to spot just by keeping his eye on the world around him. Whether his subject is Belleville-Ménilmontant (an east-Paris neighborhood he has been photographing since 1947), or fashion, or childhood, or industry, he takes a discreet, lucid, readable, unsentimental view of the world that is right on target every time. Ronis is a member of the Rapho agency and has taught photography since 1968. He has been commissioned by numerous magazines such as *Life, L'Illustration,* and *Le Monde illustré,* and in 1981 published *Sur le Fil du Hasard* (Hanging by a Thread), a beautiful summary of his many stolen images. *See pp. 94, 122, 131.*

Thomas Ruff
b. 1958, Zell am Harmersbach, Germany

After studying with Gerhard Richter and Bernd Becher in Düsseldorf, Thomas Ruff quickly became one of the leading lights in a new generation of German photographers. He uses the photographic medium in a documentary, objective manner, working in large format and in color. His portraits for *Aperto*, presented at the Venice Biennale in 1988, were so neutral that they almost looked like identity photographs. This neutrality was a methodical project that continued with the series Houses (1986) and Stars (based on scientific photographs), which operated as an introspective reflection in a world alienated by repetition. More recently, Ruff has produced a series of photomontages that are intended as a critique of the tools of propaganda and the power of the media.
See pp. 156, 165, 192.

Edward Ruscha
b. 1937, Omaha, Nebraska

Better known as a painter, in 1960 Edward Ruscha started to produce books of images, all based on the same concept. He captured the American landscape through its most significant emblems, but unlike Pop art, he opted for the least expressive, most impersonal form of photography. His books *Twenty-Six Gasoline Stations* (1963) and *Every Building on the Sunset Strip* (1966) come across as laconic inventories, mere selections of deliberately incomplete samples which, according to their creator, are nothing more than a compendium of facts or a kind of ready-made collection. He sees the crude reality of reproducibility as the most far-reaching phenomenon of modernity, and believes that photography as one of the fine arts is dead, with no place except in the commercial world as a technical and informative medium.
See pp. 174, 191.

Sebastião Salgado
b. 1944, Aimores, Minas Gerais, Brazil

Salgado earned a doctorate in economics, and until 1973 worked in London for the International Coffee Organization. During a trip to Africa, he tried his hand at photography and eventually decided to change careers. At the same time that he was reporting on current events, he undertook long-term documentary projects that can be followed through a series of publications, from *Other Americas* (1986) to *Migrations: Humanity in Transition* (2000) and *The Children* (2000), both of which center on the drama of people who have been displaced for political or economic reasons. Salgado was a member of the Sygma, Gamma, and Magnum agencies before founding his own agency, Amazonas Images, in 1994. He has won numerous prizes and awards.
See pp. 148–151.

Erich Salomon
b. 1886, Berlin, Germany;
d. 1944, Auschwitz, Poland

Erich Salomon was a businessman with a doctorate in law. He is known today mainly for his photographic portraits of personalities taken in real-life situations, sometimes without their knowledge, using a small flash-free camera called the Ermanox. After becoming a professional photographer in 1927 he concentrated on this genre, in particular during his attendance at international conferences, where he took many portraits emblematic of the secret diplomacy of the years between the world wars. A large number of those images were published in 1931 in a book entitled *Berühmte Zeitgenossen in unbewachten Augenblicken* (Famous Contemporaries in Unguarded Moments). He fled Germany in 1934 but was taken prisoner in Holland in 1943, and died in Auschwitz the following year.
See p. 98.

August Sander
b. 1876, Herdorf, Germany;
d. 1964, Cologne, Germany
See pp. 19, 84–85, 131, 154.

Jan Saudek
b. 1935, Prague, Czechoslovakia

After a childhood marked by his family's suffering in concentration camps, and later by the discovery of Edward Steichen's "The Family of Man" exhibition, Jan Saudek chose to express himself through photography. While working in a factory, he also set up a studio in his cellar where he could create his own theater of life. In his very elaborate, baroque compositions he translates the relationships between men and women, youth and death into images that combine tenderness with violence, romanticism with eroticism. Always using the same background of dilapidated walls, he takes black-and-white photographs to which he then adds color. Since the 1980s, Saudek has been well-known both in his own country and abroad and has exhibited throughout the world.

Gotthard Schuh
b. 1897, Berlin, Germany;
d. 1969, Küsnacht, Switzerland

In 1916, Schuh went to study painting in Basel. He did not take up photography until 1928, when he became a reporter for the *Zürcher Illustrierte*. He then worked for numerous weekly magazines in Europe, and in 1941 Schuh became head of the photography department at the *Neue Zürcher Zeitung*, where he published the first photographs by Robert Frank. After that he moved away from the press to concentrate on book projects. He had a huge success with *Inseln der Götter* (Islands of the Gods), which included photographs taken on his travels in Bali, Java, and Sumatra, and in 1956 published *Instant doles, Instants donnes* (Moments Given, Moments

Stolen), the first non-thematic monograph devoted to a photographer. His work was well represented in Edward Steichen's "The Family of Man" exhibit, but after his death he was forgotten. Today he is regarded as one of the pioneers of the documentary approach in Europe.

Ferdinando Scianna
b. 1943, Bagheria, Sicily, Italy
Ferdinando Scianna's Sicilian background left him with a deep interest in the religious and popular festivals of his childhood, which are central to his work as a photographer. In 1966 he published *Sicilian Religious Festivals*, with text by the writer Leonardo Sciasca; this was the first step toward their long friendship, which continued through a number of books in which the relationship between text and images is in perfect balance. Scianna worked as a journalist and photographer for the *Europeo*, which sent him to Paris in 1974. He joined the Magnum agency in 1989. Taking a cue from his master Henri Cartier-Bresson, he adopted an approach to photography that combined a rigorous gaze with a strong intellectual and humane dimension. In the 1990s he started working for the fashion industry, where he created images influenced by his Sicilian culture and imbued with the complexity of his thought. At the same time he traveled frequently to the village of Kami in Bolivia, a frequent subject of his photographs.

Andres Serrano
b. 1950, Brooklyn, New York
Andres Serrano is of Hispano-American origin. After studying at the Brooklyn Museum Art School in New York, he took an approach to photography that involved images, often provocative, that were based primarily on the living conditions of society's outcasts, other social problems, sex, and

Gotthard Schuh, *Java* (1940)

religion (*KKK* [1990], *Nomads* [1990], *The Morgue* [1991]). He attacked puritan America head-on with photographs such as *Piss Christ* (1987), which was censored. Working in series, he goes back to the rules of classical composition to create images structured on primary oppositions (life/death, sacred/profane, abstract/figurative), and enriched by dramatic lighting, making them somewhat reminiscent of Diego Velázquez or Eugène Delacroix. His photography transcends the real; it is a way of restoring presence and existence to people who, for one reason or another, have passed from our reality into another.

David "Chim" Seymour
b. 1911, Warsaw, Poland;
d. 1956, Suez Canal, Egypt
David Szymin was the son of a publisher who sent him to study printing and photography in Leipzig when he was eighteen. He then went to Paris to continue his studies at the Sorbonne, where he got the nickname "Chim." In 1933 he started work as a freelance photographer. He met Henri Cartier-Bresson and Robert Capa, who became his most loyal friends. As a liberal and anti-fascist, he went to Spain in 1936 to photograph the Spanish Civil War for the magazine *Regards*. He traveled to Mexico, moved to New York in 1939, and changed his last name to Seymour. In 1947 he was a cofounder of Magnum, and after Capa's death he served as its president until 1954. At the request of UNESCO, he went all over Europe documenting the harmful effects of war on children, a subject very close to his heart (Children of Europe, 1949). On November 10, 1956, he was killed by Egyptian machine-gun fire along the Suez Canal.
See pp. 115, 122.

Cindy Sherman
b. 1954, Glenn Ridge, New Jersey
In 1976, after graduating from the State University of New York in Buffalo, Cindy Sherman gave up painting. She then began to produce a body of photographic work in which she used herself as subject in a radical way. Using black and white, small-format prints, she created "self-portraits" that showed her as characters in

television series or American B movies in an exploration of the image of women as portrayed by the media. These "film stills" were undoubtedly the most important part of her work. She then went on to work through the idea of the self-portrait using color, large formats, and various types of presentation ranging from parodies of paintings to the visualization of dreams and nightmares. Although her early work was clearly intended as radical social criticism, her more recent photographs sometimes give a slight sense of having been manufactured for the mass market. Nevertheless, she remains one of the leading photographic artists of the late twentieth century, carrying on to perfection in the tradition of Claude Cahun and Pierre Molinier. *See pp. 170–171, 193.*

Stephen Shore
b. 1947, New York, New York

Stephen Shore was just twenty when he photographed the Velvet Underground's rehearsals and the alternative crowd that formed Andy Warhol's entourage at the Factory during that time. He began to use color in the 1970s, after discovering the wide-open spaces of the United States, and achieved such a perfect mastery

of it that in 1975 he took part along with the Bechers in the "New Topographics" exhibit in Rochester. While traveling across America by car, he took photographs in a quasi-impressionist style that captured the poetry of the everyday, the nuances and subtlety of color and ever-changing light. The distinctive nature of his vision was clearly shown in *Uncommon*

Places, a selection of his landscapes published in 1982.
See p. 140.

Malick Sidibé
b. 1936, Soloba, Mali
Malick Sidibé graduated as a craftsman jeweler in 1955, but decided instead to learn photography, and in 1957 he opened the Malick studio. Until 1976, in addition to portraits and photographs of ceremonies, he produced the images that became his specialty: shots taken at parties and clubs where the young people of Bamako came together and danced to twist and rock music. He also captured them on their Sunday excursions on the bank of the river Niger. At the beginning of the 1990s his archives were discovered, and he was honored at the first photography convention in Bamako. After that, orders for his prints steadily grew, and the Western public discovered his images through exhibits and a monograph published in 1998. In 2003 he was awarded the Hasselblad Prize.

Jeanloup Sieff
1933–2000, Paris, France
After a brief period of study—he was always being suspended from school—Sieff started taking photographs as a reporter in 1954. He worked for *Elle* from 1955 to 1959, first as a photojournalist, then as a fashion photographer. After joining Magnum, he became one of the very few photographers to leave the agency when he went to the United States to do freelance work. From 1961 to 1965 he worked for the leading U.S. magazines, including *Harper's Bazaar*. Whether in fashion or advertising, he worked with the

Malick Sidibé, *Boys on the Road* (1976)

major figures of his time, and had various key moments in his career, such as when Yves Saint Laurent posed nude for the photograph he took to launch a new perfume. Eclectic, charming, and talented, this apparent dilettante and free spirit was a great expert on the history of photography. Although he became known for his nudes and fashion photographs, he was also one of the best French portraitists of his time; he also produced remarkable landscape photographs that deserve to be better known. Like Robert Doisneau, he was a great writer. In his *Demain le Temps sera plus vieux* (Tomorrow, Time Will Be Older), he looked back over his own life.

Aaron Siskind
1903–1991, New York, New York
Siskind spent part of his life as a teacher, first in New York, then from 1951 to 1971 at the Chicago Institute of Design. Meanwhile, he was evolving from his first documentary photographs of Harlem, taken in the 1930s when he was a member of the Photo League, to the abstract images he created at the end of his career. After 1940, he became truly aware of the absence of perspective in the flat surface of the photograph. He then created the idea of the photograph as a flat, rectangular "new object" to set alongside the experiments of the abstract expressionist painters of the 1950s, such as his friend Franz Kline. He photographed cracked walls, details of facades, and fences around building sites. Using a number of techniques that were specific to photography, he was able to turn urban reality into an autonomous pictorial object.
See p. 128.

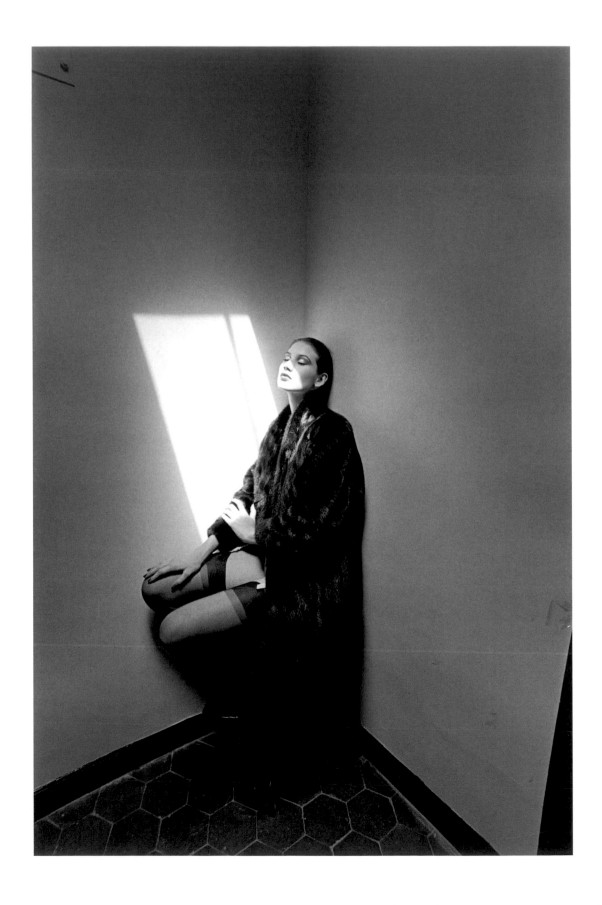

Sandy Skoglund
b. 1946, Quincy, Massachusetts
Sandy Skoglund trained in Paris, where she switched her studies from painting to photography; she then started to teach it in 1976. She took a conceptual approach to her work. This can be seen, for instance, in an early color series in which she sets up a tension between oilcloth backgrounds and culinary compositions; it is later evident in the extravagant images of staged environments, which would make her known as one of the major figures in performance photography. Her images of disquietingly green "radioactive cats" and a world invaded by goldfish have become icons, showing her very sure sense of color and ability to give substance to contemporary phobias. Food, such as meat with chocolate, is one of her favorite themes for large-format color photographs that waver between nightmare and fiction.
See pp. 170, 172–173.

William Eugene Smith
b. 1918, Wichita, Kansas;
d. 1978, Tucson, Arizona
The life and work of W. Eugene Smith can be summed up in one word: commitment. He started selling his first photographs at the age of fifteen, and a few years later went to work for Newsweek magazine. He joined the Black Star agency, then worked for *Life* magazine from 1939 to 1942, and was also the South Pacific war correspondent for *Flying* magazine. He was wounded in 1945, went back to work exclusively for *Life* magazine from 1947 to 1955, then resigned and joined the Magnum agency from 1955 to

1959. After that he decided to work alone, and undertook a series of reporting projects that he devised entirely on his own, taking full control of the images, captions, and layout to avoid any distortion of their meaning. He spent a year in a village in Spain (*Spanish Village*, 1951), photographed the city of Pittsburgh for two years, and went to Japan from 1971 to 1975 to study and document the ravages caused by mercury pollution in the village of Minamata. He worked hard to perfect the impact of his photographs, the dramatic force of his black-and-white images, and the expressive power of each of his reportages. Every image is a report, a parable intended to tell a story, bear witness, and guide the onlooker. The terrible, deeply moving photograph *Tomoko Uemura in Her Bath* (1972), which shows a mercury victim, has been compared to Michelangelo's *Pietà*; it has the same stature and majesty.
See pp. 92, 122, 131, 148.

Emmanuel Sougez
b. 1889?, Bordeaux, France;
d. 1972, Paris, France
Emmanuel Sougez trained at the École des Beaux-Arts in Bordeaux, then gave up painting to take up photography. He opened a studio in 1919, where he took portraits and worked for the advertising industry. His meeting with René Baschet opened the doors of the newspaper *L'Illustration* to him, and he founded its photography department in 1926. Sougez was not just a practicing photographer, famous for his reproductions of artworks and great buildings in Paris; he was also a technician who helped the progress of color photography by contributing to the invention of the Finlay process, as well as a photography historian who published two books, *La Photographie, son Histoire* (History of Photography, 1968) and *La Photographie, son Univers* (Photography: Its Universe, 1969). In 1993, a large exhibit entitled "Emmanuel Sougez, l'Éminence Grise [A Person of Influence]" was

W. Eugene Smith, *Welsh Miners* (1950)

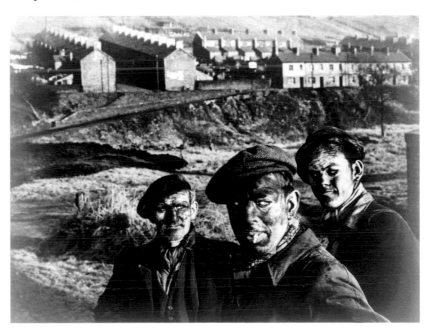

p. 272:
Jeanloup Sieff, *Fur in the Sun* (Paris, 1979)

organized in Paris by the Centre National de la Photographie.
See pp. 72–73, 80, 83.

Edward Steichen
b. 1879, Luxembourg
d. 1973, West Redding, Connecticut
In 1894, Steichen became an apprentice lithographer, and in 1896 began to take photographs. From then on his career moved along at a brisk pace. He exhibited in Philadelphia and London, was admitted to the Linked Ring in 1901, and moved to Paris, where he exhibited his paintings and photographs. When he returned to New York in 1912, he worked closely with Alfred Stieglitz in founding the Photo-Secession, 291 (the gallery), and the journal *Camera Work*. Steichen then turned his style to Straight Photography. He became a professional photographer specializing in fashion and portraiture and published photographs in *Vanity Fair* and *Vogue* between 1932 and 1938. In 1947, he was appointed head of the photography department at the Museum of Modern Art, where in 1955 he organized the traveling exhibit "The Family of Man."
See pp. 55, 56, 58, 74, 76, 85, 104–105, 130.

Otto Steinert
b. 1915, Sarrebruck, Germany;
d. 1978, Essen, Germany
This self-taught photographer was also a historian and theorist of photography. Today, he is recognized as the father of Subjektive Fotografie (the New Subjectivity movement), which came into being in Germany after World War II. From 1959 on, he was a charismatic teacher at the Folkwangschule in Essen. He put together the Folkwang museum's photography collection, which to this day is still one of the finest in Germany.
See pp. 126–127.

Alfred Stieglitz
b. 1864, Hoboken, New Jersey;
d. 1946, New York, New York
After studying in Berlin in 1881, Stieglitz became passionately interested in photography. He became a member of the New York Camera Club in 1891, was the first American photographer to be elected to the Linked Ring, and established himself as the leading figure in the American pictorialist school. In 1897 he ran the journal *Camera Notes;* after a disagreement with the Camera Club, he founded the Photo-Secession in 1902, then the journal *Camera Work* (1903–1917). In 1905 he opened the Little Galleries of the Photo-Secession at 291 Fifth Avenue (which came to be known simply as "291"), where in partnership with Edward Steichen he exhibited photographs and contemporary art until 1917. He married the painter Georgia O'Keefe in 1924, was director of the Intimate Gallery, and from 1929 to 1946 of An American Place, where he showed mainly paintings. Stieglitz stopped taking photographs when he was seventy-three.
See pp. 55, 56–59, 76, 96, 128.

Paul Strand
b. 1890, New York, New York;
d. 1976, Orgeval, France
Strand was introduced to photography by Lewis Hine. Very soon after, he came in contact with Alfred Stieglitz, who in 1916 organized his first personal exhibit at 291 (as the Little Galleries of the Photo-Secession had come to be known), and the following year devoted the last issues of the journal *Camera Work* to his photographs. Strand played on lines and contrasts, transforming architectural motifs or objects into almost abstract forms simply entitled "Photographs." In 1920, he moved into films and made a short film, *Manhattan*, in collaboration with Charles Sheeler, who was another follower of Straight Photography. He then traveled around New

Mexico, where he photographed the architecture of ghost towns before going on to Mexico to take photographs of the Indians and landscapes. After some years devoted exclusively to filmmaking, he returned to photography. In 1945, the Museum of Modern Art chose Strand's work as the subject of its first exhibit of contemporary photography. Strand spent the last twenty years of his life in France.
See pp. 53, 58, 76–77, 86, 174.

August Strindberg
1849–1912, Stockholm, Sweden
Strindberg was an artistic jack-of-all-trades; not only was he a dramatist, poet, novelist, and painter, but he also took up photography in the 1880s and practiced it during three very specific periods: 1886–1888, 1890–1894, then 1905–1907. He viewed photography as a way of offering an objective vision that could go beyond appearances and reveal a suprasensible reality, as if to echo occultist and spiritualist theories. Moving from the documentary approach (the lost photographs, taken during a trip to France in 1887) to experimental research ("celestographs" and "crystallograms" in the early 1890s, "psychological portraits" in 1905), he said that he was looking in photography for "the truth, intensely, as I look for it in other spheres."

Christer Strömholm
1918–2002, Stockholm, Sweden
Radical, rebellious, and unclassifiable, Strömholm left his native Sweden at nineteen to study in Dresden under Waldemar Winkler, with whom he very soon clashed over views on Paul Klee and the blacklisted artists of the Bauhaus. He took up photography in Paris in 1946, first taking portraits of the artists of his time (Man Ray, Le Corbusier, César Baldaccini), then developing his own body of work.

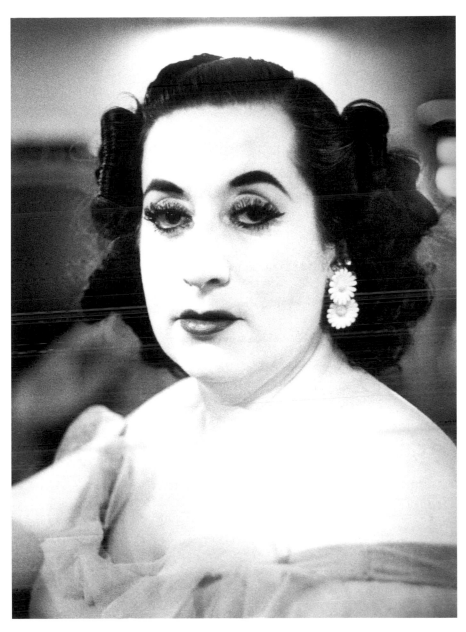

Christer Strömholm, *White Lady* (1959)

At the beginning of the 1950s he joined the Fotoform group, then returned to Paris in 1956. For six years he made a day-to-day, completely unvoyeuristic record of the lives of transsexuals on the place Blanche and place Pigalle. He traveled all over the world, then from 1962 to 1974 ran the School of Photography at Stockholm University, training more than 1,200 students and teaching them not one particular style but a set of values, including the absolute necessity for freedom of approach. It was not until the end of his life that he won recognition from the institutions, and in 1997 was awarded the prestigious Hasselblad Prize. He left behind an immense volume of work characterized by an obsession with death; its importance is only now beginning to be gauged.
See p. 126.

Thomas Struth
b. 1954, Geldem, Germany
Like Thomas Ruff, Thomas Struth was Bernd Becher's student at the academy in Düsseldorf. Working in large format and using the photographic chamber and the principle of typology, he developed a plastic style in which he rejected emotion, affects, and subjectivity, thus pioneering the entire issue of photographic objectivity. For more than twenty years he has been working on the structure of our cities, lives, and dreams. In 1978, he took as his subject the lives of city dwellers in North America, Europe, and Japan, and somewhat later moved on to family portraits and very close-up studies of flowers. His more recent

photographs of museum interiors pursue the same line of questioning: how is the way we look at masterpieces conditioned by our knowledge and the scenic layout? *See p. 192.*

Josef Sudek
b. 1896, Kolin, Czechoslovakia;
d. 1976, Prague, Czechoslovakia
Sudek took up photography in 1913 with a pictorialist approach that made the lights of Old Prague vibrate in timeless visions. In 1917, after losing his right arm, he decided to devote himself entirely to photography, which he explored by adopting every format, from the panoramic to the medium-format camera, and by experimenting with every technique, from contact printing to silkscreen to produce a unique, poetic body of work made up of architecture inventories, still lifes of glasses, panoramic views of Prague, mournful visions of

trees, photographs of the chaos in his studio, and the forms of his "magic garden." He tried out the whole range of possibilities offered by photography in its relationship to light, and rejected any kind of spectacular effect, creating work that is pure, deeply moving, dreamlike, and at the same time very real.

Hiroshi Sugimoto
b. 1948, Tokyo, Japan
Sugimoto lives and works partly in Tokyo and partly in New York, and reproduces this duality between Japanese origins and American culture in his artistic world. Influenced by both countries, he shakes up the notions of representation that are inherent to photography. For his first series, Dioramas (1976–1980), he photographed the preserved animals at New York's Museum of Natural History in

Josef Sudek, *Bread, Egg and Glass* (1950)

front of landscape paintings, thus subverting the idea of the representation of reality. In Theaters (2000), he set up his camera at the center of 1920s movie theaters, and left the lens open during the projection; the over-exposed film gives a totally white screen, whereas the decor in the theater is lit up in the tiniest detail. In Seascapes (1994), Sugimoto focused on horizons where the azure sky and the ocean meet at the limit of abstraction, and in Japan he analyzed the mechanism of light shining on sacred statues of the Buddha in such a way that the light is the only means of capturing their spiritual dimension, while the photographic image itself is a disappointment.

Maurice Tabard
b. 1897, Lyons, France;
d. 1984, Nice, France
For a long time Tabard was underrated as an artist, and only gained recognition for his work and contribution to photography at a late stage in his career. He trained in the United States and stayed there for ten years, working as a portrait photographer in a studio. After returning to Paris in 1928, he became a much-sought-after press photographer and a well-known name in the worlds of fashion, decor, and advertising.

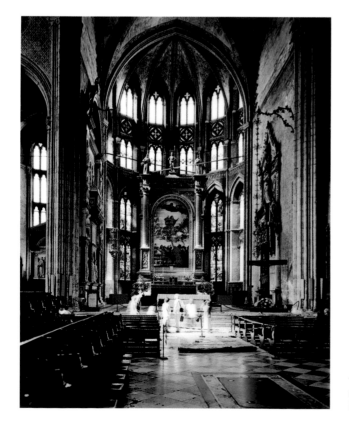

Thomas Struth,
Chiesa dei Frari
(Venice, 1995)

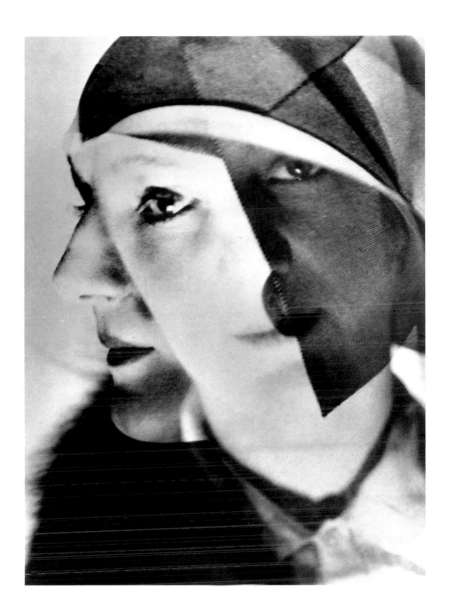

Maurice Tabard, *Composition (double exposure),* (1931)

His unashamedly romantic style shows an attraction to technical experimentation (solarization, rayograms), and a playful approach to the photographic medium—his defining characteristic. After World War II, he divided his time between New York and Paris before returning to France for good in 1960. *See pp. 83, 108–109.*

Keiichi Tahara
b. 1951, Kyoto, Japan
Before moving to Paris in 1973, Keiichi Tahara had already made some short films in Japan. He took up photography for a series entitled Windows (1975–1980), in which he used the windowpane as

an imperfect filter that enabled him to play with light and shade, the clear and the unclear, in a way that radically altered the notion of space. In another series, Transparent (1989), he printed his photographs on large sheets of glass that were then covered in scratches and streaks of paint but that still allowed the wall or floor they were displayed on to show through. For some years he has been extending this project by incorporating his sheets of glass into buildings and installing lighting fixtures in cities. He is also a remarkable portraitist. He uses a giant Polaroid and is interested in fashion and the decorative arts.

William Henry Fox Talbot
b. 1800, Melbury Abbas, England;
d. 1877, Lacock Abbey, England
Talbot was the inventor of the first negative-positive process on paper and as such is often regarded as the father of modern photography. The technique was perfected in 1840, and it was patented the following year under the name "calotype." It was the end result of research begun in 1833 into the light sensitivity of silver salts, and it was this invention that suddenly moved the photographic image into the age of reproduction. In 1842, Talbot also set up the first photography printing press and published one of the first books illustrated by photographs, *The*

William Henry Fox Talbot, *Microphotography of Moth Wings* (1838)

Pencil of Nature (1844–1846). He had an eclectic mind and was not only a crucially important inventor but also a very great photographer. His photographs and archives are shared between the National Museum of Photography, Film & Television in Bradford and the Fox Talbot Museum of Photography, which opened in 1975 in his house in Lacock Abbey.
See pp. 17, 19, 90, 93.

Wolfgang Tillmans
b. 1968, Remscheid, Germany
As a child, Tillmans gazed at the stars and photographed the moon. At twenty-four he moved to London, where he took snapshots of young members of the punk counterculture and the generation of techno, sex, and Ecstasy. He was the leading figure in "trash photography," and in 1992 published a cult series of photographs in *i-D* magazine that showed his childhood friends naked in trees. He is a nonconformist who continually changes tack and has done everything from exhibiting in the great European galleries to producing (in 2000) a series of images for *The Big Issue*, a magazine sold by the homeless, to taking portraits of stars such as Kate Moss. He uses spectacular changes in scale, and focuses on details that seem completely insignificant to create images such as a close-up shot of a man masturbating, a still life, a portrait, or the Concorde lost in the blue sky. He reproduces images in every size, from postcards to giant posters, and uses various methods of reproduction such as photocopies, which he tapes all over the wall in an apparently random way, thus creating a disturbing personal vision of a world hovering between the infinitely large and the infinitely small. In 2000 he became the first photographer to win one of contemporary art's most prestigious awards, the Turner Prize.

Patrick Tosani
b. 1954, Boissy-l'Aillerie, France
Patrick Tosani studied architecture. In 1982 he produced his first photographs, which were a reflection on photography as a pictorial form. He works in series and in large format on subjects such as ice, fire, the uneven surface of drum skins, or the shapes of shoe heels (Palais, Forums, Talons). He frames objects in a subtle way that brings out a strong sense of their materiality, showing a wealth of detail woven into a whole new imaginative experience. His latest work, Regards (2002), is an aesthetic study of form and color based on clothing, in which the naïve world of the child is transposed and transcended by modifying elements of clothing to give the portraits an added air of strangeness and spontaneity. Patrick Tosani's photographs seem to create a world of contradiction and ambiguity, somewhere between illustration and representation.

Deborah Turbeville
b. 1937, Medford, Massachusetts
Deborah Turbeville was very attracted by painting and drawing. She studied photography with Richard Avedon and Marvin Israel

Wolfgang Tillmans, *The Concorde* (1997)

and began her professional career in the early 1970s, working as a fashion photographer for magazines such as *Vogue*, *Harper's Bazaar*, *Mademoiselle*, and *Marie-Claire*. She has a very subjective vision characterized by soft focus and elegant composition, and her photographs are less concerned with the clothes themselves than with the portrayal of gently atmospheric scenes, feminine dreams, and floating imaginary worlds. She invented a highly unusual approach, rejecting the idea of photography as a descriptive medium for an impressionistic technique that she continued to use in her personal studies of the Château de Versailles and St. Petersburg, turning them under her gaze into places imbued with a strong sense of temporality.

Raoul Ubac, *Bubble with Reflections at the Parc de Sceaux* (1938)

Raoul Ubac [Rudolf Ubach]
b. 1910, Malmédy, France;
d. 1985, Paris, France
Ubac was a painter, sculptor, and artist who also took photographs over a ten-year period when he was part of the surrealist group in the 1930s. He used most of the techniques involving transformation of the image that were popular with the photographers in surrealist circles (solarization, photograms, collage, photomontage); he perfected others, such as "brûlage" (melting the negative) and inversion (giving the impression of slight relief or imprinting). He worked for the journal *Le Minotaure*, illustrated various works, and also wrote several books on his work as a photographer. During the war he gradually moved away from photography, and in 1945 turned his attention to sculpture.
See pp. 80, 83, 109.

Shoji Ueda
b. 1913, Sakaiminato, Japan;
d. 2000, Yonago, Japan
Ueda trained at the Oriental School of Photography in Tokyo, then opened his first studio in 1933. He was a member of various photography clubs and started to exhibit regularly in 1937. Described as a "poet of images," and influenced by René Magritte and Jacques Henri Lartigue, he photographed scenes showing people he knew—friends, parents, children—scattered around the sand dunes in Totorri, his native region. His figures are like objects placed in the sand, apparently emerging from a dream in which all the landmarks have disappeared and where perspective gives way to humor and curiosity. He then moved on from his sand dune scenes to subjects such as children at school and a local beauty queen, and taught photography at the University of Sakaiminato-shi. He published several works, including *Children of the Year Round* (1971) and *Sand Dunes* (1978).
See p. 125.

Umbo [Otto Umbehr]
b. 1902, Düsseldorf, Germany;
d. 1980, Hanover, Germany
Umbo trained at the Bauhaus, and started as a portraitist before making his name in photojournalism and advertising. Based on diagonals, decentered images, and high-angle shots, his style caught the spirit of the 1930s in Germany. In his photographs he played with every ambiguity of perspective, capturing the long shadows of late afternoon and the contrast between black and white: the absurd vying with the incongruous. In 1928, he founded the Dephot agency (Deutsche Photodienst), which was run as a cooperative and notably included Andreas Feininger and Robert Capa. His work was published in Franz Roh's *Foto-Auge* (Photo Eye) in 1929, and shown at the "Film und Foto" exhibit in Stuttgart. His archives were lost in World War II. He gave up working as a photographer and taught until 1974.
See p. 122.

Jeff Wall
b. 1946, Vancouver, Canada
Jeff Wall started taking photographs at the age of twenty. Ten years later, he experimented with giant-format photography, showing his images in light boxes and

Umbo, *Mystery of the Street* (1928)

using actors to create hugely expensive staged versions of scenes he had witnessed. This project was the end product of long reflection on the part of the photographer, based on photographic reportage, art history, and cinema, with the photograph acting as a kind of frozen cinema shot. The Destroyed Room (1978) shows a vandalized room, and refers to Eugène Delacroix's Death of Sardanapolis, while Dead Troops Talk, taken in 1991 in Afghanistan, required a team and budget worthy of the movies. As a theorist and art history professor, Jeff Wall regards himself as what Baudelaire called "a painter of modern life," capable of dealing with everyday subjects, with politics, and the ordinary man. Since 1995 he has worked in black and white but has kept the same large formats. His recent works are interconnected by enigmatic stories drawn from everyday life, which he describes as illustrations of his interest in the photography of close-up documentation. Ultimately, this staging of reality is just an insoluble enigma, that of photography itself.
See pp. 170, 190, 193.

Andy Warhol
[Andrew Warhola]
b. 1928, Pittsburg, Pennsylvania;
d. 1987, New York, New York
Warhol moved to New York to work as an advertising illustrator and graphic designer. He painted his first canvases by hand, then in 1962 adopted a very personal technique. Starting with black-and-white photographs, he first added color to them then reproduced them by serigraphy and transferred them to canvas. The content of the image is reduced to a sign, and it often draws its visual impact from the effect produced by repetition. The subject of the original photograph is carefully chosen as something that is at once familiar and emblematic (*Coca-Cola*, 1962), famous and tragic (*Marilyn*, 1962), spectacularly neutral (*Cows*, 1966), or political (*Mao Zedong*, 1972). At the same time Warhol also founded the Factory, which spawned the Velvet Underground, and where he made films with Paul Morrissey (*Sleep*, 1963). By basing his work on the process of mechanical reproduction, Warhol revolutionized the existing concept of authenticity. He profoundly questioned the importance of the artist's individual stamp and the very nature of creation.

Weegee [Arthur H. Fellig]
b. 1899, Zloczew, Poland;
d. 1968, New York, New York
"Weegee…I've never known a better name or a better photographer," declared the famous American photojournalist, who began his career as an independent photographer in 1935. Sitting in the early hours of the morning in his Chevrolet, which was fitted out as a laboratory, with his Speed Graphic flash camera, he got his information direct from the Manhattan police and arrived at the scene of the crime at the same time as they did. Drownings, suicides, accidents, fires, murders, gawking onlookers: he inundated the gutter press with photographs under the name "Weegee the Famous," in which he bore witness to the daily routine of violence and the nightmares of the hours of darkness. His images are heavily contrasted and blasted by the light of the flash. Using infrared film he also tracked down tramps in hostels, drinkers in bars, transvestites, and society ladies going to the opera. He rose to fame in 1945 with his book *Naked City*, in which he chronicled New York life of the 1930s. In 1947 he was called to Hollywood as a technician and actor, then returned to New York and amused himself by caricaturing personalities viewed through distorting mirrors.
See pp. 99, 129.

William Wegman
b. 1942, Holyoke, Massachusetts
Wegman began by working in photography and video at the end of the 1960s, while at the same time developing a body of graphic work centered on drawing. At the beginning of the 1970s he started to photograph his dog, Man Ray, in series that were full of humor and fantasy that combined derision and psychology. The dog was to become the central focus of his work, which consists of hundreds of images, mainly large-format color Polaroids, in which dogs play

Andy Warhol, *Self-Portrait* (1986). Color Polaroid

the viewer with their strong presence, which derives from a combination of natural grace and very intense emotion.
See p. 122.

Edward Weston
b. 1886, Highland Park, Illinois;
d. 1958, Carmel, California
Edward Weston began his career as a photographer at the age of sixteen, when his father gave him a camera. He started with some portraits, then in 1908 went to study at the photography college in Illinois before heading to California, where in 1911 he opened a studio in Tropoico. He was highly successful as a pictorialist, and in the 1920s became one of the masters of pure photography, concentrating on still lifes of shells and plants, abstract close-up shots, the texture of surfaces and the majesty of the nude, in black-and-white images of remarkable perfection which he printed with great virtuosity. He was a founding member of the Group f/64, and in 1937 received a grant from the Guggenheim Foundation to travel throughout California. After developing Parkinson's disease, he was obliged to give up photography in 1948.
See pp. 74, 77, 116, 128, 174.

human roles in a spectacular fashion. With his canine companions he also produced a remarkable video alphabet and several fairy-tales for both children and their parents. With its casual, appealing quality, his work has been exhibited throughout the world and is extremely popular. Although repetitious, it is one of the most original contributions to the performance photography trend.
See p. 143.

Sabine Weiss
b. 1924, Saint Gingolph, Switzerland
In 1945, Sabine Weiss received her photography diploma in Geneva. She started work as Willy Mayvald's assistant in Paris, then became an independent photographer in 1950. In 1952 she met Robert Doisneau, joined the Rapho agency, and signed a contract with Vogue. After that came a string of commissions, grants, exhibits (including "The Family of Man" in 1955 and the "Maison Européenne de la Photographie" [European House of Photography] in 1996), and publications (*En Passant* [In Passing], 1978; *Des Enfants* [Some Children]; 1997, *Sabine Weiss*, 2003). Throughout the world, she has taken photographs for "the love of people," and her black-and-white images surprise

Clarence H. White
b. 1871, West Carlisle, Ohio;
d. 1925, Mexico City, Mexico
White initially allowed his parents to hold him back from his artistic ambitions, and worked as an accountant for a firm while devoting his spare time to photography. The year 1899 was key for him: he took his first stabs with the gum bichromate process and took part in several exhibits— at the Camera Club in New York; the Newark Camera Club, which he had helped found in 1898; the Boston Camera Club; and finally in London, at a show organized by the Linked Ring. He was elected to

Edward
Weston,
Pepper
(1930)

the Linked Ring in 1900, at the
same time as Gertrude Käsebier,
who became his friend. In 1906
he exhibited at 291 (as the Little
Galleries of the Photo-Secession
were known) and moved to New
York. Together with Alfred Stieglitz,
he created a series of nudes named
after the models, The Cramer-
Thompson Series. In 1914 he
founded the Clarence H. White
School of Photography in New
York. From 1921 on, he concen-
trated on his own personal work.
See pp. 56–58, 77.

Minor White
b. 1908, Minneapolis, Minnesota;
d. 1976, Boston, Massachusetts
Minor White was a poet and mys-
tic. From 1965 on, he was an influ-
ential figure in San Francisco and
at MIT because of his philosoph-
ical convictions and photography
teaching, but above all he was a
master of photographic abstrac-
tion. Using the Zone System to
control the exposure and develop-
ment of his images, he took photos
of rock, wood, and metal, their
lines, forms, and colors springing

out of the photograph. He grouped
his images in sequences with
different resonances, giving scope
for sensation and emotion. In the
studios he ran and the books he
wrote (*Mirrors Messages Manifes-
tations*, 1969) he delivered his con-
ception of photography: a passage
leading to self-discovery and the
fusion of mind and matter, in a
process of creation, meditation,
and the search for the sacred.
See pp. 128, 174.

Garry Winogrand

b. 1928, New York, New York;
d. 1984, Tijuana, Mexico

Winogrand discovered photography in 1948. He trained under Alexey Brodovitch at the New York School for Social Research and was highly impressed by Robert Frank's *The Americans*. In the 1960s, he found a photographic style in which humor brings on anxiety, with a smile that conceals the apprehension of an unbearable, disturbing, unhinged world. As a street observer who photographed zoos, the visitors there, and the New York crowd, he captured the way in which gazes circulate in a complex network. He also examined the surface signs that reveal chaos, barely perceptible violence, the terrifying reality that he alone perceived with such acuity. He published thematic series such as Animals (1969) and Public Relations (1977).
See p. 129.

Joel-Peter Witkin

b. 1939, Brooklyn, New York

Precocious and determined, Witkin photographed his first grotesqueries at the age of sixteen, then went on to study sculpture. He moved to New Mexico, wrote a thesis on photography, taught, and developed a highly uncommon body of work in which he presented strange situations and visualizations of fantasies bringing together the body, death, sex, animals, and mythology. Sometimes morbid, always scholarly, his compositions look like possible provocations or the materialization of nightmares. He refers to art history from Diego Velázquez to the nude to the still life, cultivates deformities from dwarves to hermaphrodites, and creates refined, disturbing images that obsessively question the notion of normality.

Wols [Alfred Otto Wolfgang Schulze]

b. 1913, Berlin, Germany;
d. 1951, Champigny-sur-Marne, France

Originally from Germany, Wols was both a painter and an artist. He did most of his photographic work in Paris over a relatively short period, between 1936 and 1940. Although his repertoire consisted mainly of images taken on his solitary walks around Paris (cast-off objects, the banks of the Seine, tramps), it should not be forgotten that he also spent time as a fashion photographer producing compositions tinged with surrealism. He had a great enthusiasm for bizarre, unwholesome still lifes. He was interned in various camps during the war and gradually abandoned photography for painting. Drinking wrecked his health, and he died at the age of thirty-eight.

Willy Zielke

b. 1902, Lodz, Poland;
d. 1970, Bad Pyrmont, Germany

Zielke began his studies at the railway school in Tashkent. He then went to the Bavarian State Institute for Photography in Munich, where he was a professor from 1928 to 1936. Starting in 1929, he exhibited photographs that were perfectly constructed and expressed a specific approach to everyday objects such as bottles, glasses, and boxes. He was attracted by the movies, however, and in 1931 made his first film, *Anton Nicklas*, after which he continued his career as a filmmaker. He helped Leni Riefenstahl shoot the prologue to her film, *The Gods of the Stadium* (1936), and at the same time photographed a major series of nudes. From 1951 to 1970 he directed films for industry.
See p. 72.

Willy Zielke, *Glass Plates* (1932)

René Zuber

b. 1902, Doubs, France;
d. 1979, Meudon, France

Zuber gave up the chance to become an engineer in his family's paper factory in order to work in the world of books, which were his great passion. In 1927 he went to Leipzig, where he became a student of László Moholy-Nagy. When he returned to France in 1929, he entered the photography department at *L'Illustration*, under the direction of Sougez, and was selected to take part in the "Film und Foto" exhibit in Berlin. From 1903 to 1932 he worked for the Parisian advertising agency Damour, then set up his own studio with Pierre Boucher. Their photographs were published in magazines such as *Art et Médecine*, *Votre Beauté*, and *Vu*. He was passionately interested in film and made documentaries in Crete, Syria, and Lebanon. After the war he gave up photography, founded a small publishing house called Compas, and went on directing films.
See pp. 73, 122.

INDEX

Project Manager,
English-language edition:
Céline Moulard

Editor, English-language edition:
Virginia Beck

Jacket Design,
English-language edition:
Michael Walsh

Design Coordinator,
English-language edition:
Christine Knorr and Merri Ann Morrell

Production Coordinator,
English-language edition:
Kaija Markoe

Library of Congress
Cataloging-in-Publication Data
Petite encyclopédie de la photographie.
English
The Abrams encyclopedia of photography /
edited by Brigitte Govignon, Quentin Bajac, and
Christian Caujolle.
p. cm.
Includes bibliographical references and index.
ISBN 0-8109-5609-8 (hardcover)
1. Photography--Encyclopedias. I. Bajac,
Quentin. II. Caujolle, Christian. III. Title.

TR9.P4813 2004
770'.3--dc22
2004007710

Printed and bound in Italy
10 9 8 7 6 5 4 3 2 1

Harry N. Abrams, Inc.
100 Fifth Avenue
New York, N.Y. 10011
www.abramsbooks.com

Abrams is a subsidiary of

LA MARTINIÈRE
GROUPE